WALKING ON WATER
LONDON'S HIDDEN RIVERS REVEALED

STEPHEN MYERS

AMBERLEY

First published 2011

Amberley Publishing
The Hill, Stroud
Gloucestershire GL5 4EP

www.amberleybooks.com

Copyright © Stephen Myers 2011

British Library Cataloguing in Publication Data.
A catalogue record for this book is available from the British Library.

ISBN 978-1-4456-0067-3

Typesetting and Origination by Amberley Publishing.
Printed in Great Britain.

Contents

About the Author 7

Disclaimers 9

Geographers' A–Z 10

Acknowledgements 11

Foreword 13

Chapter 1 London and Its Hidden Rivers 17
 Watery Definitions
 Rivers and Founding of London
 The North Bank Tributaries of London's Thames

Chapter 2 Noble Beginnings, Brief Renown, Rack and Ruin 29
 Basic London Geology
 Normal Wells and Artesian Wells
 Springs
 London's Spas, Springs and Wells
 How Do Rivers Form?
 What Did London's Rivers Look Like?
 Where Have all the Rivers Gone?

Chapter 3 A City Grows, Its Rivers Beggared 68
 London's Population Growth and Urbanisation
 London and Its Hidden Rivers – the Historical Context

Chapter 4 A Story of Use and Abuse 86
 Rivers and Society – The Paradox
 The Royal Parks and Their Lakes
 Strategic Value
 Bathing, Laundry and Public Baths
 Water Supply
 Recreation
 Navigation
 Rivers as Sewers
 Mills and Power

Chapter 5 Mapping London's Hidden Rivers 117
 Step 1 – Initial Literary Search
 Step 2 – Cartograhic Research
 Step 3 – Walking the Hidden River Routes
 Step 4 – Consultation with Local Library References
 Step 5 – Consultation with Records of Thames Water

Chapter 6 The River Walbrook 126
 The Walbrook – The City of London's River
 The Walbrook - Principal Sources, Watercourses and Tributaries
 The Walbrook Through History

Chapter 7 Hampstead Heath – Source of Three of the 136
 Hidden Rivers
 Sources of the Three Hidden Rivers: The Fleet, the Tyburn
 and the Westbourne
 Highgate and Hampstead Villages
 Hampstead Heath

Chapter 8 The River Fleet 145
 The Fleet – River of Many Names
 The Fleet River – Principal Sources, Watercourses and Tributaries
 The Fleet Through History

Chapter 9 The River Tyburn 159
 The Tyburn – Origin of the Name
 The Tyburn – Source and Watercourse
 The Tyburn Through History

Chapter 10 The River Westbourne 172
 The Westbourne – Origin of the Name
 The Westbourne – Source and Watercourse
 The Westbourne Through History

Chapter 11 Counter's Creek 184
 Counter's Creek – Origin of the Names
 Counter's Creek – Source and Watercourse

Chapter 12 Stamford Brook 189
 Stamford Brook – Origin of Name
 Stamford Brook – Source and Watercourse

Chapter 13 The Black Ditch 194
 The Black Ditch – Origin of the Name
 The Black Ditch – Principal Sources and Watercourse
 and its Tributaries

Chapter 14 Hidden River Assets – Resurrection and Revelations? 199

References 209
List of Maps Consulted 213
Index 219

About the Author

Stephen Myers.

Born in 1942, in London, Stephen Myers has had a lifelong interest in matters aquatic. His childhood interest in water developed to the point where, at the age of twenty-five, he qualified as a chartered civil engineer, specialising in water and wastewater projects. After an initial career on major wastewater projects – including Tyneside and Edinburgh – he opened an Italian office in 1972 for J. D. & D. M. Watson, one of the world's oldest and most eminent companies in the sector. Over the next five years, there followed a series of studies and projects on remedying the polluted waters of the Mediterranean and the Adriatic, including the Gulf of Naples, Genoa, Elba and Venice, and numerous pollution control projects relating to towns, villages and industries in the Po and Isonzo river valleys. During this period, he was also involved in projects in Somalia and the southern Sudan, which even then was suffering a civil war.

From 1977 to 1979, he headed what was then the world's largest marine pollution control project, the Greater Athens Liquid Wastes Disposal Project, funded by the Government of Greece and the World Health Organisation. The main study recommendations were implemented over the next twenty years and were key to the Saronic Gulf becoming clean enough to be used for the sailing events of the 2004 Olympic Games held in Athens. He was made a full equity partner of his company, by then known as Watson Hawksley, which had 850 staff in almost thirty countries. There then followed two years of promotional and project work which took him through almost every European and Latin American country. In this period, he was also responsible for the Algarve Pollution Control Project in Portugal, funded by the World Bank.

In 1981, Stephen took up residence in Hong Kong, where the company was responsible for most of the territory's wastewater management work. He also directed the marine

survey and environmental study for the proposed new airport on Lantau Island. His project, promotional and educational work took him to most East Asian countries, perhaps the most fascinating being mainland China.

Leaving Hong Kong in 1986, he was project director in Istanbul for the World Bank-funded project for Greater Istanbul Wastewater Management. He retired from Watson Hawksley, now a part of Montgomery Watson Harza, the world's largest consultancy in the water and wastewater sector, in 1990 at the age of forty-seven. He has since practised as a consultant working with many of the world's development banks as a senior strategist in the water sector. His career has taken him to nearly seventy countries across four continents.

The achievement of which he is most proud is his most recent involvement with India for the World Bank. In 2002, when he was first asked to visit the country, not a single town or city had a continuous water supply service, the average urban supply being for two hours every two days. Eighty per cent of disease in India is water-related and half a million children under the age of five died from acute diarrhoea in the country every year, in great part due to poor urban water supply. Women and children in poor households are disadvantaged in respect of education and earning capacity as they spend so much time on water-gathering activities. Stephen conceived a process by which cities and towns could convert their water supply service to continuous supply. This was accepted by the World Bank and the Government of India and, after five years, in 2007, the first pilot projects became operational and were successful. By 2010, more than fifty cities had projects to convert to continuous supply. The improvement to the circumstances of poor women and children has been immediate in the areas receiving continuous supply; no doubt, health will also improve dramatically.

Stephen's family, his wife Marion and their children Nicola and Joel, lived with him overseas – in Italy, Greece and Hong Kong – over a total of fourteen years. It is a matter of the greatest and continuing sadness to them that Nicola lost her life at the age of eighteen in Hong Kong. This book is dedicated to her memory.

Disclaimers

The routes of London's hidden rivers, as depicted on maps included in this publication, are a best representation of the author's understanding based upon considerable research. This has included the study of historical and contemporary maps, literary searches and on-site examination of the underlying natural topography of the urban areas through which each of them passes from their respective source or sources to their confluence with the Thames. However, by the very nature of their character, that of being hidden from sight, combined with a lack of accuracy in the historical records consulted, the conclusions drawn as to the routes of the rivers have, for some sections, involved a degree of speculation.

Therefore, in spite of the best efforts of the author, the actual routes taken by the hidden rivers – and their successor culverts and pipelines – may not, in some sections, be accurately depicted on the plans in this book. Such inaccuracy could occur at any point along the lengths of the routes shown for the hidden rivers. These maps, therefore, are not intended for use for any other purpose than for the guided walks that form an important part of this book. In particular, there is no intention to imply that the route of any of the hidden rivers depicted in this book pass beneath any particular building, house, structure or infrastructure. As such, these plans of the routes of the hidden rivers must not be used for insurance, property conveyancing or for any legal purposes or processes.

A practice has grown up in recent years in London which carries with it extreme risk. This practice entails individuals or small groups entering those sewers that were once the rivers of London, particularly the Inner London sections of the Fleet, the Tyburn and the Westbourne. Notwithstanding the legality of this practice, it could result in the deaths of those participating from one of a number of causes. These are expanded upon at the end of Chapter 2. Nothing in this book should be considered in any sense an encouragement to engage in this practice. The author abhors the practice and considers those that indulge in it foolhardy and irresponsible, in that they actively encourage others to follow their example by publicising their experiences on the web. Entry to the sewers of London, including those that were formerly rivers, should only be undertaken wearing appropriate protective clothing and appliances, with the permission of Thames Water and under the guidance of experienced crews of sewer personnel.

Geographers' A–Z Map Co. Ltd

The work of plotting the routes taken by the hidden rivers onto maps and their manipulation and printing was rendered a much simpler task than it would otherwise have been by Geographers' A–Z Company's digital version of their *Greater London Street Atlas*. This has proved an excellent, user-friendly product and can be thoroughly recommended. London street maps can be reproduced from this digitised version to any practical scale, small or large. They have enabled me to produce walking maps for the thirteen detailed descriptive walks along the hidden rivers that will be published in the autumn of 2011 as a companion volume to this present book.

I approached the company later than I should to request their permission to use their maps in this publication. They were extremely helpful in immediately issuing a licence to use the maps, and my sincere thanks for this are due to the Directors of the company and to the manager of their licensing department, Jenny Fancett.

Acknowledgements

I would like to thank my wife, Marion, who has been very tolerant of my obsession with the hidden rivers over a number of years. Her patience while being regaled with story after story about my on-site researches and encounters was exceptional. Her tolerance must surely have reached its limit when it came to the point that we could not venture out in the car without my commenting several times of the links of an area to one or other of the hidden rivers.

Mention has already been made of a companion volume to be published in the autumn of 2011 which will detail thirteen walks along the hidden rivers: *Walking on Water – the Hidden River Walks*. I would like to offer my sincere thanks to the many friends who piloted the first two hidden river walks, one along the Walbrook and the other that explored the Heads of Rivers. I will be thanking these friends by name in that later book. However, many of their constructive comments led to changes and additions to the present book and so they also deserve a mention here.

In researching the hidden rivers, I have walked each of the routes taken by their watercourses many times. It has been a great pleasure to encounter numerous people along the way who, having learned what I was doing, then stopped to discuss the subject and contribute local knowledge. Amazingly, this included a number of people who invited me into their houses, offices and gardens when I needed to get a better view of a particular point on a river's course.

I am indebted to the authors of essential reading on the hidden rivers, or lost rivers as many prefer to call them, as indicated by the numerous literary references in the text, but in particular, Nicholas Barton's *The Lost Rivers of London* and Richard Trench and Ellis Hillman's *London Under London*, for its chapter 'Smothered Streams and Strangled Rivers'. My thanks are also due to Greg McErlean and Edward Strickland of the Royal Parks, Alan Lenander and Matthew Wood of Thames Water, and Ben Nithsdale, formerly of Thames Water.

In addition, I would like to offer my gratitude, and acknowledge my debt, to those responsible for producing the many sources accessed during my researches. The texts of many of London's historians have been the source of much background to this book. In particular, it would have been an honour to meet with and discuss the works of two long-dead authors:

William FitzStephen, Thomas à Beckett's faithful clerk, who in 1190 eulogised the London of his day in a preface to his work on the life of his master, and John Stow, who wrote an extensive, detailed description of London and its wards at the end of the sixteenth century. Another source that has been consulted many times is British History Online, a magnificent cornucopia of well-researched and painstakingly reported details, particularly regarding the development of individual London districts.

It would have been difficult to initiate the research of the courses taken by the rivers without the assistance of mapmakers from the early Middle Ages through to the mid-Victorian period, at which time the hidden rivers finally disappeared underground. In particular, those who depicted London to scale, starting in the early seventeenth century, and showed the location of some of the now hidden rivers in relation to roads and buildings which still exist today. Most notable of these, perhaps, would be John Rocque and his detailed map of London produced in 1746.

My researches included many visits to the Museum of London and LAARC, its extensive archive, the Guildhall Library and the British Library, as well as visits to local libraries of the London boroughs through which the hidden rivers pass.

It is difficult to envisage the nature of the research that would have been needed were the World Wide Web never to have been established. I have accessed literally hundreds of websites, one often leading to others, in the search for interesting aspects of the hidden rivers, particularly when researching points of interest for the later book of walks. Generally, I have tried to find corroboration from sources independent of each other before quoting something as fact, preferably from sources other than another online site. In general, it is possible to detect when one website has fed off another, but clearly this cannot always be done, nor can a researcher be sure that they have avoided this pitfall. Nevertheless, my thanks are due to those who take the time to place their knowledge on the 'web', and I would like to express my admiration of their rarely acknowledged efforts.

Foreword

Growing up in London and having been fascinated by all things watery from a very early age, I have always had a special interest in the rivers of that great metropolis – those that can be seen and those that are there but hidden from us. Recently, there has been a certain upwelling of interest in the hidden rivers – in particular the Fleet River which, in its lower reaches, passes beneath Farringdon and outfalls to the Thames under Blackfriars Bridge. The present Mayor of London, Boris Johnson, has suggested that sections of the 'hidden' rivers might be uncovered, their banks beautified and walks created in the inner city. Unfortunately, due to thousands of sewage connections to the rivers, the location and magnitude of which are unknown, it would be impractical and impossibly expensive to do this. However, Chapter 14 of this book sets out a practical, affordable and sustainable project for resurrecting the hidden rivers in a phased approach which would bring the central London rivers back to the surface, providing pleasant walks and quiet recreational areas for its citizens and visitors to enjoy.

My childhood interest in water was fostered by my contact with the New River, along which I walked and played using the riverside path from Finsbury Park through to the castle-like folly of a pumping station and the vast sand filter beds at Green Lanes.

The New River is a man-made channel, constructed early in the seventeenth century, which still brings water from Hertfordshire into London as a significant part of its water supply. In its earlier form, it remained an open channel right through to the Angel, Islington. However, in the nineteenth century, a water treatment plant was constructed either side of the main road south of Manor House, and the New River was culverted and covered over downstream of the construction for most of its length. My fascination in this transition from a visible to a hidden river was heightened by the work of an eccentric Victorian engineer who designed that treatment plant's pumping station to appear like a full-size medieval castle! The pumping station, now defunct, is still there. Making appropriate use of its tall towers and turrets, it has taken on a new lease of life as a climbing centre! Sadly, the filter beds that resembled large lakes have been filled in and are now a featureless housing estate.

My childhood interest in all things aqueous strengthened and I became a professional water engineer, working on major projects in the UK and around the world, protecting rivers and coasts from pollution and providing water supplies to cities. Although, by now, having

worked as a consulting engineer in seventy countries over more than forty-five years, my fascination with London's hidden rivers remains and, if anything, has increased.

Recently, when I first began to look again at the hidden rivers, it was a considerable surprise to me to learn that there were no large-scale maps, readily accessible to the general public, which showed their routes through the metropolis. I decided to attempt to map the natural courses taken by London's hidden rivers. The hidden rivers of London – with the exception of the man-made New River – all outfall directly or indirectly into the River Thames. Although there are hidden rivers on both the north and south banks of the Thames, I have concentrated on the seven which discharge directly along the north Bank to the Thames. From east to west, they are the Black Ditch, the Walbrook, the Fleet, the Tyburn, the Westbourne, Counter's Creek and the Stamford Brook, which I have taken to include a short watercourse within its general catchment, Parr's Ditch.

I have used the term 'natural courses' for the mapping because over the years, as London developed and the rivers became progressively culverted and covered, the routes taken by the hidden rivers today have been altered along some stretches. A section of the book has been devoted to the methodology used to determine as accurately as possible the natural routes of the hidden rivers, and a listing of the extensive references consulted has been provided.

Four of the now-hidden rivers – the Walbrook, the Fleet, the Tyburn and the Westbourne – played a significant role in the development and transformation of London from its Roman origins, almost 2,000 years ago, into the world-class capital of today. All four of the Central London hidden rivers included in this book either have fascinating histories themselves or pass through areas with a past worthy of particular interest. Other areas through which the remaining three hidden rivers pass have experienced recent re-development, the quality and interest of which is known principally to those who live, work and find their recreation there, but are worthy of being made known to a wider public.

The principal intention of the book is to raise the profile of the hidden rivers of London for a wider audience to enjoy and, hopefully, to generate that level of interest that has excited me for so many years. It is for this reason that thirteen walks along the hidden rivers have been devised and developed and will be published in a separate volume in autumn of 2011. *Walking on Water – The Hidden River Walks* will contain maps of the rivers to assist walkers; the local impact of each of the rivers along the route as well as detailed descriptions of points of interest along the way will be included.

This present book will provide essential background to an enjoyment of the walks in the later volume. The walker who then completes all thirteen of the hidden river walks will have a fairly comprehensive picture of modern London in all its various forms: the City, Westminster, its parks and its central and suburban communities. Reading the descriptions of noted points of interest should also provide an insight into some of the social conditions found in London through the ages. Perhaps most interestingly, the walks associated with the Central London rivers – the Walbrook, the Fleet, the Tyburn and the Westbourne – pass through areas of London that suffered terrible damage due to Second World War bombing raids and illustrate the imaginative and sensitive housing and commercial developments that have reinvigorated large areas of this wonderful city.

As background to the book, there are initial chapters on the hidden rivers – their origins, the uses to which they have been put over time, the abuses that they have suffered and

the processes that have led to their disappearance. Given that this is the first time that the routes of the rivers have been reported on large-scale maps in a form readily accessible to the public, the methodology used to achieve this has also been reported. A separate chapter is then devoted to each of the seven hidden rivers discharging to the north bank of the River Thames.

Whether readers just have a passing interest in the hidden rivers or harbour a more profound one, the principal objective of the book is to assist them to appreciate the former importance of these mistreated watercourses and the role that they played in the development of London from Roman times until the present day.

CHAPTER 1

London and Its Hidden Rivers

Let's take a flight of fancy, to a London that might have been.

It's 2012, the year that London is hosting the Olympic Games. Hundreds of thousands of visitors are arriving from almost every country in the world. It is time for one of the greatest cities on Earth to showcase itself with pride. Most of the city's guests arrive by air and as their planes make their final approach into Heathrow, they are treated to a magnificent panoramic view of the host city. The Thames cuts a curling, snake-like swathe through the city and as the plane progresses past the Olympic site, the Millennium Dome, now the thriving O_2 Centre, Docklands, the City, the London Eye and Westminster, the travellers note the numerous green areas, parks and heaths, dotted throughout the city. As they continue to descend, the sunlight reflects not only from the Thames but also fromn other rivers, particularly four of them which wend their way through the middle of the city to the Thames. Now, first-time visitors understand why they have learned from childhood of London as the Riverine Capital of the World. Clearly, this is a city of green parks and many beautiful rivers, all flowing into the Thames.

Having arrived, the visitors are hosted by local guides around the great city in which they clearly have so much pride. Passing through Hyde Park, their guide explains how the Serpentine was formed from the Westbourne River and continues to be fed by its sparklingly clear waters. They gather at the cascade of water at the outlet from this famous ornamental lake and hear how, several hundred years ago, highwaymen and footpads would ply their criminal trades where the Westbourne was crossed at Knightsbridge. It is fascinating to think that, surrounded as they were by such opulent development, this was once a dark, densely wooded area where the bodies of robbers' victims would be thrown into the Westbourne River from the bridge. They are now standing on that very same bridge and looking down into the waters of the Westbourne, on their way through Belgravia to the Thames at Chelsea.

They continue to the Houses of Parliament, the Palace of Westminster and the Abbey, and marvel at the feeling of space given to these world-famous buildings by their location on an island. They learn that Thorney Island had been formed in the middle of the delta where two of the principal branches of the River Tyburn meet the Thames. The island had been chosen as a site for the first abbey, the West Minster, more than a thousand years earlier, and

was chosen deliberately for its tranquillity. Now the beauty of the Westminster Abbey is emphasised by its visibility from a substantial distance due to its island isolation. Today, the sense of openness and beauty is further enhanced by the reflections of so many more world-famous buildings in the encircling waters of the Tyburn and the Thames.

The visitors make their way along the Strand, High Holborn and onto the Holborn Viaduct. The guide suggests that they stop to gaze down into a steep-sided ravine through which the River Fleet tumbles, broadening out to a wide estuary and its tryst with the Thames. The Fleet is also more romantically known as the River of Wells due to the large number of therapeutic spas founded 300 years earlier, and which continue to line its banks between the viaduct and King's Cross to the north. On an island at the head of its estuary, a well-preserved water-powered mill, constructed 1,900 years ago by the Romans, can still be seen. The pleasant clacking sound as its machinery is turned by the water rushing down the mill race can be heard from the viaduct. Continuing on and through its mighty walls, the visitors enter the City of London itself, with its 2,000-year association with international trade and finance.

To the delight of the visitors, and to the great pleasure of the city workers, a fast-flowing river, the Walbrook, runs through the very centre of the City, finally tumbling down a precipitous slope into the delta formed at its confluence with the Thames.

The visitors are struck by the foresight exercised by the citizens of London over the ages to have preserved the rivers that ran through their great metropolis. They appreciate that, as had been the case back in their own cities, there must have been intense pressure to cover the rivers when the land they passed through had been urbanised to accommodate burgeoning population numbers. They envy the advanced culture that provides and protects green spaces along these urban rivers, havens preserved for future generations where hard-pressed citizens can rest or walk in peace, away from the frenetic pace of a modern, thriving and exciting city.

Yet, unfortunately, this is only a flight of fancy. The picture painted of a London of well-preserved rivers, protected from the abuses and ravages of urbanisation, is only a dream. The reality is more like a nightmare.

What is most definitely not a dream are the rivers. On the north bank of the Thames, they are seven – four Central London Rivers, the Walbrook, the Fleet, the Tyburn and the Westbourne, flanked by the Black Ditch in East London and Counter's Creek and the Stamford Brook to the west. These are the rivers that form the subject of this book. They can no longer be seen. Increasingly covered over as London developed, they disappeared from view and became London's hidden rivers.

In truth, the fantasy need not have been a dream. The four Central London rivers – the Westbourne, the Tyburn, the Fleet and the Walbrook – had been significant features of the city in the past. They each played significant roles in its development and in its history. They each had the characteristics described in our flight of fancy. However, the citizens of London did not exercise foresight in their regard and the rivers are now nowhere to be seen. But, be assured, it is a fantasy based on fact. All seven of those north-bank rivers do exist today. They continue to flow as drains and sewers beneath the city's streets – and there are more hidden rivers that flow into the south bank of the Thames but which are outside the scope of this present book. The description of what the visitors to London's Olympics could have seen

would have been correct if the rivers had not been buried beneath the city's streets, converted into sewers and drains. If only London's citizens through the ages had thought about the riverine legacy that could have been preserved for future generations. If only as much thought and effort had been given to preserving that part of London's legacy as has been given to the post-Games legacy of the Olympic development itself.

The object of this book is to attempt to breathe life back into the four Central London rivers and the three suburban ones that discharge into the Thames from its north bank. The story of London's hidden rivers is not quite that of a paradise lost, but our city is the poorer for their disappearance. This book has been produced for those who would like to learn of the importance of London's hidden rivers to the city's history, development and society. However, it is not only relevant to Londoners. The situation is a common one throughout the developed world. It has been the norm for cities to abuse and swallow up the rivers on which they were founded. It is those countries just entering their phase of intensive development which can learn most from the mistakes that the developed world made. Those mistakes were made before our awareness of the environment – and the need to make a conscious effort to preserve it – was raised by our understanding of the value we had lost.

To help raise the awareness of our hidden rivers and the legacy lost, a companion to this volume will be issued in the autumn of 2011 and will include details of thirteen walks along each of the routes taken by the hidden rivers beneath the city streets. Of course, without entering London's comprehensive sewer system, it will no longer be possible to see the rivers themselves on the walks. However, the routes taken closely follow the watercourses beneath the feet, hence the title of the future volume, *Walking on Water – The Hidden River Walks*.

In researching the book, considerable work has been carried out on the routes taken by the rivers and their watercourses have been plotted onto large-scale street maps. It is hoped that the character of each of the rivers will be evoked by the guided walks along the seven hidden rivers. By tracing each of the river's paths through the city to a degree of detail not previously attempted, it is hoped that the rivers will be given back at least a part of their former lively and influential characters. For the time being, the story of the hidden rivers related in this book has to be 'what was, and now is', but perhaps it can also elicit a sense of 'what might have been – and could be again'.

As already mentioned in the Foreword, Boris Johnson, Mayor of London since May 2008, has suggested that sections of the 'hidden' rivers might be uncovered, their banks beautified and walks created in the inner city. As a result, media activity has attempted to stimulate public interest in these hidden rivers and the prospect of bringing them back to life. The professional experience of the author as a water engineer instinctively led him to question the practical and economic feasibility of this idea.

However, there is most definitely a practical solution as to how the hidden rivers could be resurrected, with considerable recreational, environmental and social benefits accruing for a very modest outlay. The concept is outlined and discussed in the concluding chapter of this book, Chapter 14. It provides hope for the hidden rivers and could well prove highly appealing to the citizens of London, their Mayor and its local governments. The concept as proposed would not only enhance the City and the lives of its citizens, but is also practical, affordable and sustainable in the long term.

WATERY DEFINITIONS

A number of terms are used when describing natural watercourses and artificial structures for the carriage of water and wastewaters – and commonly used incorrectly. So, first let's attempt definitions of a few of the terms used in this book.

Some of the definitions have been culled from the Oxford Dictionary, some from the author's professional experience as a water engineer; some may be a surprise to the reader as inaccurate use of some of the terms is common and widespread.

River: a copious stream of water flowing in channel to sea, a lake, a marsh or another river – 'copious' is the important word in this description.

Stream: body of water flowing in bed, river or brook – actually synonymous with 'river', however, a stream, in the sense of a watercourse, is generally used to describe water flowing in a channel that is not quite as substantial as might be expected of a river.

Brook: a small stream – the word is used to convey the impression of a local stream.

Bourn, bourne or burn: a small stream – in a strict sense, a bourne is a river or stream that either runs occasionally or seasonally, or that at one point flows above ground and on another section flows underground before re-appearing on the surface again lower down (this does not necessarily apply to 'burn' nowadays, a word perhaps most frequently confined to use in Scotland and north-east England).

Creek: correctly used, a creek is a tidal inlet by the coast, frequently including a short stretch of river, but it is also commonly used to describe a short, inland section of a winding river that is more often than not dry or carrying little flow.

Ditch: long, narrow excavation, esp. to hold or conduct water or serve as a boundary – note 'excavation'; a ditch is an artificial watercourse, generally constructed to drain water from an area of land to be put to a purpose that requires dryness.

Dike, dyke or dyche: ditch; natural watercourse; low wall; embankment – the term is not synonymous with 'ditch', as it can be used to describe natural or artificial watercourses as well as the embankments that may be needed to form the watercourse.

Fosse or foss: long, narrow excavation, canal, ditch, trench esp. in fortification – again, definitely an artificial construction; in Latin, its origin, it can also be used to mean a small tank for holding liquids, for example *fossa asetica*, a septic tank.

Culvert: channel or conduit carrying water across or under a road, canal, etc – it has been used frequently in the book, as most of London's hidden rivers began the process of their disappearance by being 'culverted' in order to allow development of one sort or another to take place over their channel.

Conduit: channel or pipe for conveying liquids – interestingly, in London of the twelfth to sixteenth centuries, 'conduit' was used in this original sense, but was also used to describe the ornamental, monumental structure constructed at the end of the water pipeline where the water could be drawn off by citizens and traders for their use.

Drainage: draining; system of drains, artificial or natural – nowadays a drain carries surface water run-off, which is water originating from rainfall, hail or snow melt.

In addition to offering definitions of terms used to describe natural and artificial watercourses, the following for their wastewater counterparts may help an understanding of the contents of this book.

Sewage: the collective term for 'foul' wastewaters, that is domestic wastewater and trade and industrial effluents – the term specifically excludes surface water run-off, rain, hail or snow melt from roofs and paved areas (as long as these are not part of an industrial site which could generate polluted surface water).

Midden: a domestic pit into which human and animal excreta is dumped, often together with solid refuse, garbage – in practice, the midden would often be very shallow to facilitate its emptying; the contents of a midden were meant to be used as a form of compost by farmers near the settlement or dumped outside the city limits in a remote place but, more often than not, they were not transported far and sometimes only as far as the nearest stream.

Sewer (prior to nineteenth century): a channel, natural or artificial, draining surface water from an urban area – an act of 1427 established the Commissioners for Sewers and, at the time and until the late eighteenth century, their duties were with the prevention of flooding in urban areas through the maintenance of good drainage practice, not with the conveyance of waste; at this time, sewers were not intended for conveying human waste, which was meant to be discharged to a midden; in practice, sewage commonly made its way to the drains intended for rainfall run-off or were dumped into streams, sometimes outside the confines of the town.

Sewer (after the turn of the nineteenth century): a pipe, pre-fabricated conduit or a channel, usually covered, for conveying drainage waters, waterborne household waste and trade and industrial effluents, discharging them to a treatment plant or directly into a river, lake or the sea – in strict technical usage, a sewer should only carry wastewaters, but in practice they may carry a mix of wastewater and rainwater run-off, sometimes termed surface water; perhaps rather disturbingly, 'sewer' is also used to describe 'a person who set out a table, placed guests, carried and tasted dishes', hopefully derived from a corruption of 'server'.

Sewerage: a system of sewers (often incorrectly used as synonymous with 'sewer'): the term is used to collectively describe the whole system of pipelines, manholes, pumping stations and other hydraulic structures used in the system.

Combined sewer: a sewer that carries both 'foul' sewage and surface water run-off from roofs and paved areas – this was the most common form of sewer constructed until well into the twentieth century.

Separate sewer: a sewer from which surface water is excluded, and which therefore carries only sewage.

CSO: a combined sewage overflow, a structure on a combined sewer system which, at times of storm over an urban area, separates a portion of the flow to go forward for treatment, the balance of the flow being discharged to a natural watercourse – the multiples of base flow going forward to treatment vary but are frequently taken to lie in the range of three to six times base flow. As the flow to a combined sewer serving small areas can rise to 100 times base flow, a large proportion can be discharged to the watercourse untreated,

albeit 'diluted' by relatively clean surface water run-off. In London, the combined sewers typically carry an average maximum of about twenty times the flow that they carry in dry weather.

It would be quite incorrect to give the impression that there is a definite limit to the 'size' of a watercourse which determines it as a river or as a stream. The use of one term as opposed to another is a function of a combination of a number of factors – width, depth and flow – assessed qualitatively rather than quantitatively. One person's river may well be another's stream and vice versa. However, the Thames at London is quite clearly a river, whereas the Dollis Brook in North London, one of the feeders of the River Brent, and a maximum of 6 metres wide, could definitely be referred to as a stream, or a brook as in this case.

From the foregoing definitions, it might seem more appropriate to make reference to London's 'Hidden Streams' rather than to London's hidden rivers, as the flows in them could not really be described as 'copious' and their water surface widths generally lay in the narrow band of between 2 and 6 metres. However, these watercourses have been referred to historically and collectively as 'rivers', and so this book will perpetuate that possibly inaccurate usage.

RIVERS AND THE FOUNDING OF LONDON

Almost 2,000 years ago, midway through the first century of the Common Era, the army of the Roman Emperor Claudius successfully invaded Britain. It is virtually impossible for us to imagine what they would have seen when they arrived at the point on the southern bank of the Thames opposite the area of land that was to become one of the world's greatest metropolises.

From a vantage point on the hills of the North Downs, south of the river, the Roman armies would have been able to see as far as the hills some 48 km (30 miles) to the north and west. Their gaze would have seen nothing but a vast swathe of land, virtually uninhabited. In front of them, leading to the southern river bank, was marshland and rivulets forming islands in the foreshore. On the other bank, there was marsh to the west and east, with two smaller rivers issuing into the major river before them. The easterly of the two rivers was flanked on either side by two low hills. Behind this immediate foreground, the land rose gently away from the river to hills in the distance. Much of this land was covered with dense forest, occasionally interspersed with more open heathland. The wide, meandering river before them slowly wended its way from the west by way of a series of large oxbow bends towards its broad, extensive estuary in the east bordered by low-lying fenland. A careful observer might have been able to pick out a few settlements to the west and east, mostly widely scattered farms but none larger than a few houses. If the sun were shining, they might have caught occasional flashes of light, reflections from small streams and rivers, and noticed that many of the farms and gatherings of dwellings were located near to these.

The wide river was, of course, to become known as the Thames. The occasional flashes of light were reflections from rivers that ran southwards from the higher ground to the north of the Thames and were its tributaries. It is these rivers, pristine clear water as viewed by the

first Roman invaders, but now degraded to sewers and drains, which form the subject of this book. As the city has developed and spread over the whole of the London Basin, these rivers have been progressively arched over, culverted and covered, made to disappear from our view and our consciousness. But they are still there – they are London's hidden rivers.

The Romans had initially invaded from the east coast, north of the Thames estuary, and established themselves at Colchester, where they set up their administrative capital. However, 50 miles to the west, arriving from the south, their military had bridged the Thames – in all probability by lashing together boats anchored side by side. The chosen crossing point was almost certainly near the location of today's London Bridge, although some archaeologists and historians favour Westminster as the crossing point. At the time, the river was three times as wide as it is today. Nevertheless, it was the most convenient point to bridge the river, as this point was the inland limit of its tidal reach as well as being relatively shallow.

The point on the Thames chosen for the crossing was not arrived at by chance. The army of Julius Caesar's earlier invasion of Britain in 54 BCE had fought a decisive battle, thought either to have been here or near the future site of Westminster. The Roman army of the Emperor Claudius was therefore aware in advance of their arrival that the Thames was fordable at this point. Although Caesar soon withdrew and the Roman army did not return for nearly a century, trade continued with the local tribe, the Trinovantes, and others. So in the intervening period between the two invasions, the Romans gained an understanding of the Thames and its surroundings, and of its strategic strengths and weaknesses.

In 43 CE, as part of the force involved in this second invasion, it rapidly became clear to the army of Claudius that the point on the north bank of the Thames to which they had crossed would make an excellent site to develop a garrison town. Not only that, but it was also well-suited to constructing a port for receiving supplies for the support of the invasion and for an army of occupation.

For the Romans, the three most important factors in choosing the site were its physical characteristics with respect to defence of the town, its capacity to furnish a clean and sufficient supply of drinking water, and the tidal movement that would speed vessels up and down the river, from and to the sea.

The north bank of the Thames, at the point they had bridged the river, amply satisfied their requirements. The area near the river was relatively flat. However, set back from the river bank, but still relatively close to it, were two low, closely-spaced rises in the land that could provide a view over the surrounding countryside – the two hills now known as Cornhill to the east and Ludgate Hill to the west. The southern approaches to the bridge formed a natural strategic defence as, apart from the need to cross the river, the area was generally flat, low-lying and marshy, and so difficult for an attacking force to use effectively. However, there were two rivers that flowed from north to south across the area that they considered suited for the development, both of which were in their respective ways significant factors for siting what was to become the City of London.

On the western boundary was the watercourse that came to be called the Fleet River. The river flowed through a deep ravine and into a broad estuary at this most downstream point in its course, where it flowed into the Thames. The Romans viewed these features, the ravine and the estuary, as strategic assets that could assist in the defence of the settlement in the event of an attack from the west. The estuarial length of the Fleet was short, not more

than a few hundred metres in length. However, the river mouth was then far wider than it was to become over the next 800 or 900 years. It was then about 100 metres (330 feet) wide, compared with just 30 metres in the late seventeenth century. The Fleet was navigable upstream for a few hundred metres from its mouth, to the point where the ravine began and where the Fleet's tributary that was to become known as the Oldbourne discharged to it. The Fleet's estuary was therefore a natural harbour off the main run of the Thames.

Running through the centre of the area that would soon become the Roman city of Londinium, between Ludgate Hill and Cornhill, was another substantial and fast-flowing river, later to be known as the Walbrook. This river was at first considered as a potential source of drinking water during the establishment of the development. However, it soon became polluted by the growing town and other sources of drinking water were employed – wells into the gravel and water drawn from the Thames. As London grew in importance, the Romans constructed their imposing public buildings. The valley of the Walbrook became the site for craft industries that needed water, for public baths and for a mysterious cultic temple to Mithras. Early in the Roman occupation, land close to the Walbrook and the Thames became a desirable location for constructing residences for the wealthier classes.

Today, hidden from view as they are, we are reminded of the former existence and significance to London of the Fleet and the Walbrook only through the use of their names to identify streets, public and religious buildings, and businesses. A similar fate has befallen the other five hidden rivers discharging at the north bank of the Thames.

THE NORTH BANK TRIBUTARIES OF LONDON'S THAMES

Each of the seven hidden rivers, tributaries of the Thames, all entering from its north bank through London, has its own individual character and each has exerted its own unique influence over the part of London through which it flows:

The City Rivers: the Walbrook, which flowed from north to south through the centre of the city within the Roman walls; the Fleet, the largest of the hidden rivers, which acted as a western limit first for the Roman city of London and later as a boundary between the City of Westminster and the City of London – its lower reaches accommodated the least salubrious areas of London until the late eighteenth century, before which time its polluted stink had long become legendary.

The Royal Park Rivers: the Tyburn, which was used to form the ornamental lakes in Regent's Park, Green Park and St James's Park; the Westbourne, which was used to form the Serpentine in Hyde Park.

The Suburban Rivers: Counter's Creek, Stamford Brook and Black Ditch, which only came to the notice of the public as they were swallowed up by the urbanisation of rural villages and areas to house the burgeoning population of London from the late eighteenth, through the nineteenth and into the early twentieth century.

Although they are hidden from view, the hidden rivers are still marked by the names used for streets or districts. Although Londoners will be familiar with the names, few will realise

their connection to London's rivers. The seven hidden rivers that form the subject of this book all flow directly into the Thames along its north bank. There are a similar set of hidden rivers that discharge to the Thames along its south bank, but time constraints on the author have not yet permitted their study. Consulting a map of London, it will become apparent that, in general, each of the Thames north bank tributaries has its counterpart on the south bank. This is not a coincidence. Thousands of years ago, each of the pairs – respectively on the north and south banks of the Thames – was a single river. It is the Thames that cut them in two as it encroached upon them and meandered its way eastwards, its curves and bends moving progressively towards the sea.

To Londoners, the names of the seven northern hidden rivers will each evoke different thoughts. From east to west, they are:

The Black Ditch: This river remains in the memories of just a very few, extremely elderly East Londoners; compared to the other six rivers, it runs for a relatively short distance outside of the City of London's walls, through East London, to discharge into the Thames east of Tower Bridge at Limehouse, just upstream of the modern Docklands development.

The Walbrook: In spite of its importance to London's origins, this river is perhaps the least known of the Central London hidden rivers. It has almost entirely been wiped from Londoners' collective memories. Its point of entry into the Thames can still be viewed immediately upstream of the railway bridge at Cannon Street Station.

The Fleet: Until recently, Fleet Street was synonymous with the country's national newspapers; however, the street does not mark the course of the river but runs down from the Aldwych to meet it at its eastern end, where the river coming from Battle Bridge, or King's Cross as it is now known, flowed down Farringdon, passed Fleet Street and into the Thames at Blackfriars Bridge.

The Tyburn: The name Tyburn is used for naming two distinctly separate entities: the district and the river. The name is best known as the Manor of Tyburn, which was notorious for the site which was used until the mid-eighteenth century for the public execution of criminals by hanging. The Tyburn Tree, a triangular set of gallows, despatched an estimated 50,000 Londoners in multiple hangings in its 580-year history. The 'tree' was demolished and the Marble Arch now occupies its place. Less universally known, the name Tyburn is also used for the river that started in Hampstead and passed through the lands of the Manor of Tyburn, through Mayfair and Westminster before dispersing into the Thames through a number of rivulets, two of which formed a small island, Thorney Island, on which the Palace of Westminster was first founded. River Tyburn water was used to form the ornamental lakes in three of the Royal Parks.

The Westbourne: One of the districts of West London, Westbourne Grove, and a number of streets in or near that district are named for the river which was used to form the Serpentine in Hyde Park. The Westbourne flows on from there past Sloane Square, where it is now called the Ranelagh Sewer, being visible as it crosses above the platforms of Sloane Square

Station in a large pipe, which eventually discharges to the Thames near the start of the Chelsea Embankment.

Counter's Creek: This is another lesser known river, probably once called Countess Creek. It rises in Kensal Green Cemetery, passing to the east of Wormwood Scrubs. The course of the river is then paralleled over much of its length by a branch of the District Line of the Underground, from Earl's Court through to the Thames, into which it flows a few hundred metres upstream of Battersea Bridge at Chelsea Wharf.

Stamford Brook: This West London suburban river has three tributaries that combine to form the river, rising respectively in Acton, the southern slopes of Hangar Lane and to the west of Wormwood Scrubs. They unite near Hammersmith, where the river discharges into the Thames. The river discharges to the Thames through two arms, close together, both upstream of Hammersmith Bridge. Another river, Parr's Ditch, forms part of the Stamford Brook catchment and may at some time have been a tributary. Now it rises at the western, Shepherd's Bush Road end of Brook Green, loops around over Hammersmith Road and Talgarth Road at Baron's Court Station and then flows westwards into the Thames, a short distance downstream of Hammersmith Bridge. Stamford Bridge, the name of Chelsea Football Cub's ground in West Brompton, appears to have nothing to do with the Stamford Brook, as it lies some 2.5 km (1.6 miles) from the easternmost branch of the river at Hammersmith.

General background to the hidden rivers is provided in the following chapters:

Chapter 2: Noble Beginnings, Brief Renown, Rack and Ruin
Chapter 3: A City Grows, Its Rivers Beggared
Chapter 4: A Story of Use and Abuse
Chapter 5: Mapping London's Hidden Rivers

These are followed by eight chapters, one for each of the north bank hidden rivers and their associated walking routes, and one providing more detail on the sources of three of the rivers:

Chapter 6: The River Walbrook
Chapter 7: Hampstead Heath – Source of Three of the Hidden Rivers
Chapter 8: The River Fleet
Chapter 9: The River Tyburn
Chapter 10: The River Westbourne
Chapter 11: Counter's Creek
Chapter 12: Stamford Brook
Chapter 13: The Black Ditch

Chapter 14, Hidden River Assets – Resurrection and Revelations, presents a practical and affordable proposal for making use of the clean water issuing from Hampstead Heath to

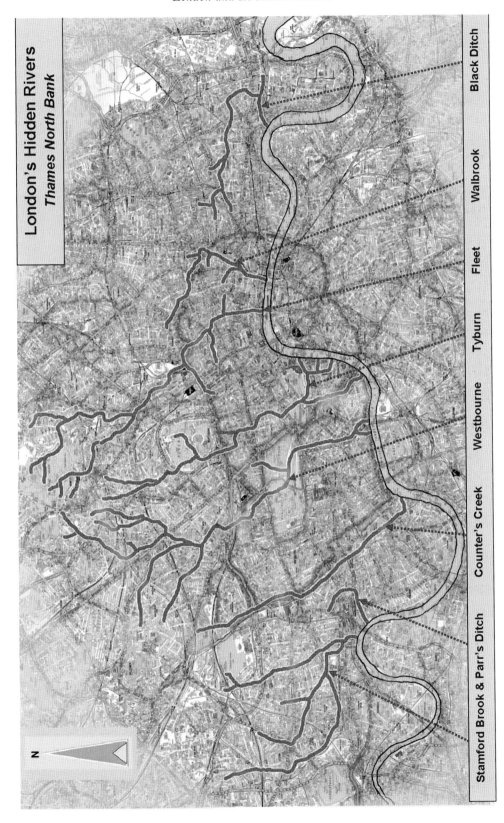

London's Hidden Rivers
Thames North Bank

N

Black Ditch

Walbrook

Fleet

Tyburn

Westbourne

Counter's Creek

Stamford Brook & Parr's Ditch

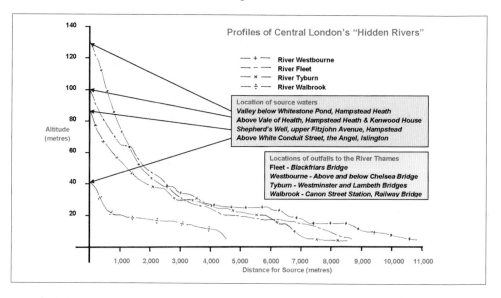

improve the lives of Londoners and reduce the environmental cost of refreshing the lakes in the Royal Parks.

Finally, two sets of references consulted by the author have been provided. The first is a list of the publications that have provided so much background with respect to the hidden rivers themselves. The second is a list of the maps of London that have proved vital to the initial tracing of the hidden rivers, dating from about the time of the Norman invasion, through to the present day. It is worth noting that the World Wide Web made research possible that time constraints would otherwise, almost certainly, have ruled out.

The maps included for each of the hidden rivers covered in Chapters 6 to 13 are to a large street map scale. This is the first time that the river routes have been available to the general public at so large a scale. Considerable cartographic, literary and on-site research has been carried out by the author to back up the routes as depicted to this scale.

A map follows which illustrates the routes taken by all seven of the hidden rivers from their respective sources on the north bank through to the River Thames. This map is at a small scale in order to assist the reader in determining their respective general locations within London.

Following the map is a diagrammatic representation of the watercourse profiles of the four Central London hidden rivers. As will be described, these rivers, once running open to the air, now form an integral part of the drainage and sewerage networks of London and are all underground. The profiles assume that the rivers are now all within a range of 2 to 4 metres (6.6 to 13.1 feet) beneath the ground. This will be the case for all but the section of the Walbrook which runs from where the river crosses the line of the London Wall through to the Thames. Archaeological excavations in the City of London have demonstrated that the Walbrook used to run far below the ground, particularly from the Bank of England to the Thames. For this stretch, the river may be anything up to 12 metres below ground level, due to the considerable amount of infilling of natural valleys with rubble which was not carted off-site when buildings have been demolished or burnt to the ground over a period of almost 2,000 years.

CHAPTER 2

Noble Beginnings, Brief Renown, Rack and Ruin

The hidden rivers of London are perennial. That is, they flow throughout the year with a reasonably constant base flow that increases in periods of rainfall, when drains and ditches discharge rainwater run-off to them. However, contrary to popular belief, and with the exception of the Thames, London's rainfall is neither sufficient nor constant enough at all times of the year to provide water to flow in its hidden rivers at all times.

So, where does the base flow in the rivers originate? How can that which at first appears to be a paradox be explained? If not from rainfall falling on their catchments, from 'whence cometh' this almost constant base flow?

Rainfall run-off is not the sole factor which produces flow in rivers. In the case of London's rivers, as in many other places, the underlying geology of the area is of fundamental importance to the formation of natural rivers. It is water stored in and then flowing out of the porous or permeable geological strata beneath London that constitutes much of the base flow in the hidden rivers. This groundwater was originally rainwater which fell on areas which could absorb it. The water which is soaked up then percolates down into permeable rock strata below.

With respect to the hidden rivers discharging to the north bank of the River Thames, there are two natural geological structures which lead to the release of water soaked up by and stored in the ground which then provides the base of the rivers. One of these structures can result in the formation of springs and the other a particular form of well – an artesian well.

BASIC LONDON GEOLOGY

At the time of the Roman invasion of Britain, the site chosen for the settlement later to be called London was situated on land which formed the surface of a basin, as seen in the cross-section overleaf. This is depicted diagrammatically. In fact, the shape is more like a section taken through a soup plate than a basin! The Romans found an area almost totally devoid of settlement, an area of forests, meadows and marshes. As the city has developed, it has spread over the alluvial plain and up the slopes of the geological form known as the London Basin.

In North London, the outer suburbs have overtopped and spread well beyond the rim of the basin.

The basin effect is created by low hills to the north and south of the Thames. On its northern banks, these hills are sometimes referred to as the Hampstead and Highgate 'Massif', although they rise to just 135 metres (440 feet) above sea level. It is nice to know that even geologists can have a sense of humour! The Massif Centrale in France rises to nearly fifteen times this height. In comparison, perhaps the Hampstead and Highgate 'Crinkle' would be a more apt name.

To the south of the River Thames, the side slopes of the basin are formed by the North Downs. The wide, relatively flat area between the two sets of sloping sides is the flood plain of the River Thames, the river having meandered its way across much of this area at some time in its long geological history. Indeed, difficult as it may be to imagine it today, much of the land north and south of the Thames was marsh in the vicinity of, and on each of the flanks, of Central London.

The river carried soil and other material from its upper and middle reaches and deposited them in its lower, estuarial reaches where, the land being flatter, the river broadened out and its speed of flow diminished. Also, over millions of years, the area to be developed much later as London rose and fell under successive geological movements and, at times, lay below sea level. Grinding of rocks and pebbles on the shoreline and massive deposits of the shells and skeletons of marine creatures respectively laid down strata of sand and chalk. The combined consequence of these actions was to lay down successive geological strata, each with totally different characteristics.

Without going into too much detail and considerably simplifying the complex layers and their inter-mingling, the following diagram depicts the general geological situation underlying the Greater London area:

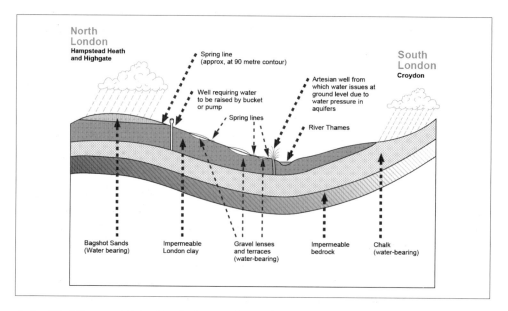

A simplified diagram showing London's spring line and artesian well geology (not to scale).

Permeable strata, bands of rocky material into which water can enter and then pass through, composed variously of chalk, sand and gravel, are sandwiched between impermeable strata, composed of clay and bedrock. Whereas impermeable clay forms the surface layer over most of the ground surface of the London Basin, at the northern and southern 'rims' the surface of the land is, for the most part, formed from permeable material. Rain falling on these permeable surfaces is absorbed into and transmitted through this porous material. Over geological time, the permeable chalk, sand and gravel layers have become saturated with water as the impermeable clay above and below these layers progressively retained the water 'captured' within them.

NORMAL WELLS AND ARTESIAN WELLS

The Romans dug many wells within the walls of the City of London. These penetrated the water-bearing gravel terraces that lay below, sometimes just below, the ground surface of much of Londinium. These wells may be termed 'normal' wells, as opposed to 'artesian' wells, as it was necessary to provide some means of raising water from the base of the well to the surface. Where a well supplied a single household, the classic bucket on a rope wound around a horizontal shaft would suffice to raise water. However, machinery worked by cattle or horses could well have been needed to lift sufficient water to serve a district or a water-consuming industry.

However, many of the wells outside of the boundaries of Roman London but within the older core of London, the extent of its urbanised area up to the end of the eighteenth century, were artesian in character.

What is the difference between a normal dug well and an artesian one? A normal well is one which is dug down to water-bearing strata, the aquifer, and a bucket, water wheel or pump used to raise the water from the bottom of the well up to ground level. In the case of an artesian well, once the well has been dug down to the aquifer, water rises some way up the dug shaft and may even overspill onto the ground around the well without any intervention by man.

In order for the water to do this, it must clearly be under some sort of pressure in the ground. The main water-bearing layers beneath London are of chalk, which outcrops at the northern and southern edges of the London Basin at elevations up to 100 metres and more above ground surfaces in the central core of London. Rainfall percolates into the chalk at these outcrops and travels through it, down under Central London. The chalk strata are overlain by clay which varies in depth over the basin, sometimes being very shallow, but always acting as a barrier to the water in the chalk rising to the surface. As chalk consists of very fine particles, water travels very slowly through it and, astonishingly, may take up to 20,000 years to pass through the chalk from its hilltop outcrops to the Thames. However, the chalk is also shot through with fissures and some of the water within it travels very quickly through the interconnections between these fissures. Water in the chalk under Central London is therefore under considerable pressure. Wells dug through the overlying clay to the fissured chalk below release this pressure and water rises up the well shaft and, if capped, can be used to form a fountain. If it is not capped, the water flows uncontrolled from the ground and unused flow passes to ditches and forms part of the base flow of London's rivers.

This is the process that creates artesian pressure in aquifers and has led to the formation of many notable wells situated outside of London's city walls which gave names to districts such as Sadler's Wells, Clerkenwell and Holywell.

Perhaps one of the best-known man-made London examples of an artesian well are the boreholes that were drilled through the clay to the water-bearing strata below in order to produce the magnificent ornamental fountains that flank Nelson's Column in Trafalgar Square. However, although the water was originally brought near to the surface under artesian pressure, it is an urban myth that the fountains continue to operate today under that same pressure.

The oldest fountain still functioning in London and still claimed to be operating under artesian pressure is located in one of the two older Inns of Court, the Middle Temple, at Fountain Court. Formed in the 1600s, it is featured in *Martin Chuzzlewit* by Charles Dickens.

A significant portion of London's water supply is pumped from the aquifer beneath the city. For part of the nineteenth century and much of the twentieth century, withdrawal from the aquifer exceeded the rate at which it was replenished and water levels were lowered in the ground beneath London. With the closure of water-consuming industries, water levels have begun to rise again and in some places now threaten to flood the tunnels of the underground system and deep basements of buildings. This has led to a need to use pumps to artificially lower the water table again in some parts of Central London.

For those readers of a practical and inquisitive bent, those with a bit of an engineer within them, the artesian well phenomenon can be simply demonstrated. Cut a length of hose about a metre and a half (say five feet) long, fill it with water and hold the hose at both ends to mirror the shape of the permeable layer in the diagram of London's geology. Have someone make a small hole in the flat section at the bottom of the curve in the hose. For a short time, water will drain from the hose forming a miniature fountain. Continue to keep the hose filled and the fountain will continue to flow. The higher up the sloping portion of the hose the hole is made, the weaker will be the flow from it. That is a practical demonstration of artesian pressure.

SPRINGS

The geological formation that gives rise to the springs of north London is the reverse of that which can produce artesian wells. In this case, permeable material such as sand and mixes of sand and gravel overlay the impermeable London Clay.

Parts of the Hampstead and Highgate districts of London are founded upon a layer of sand, referred to by geologists as the Bagshot Sands. Sandy soil is often indicated where there is open heathland supporting gorse, heather, birch and pine, and this is so with Hampstead Heath. The sand is not of marine origin but is a very fine, silt-like sand which was carried and laid down by a mighty river, the Great Bagshot River, which once flowed eastwards from the south and south-west of England over the area now occupied by London many millions of years ago. Before a combination of climatic and geological action formed the North Sea and English Channel less than 20,000 years ago, the Great Bagshot River, the forerunner of the Thames, was a tributary of the Rhine!

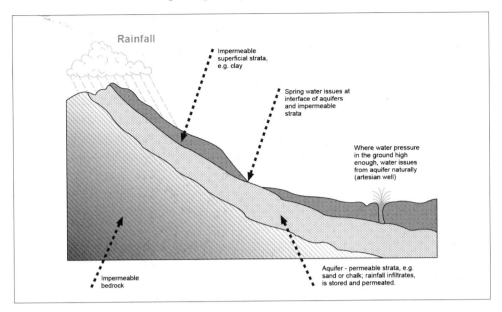

Geological conditions leading to creation of artesian wells and springs.

The sand stratum overlays London Clay and forms the highest parts of the Heath above an elevation of about 90 metres (295 feet), give or take 5 metres or so. The clay forms the base of the Heath below this elevation.

The sand is highly permeable and absorbs rain which falls on the area. At the sand-clay interface on the Heath, and at other points in the urban area of Hampstead and Highgate, water flows out onto the land surface as a spring. This geological condition can generate the springs and is shown in the diagram.

These springs are not only the primary source of water for the Fleet, Tyburn and Westbourne rivers; they also feed the various lakes and ponds formed in depressions in the ground on the Heath at South Hampstead and in the heathland above Highgate.

It is, therefore, springs of Hampstead and Highgate and the artesian wells situated in the lower areas nearer the centre of London that form the base flow of London's hidden rivers.

The importance of Hampstead and Highgate and the Bagshot Sands to London's rivers is further developed in Chapter 7, which highlights the sources of three of the four rivers of Central London.

The covering-over of land with housing, commercial and industrial buildings and the paving of roads means that, today, less water runs off into the upper reaches of the permeable layers in London's suburbs. As a result, less water issues from the springs and wells of Inner London than in the past. However, there is still sufficient to maintain a flow from some of them.

LONDON'S SPAS, SPRINGS AND WELLS

Throughout the world, particularly in areas where water is scarce, the sudden appearance of water from the ground, from springs and wells, is viewed as a mysterious, divine gift. These sources of water are often so vital to the life that gathers in their vicinity that the waters themselves are considered as possessing powers of healing through their association with the gods. This belief is not without some basis in fact as, in a very small number of cases, the waters have a content of minerals and natural chemical compounds sufficiently high as to have a beneficial effect on human health when drunk or used for frequent bathing. It is also true that in many situations, concentrations of minerals and chemicals can be so high that they actually cause serious damage to health. High levels of arsenic in groundwater in Bangladesh and many other places has had carcinogenic (cancer-causing) effects on large swathes of the population; in parts of England, high levels of iodine have caused the growth of unsightly goitres and high levels of fluoride have discoloured and rotted teeth.

However, rather than harm, London's groundwater contains minerals that many people consider have a potential to improve the well-being of those that drink them or bathe in them. Waters issuing from the springs and wells of London are chalybeate in character. What does this mean? A chalybeate spring or well is one that contains unusually high levels of the mineral iron, 'high level' being measured in parts per million or milligrams per litre (mg/l); for example, the waters at Tunbridge Wells contain about 25 parts per million of iron. These mineral levels, although indicative of extremely low concentrations, impart a taste to the water. Tunbridge Wells' water contains other minerals (manganese and calcium and magnesium sulphates, respectively chalk and Epsom salts) which are still used to aid problems arising from over-indulgence in food and drink.

The wells of London played a significant part in the life of the metropolis. There were so many wells in the valley of the Fleet that for centuries the river above its tidal limit at Oldbourne Bridge was known as the River of Wels or Wells. As has already been noted, there are many springs and wells in other parts of London that form the origins of other rivers or contribute to their flow along their length. The springs in Hampstead are particularly notable for their spawning of three of London's rivers – the Fleet, the Tyburn and the Westbourne.

The healing properties of particular springs and wells formed part of local folklore from the very earliest of times. In London, the healing properties of the London wells at Holy Well, Mary St Clare, St Clement's and St Chad's were noted in medieval writings.

William FitzStephen, who wrote about London towards the end of the twelfth century, was well aware of the attractions of the springs and wells that lay in the northern suburbs outside of the City's walls:

> There are near London on the north side, especialy welles in the Suburbes, sweet, holesome, and cleare. Amongst which, Holywell, Clarkenwell, and Saint Clemons well, are most famous, & most frequented by schollers & youthes of the City in summer euenings, when they walke forth to take the aire.

He went on to describe St Clement's Well, which is off the Strand to the west of the Royal Courts of Justice, as having 'peculiar efficacy in the cure of cutaneous (skin) and other disorders'.

However, he observed that a belief in their powers had faded by the time of his writing. In 1734, Seymour was still noting the excellent quality of St Clement's Well.

In the seventeenth and eighteenth centuries, various people began to write about the healing properties of certain springs and wells, and a form of quasi-science grew up around them. Building on the health concerns of the time, businesses were built up around the most famous of the wells. Visits to spas as a day away from the stench and dirt of the city, or for a more prolonged stay, became increasingly fashionable from the middle of the seventeenth century through the eighteenth century and into the first half of the next.

In all probability, 'taking the waters' as a fashion grew out of Charles II's interest in visiting Bagnigge House and Wells, near the Fleet not far from King's Cross.

Interest in the spas was only partly to do with their power to soothe and heal. The citizens of London would make their way there by carriage, horse and foot to promenade, to take tea, to see and to be seen, to catch up on the latest gossip and scandal, and, through 'chance' meetings, to lay the foundations for yet more gossip and scandal. The spas based on springs and wells were a major part of the scene through the eighteenth century.

The soothing effects of bath salts, which are generally based upon Epsom salts, are well-known. Although much the same effect would probably be achieved by bathing in warm water, the salts do seem to enhance the effect and soothe away the aches and pains of a hard day. So it is with spa waters, which were heated to increase their soothing potential.

Although they are not highlighted here, the Kilburn Well at Kilburn Priory in the catchment of the Westbourne and the springs in Acton which were developed as a spa, and which form some of the headwaters of the Stamford Brook, are described in the respective chapters dealing with those rivers.

The following are some of the better- and lesser-known wells and springs of London, grouped under the hidden river catchments within which they are found.

Fleet River or River of Wells Catchment – Spas, Springs and Wells

The Fleet River has had a number of names for its non-tidal length, and one of the oldest is River of Wells. Within its catchment there are probably hundreds of wells. Those that are best-known or that have an interesting history are:

- The Clerk's Well
- Coldbath Spring
- St Chad's Well
- St Mary's Hole (Black Mary's Hole)
- Bagnigge Wells
- Sadler's Wells
- St Pancras Wells
- Hampstead Wells

Other wells of note were St Clement's Well, in the Strand, close by the Royal Courts of Justice, Skinners Well (Clerkenwell) and Fagges Well.

The Clerk's Well gave its name to the area of Clerkenwell. It was here – and at a nearby well, Skinner's Well, Charterhouse (near Smithfield) – that in the Middle Ages the clerks of London would gather once a year to perform a mystery play. These plays could last for days. One presented in 1409, based on the creation, lasted eight days and was attended by most of the royal court. The Clerk's Well was a focus for social gatherings and a source of water for the residents about the St Mary's Nunnery, but it is uncertain if any claims were ever made as to healing powers. It became quite polluted and was already out of use by the Tudor period. However, it is possible that the well was rehabilitated, as it came back into use until the middle of the nineteenth century.

Coldbath Spring was 'found' at the foot of the southern slope of Mount Pleasant in 1697 by a Mr Baynes, who used it to cash in on the fashion for taking the waters. He constructed a bath-house fed by the spring which, as its name suggests, was famed for its cold water. Probably on the basis that a cure for ailments should be the reward for suffering immersion in such cold water, the bath-house gained a reputation for its curative powers and its ability to stimulate an appetite. It must have had a strong attraction in this respect as its immediate surroundings were not the most salubrious. The name Mount Pleasant is rather tongue-in-cheek, as the area had been used as a dumping ground for rubbish of all sorts for many years, and a huge mound of refuse had accumulated far higher than the natural rise of the hill itself.

At the end of the eighteenth century a house of correction, Coldbath Fields Prison, sometimes known as Clerkenwell Gaol, was constructed, a re-development of a prison originally constructed in the reign of James I. This prison rapidly gained a horrendous reputation under the sadistic management of its governor. Prisoners were beaten by him with a knotted rope and were forced to work six treadmills to pump water and to grind wheat for the prison bread. They were employed in the onerous task of picking oakum, entailing the pulling apart of used tarred rope so that it could be re-used. Over-crowded conditions and sewers blocked by faulty construction led to a cholera outbreak. The prison only operated for a little more than eighty years. In 1889, the site was taken over by the Post Office and it has been used ever since as its main letter and parcel sorting office.

St Chad's Well, named for the patron saint of wells, was located near King's Cross, which was called Battle Bridge in the heyday of the well, from the middle of the eighteenth century through to the early 1800s. The well was known to have been in use before the arrival of the Normans. Its waters were said to have healing powers and it was a spa popular with the local population. Its water was bitter to the taste – and therefore was assumed to have been good for the drinker's health – and it was heated before being dispensed into glasses for drinking.

St Mary's Hole, often referred to as Black Mary's Hole, was a popular well which had chalybeate waters and had a reputation for healing sore eyes. There are many stories as to the origin of its name, many difficult to believe, but the most likely origin is that the well was situated in the grounds of a nunnery called St Mary's where the nuns wore a black habit. The well fell into disuse and was converted to a cesspit by an owner of the land in the early nineteenth century.

Bagnigge Wells are located very close to St Mary's Hole, in the outhouses and grounds of a private residence, Bagnigge House. It is claimed – but, quite frankly, with little concrete

The Long Room at Bagnigge Wells Spa in the middle of the eighteenth century.

evidence to support it – that the house and its wells first came to the attention of the general public when Charles II took an interest. The King's primary interest was not in the medicinal effects of the waters but in assignations with his mistress, Nell Gwynne, whom he housed there. He considered Bagnigge House far enough from the cities of London and Westminster for him to be able to carry out his amorous adventures with the upwardly mobile orange seller away from too many prying eyes. However, no matter the truth of the story, it was the wells and the claims of the medicinal properties of their waters that led to the general public's interest in them.

Bagnigge House and its wells were purchased by Thomas Hughes, who converted them into a spa in about 1760, possibly building upon the popularity of Kemp's Peerless Pools at Shoreditch. The Fleet River ran through the gardens of Bagnigge House and was a part of its attractions. The gardens also offered a fountain, a fishpond, a tea and bun house, a grotto, a skittle alley and a bowling green. The establishment ranked among the most popular of all the spas until it closed in 1841. However, the social standing of its clients fell away from the first decades of the 1800s and, in common with many similar establishments at that time, it gained an unsavoury reputation. There were two wells, one chalybeate and the other having strong cathartic (laxative) properties. The effects of taking a laxative had been known at least since the times of Aristotle, who lauded the cathartic process as opening up the soul, inducing a state of rest and peace.

Sadler's Wells, owned by Dick Sadler, was sited adjacent to the reservoirs and water distribution facility at the Islington end of the New River, just below the Angel in Islington.

He conceived the idea for an out-of-town pleasure garden and concert hall and in 1683 constructed the first of the six theatres that were to be built on the same site. Having chanced upon an old well in his property, he planned to open a theatre and pleasure garden, attracting clientele not only for the music but also to take of the waters, which he claimed were well suited to the treatment of

dropsy, jaundice, scurvy, green sickness and other distempers to which females are liable – ulcers, fits of the mother, virgin's fever and hypochondriacal distemper.

Dropsy is an old-fashioned name for oedema, an accumulation of fluid beneath the skin; scurvy results from a deficiency of vitamin C; green sickness is a form of anaemia called chlorosis; distemper was used as a general term for a disease; and possibly only Dick Sadler knew what he meant by 'fits of the mother' and 'virgin's fever'. Almost certainly, the Sadler's Wells water was beneficial for none of these real or imagined ailments and Dick was a quack to claim that they were. Fashionable for a short period, the theatre and its gardens rapidly gained a disreputable reputation for criminality and debauchery – certainly there are reports of brothels in the area. The establishment was well into decline by the mid-eighteenth century. It was to revive again fifty years later when a large tank was filled with New River water and naval battles were re-enacted.

The Fleet runs along the western side of St Pancras church, under St Pancras Road, and the St Pancras Wells were located to the immediate south of the church. This church is extremely old, reputedly the oldest in the country, the first having been built there at the beginning of the fourth century. It is possible that the healing properties of the water from the wells had been known for well over a thousand years before the area became a spa at the end of the seventeenth century. The waters were claimed to be effective in the treatment of stones and the vapours (whatever they were). They fell out of use about a hundred years later, but not before two public houses adjacent to the church and the spa, the Horns and the Adam and Eve, had earned much custom from the patrons of the wells.

The wells and ponds of Hampstead lying within the catchment of the Fleet River are of a chalybeate nature and, as such, were considered as having medicinal qualities. The wells below Hampstead Village were first rented to trustees of the wells in 1698, but a requirement of the lease was that their waters be dedicated for the sole use of the poor of the parish. The trustees do not appear to have honoured this requirement as the wells and their beneficial effects on health were widely advertised in London. Early in the eighteenth century, responding to the developing fashion for spas, a building in what is now Well Walk was dedicated to pumping the waters to the surface so that they could be drunk, and a hall for dancing and concerts was constructed. It seems that the crowd that was attracted did not necessarily keep to the medicinal waters and rowdy behaviour from nearby taverns put a brake on the popularity of the Hampstead Wells. New facilities were built to replace the original pump room and price was used to discourage the rowdier element. Many people travelling out of London to take the waters discovered the pleasant walks and views over the city from the area, which led to it becoming the place of choice for the homes of wealthy citizens who did not want to both work and reside in the 'smoke'.

Near Well Walk in Hampstead is Flask Walk. Water from the chalybeate well was decanted there into flasks and conveyed each day for sale at the Eagle and Child, a grocer's

St Pancras Wells Spa with St Pancras church in background.

shop in Shoe Lane, near Fleet Street. The water was sold at the shop for '3 pence per flask' – about 1p in today's currency – but for a penny more, it would be delivered to houses on the understanding that the flask would be returned to the shop. This is possibly one of the first commercial mineral water businesses in London.

Walbrook Catchment – Spas, Springs and Wells

Perhaps not as noted for its springs, wells and spas as the Fleet, the catchment of the Walbrook contained some significant establishments:

- Holy Well
- St Agnes le Clere's Well
- Perilous or Peerless Pool
- White Conduit House

William FitzStephen, writing at the end of the twelfth century, relates that

> ... in the northern suburbs of London springs of high quality, with water that is sweet, wholesome and clear and whose runnels ripple amid pebbles bright. Among which Holywell ... have a particular reputation; they receive throngs of visitors ...

Holywell was the name given to the priory of St John the Baptist, which was founded in the first half of the twelfth century and was the home of Benedictine nuns. The well was in the orchard of the priory. However, by the time that John Stow, at the end of the 1500s, was writing his chronicle, the water of the well was highly contaminated. This was possibly because the buildings of the priory were destroyed shortly after the Dissolution in the middle of the sixteenth century. Interestingly, Richard Burbage bought the land and, being just outside the reach of the authorities of the City of London, was able to build a theatre there and stage whatever plays he wished. It is probably through the income from his twenty-two years of operation of this theatre that Burbage was able to fund the building of his Globe Theatre in Southwark.

St Agnes le Clere's Well (sometimes known as Dame Agnes de Clare or Dame Annis the Cleare) and Peerless Pool are sited very close to each other. Using current street layouts, they are in the vicinity of the large roundabout at the junction of Old Street and City Road, the site of access to the Underground's Old Street Station. Indeed, the roundabout is sometimes noted as 'St Agnes' Well' on street maps. It is considered that St Agnes le Clere's Well was on the north-east side of the roundabout. The location of Peerless Pool can be pinpointed with greater certainty as it is shown on John Rocque's map of 1746. The pool and its springs were to the north-west of the roundabout, in the area bounded by Bath Street in the west, Peerless Street/Baldwin Street to the north, City Road in the east and Old Street in the south.

Excess waters from both these sources drained into the Walbrook tributary that flowed down City Road and through nearby Shoreditch and Hoxton.

St Agnes le Clere's Well was originally a spring, the waters of which were considered to have medicinal powers. The well was recorded in the mid-seventeenth century as having a

raised pump-house where a labourer would hand-pump the water to a nearby brewery. The well was, in fact, more a storage pond which was fed by the many springs that surrounded it. Breweries, large and small, were numerous in London as ale with a very weak alcohol content was often drunk in place of water as it was less likely to be contaminated – and tasted better. However, because of the large quantities of water they used in their processes, brewers were frequently either excluded from taking water from the public conduits or charged a high price for so doing. Hence the incentive to have drawing rights over a well retained exclusively for their own use.

Rights over ownership and use of the well were disputed in the courts on many an occasion and it was the subject of various acts of Parliament to resolve these disputes.

The well and its healing properties must already have been widely known and an establishment based upon these operated commercially in 1699. It was in that year that its reputation for curative power must have been sorely tested. A newspaper reported that a gentleman, having walked all the way from the Tower of London, had drunk a glass of the well's water in what were called the Spring Gardens, after which he fell to the floor and died. The well must have recovered from this misadventure, as an advertisement in 1731 announced

> that there is now opened at St. Agnes le Clear, Hoxton, not far from Moorfields, the place formerly distinguished by the sign of the Sun and Pool of Bethesda, a new cold bath, larger and more commodious than any in or about London ... the water continually running, where ladies and gentlemen may depend upon suitable accommodation and attendance.

Near St Agnes le Clere's Well was a set of ponds, the Perilous Ponds, that were fed from local springs – almost certainly the same underground source of water serving both. These ponds remained unfenced until the eighteenth century and, being deep, were called Perilous Ponds, because many drunks and careless people, together with cattle, had drowned in them over the years.

In 1740, William Kemp, a city jeweller, purchased the land surrounding the pools with the intention of creating one of the best spas in London. He reconstructed the ponds, landscaped the surrounding areas, planted trees and bushes to shield patrons from the prying eyes of the public and built boxes where men and women could change into bathing clothes in private. He created the first formal swimming pool in London and laid it out with walks in the grounds of the pools which were nowhere deeper than 1.5 metres (5 feet). He re-named the spa Peerless Pool, a play on the original name, on the basis that they had no equal in London.

The Fountain pub, which still operates in Baldwin Street, built in 1736, can be seen on Rocque's map of 1746 and was either purpose-built to serve as the refreshment house for the baths or converted to that use.

By the end of the eighteenth century, a report by Thomas Pennant was still noting that the Peerless Pool baths had

> ... been converted into the finest and most spacious bathing place now known; where persons may enjoy the manly and useful exercise with safety. Here is also an excellent covered bath with a large pond stocked with fish, a small library, a bowling green and every

innocent and rational amusement; so that it is not without reason that the proprietor hath bestowed on it the present name.

The baths had ceased operation by the mid-nineteenth century, but the water from the well was still being used by a nearby factory making drugs. When, in the late twentieth century, an underground car park was constructed opposite the Fountain pub, the deep excavation became flooded by a spring. This was almost certainly one of the original springs feeding Perilous Ponds. As has so often been the case with such points of interest, the developer sealed it with a plug and raft of concrete and will have concealed it from sight forever.

White Conduit House was located at the headwaters of the Walbrook, on the slopes above the Angel Islington. Its long association as a source of water to the London Charterhouse is detailed later in this chapter. A tavern was constructed adjacent to the White Conduit in 1649, and the land on which it was founded was used as the site for the building of a grander establishment nearly 100 years later.

Loaves of bread were baked there, using the pure waters of the local springs, and were sold in the streets of London by peddlers touting what became a famous London cry, 'White Conduit Loaves!' The proprietors of the White Conduit House, Robert and Elizabeth Bartholomew, advertised in 1754, stating

.... the proprietor, for the better accommodation of gentlemen and ladies, has completed a long walk with a handsome circular fishpond, a number of shady arbours, inclosed with a fence seven feet high to prevent being in the least incommoded from the people in the fields. Hot loaves and butter every day; milk directly from the cows; coffee and tea and all manners of liquors in the greatest perfection; also a handsome long room, from whence is the most copious prospect and airy situation of any now in vogue.

However pleasant it might have been, and in spite of a neighbouring cricket club patronised by 'the nobility and gentlemen', White Conduit House was never to make its mark with the upper echelons of society as did Bagnigge Wells. It was considered '... a resort for tradesmen and their families and "lower orders"' and was deprecatingly described as a 'minor Vauxhall', in a comparison with those celebrated pleasure gardens on the south bank of the Thames.

Unfortunately, on the deaths of the original owners, and in spite of arranging hot-air balloon and firework spectacles, the reputation of the establishment went downhill under the management of their gambler son, Christopher Bartholomew. To its shame, in 1837, the White Conduit House was described as '... one of the most doubtful places of public resort'.

The White Conduit that served the Charterhouse with water was demolished in 1854.

Tyburn River Catchment – Spas, Springs and Wells

Shepherd's Well, located at the top of Fitzjohn's Avenue, Hampstead, is acknowledged as the headwater of the Tyburn River and was described as such by William Hone in 1828 as:

The arch, embedded above and around by the green turf, forms a conduit-head to a beautiful spring; the specific gravity of the fluid, which yields several tons a day, is little more than that

of distilled water. Hampstead abounds in other springs, but they are mostly impregnated with mineral substances. The water of 'Shepherd's Well,' therefore, is in continual request; and those who cannot otherwise obtain it are supplied through a few of the villagers, who make a scanty living by carrying it to houses for a penny a pailful. There is no carriage-way to the spot, and these poor things have much hard work for a very little money … The water of Shepherd's Well is remarkable for not being subject to freeze.

This well has an association with Dr John Snow's famous work of 1854, which demonstrated beyond doubt that cholera is a disease propagated by dirty water and not by breathing an 'effluvium' in the air. His work was mainly based upon a careful plotting of cases during a cholera outbreak in the population living around the Broad Street pump in Soho. However, a wealthy woman resident in Hampstead, near Shepherd's Well, would not drink water from this local source as she considered it lacked any taste (bearing out the above account of its waters lacking minerals). She had lived near the Broad Street Pump and insisted on her servant bringing water from that pump each day. She, and a niece of hers in Islington who did the same thing, were among the first to die in the Broad Street cholera outbreak, even though they lived remote from Soho. Theirs were the only cases of cholera in their respective areas. In a rather perverse way, this had been a further demonstration that Dr Snow's theory was robust.

HOW DO RIVERS FORM?

Rivers form in many different ways around the world, dependent upon a myriad of combinations of geology and weather patterns. However, this book is only concerned with London's rivers and the geology underlying their catchments and the weather affecting flow in them.

First, let's restate a well-known and fundamental principle – water naturally finds its own lowest level. That is, if left to its own devices, it will flow down a slope as far as it is able to go, the lowest possible point in its travels generally being sea level.

Drops of rain falling on a vertical window pane run down the pane, coalescing with other raindrops, and as the drop gains in size, it runs faster. If the window pane is at an angle rather than vertical, like a glazed conservatory roof, the droplets still run down the slope but they may meander from side to side, sometimes deflected from a path straight down the slope by imperceptible imperfections in the surface of the glass, sometimes by accumulations of dust and other obstacles. The nearer the glass is to being horizontal, the more unpredictable and greater will be the diversions of the droplet from a straight path. Were the glass to be horizontal, water would accumulate on it as a pool, and it would only drain away when it 'floods', or overtops, the edge of the glass.

The situation is similar for rain falling on a ground surface, but with one major difference. Ground surfaces are not often as hard and smooth as glass. Standing on the seashore, we can see how even on the calmest of days, water sweeping in a curve along a beach remoulds the sand surface with every tiny wavelet. With rough seas coming ashore, even large pebbles and rocks are moved over each other by the waves. Sand crashing against sand and rocks against

pebbles gradually breaks them into smaller pieces and grinds them down to tiny particles. Water has a great power of attrition when moving over ground surfaces.

Many will be familiar with huge rocks on hills and mountains, and even at the coast, which have been cleft cleanly in two. Rain, and sometime seawater, accumulating in depressions in rocks can freeze in winter. Frozen water is denser than liquid water and therefore expands. When water is trapped in small holes in the rocks and freezes, the rock may be unable to withstand the pressures of expansion and cracks. Water that freezes possesses a massive potential for destruction. Witness the devastation caused to road surfaces by just one hard winter.

So, water moves downhill and possesses great powers of attrition and destruction. These are some of the basic characteristics of water that, when applied in nature, eventually lead to the formation of rivers.

A single rainfall event would be unlikely to have a significant effect on a land surface. But we are not dealing with a single event; where rainwater moulds land surfaces, we are approaching the realms of geological time. Land surfaces in the region of London before any development took place will have been subjected to the forces that rainwater has at its disposal not just for a year, not just a decade, not just for a century, but for millennia. In fact, the ground surface will have received rainfall – from drizzle, through heavy prolonged rainfall, to extreme storms – perhaps a hundred times a year, every year since the ice receded, about 20,000 to 30,000 years ago. So, although the effect of each rainfall event may be almost imperceptible, the combined effect of say 2 to 3 million events will be considerable.

Now let us take the River Fleet as an example of how London's rivers formed and then were sustained.

The Fleet rises on Hampstead Heath and has two main streams flowing off the heathland which combine at Camden Town and then flow as a united stream to the Thames at Blackfriars. Twenty thousand years ago, when the ice sheets covering England had just retreated northwards, the land would have received its first moulding by the water from ice-melt. This water would have cascaded from some height as the glaciers moved back and would have made major changes to the landscape, forming the first valleys down which the water moved. Almost certainly, the main watercourses of London's rivers were carved out by streams swollen with ice-melt at this time.

But as the glaciers retreated ever further distant from the London region, the volume of water in the streams would have fallen dramatically. The watercourses may well have begun to silt up at this point as there may not have been sufficient rainwater run-off to keep them clear of detritus. The lower, flatter land of the Thames Basin, mainly of clay with only very occasional accumulations of water-bearing gravels and sands, was covered with dense forest. The forest would have soaked up much of the rainfall to sustain its growth, and the canopy and dense vegetation would have slowed any excess available to drain to the streams. This was the macro picture; now for the micro-picture.

The geology of Hampstead Heath is quite different to the rest of London. Apart from some higher ground near the River Thames where superficial deposits of gravel may be found, most of the ground surface of the London Basin is clay. The southern-facing slopes of Hampstead and Highgate, those facing towards the Thames, rise to about 130 metres above the level of that river. Above the 90-metre contour level, a sandy stratum sits on clay for a

maximum depth of between 40 and 50 metres (130 to 165 feet). Few trees grow naturally on heathland; vegetation tends to be of bushes, scrub and grass. Rainfall falling on the slopes of the heath is absorbed into the permeable sandy stratum and flows down through it to the impermeable clay interface. Where the water-bearing sand meets the clay, water flows down the slope along that subterranean interface until it reaches ground surface. This was – and remains – at about the 90-metre contour level. This is the level at which springs form in Hampstead, Highgate and Hampstead Heath.

There are therefore two sources of water for the River Fleet, as well as for the Tyburn and Westbourne, all of which have their origins in the Hampstead and Highgate area. Water which issues from the springs and which now drains over the clay surface to the rivers, and rainfall falling on the clay surface, below the 90-metre contour, which also then drains down the slopes to the river valleys.

Still at the micro-level, how does rain falling on a land surface reach a river and feed its flow? It uses the same basic characteristics described earlier – attrition and freezing. Rainfall that is not absorbed into the ground has to flow somewhere. Initially, it flows down the greatest slope. Eventually, it begins to carve out its own course, still down the slope but not necessarily down the steepest gradient. This is because soil is not uniform in strength and consistency and water finds a path of least resistance to its attrition capability. That is, it winds its way downhill, carving a path through the weakest areas of soil. Water trapped in hollows in these rivulets freezes in winter, a process which contributes to the ground surface being broken up more rapidly, gradually turning a small rivulet into a definite ditch. Rainfall flows through myriad tiny rivulets to the ditches, and eventually ditches meet and flow becomes more continuous and consistent. The ditch is now a small stream, and streams that meet and combine their flows form rivers.

The two principal watercourses of the Fleet were therefore almost certainly formed by ice-melt as glaciers retreated at the end of the ice age. However, they were then sustained by rainfall draining from the springs and ditches on heathland – and to a lesser extent by rainfall draining from the forest areas in their individual catchments in the Thames Basin.

The artesian nature of some of the wells in the London Basin would also have contributed flow to the Fleet in its middle and lower reaches.

All of London's rivers have a story of their formation and their continued existence similar to that of the Fleet, even, on a much larger scale, the Thames.

WHAT DID LONDON'S RIVERS LOOK LIKE?

When researching and writing this book, it became clear that most people found it difficult to visualise what London's hidden rivers might have looked like before they disappeared from view. Were they wide or narrow? Were they fast-flowing or meandering? Were they deep enough to be navigable? It is clearly inadequate to say that they were very much smaller than the Thames, even if this is so. With the exception of a very short length of the River Fleet, which was approximately 100 metres wide where it met the Thames until about a thousand or so years ago, the seven hidden rivers might be better described as streams, which gives an impression of shallow watercourses of quite narrow width.

So what did they look like?

Perhaps the best impression of what the hidden rivers looked like before they disappeared from view can be provided from seeking out rivers rising in the Greater London area and which remain uncovered. Two of North London's rivers that have not yet been covered over to any extent are the River Pinn, which drains an area of West London, and the Dollis Brook, which feeds the River Brent and which starts to the north of London.

The watercourse of the Dollis Brook/River Brent is considerably longer and drains a much larger area than the River Pinn. The former may best be used as a surrogate for the rivers Fleet and Westbourne, which are longer than, and carried a greater flow than, the other five hidden rivers.

The upper reach of the Dollis Brook, north of Woodside Park, is formed from three tributaries. These tributaries have their origins from three separate points on the same slopes, at Barnet Gate Wood, Totteridge Common and just east of Highwood Hill, north of Mill Hill. The reason for this are further outcrops of the Bagshot Sands and the springs that this gives rise to. The Dollis Brook also receives water flowing off the north-western slopes of Hampstead and enters the Welsh Harp Reservoir just before Neasden. The Welsh Harp Reservoir is also fed by two other streams, the Silk Stream and the Wealdstone Brook. The Silk Stream drains water from Deacons Hill, above Edgware, and enters the reservoir at its north-eastern corner. The Wealdstone Brook drains surface water run-off from Wealdstone, Kenton, Preston Road and Wembley before entering the reservoir at its north-western corner. The reservoir was formed in the early 1800s as a source of water for the Paddington arm of the Grand Union Canal. The river leaving the reservoir is called the Brent and flows south-westwards, close to Wembley Stadium, beneath the Paddington arm of the Grand Union Canal, which is carried over the river in a viaduct, past Alperton and Hangar Lane and turning south at Greenford. Having passed through Hanwell, it drains into the Grand Union Canal and from there, after 4 km more, into the Thames at Brentford.

The smaller River Pinn, which rises on Harrow Weald, may be used as a comparator for the smaller rivers – the Walbrook, Tyburn, Counter's Creek, Stamford Brook and Black Ditch.

The Pinn rises in West London, on the high ground and slopes of Harrow Weald, and passes through the Hatch End and Pinner districts of Harrow. Although this area forms part of suburban London, a lot of open land remains. Some of these fields have been set aside to deliberately flood as a safeguard to the urbanised districts downstream. The rest of the open land along the Pinn is a mix of farmland, many public parks and a ribbon of green space along the Pinn itself for a considerable portion of its length. It appears that its headwaters are derived from springs and general seepage from its banks and the resulting base flow is significantly increased at times of rainfall and storms by run-off from open and paved areas. Springs, seepage and run-off continue to feed into it all along its course. The river continues south and west and becomes the Yeading Brook after its junction with the River Roxbourne south of the Western Avenue (A40), between West End Road and Long Lane. The Yeading Brook, in turn, becomes the River Crane south of Hayes Town, eventually flowing into the Thames at Isleworth.

It is relevant to the subject of this book that the 'green' strip along the River Pinn has been protected from any future development and a walk along it has been devised by Hillingdon Council, with information boards explaining local history, buildings, flora and fauna. The 19-km (12 miles) walk, the Celandine route, named for the varieties of buttercup and poppy

found there, runs between central Pinner and where the Pinn passes beneath the Grand Union Canal, between Cowley Peachey and Yiewsley.

Similar effort has been made by councils along the Dollis Brook/Brent with the Dollis Valley Green Walk and the Brent River Park Walk.

These are both excellent examples of what might have been achieved for the residents of London had the hidden rivers been protected from pollution and not suffered from urbanisation.

Four points have been chosen along each of these rivers, the Dollis Brook/Brent and the Pinn, to illustrate what the London's hidden rivers might have looked like. These points have been photographed following a long period of dry weather, when flow was at a minimum. Unfortunately, in the period that this section was written through to the publication process, there was a prolonged period of wet weather and the ground had already been saturated.

Estimates of the flow in the rivers at these points have been made from observation of the minimum flow regime.

In order to put these estimates of flow in some sort of understandable context, they have been translated into the population that could have been served by them with a supply of drinking water. To do this with some degree of credibility, only a half of the minimum flow has been taken to be available for water supply and a figure of 100 litres per person daily, including the loss of water in supply, has been used. This amount of water would not have been needed for their domestic use by the population in pre-Victorian times but a substantial amount of water was lost in leakage from the supply networks, which were made from hollowed-out tree trunks with very poor joints linking them. Even with these limitations, these two relatively small rivers could have supplied populations of significant size.

Two measures of river channel width are shown in the table; the first is the water surface width and the second is the maximum width of the channel between the banks. The distances from the source of the example points have been measured off maps and must be considered approximate, as are the flow rates in the rivers, measured using the classic movement of an orange on the surface and taking 80 per cent of that value for an average velocity. The reader may well express a certain scepticism about this method, but it has been used as the basis of many a major project. However, notwithstanding this fruity approach to gathering data, the statistics do provide a reasonable picture of the situation of the flows in the rivers in dry weather.

The tabulated data does illustrate the reliable water supply potential of even the smallest of streams. The Moss Close value on the Pinn would supply a very large medieval village of perhaps 350 families (an average of five persons per household, normal at the time and common today in developing countries). It would only be necessary to provide a small storage tank on entry of the supply to the village to secure a reliable supply, satisfactory in all but the worst droughts.

After the river has flowed for just 10 km, the Pinn accumulates so much seepage and run-off that it could have supplied all of Roman London's population of 25,000 with potable water. After 18 km, it could have supplied the City of London until the middle of the thirteenth century. However, the Corporation of the City of London was unable to consider the River Pinn as a source for its water needs, as the river was too remote from the urban area at the time. Chapter 4, in which London's sources of water supply are described, notes how the Corporation did obtain water from 1236 from the River Tyburn, which was only some

5 km from the City at the time, as well as from the River Westbourne from 1440. It can be deduced from the table that those rivers would have been capable of satisfying the demands of London's population of the time.

To complete this section, it should be noted that the present-day nature of the catchments of the Pinn and the Dollis Brook/Brent feeding the rivers are quite different to those that would have fed London's hidden rivers. Urbanisation brings with it a far greater percentage of impermeable covering to the ground. So less water will permeate into the ground and issue as springs today than pre-urbanisation. This means that the dry-weather flows are lower

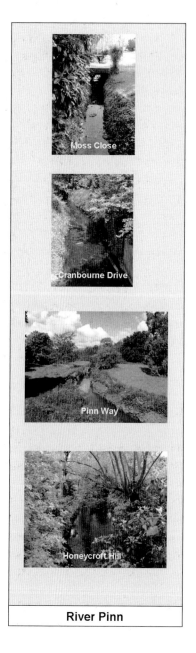

River Pinn

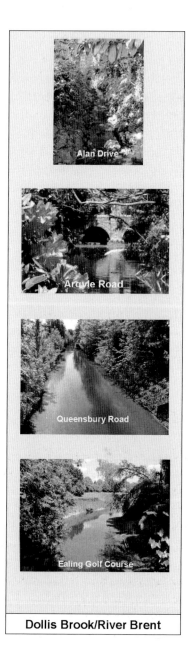

Dollis Brook/River Brent

The River Pinn and Dollis Brook/Brent.

in today's rivers. On the other hand, when it rains on a modern urbanised catchment, more water flows off rapidly – in a matter of a few hours, often just minutes – into the streams and so flows in wet weather are much greater today than they would have been with a rural setting. In general terms, the variation in flow between minimums and maximums would therefore have been less pre-urbanisation; the minimum flows would have been higher and the maximum flows probably somewhat lower.

River	Place	Distance from source (km)	Width of channel (metres)	Flow in river (litres/sec)		Population that could have been supplied with water (50% dry period flow; 50% supply leakage)
				Flow after rain	Low flow	
Dollis Brook/ Brent	Alan Drive	2.6	1.0–2.0	N/A	8	6,910
	Argyle Rd	8.2	4.0–6.0	N/A	70	60,480
	Queensbury Road	23.6	10.0–10.0	N/A	144	124,410
	Ealing Golf Course	26.5	9.0–14.0	N/A	315	272,160
Pinn	Moss Close	4.0	0.5–2.5	190	2	1,730
	Cranbourne Drive	6.7	2.2–2.5	640	7.5	6,480
	Pinn Way	10.7	2.0–3.5	740	26	22,460
	Honeycroft Hill	18.4	5.0–8.0	960	60	51,840

WHERE HAVE ALL THE RIVERS GONE?

Borrowing loosely from Pete Seeger's iconic song of the 1960s, we might well ask the question, 'Where have all the rivers gone?' As with the flowers of that folk song, the response would once again be 'Long time passing'!

For those who consider the underground rivers of London as having spiritual powers – and there are many good folk who do – it would be best to look away now. The progression from open, sparkling streams to their burial beneath the weight of urbanisation is not a pretty one.

The processes by which London's rivers became hidden from sight are not complex. These processes stem from two characteristic uses of rivers and streams: their natural use as drainage channels and their abuse as sewers.

First and foremost, rivers form as natural drainage channels, carving paths for themselves out of the ground through which they pass as they drain rain waters from an area.

Occasionally, as is the case with London's hidden rivers, these channels may first be generated to carry away headwaters flowing naturally from springs and artesian wells while also serving to drain away surface water from land within their catchment.

As areas become progressively more densely developed, it becomes increasingly difficult to rely upon natural ditches and streams to carry away rainwater without the risk of flooding of surrounding areas. This is due to the increase in impermeable areas such as the roofs of buildings, pavements, cobbled streets or, as later became the norm, tarmac roads. As the primary purpose of rivers is drainage, their watercourses follow downward gradients through the lowest part of any area through which they pass.

To accommodate higher rates of runoff from urbanised areas than would otherwise be necessary were an area to be undeveloped, it is therefore common to consider systemising these natural channels, enlarging them as necessary. To do this, they are converted to culverts, covered channels with their sides and bases constructed from brick or concrete. Pipes and smaller culverts are used to drain the area to the now-hidden rivers. In some areas, of course, run-off in times of storm was so great that new large culverts and piped systems became necessary to supplement the generally limited capacity provided by the hidden rivers. The sole exception to this in London was the River Fleet downstream of Holborn Viaduct, which has remained wide enough to accommodate a sizeable river vessel – although the journey, were it possible to make it, would not be a pleasant one.

People have always sought to build their dwellings close to sources of water, so essential to survival, whether for drinking or for watering their domesticated livestock and their crops. In general, these were individual dwellings and only occasionally would settlements consist of more than half a dozen dwellings. This was the situation with all seven of the rivers that are the subject of this book up to the start of the Common Era. Activities of laundering clothes and bathing, which were not universally practised, added pollution to the rivers, but remained so limited that the water was, to all intents and purposes, clean. Pit latrines and open defecation were the normal way of dealing with bodily wastes. Earth has a huge potential for purifying waste matter and drainage from a latrine to a river would be cleared of pathogens (disease-causing organisms) within a few metres of percolation.

However, over time, villages and small towns developed along the courses of the hidden rivers and their waters became progressively more polluted by sewage and the effluents from industries such as tanning, dyeing and brewing. In addition, refuse thrown into the channels began to choke the flow, leading to localised flooding.

By the early Middle Ages, the rivers that ran through the developed areas were so polluted as to give offence. Very few families had access to water piped into the city from relatively unpolluted sources and few could afford to purchase sufficient water for their needs from persons trading as water carriers. Limited water was made available to the general public from public taps known as cisterns, but to make use of them, they had to be within a reasonable distance from the dwelling.

Until the end of the eighteenth century, all of the seven hidden rivers discharging to the north bank of the Thames flowed in open watercourses from their respective sources through to the limits of the then-urbanised area. At that point in time, Counter's Creek and the Stamford Brook remained open-channel watercourses, as the land through which they flowed had not yet been 'swallowed' by the voracious extensions to the metropolis.

Even within the urbanised development, short lengths of the Fleet, the Tyburn and the Westbourne remained open to the sky.

The lower section of the Fleet was covered over early in the nineteenth century, when there were still living witnesses to a channel which could be seen from the Thames at Blackfriars, running northwards for about 750 metres (about half a mile) to what is now known as Holborn Viaduct.

The Tyburn remained open into the first half of the nineteenth century and was used as one of the sources of water for the ill-fated, short-lived Chelsea Waterworks sited at one of its many confluences with the Thames, just downstream of the site of the future Chelsea Bridge. A short section of the downstream Tyburn, close to the Grosvenor Road section of the Thames Embankment, remained open until 1970 through the Tachbrook Estate.

Until about the middle of the nineteenth century, the Westbourne flowed uncovered from the lake it was used to form, the Serpentine in Hyde Park, through much of Belgravia, passing to the south-east of Sloane Square, across Chelsea Barracks, to discharge to the Thames in the vicinity of Chelsea Hospital, upstream of Chelsea Bridge. Three large bricked-up barrels can still be seen built into the retaining wall behind the Victorian Pumping Station in Hyde Park. These carried the Westbourne under the Bayswater Road – the Uxbridge Road as it was called in the nineteenth century – and into the Serpentine. With the construction of Sir Joseph Bazalgette's Mid-Level Interceptor Sewer along the Bayswater Road and Oxford Street in the late 1850s and early 1860s, the flow of the Westbourne was intercepted and the barrels bricked up.

However, for the four rivers of Inner London, the Walbrook, Fleet, Tyburn and Westbourne, the transition from open water courses to hidden rivers was virtually complete by the middle decades of the nineteenth century. The covering of Counter's Creek and Stamford Brook appears to have taken place later in the nineteenth century and early in the twentieth.

A more detailed account of the progressive culverting and covering over – and in some places, their filling in – of each of the hidden rivers is given in their respective chapters.

The foregoing still begs the question, 'Yes, the rivers may have been culverted and covered, but where do the river waters now go and what does "culverting and covering over" entail?'

The response to these two questions will take us down a long road – but it is worth the journey.

First, it is necessary to delve back into the historical development of London's sanitation. Initially, by royal decrees issued in the Middle Ages through the early Jacobean Period, and later by acts of Parliament, domestic sewage was precluded from being discharged to London's rivers and, most importantly, to its sewers. The latter were constructed for draining rainwater from the city's streets and conveying these flows to the nearest suitable watercourse; they were not designed to receive or convey domestic sewage. We are taught from an early age that Roman cities, including Roman Londinium, were served by sewer systems. In modern minds, this conjures up an image of a system for carrying domestic wastewater away from residences. However, this is a false impression. The Roman *cloaca* was constructed to carry away rainwater, not domestic sewage.

It would have to be admitted that compliance with the decrees and laws forbidding sewage discharges to streams and sewers was not effectively policed, and contraventions were common. Although the Commissioners for Sewers, that is surface-water drains, were

established in 1427, with powers to raise a tax on citizens for the management of systems to prevent urban flooding, they were too weak to police the drainage systems. There were numerous instances of discharges of domestic sewage and industrial effluents to the rivers, whether hidden or open, as well as to the sewers. However, in the main, properties discharged their sewage either to cesspools located within their property or to communally shared cesspools constructed within a very short distance of a group of properties.

The ground on which much of London was built is clay, and so there was little seepage from the cesspools into the ground of the liquid portion of the waste. Cesspools were simply tanks for the storage of domestic wastewater and, as such, stank to high heaven, particularly in warmer weather. Wealthy property owners might have their cesspools regularly emptied, but for citizens in general, the emptying of a cesspool would cost the equivalent of a day's wage, and so they were reluctant to have them emptied – in fact, it was rarely done. The result can readily be imagined. Backyards of houses would be awash with stinking sewage and muddy sludge which overflowed from cesspools. Open channels would conduct the sewage and sludge from the backyards into public streets, which would only be partially flushed clean at times of heavy rainfall. Carriages would wend their way through sewage-contaminated streets, splattering passers-by with evil-smelling 'muds'. Indeed, the atmosphere throughout the metropolis was continuously permeated with foul, sickly odours and walking the streets was a hazardous activity.

In ignorance of the existence of bacteria – and, in particular, pathogens or disease-causing bacteria – it was generally thought that diseases such as cholera and typhoid were spread by polluted air and evil smells. This was known as either the Miasmatic or the Effluvium Theory for the propagation of disease. The transmission of cholera and typhoid through the ingestion of polluted water was only formulated by Dr John Snow in the middle of the nineteenth century, as a result of his analysis of the Broad Street Pump cholera outbreak. His theory that enteric diseases were waterborne was strongly disputed for many years by many in the medical profession. Florence Nightingale went to her death fifty years after Dr Snow's theory first saw the light of day, still a firm believer in the Miasma Theory. The 'pockets full of posies' of the children's nursery rhyme were carried by a person in order to ward off the bad effects of the miasma that was incorrectly thought to cause plague.

The air of the metropolis smelt sulphurous and was so obviously polluted that it was no surprise to citizens of industrial-era London that child mortality reached 50 per cent, i.e. one in two children died before reaching their fifth year.

Until the first half of the nineteenth century, heavy reliance was placed on middens serving one or more properties for disposal of solid waste, and on cesspools for liquid wastes. However, this distinction was probably honoured more in the breach, and middens would also be used for human excreta and cesspools for discharging garbage. This practice continued to be the domestic norm until the early decades of the nineteenth century.

Three factors of nineteenth-century life in London combined to render the wastewater situation completely intolerable and the previous use of cesspools and middens totally impractical. These were a rapid and considerable increase in the city's population, increasing availability, convenience and use of water by all and the popularisation of the flush toilet, the water closet.

The population of the city grew rapidly and considerably throughout the nineteenth century. The first official population census since the Domesday Book was carried out in 1801

and counted the residents of London out at 1.1 million. By 1851, the population had increased to 3.2 million due to the increasing rate at which rural folk left the countryside for the towns, attracted there by work in industry and commerce. In 1881, London's population had grown to 4.5 million, and by the end of the century it had reached 6 million, an almost six-fold increase since the 1801 census.

The second factor was the use of water by households. At the start of the nineteenth century, water was piped only to the homes of the wealthy and financially secure, a middle class that had not grown to any significant size at all since the 1600s. Although water was delivered directly to homes, it was actually supplied only intermittently and unreliably, that is to say perhaps three or four times a week, and then only for a couple of hours a day. Water was stored in cisterns in the houses – but in the basement, as water pressure in the supply system was extremely low due to poor quality, mainly wooden, pipes that leaked terribly from joints and cracks. In the author's experience of South Asia – with poor quality, intermittent water-supply systems, badly managed, maintained and operated – the amount of water leaked from a water distribution system is rarely less than 40 per cent of the water fed into it. The norm for water lost through leakage is normally between 50 and 60 per cent, and in extreme cases can reach levels exceeding 70 per cent. The same would have been the situation in Georgian London.

Towards the end of the eighteenth century, pipes manufactured from cast iron were introduced and rapidly replaced hollowed-out elm trunks – from whence, by the way, comes the term 'trunk mains'. These cast-iron pipes could be fabricated with accurately formed spigot and socket joints, a cup shape into which the spigot end neatly fits, so the joints can be rendered watertight – to a great extent. The use of these pipes made the whole system more robust, and so water could be delivered to houses at higher pressure – storage tanks could be placed in the roofs of houses and gravitated to use – and more water got through to customers. In addition, eventually, as more water became available, the systems were operated continuously and water was on tap twenty four hours a day, every day. Water supply became more reliable and convenient – and, most importantly, safer. When water is supplied intermittently, the pipes empty down through people drawing off the last drop from the system and leakage. At that point, the pipe fills with groundwater through the same cracks in the pipes and broken joints and, in most towns and cities, London included, that groundwater is heavily polluted by cesspool effluents and drainage generally. When the water supply is resumed, the first flow of water through the pipes into houses is highly contaminated. Again, a situation mirrored in today's South Asian cities. People of Georgian London were unaware of the concept of waterborne disease but, with our present-day knowledge, we can understand how diseases such as typhoid, paratyphoid and cholera could be readily propagated by these 'closed-circuit' situations. The Water Act of 1854 required water providers to convert to continuous supply, although in London this process was not completed until early in the twentieth century. So, by the middle of the nineteenth century, water was becoming available to all classes of the city's population and per capita water usage was greatly increased by an innovation that was a mixed blessing – the third factor.

Dependence upon cesspools began to come under threat by the arrival on the scene towards the end of the eighteenth century of the water closet. A personal toilet where faecal waste was flushed away with water had been revived in Elizabethan times. However, its use was restricted

Bored-out elm trunk pipes.

to only the wealthiest of families. In the second half of the eighteenth century, an enterprising watchmaker, Alexander Cummings, and a cabinet-maker, Joseph Bramah, improved on the flushing mechanism and went into mass-production of the device. Why should water closets be considered a mixed blessing?

It is true that the water closet was extremely convenient to use and led to significant improvements in personal hygiene. However, to be effective, they need to use large amounts of water. Even today, about a quarter to a third of domestic wastewater, 50 to 60 litres for each person daily, is generated by toilet flushing. That is to say, of the half-tonne of water delivered each day to every modern London home consisting of four people, between 125 and 160 kilograms is flushed through the toilets. Thus, as the popularity of water closets grew rapidly, so did the amount of sewage generated.

These three factors then led to greatly increased quantities of wastewater being generated by London's population. By the early nineteenth century, London was estimated to have had about 200,000 cesspools, for the most part badly maintained and rarely emptied. As an initial response, those citizens that could afford to do so dug their cesspools deeper and reached gravel and sand, so that the polluted liquid seeped away into the groundwater, in the process badly polluting local wells. However, in most areas, the streets were now continually awash with sewage. In some cities, Manchester being one, the situation became so bad that the installation of water closets for use by the lower classes was actively discouraged.

This situation could not be tolerated for long, and in 1815 permission was granted to discharge sewage to drains and to the sewers. At this point, it should be recalled that the term 'sewers' still referred to surface water drains and the system of rivers. Clearly, this added considerably to the pollution of the visible streams and rivers as well of the hidden rivers flowing beneath London's streets.

Billingsgate, London's fish market, was originally established in the sixteenth century, first as a Thames-side street market and some centuries later in its own purpose-built structure. It was based upon an active fishing of the inland Thames and its estuary at a time when the river could support a wide variety of fish. At the start of the nineteenth century, the Thames in and about London still supported that active fishing industry. However, within another decade or so, the river had become so polluted that fish could no longer live in its waters. This remained the situation until the 1960s, when considerable investment in sewage treatment finally paid off and the Thames again began to support a wide variety of fish and other aquatic life.

Ever-increasing quantities of domestic sewage and a rapid increase in the variety and quantity of noxious effluents from all types of manufacturing industry and gas production were discharged to the sewers and underground drainage channels and rivers. There was virtually no attempted to limit or control this type of pollution. The state of the water quality in the Thames therefore continued to deteriorate rapidly through the first half of the nineteenth century to the point where the river could no longer support fish and the smell emanating from it became intolerable. Social reformers such as Edwin Chadwick and eminent engineers such as Thomas Hawksley pressed throughout this period for improvements to water supply and wastewater management systems. However, as is the case everywhere in the world, improvements to water supply were given priority while wastewater was given little attention. Sewerage was – and tends to remain – the 'Cinderella service'.

Only when the noses of Members sitting in Parliament were grossly offended by the all-pervasive smell of putrid sewage which invaded their sessions was any serious progress made towards improving wastewater management in the metropolis, including the installation of an effective sewerage system. The Metropolitan Sewers Act, 1848, set in train a series of six Metropolitan Commissions of Sewers, which deliberated over a period of eight years. They reviewed hundreds of plans submitted to them but failed to produce a comprehensive plan. However, they did establish a number of principles that would set the scene for the project that would eventually be promoted and implemented by the chief engineer to the Metropolitan Board of Works, Joseph Bazalgette. These principles were:

- Domestic and industrial wastewaters to be discharged into the same system of pipes as surface water drained from the streets, roofs and backyards – a unitary system of pipes known professionally as the 'combined system' of sewerage;
- Wastewater should be prevented from reaching the Thames by a system of intercepting sewers, i.e. large sewers running parallel to the contours of the land into which flows from all sewers and drains crossing them would be diverted;
- Intercepting sewers to convey wastewater to a tidal outfall well downstream of the metropolis.

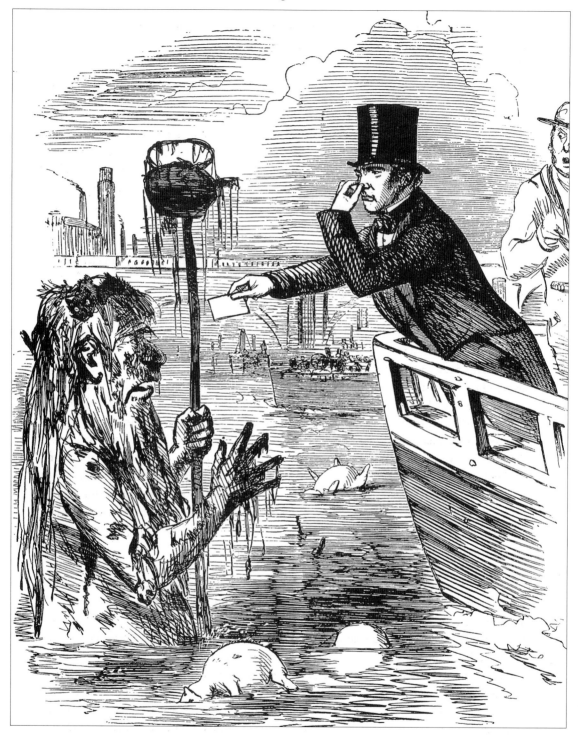

'The Great Stink', a cartoon from *Punch*, July 1855.

Earlier in his career, Bazalgette had spoken out publicly against piped sewer systems and as late as the early 1850s, he is on record as being against the concept of intercepting sewers. Thankfully, his views altered on his appointment to the board.

Strangely, it was an artist, not an engineer, who first proposed that a system of intercepting sewers be laid in a purpose-built embankment lining both banks of the Thames, where the river passed through central London. John Martin, a painter famous in his time for his garishly coloured fantasy paintings, was obsessed by London's sewers and drains. He produced an interesting series of draughtsman-like drawings which showed a river wall with a large sewer channel behind it. Behind the wall and above the sewer, he showed beautiful buildings constructed in the classical style. Martin was the first to publicly propose a system of interceptor sewers for London laid within a purpose-built river embankment – although his thoughts may have been prompted by the system already used in Paris.

It is not known whether the Metropolitan Board of Works, successors to the Commission for Sewers, or Bazalgette drew inspiration from John Martin's concept and drawings, but his drawings bear a remarkable resemblance to what came to be constructed. The scheme designed under Bazalgette's direction included two separate sets of intercepting sewers, pumping stations and rudimentary treatment plants, one set serving the north bank of the Thames, outfalling to the river at Beckton, and the other to serve the south bank, with its treatment plant and outfall at Crossness.

Drains and sewers, though laid below ground, normally follow or nearly follow the natural slopes of the ground through which they are laid, eventually discharging to a natural body of water – a river, a lake or the coast. In the case of London in the 1850s, local sewers discharged to the now-hidden rivers, to tributaries of these rivers or directly to the Thames. In order to achieve this without pumping, they were laid beneath the surface at a gradient that followed the natural downward slope of the ground above, that is they were laid across the contours of the land. An interceptor sewer is designed to a different concept. It travels along the contours and therefore crosses the line of existing rivers, sewers and drains. As an interceptor sewer is laid deeper, sometimes much deeper, than the existing sewers, drains and rivers, it can intercept the flow in these, thus preventing the polluted water from reaching the main river – in London's situation, the Thames.

With respect to the north bank of the Thames, the area with which this book is concerned, Bazalgette proposed five large interceptor sewers. As the existing sewers, drains and rivers ran generally from the north towards the Thames in the south, the interceptor sewers were to slope gently from higher ground in the west towards the lower, flat areas of east London. The five interceptor sewers were named for the level of the areas through which they passed – the Northern High Level Sewer, two Middle Level Sewers and two Northern Low Level Sewers.

In their turn, the two Middle Level Sewers were themselves intercepted in East London by the principal sewer, the Northern High Level Sewer. Sewage in the northernmost of the two Low Level Sewers arrived at the Northern High Level Sewer at Abbey Mills by gravity. The Low Level sewer which ran closest to the Thames was raised at Chelsea Bridge Pumping Station to allow it to continue by gravity to Abbey Mills. The Low Level sewers were about 12 metres (40 feet) below the level of the main sewer by that point. A second pumping station was constructed at Abbey Mills to pump the Low Level sewage into the main sewer, the Northern Outfall Sewer. This sewer, which carried the whole of North London's sewage to

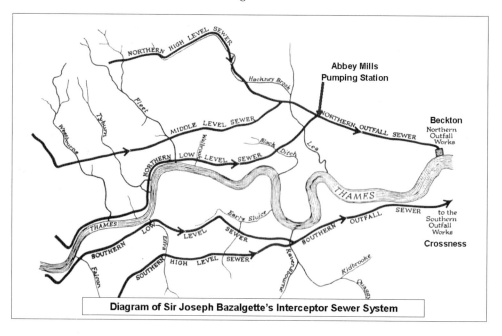

Diagram of Sir Joseph Bazalgette's Interceptor Sewer System.

the Beckton Sewage Treatment Works, originally consisted of three brick barrels constructed side by side, each 3.6 metres (12 feet) high; the sewers were built in engineering brick, which was laid using the highest standards of workmanship. Another two barrels were added towards the end of the nineteenth century.

The whole length of the Northern Outfall Sewer, 6.3 km (3.9 miles), through East London from Abbey Mills in Stratford, just south of the Olympic site, to Beckton, is set 3 to 4 metres above natural ground level. The tall embankment formed by the sewers has recently been landscaped and turned into a cycleway, but the sewers upon which people cycle continue to be the main artery for London's north bank sewage through to the Beckton Sewage Treatment Works. In Bazalgette's day, the sewage was only subjected to a settlement process before discharge to the Thames. However, over time, treatment has improved, with biological treatment stages being added. Nowadays, London's sewage is treated to the highest standards, and what had been a stinking watercourse has been improved to the point that the Thames is now clean enough to support many varieties of fish.

As a graduate engineer, the author developed the concept for a pipeline to convey sewage sludge from the Deephams Wastewater Treatment Plant in Edmonton, North London, through East London to Beckton. As he had decided to propose laying the downstream end of the pipeline along the Northern Outfall Sewer between two of the sewer barrels, he was privileged to view the original Bazalgette drawings. Not only did each of these drawings appear to be a minor work of art, every one of the drawings having been colour-washed, but the size of the sewers was quite clearly staggering. Our generation owes a great debt to the foresight of Victorian engineers as the capacity of this sewer system is still sufficient to cope with the base flows from a much larger population producing far greater quantities of wastewater.

The Low Level Sewers ran along the banks of the Thames from west to east. One of Bazalgette's greatest achievements was to win approval for a wholesale redevelopment of the banks of the Thames through Central London. Prior to the construction of his sewerage scheme, the Thames through London was much wider than today, at London Bridge perhaps twice as wide. When the medieval London Bridge spanned the river, it was about three times as wide as it is today. Bazalgette built walls to line both banks, building them in the river bed, significantly reducing its width. The void created behind walls was filled to create new land, the Embankment. In this reclaimed area on both banks, he constructed his interceptor sewers. However, on the north bank, this left a considerable width available for another use – and into this 'hole' went the District Line of the Metropolitan underground railway. Once backfilled, the reclaimed land was used variously for major roads, riverside walks and parks, as well as for notable public and private buildings. The Embankment was another incredible legacy from which London still benefits.

The interceptor sewer system built by Bazalgette sealed the fate of the four central London rivers, the Walbrook, the Fleet, the Tyburn and the Westbourne. No thought was given to protecting them as rivers; they were fully integrated into the sewerage and drainage networks of London.

First, it is as well to know that only in dry weather and times of rain that do not generate significant runoff can all flow in the hidden rivers, now mainly sewers, be diverted into the interceptor sewers.

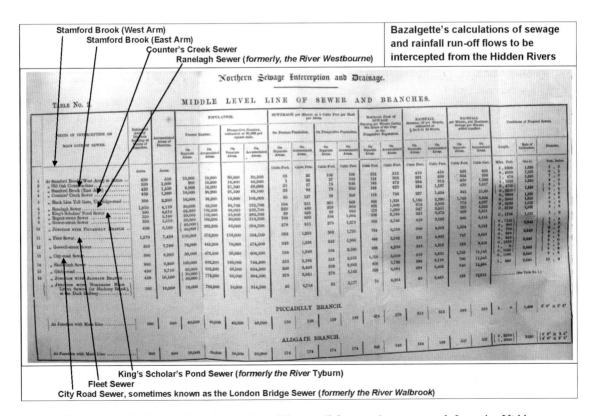

Bazalgette's calculations of sewage and rainfall run-off flows to be intercepted from the Hidden Rivers.

This is well illustrated by a page copied from Bazalgette's calculations which was contained in an appendix to his report to the Metropolitan Board of Works on 22 May 1856. In this, he notes various interceptions of the hidden rivers by the Middle Level Sewer and its tributaries. These interceptions are highlighted in the table reported overleaf.

It is of interest to note from the table that, following the huge increase in London's population in the first half of the nineteenth century, the hidden rivers carried large amounts of foul sewage. The Fleet Sewer (previously the Fleet River) received discharges of sewage from a population of 100,000 between the High Level and Middle Level Sewers in the mid-1800s, and this was projected to rise to 372,000 in the 'design life' of the sewers. It is little wonder that the flow in the hidden rivers was so polluted.

When it rains heavily, it is not possible to discharge all of the run-off draining from the roofs, streets and other impermeable areas into the interceptor sewers. This is because, depending upon the size of the catchment draining to the river, flows at times of storm can be between twenty and a hundred times the average flow of foul sewage and, in general, interceptor sewers are designed to accept a maximum of six times the foul sewage flow from an area. The flow that cannot be intercepted has to go somewhere, and it continues along the river.

In Bazalgette's system, flow in excess of the High Level Sewer continues in the river until it encounters the Middle Level Sewer, when more flow is decanted off from the river into that interceptor sewer. Any further excess continues in the river to the Low Level Sewer, where the process is again repeated. Flow in excess of the capacity of the Low Level Sewer is discharged into the Thames.

What now happens to the flows in each of the four central London hidden rivers?

The Northern High Level Sewer begins its eastward course on the border between Hampstead and Highgate and intercepts the upper reaches of the Fleet. Flows in excess of the capacity of the interceptor sewer continue along the bed of the River Fleet to be intercepted by the lower-level interceptors, and finally the Thames.

The two Middle Level Sewers begin their eastward passages, one at Kilburn and the other at Kensal Green, and on their way respectively intercept the Westbourne at Paddington and Bayswater, the Tyburn at Baker Street and Oxford Street and the Fleet at King's Cross and Clerkenwell. They also intercept tributaries of the Walbrook outside the City Wall. Flows in excess of the Middle Level Interceptor Sewers continue to the Low Level Sewers, and finally the Thames.

The Low Level Sewers run very close to, and parallel with, the Thames. The northernmost Low Level Sewer begins its travel eastwards from Ravenscourt Park, and in its course intercepts river flows from the Stamford Brook, Counter's Creek, the Westbourne and the Fleet. The southernmost of the two Low Level Sewers intercepts Counter's Creek at Hammersmith, the Westbourne at Chelsea, the Tyburn at Westminster, the Fleet at Blackfriars Bridge and the Walbrook near Cannon Street Station.

For the most part, as Bazalgette's sewers were only of sufficient size to intercept the base flow of sewage and a small portion of the rainwater draining to the rivers in wet weather, the hidden rivers continued to carry storm sewage beneath the streets of London. However, developers needed to maximise the land area available to them for new housing and commercial and industrial buildings essential to serve the growing needs of the

metropolis. The rivers were unsightly and now carried more sewage than clean source water, and so permission was readily granted to cover them over and thus create more land for development. This is the background to the term 'culverting and covering over'. The process of 'culverting' is similar to constructing a bridge over a river, with the big difference being that, in culverting a river, the bridging extends right the way along the length of the river. In Victorian times, when much of this work was undertaken, the walls, the roof and the invert of the culvert were usually constructed in brick. However, in earlier times, stone was also used and in the twentieth century, the most common material was concrete. In many places, the stream will have been completely arched over by one or more arches.

While producing this book, the author was given access to hundreds of the original 'Works as Executed' drawings for Bazalgette's project which, together with the drawings of later extensions to the system, are held in Thames Water's archive at Abbey Mills Pumping Station. These show how the base flows in the rivers were intercepted and how, for the most part, they continued in use for carrying storm sewage flows in excess of the capacity of the interceptor sewers. The example of the River Westbourne at the point where it enters Hyde Park to form the Serpentine is an interesting illustration of what happened to the hidden rivers. Parts of three of Bazalgette's drawings have been reproduced here with the kind permission of Thames Water to demonstrate how the Westbourne was intercepted.

Early in the eighteenth century, the Westbourne had been used to form the Serpentine lake in Hyde Park; Queen Caroline had a dam constructed across the river near Knightsbridge. By the middle of the nineteenth century, due to development of the land north of Hyde Park, the river and consequently the lake had become grossly polluted. When development began in the area to the west of Paddington in the early decades of the nineteenth century, a sewer had been constructed along one of the terraced roads, Gloucester Terrace, called the Ranelagh Sewer. The Ranelagh Sewer was laid down to the Bayswater Road, then turned east along the main road to Albion Gate, where it turned south across Hyde Park to cross Knightsbridge at the Albert Gate and pass through Belgravia to the Thames at Chelsea Bridge. South of Hyde Park, the Ranelagh Sewer followed the general line of the River Westbourne. However, at the south-eastern end of Gloucester Terrace, excess storm sewage was overflowed to the Westbourne at Lancaster Gate, immediately upstream of the river's entrance into Hyde Park.

Bazalgette designed one of his middle level sewers to pass along the Bayswater Road, crossing the Westbourne, which it would intercept. It was also intended to intercept the Ranelagh Sewer at about the same point.

The first drawing overleaf, probably drawn up in the late 1850s, shows the original concept. Part of the flow in the Westbourne was to be intercepted into the Middle Level Sewer using side weirs to decant the flow, while part of the flow in the river would continue to flow into the Serpentine, particularly at times of rainfall. The brick arches that would have continued to carry the Westbourne beneath and across the Bayswater Road can still be seen. In the same way, the base flow in the Ranelagh Sewer was to be intercepted but excess storm flows would continue to enter the Westbourne.

However, at this time, it was recognised that the polluted flow of the Westbourne had to be treated before it could be passed to the Serpentine. Thomas Hawksley drew up plans for a set of ornamental filters to achieve this which, although constructed, were never used as filters

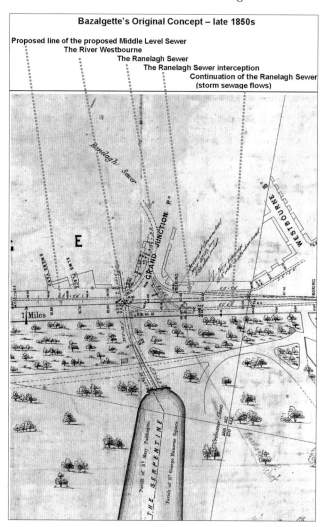

Bazalgette's Original Concept – late 1850s

Proposed line of the proposed Middle Level Sewer
The River Westbourne
The Ranelagh Sewer
The Ranelagh Sewer interception
Continuation of the Ranelagh Sewer
(storm sewage flows)

Bazalgette's original concept for the diversion of the Westbourne into the Middle Level Sewer in the late 1850s.

due to practical difficulties. These filters became the ornamental fountains and Italian gardens of today. It was decided that the waters of the Westbourne had to be diverted away from the Serpentine and groundwater was pumped from beneath the lake in St James's Park to refresh the Serpentine. The second drawing (also overleaf) shows the fountains and what was actually constructed under the Bazalgette scheme in the early 1860s. The base flows in the Westbourne and the Ranelagh Sewer were diverted into the Middle Level Interceptor Sewer. A long weir was constructed by the side of the Westbourne, and was used in times of storm to decant storm sewage away from the Middle Level Sewer and into a new storm sewer constructed around the north side of the Serpentine, called the Ranelagh Storm Sewer.

Unable to take all of the base flow of the Ranelagh Sewer at Lancaster Gate, some of the sewage continued to flow along the Ranelagh Sewer parallel to the Middle Level Sewer along the Bayswater Road for several hundred metres to Albion Street. Here, a polluted tributary of the Westbourne was intercepted by the Middle Level Sewer before it entered the park and flowed south to the Serpentine. Excess flows from this river were diverted to

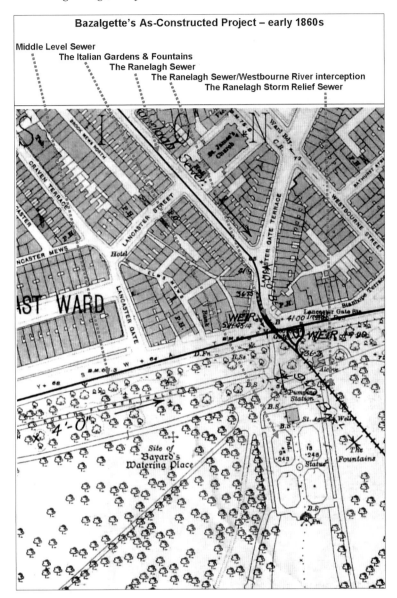

The diversion of the Westbourne into the Middle Level Sewer as executed by Bazalgette in the early 1860s.

the Ranelagh Sewer which, as previously described, there turned south to cross the park to the eastern end of the Serpentine.

The third drawing (overleaf) shows the Ranelagh Sewer discharging to the Ranelagh Storm Relief Sewer just after they have passed the dam at the eastern end of the Serpentine. It is interesting to note that, quite correctly, the channel taking water which has overflowed the dam is labelled on the drawing as 'The Westbourn'. This channel also enters the Ranelagh Storm Relief Sewer. Downstream, it is once again simply called the Ranelagh Sewer as it passes through Belgravia to the Thames.

Similar works took place at all the interception points involving the hidden rivers. The consequence of all these works – post-Bazalgette – was that the four hidden rivers of

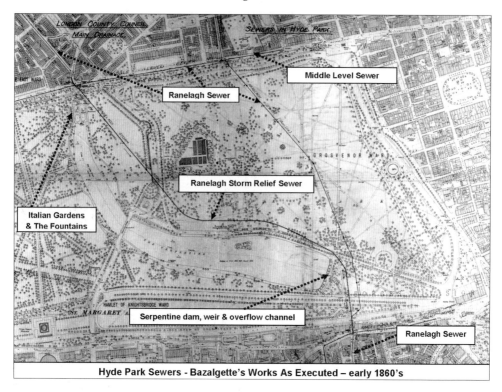

Hyde Park Sewers - Bazalgette's Works As Executed – early 1860's

Bazalgette's work on the Hyde Park sewers, as executed in the early 1860s.

Central London and their tributaries had become an integral part of London's sewerage system.

In some situations, a river was temporarily diverted while a sewer was constructed in its original bed. In some cases, it would not have been practical to temporarily divert the river to assist construction and a separate sewer was constructed. In the Westbourne example, the flow capacity of the river channel was supplemented by a separate sewer, an extension to the Ranelagh Sewer, running parallel to the river. However, here it was not constructed alongside the river but sited some hundred metres to the north-east of it. There were a few instances where the continued existence of the river would have imposed unacceptable limits on development. In these situations, a new sewer was constructed with sufficient capacity to completely substitute for the river. The bed of the river would then have been back-filled and the river would have ceased to exist over that length. However, as a general rule, an engineer would think very hard before defying nature by eliminating a river, as it has many and dreadful ways of hitting back at those who interfere with it. So, wherever possible, the original river was left in operation, albeit often realigned, upgraded and supplemented.

In an unromantic gesture, the Victorians renamed three of the central hidden rivers as sewers. This was due in great part to the fact that, in earlier times, no distinction had been drawn between a drain carrying just rainwater run-off and a channel carrying both rainwater and sewage. The Fleet River became the Fleet Sewer, the Tyburn was known as the King's Scholar's Pond Sewer, after a pond in the grounds of the school attached to Westminster

Abbey, and the Westbourne River became known as the Ranelagh Sewer over much of its downstream length. In truth, short sections of the downstream reaches of the Tyburn and the Westbourne had been known respectively as the King's Scholar's Pond Sewer and the Ranelagh Sewer from a much earlier date, when they had been taken into the jurisdiction of the Commissioners for Sewers, being part of the surface water drainage network. However, these sewers do not necessarily follow the route of their respective original watercourses over all of their lengths. This book attempts to map the original routes. In tracing the original routes taken by the hidden rivers, it is essential to distinguish between these and sewers constructed to complement and substitute for them. The Ranelagh Sewer running along Gloucester Terrace in Bayswater is often mistaken for the route of the Westbourne, which actually lies about 100 metres to the west, at the bottom of the terraced slopes. Another common error is to think that Westbourne Terrace is the original route, the mistake being due solely to its name, even though this road is set even higher up the slope.

Although Bazalgette's first scheme significantly reduced pollution in the Thames, it did little to improve a related situation, the floods that parts of London frequently suffered after heavy rain. London's rivers had never coped well with extreme rainfall events and, at times of storm, areas of London would flood, sometimes with catastrophic results to lives and property. The situation was made far worse through the nineteenth century due to the immense amount of urbanisation that took place. This led to greatly increased surface water run-off concentrating in low areas in much reduced time frames, leading to flash floods. The extension of London required the paving-over of vast areas of land that previously had been open countryside, capable of absorbing or at least slowing the flow of rainfall from it. Paving and housing creates large impermeable areas from which rainfall is designed to drain quickly. This leads to overloading of drains – and natural rivers – not designed to take this magnitude of flow. So, from 1870 through to 1910, storm-relief sewers were constructed to alleviate the risk of flooding. These worked and continue to work only in part and today areas of London are still at risk. Seventy-five per cent of the properties on the Environment Agency's national register of properties at risk of flooding are in London, due to the large number of older buildings with basements.

As Bazalgette's interceptor sewers cannot cope with all the rainwater running off London's streets, storm sewage – which is a mix of sewage 'diluted' with much larger quantities of rainwater – still flows into the Thames today. Through Central London, from Hammersmith in the west to Beckton in the east, thirty-six combined sewage overflows discharge storm sewage to the Thames for an average of about 400 hours each year, that is about 4.5 per cent of the time.

This continuing pollution of the Thames – albeit to a far lesser extent than was the case in Bazalgette's day – has been deemed unacceptable. A new project to deal with this, the London Tideway Improvement Project, is presently passing through the first stage of the public consultation process in the autumn of 2010.

The main component of the project proposes that a tunnel beneath the Thames be constructed to collect these excess 'storm sewage' flows and to carry them downstream of London for treatment. In the favoured option, this storm sewage sewer will follow the course of the Thames for about half its length, between Hammersmith and Limehouse, with an initial section between Acton and Hammersmith, away from the river. From Limehouse the gravity

The proposed London Tideway Improvement Project.

sewer passes first to Abbey Mills, and then on to Beckton. All 22 km of the new sewer will be constructed in a tunnel having a diameter of 7.2 metres (23.6 feet), as it will be at considerable depth, varying between 35 and 75 metres (115 and 245 feet) below the river bed. In this way, the tunnel will be in a position to intercept flows of storm sewage that would otherwise discharge to the Thames untreated, from both the north and south banks of the river. The tunnel will be used to intercept thirty-four of the thirty-six combined sewage overflows, the remaining two storm sewage flows being captured by other projects. In 2010, estimates of the cost of the project range from £3.6 billion to £4.3 billion. If this huge undertaking is completed, the last significant discharges of waste to the Thames will have been removed and a project begun in the middle of the nineteenth century by Sir Joseph Bazalgette will have been completed.

A question has been posed as to whether the London Tideway Improvement Project will reduce flooding in London. It has proved extremely difficult to assess the likelihood of achieving this side benefit. However, it has been estimated that there could be a 10 per cent reduction in such flooding, although whether this occurs will almost certainly prove difficult or even impossible to monitor.

Before concluding this chapter, the author would like to expand upon the disclaimer prefacing the main text of the book.

In recent years, a number of people have been forcing access into the larger sewers and drains associated with London's hidden rivers. The objective appears to be to explore the watercourses of the former rivers and then to report their exploits on the Internet. Thames Water is very concerned about this 'fashion', which is foolhardy in the extreme. The author supports Thames in its concerns.

Entry into any sewer system can be an extremely dangerous activity. It is not for nothing that the procedures for doing so are strictly adhered to by Thames Water personnel. The main risks are as follows:

- Unpredictable and sudden inflows of rainfall, particularly from rain storms, which lead to a rapid increase in sewage levels in the sewer and increases in the velocity of flow, generating a force sufficient unbalance a person caught unawares.
- A fall from which it is difficult to regain a standing position due to the slippery nature of the invert of the sewer.
- Release of poisonous and inflammable concentrations of sewer gases, in particular hydrogen sulphide (smell of rotten eggs) and methane. Relatively low concentrations of hydrogen sulphide, 100 parts per million and more, can kill. The terrible fact is that while the rotten-egg smell of hydrogen sulphide is readily detected at very low concentrations, well below lethal levels, the gas anaesthetises the sense of smell. Due to what then appears a lack of bad odours, someone in the sewer may think the gas is no longer present, but it is and builds to a concentration that overpowers and kills immediately. Many sewer personnel have died from casual, unprotected access to sewers from this gas, and so have colleagues who followed, unprotected, to rescue them.
- Methane gas is produced by organic solids that settle and accumulate as a 'mud' on the invert of the sewer. If this gas is held in a sealed area, say the shaft of a manhole, it can be ignited by sparks given off when metal scrapes metal in the sewers, causing a devastating explosion. Rarer than incidents of asphyxiation, explosions do occur in sewer systems.
- Rats are common in sewers and carry the terrible disease leptospiral jaundice, among others.

The very real dangers of entering sewers and drains without permission and full precautions can conclude with death by drowning, asphyxiation, an explosive blast or disease. Only fools enter sewers without wearing protective gear and breathing apparatus and means of communication with a support gang with appropriate appliances waiting at ground level. It is foolhardy to enter sewers and drains casually and without all necessary precautions, and it is the highest form of irresponsibility to encourage others to do so. It is to be hoped that the practice will cease.

CHAPTER 3
A City Grows, Its Rivers Beggared

This chapter explores the part played by London's rivers in the 2,000-year history of the development of the city, beginning with their influence on the Romans when they first identified the site for the city. The nature of the subject means that the history found here is highly selective but, where essential to the story of the hidden rivers, some background colour has been painted in.

Before embarking on a historical journey on the rivers, homage should be paid to those whose work and records have enabled the author to attempt to breathe life back into these hidden bodies of water.

Painstakingly documented work carried out by dedicated archaeologists, mainly since Victorian times and continuing today, has gradually enabled a picture to be sketched out of the life of Roman London. The word 'sketch' has been used, as every new discovery – and some of these are startling – adds a new dimension and perspective. It should also be mentioned that discussions with archaeologists working today has demonstrated that opinions frequently differ as to the interpretation of finds. These differences can extend even to the purpose of whole buildings excavated in the City. Even when there is a general acceptance of interpretation at one point in time, new evidence may lead to alterations to that view at a later point. This is because archaeological excavations within the City are not planned; they are undertaken only when a building or infrastructure is demolished for redevelopment. As a result, such responsive research means that, notwithstanding the large number of sites excavated within and just without the city walls, they represent only a small area of the Roman city and sometimes include only a small part of a Roman building or piece of infrastructure such as a well or conduit.

Similarly, as with the Roman period, written records from the time of the Anglo-Saxons are sparse and archaeology provides us with the best insights into the development of Lundenwic, as London was called in that period.

The valuable work of the archaeologist Professor W. F. Grimes and many others, together with the Museum of London, has made a major contribution to an understanding of London's early history and heritage. With respect to this book, their archaeological work relating to the rivers Walbrook and Fleet provided a considerable amount of material.

Written records which provide background to London appear to increase from the turn of the first millennium and anyone researching London's rivers will become highly indebted to

three authors of the Middle Ages and Tudor period – principally William FitzStephen and John Stow, but Robert Fabyan also plays a useful part.

William FitzStephen wrote at the end of the twelfth century. His main intention was to write a biography of his great master, Thomas Becket, assassinated at Canterbury at the expressed wish of Henry II. However, FitzStephen also wrote a preface to the work which lauded London and described its environment, including its rivers. He was so intoxicated by his love for the city that his descriptions can only be described as having been written while writing myopically through heavily rose-tinted glasses. However, he provided intriguing insights into the life of a Londoner of the time, for example on 'fast' food outlets, winter sports and horse-racing. These leave the reader with a distinct sense of *la plus ça change*. The work was written in Latin and great reliance has had to be placed upon the skills of his many translators, whose interpretation of FitzStephen's degree of effusiveness varies considerably.

Robert Stow wrote his *Survey of London* at a time which bridged the Tudor and Jacobean periods around the turn of the sixteenth century. He walked extensively around the city and produced extremely detailed descriptions of what he found. Fortunately, he appears almost to have been as interested in the city's rivers as the present author, and the book makes numerous references to the Fleet, Walbrook and Tyburn rivers and their tributaries. He also notes and comments on the city's numerous wells and conduits. His book is a rich source of material based upon observation, reliable historic sources and, less reliably, hearsay. Unfortunately, it is not always possible to distinguish the reliability of the source.

In the period between these two major works, written 400 years apart, we are fortunate to have another source, Robert Fabyan. He was a merchant, a member of the Drapers' Company, and became an alderman and then Sherriff of London. He would have risen to become Mayor but opted out, pleading 'poverty', and retired to his estates in Essex. To the benefit of future generations, he was a chronicler. Whereas the historical elements of his work, published three years after his death, were drawn uncritically from other sources, his personal comments on life and conditions in the London of his day, observed on his extensive walks around the city, have provided a useful contribution to this account of the rivers and wells.

The author would be remiss if he did not make clear that he was led to these invaluable sources by three modern authors who have previously written on the hidden rivers, Nicholas Barton, Richard Trench and Ellis Hillman. Nicholas Barton wrote *The Lost Rivers of London*, first published in 1962 and revised in 1992, and Trench and Hillman wrote *London Under London*, first published in 1984 and revised in 1993. Their respective descriptions have orientated the present author's researches, but the sources have been revisited for the purpose of producing this work.

The author's separate research into the history of London's water supply has provided other background material. For an insight into the Jacobean period and the creation of the New River, a book by Robert Ward (*London's New River*, 2003) proved an excellent and entertaining reference.

Finally, but by no means least, the World Wide Web has provided a wealth of useful references. In particular, the author's gratitude is due to one site in particular, British History Online. The detailed references found here on districts of London proved invaluable and such interesting reading that it was difficult at times to keep focussed on those aspects relating solely to the hidden rivers.

LONDON'S POPULATION GROWTH AND URBANISATION

The growth in London's population and, as a consequence, the extent of the land urbanised at any point in time, have an important bearing on London's rivers. The most frequently asked questions about the rivers are, 'Do they still exist and, if so, where are they today?' The answers are relatively simple, at least superficially. Yes, they still exist, but they are all out of sight, covered over by the urbanisation of London. The follow-up question is frequently, 'Were they ever used as a water supply for London?' Again, the answer is straightforward. Four of them were used in systemised water supply for a time, namely the Walbrook, the Fleet, the Tyburn and the Westbourne. The suburban rivers, Counter's Creek, Stamford Brook and even the Black Ditch, were almost certainly used by residents on or nearby their banks as a source of water through point abstractions by individuals. However, increased urbanisation led to the use of the rivers for disposal of waste, liquid and solid, as well as surface water drains. As a consequence, they were used less and less for drinking water and the last was taken out of use for this purpose in the middle of the nineteenth century.

It is not a straightforward thing to obtain data on the size of London's population at any one point in time. After William the Conqueror's efforts to quantify what he had conquered when he produced the Domesday Book in 1086, the next census was carried out in 1801. Before William's time, and between 1086 and 1801, all population estimates are speculative. A number of sources have been accessed in order to compile a picture of the population growth of London but it is important to understand that, until 1801, they are estimates which give an order of magnitude, not absolute numbers. The work of estimation is complicated by periodic outbreaks of bubonic plague from the first decades of the 1300s onwards to the Great Plague of 1665. Significant outbreaks, with devastating reductions in the population in the course of each of them of between 25 and 35 per cent, occurred in London in 1348–49, 1603, 1625 and 1665. Indeed, plague was endemic to London in that period and there were also many other, smaller outbreaks. Later, particularly in the late eighteenth century and the first half of the nineteenth century, cholera also led to many deaths, but it was not as devastating as the Plague.

In modern terms, the size of London's population was quite modest until the end of the Tudor Period. It has been estimated that Roman London's population never exceeded 30,000, even at the height of its commercial and trading activities early in the third century. When William the Conqueror arrived to be crowned at Westminster Abbey, the population was almost certainly less than 15,000. Over the next 600 years, the population numbers crept up to about 120,000. From that point, about the year 1600, the rate of growth accelerated, reaching half a million in about 1670 and passing one million by about the start of the nineteenth century. By the start of the twentieth century, London's population had topped 6 million and although it reached 8.7 million in 1939, it has since fallen back to about 6.5 million.

The two graphs, based on population statistics gleaned from many publications at more than thirty points in the period, cross-checked where possible, show this growth of population through time in diagrammatic form. One shows London's population through to 1900 and the other uses a larger scale for the population numbers through only to 1675, in order to pictorially demonstrate the real magnitude of growth, when the pace of growth was slower, as yet unaffected by industrialisation.

The population at any time is reflected in the area of land affected by urbanisation. The diagram of London, which has been drawn more or less to scale, shows the extent of

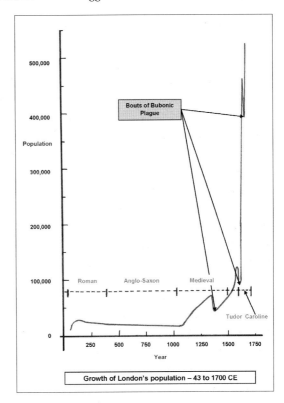

Growth of London's population from 43 to 1700 CE.

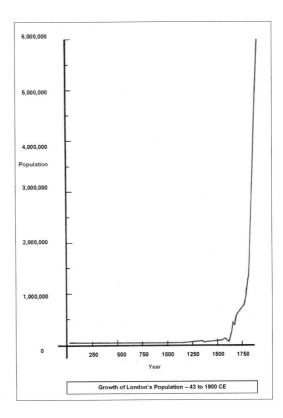

Growth of London's population from 43 to 1900 CE.

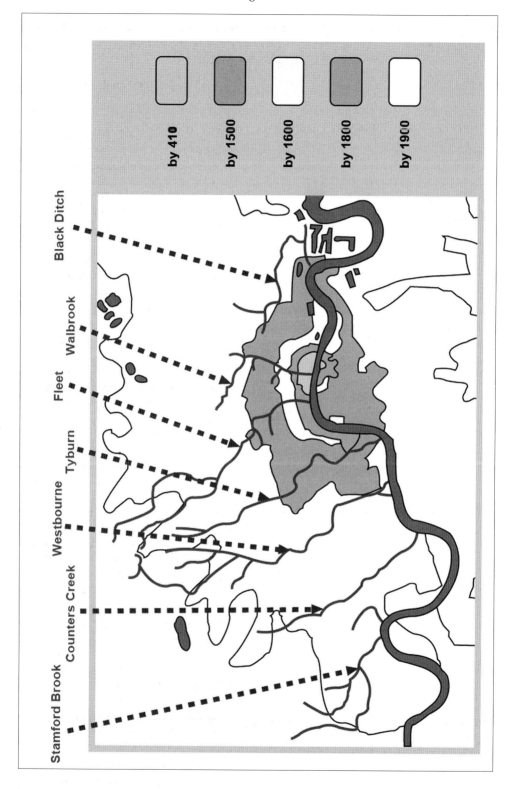

The development of London relative to its north bank rivers and the Thames between 43 and 1900 CE.

urbanisation at particular times. The watercourses of London's rivers have been superimposed upon this plan in order to illustrate how the process of urbanisation affected them, resulting in their progressive disappearance beneath the urban sprawl.

The population statistics imply key events in the history of London's water supply:

Period	Key Date(s)	Population	Water Supply
Roman 43–430 CE		Maximum 30,000	Initially, for a few years, River Walbrook abstraction, then wells sunk into gravel
Anglo-Saxon 430–1066		10,000–20,000	Roman city abandoned; springs, artesian wells and water hauled from Thames to Strand ribbon development
Early Middle Ages 1066–1236		10,000 rising to 50,000	Walbrook too polluted; well capacity exceeded; water hauled from Thames
Middle Ages 1236–1440	1236	50,000 rising to 60,000	First remote source tapped; water abstracted from River Tyburn at Oxford Street/Bond Street area and to conduits around the City
Late Middle Ages/Tudor 1440–1550	1440	60,000 rising to 80,000	Second remote source tapped; abstraction from River Westbourne springs at Paddington
Tudor & Jacobean 1550–1666	1580, 1593, & 1613	80,000 rising to 460,000	Private suppliers - Peter Morice's Thames tidal-water-wheel-driven pumps; Beavis Bulmer's Thames horse-powered pumps; New River water imported
Jacobean to Victorian 1666–1837	1692, 1723 etc	460,000 rising to 3,000,000	More private water companies. Hampstead Water Co. (1692) draws from Fleet; Chelsea Waterworks Co. (1723) draws from Thames, Westbourne & Tyburn; four others draw from Thames. Water supplied only a few hours a day. Water given partial treatment. No disinfection
Victorian 1837–1904	1854 & 1904	3,000,000 rising to 6,000,000	Private water companies merge; Thomas Hawksley's campaign for continuous water supply successful. Water Act requires conversion from intermittent to continuous supply; full treatment and disinfection (1852); Dr John Snow shows cholera is a waterborne disease (1854); MWB, a public authority, takes over private water companies (1904)

The late eighteenth century made the improving water supply available to increasing numbers of the population, not just the very wealthy. This increased water usage meant that cesspools and septic tanks could no longer cope in a densely populated urban environment. In the absence of a comprehensive network of sewers, domestic wastewater, together with ever-increasing quantities of industrial effluents, were conducted in pipes and channels to the nearest ditch or stream. London's rivers, the Walbrook, the Fleet, the Tyburn and the Westbourne, now rapidly disappearing beneath the City and suburban streets, became heavily polluted. The same fate befell the suburban rivers – the Black Ditch in the east and Counter's Creek and the Stamford Brook – as they were progressively engulfed by rapid urbanisation. The Thames, which received the polluted flows from these rivers and from sewers discharging directly to it, also became polluted and the stench rising from the river could, by Victorian times, be almost unbearable. Hence the London name for the period, the Big Stink.

As the Westbourne, the Tyburn and the Thames had become extremely polluted by the 1850s, the Chelsea Waterworks Company closed its treatment plant by the Thames at Chelsea in the 1850s and moved upstream to abstract cleaner water from the Thames at Kew. At about the same time, the New River Company took over the Hampstead Water Company and only abstracted water from the ponds at Hampstead and Highgate to use the water for supply to industry. So, by the middle of the nineteenth century, the hidden rivers had ceased to provide drinking water to London's population.

Thomas Hawksley's success in his epic 'battle' for continuous supply against Edwin Chadwick, a supporter of intermittent supply, together with Dr John Snow's demonstration that cholera was a waterborne disease transmitted through polluted water supplies, led to the eradication of cholera from the United Kingdom. Most other waterborne diseases such as typhoid and paratyphoid were also drastically reduced through the second half of the nineteenth century as personal hygiene practices improved and continuous, chlorinated and piped water was made available to all.

LONDON AND ITS HIDDEN RIVERS – THE HISTORICAL CONTEXT

The rivers that played a key role in the initial siting of the city by the Romans were the Thames, the Walbrook and the Fleet. Between 500 and 600 years later, it was the estuarial River Tyburn that was influential in the choice of a suitable site for St Peter's Abbey, the West Minster. Between them these four rivers can claim to have played a significant part in the siting of the two main centres of development, the City of London and the City of Westminster. However, these same four rivers also determined the quite different nature of the two centres, each essential in its way to the evolution of the modern-day metropolis into one of the greatest in the world: trading and finance in the City of London, and Government and the influence of the Establishment at Westminster.

These four rivers continued to play a significant role in the life of London through to the end of the Tudor period. By this time, although the Thames and the Fleet remained open, the Walbrook and the Tyburn had been arched over, culverted and converted to hidden

rivers within the limits of the then-urbanised areas. The Thames continued, and continues, to play a major role in London's development. However, as the city extended its suburbs, the Walbrook, Fleet and Tyburn progressively disappeared from view, from their outfalls into the Thames through to their respective sources.

Extension of the suburbs westwards along the Thames in the seventeenth and eighteenth centuries and back into the hinterland, north-westwards, brought other rivers into focus. The Westbourne, which was used to form the Serpentine in what is now Hyde Park, was the first of these rivers to figure in the consciousness of Londoners. Further west, the catchments of Counter's Creek and Stamford Brook were developed mainly in the nineteenth century. Black Ditch, east of London's city wall, was the site of poorer housing that sprung up from the late eighteenth century in response to the huge influx of poor agricultural workers seeking employment in industry and work in the expanding dockland areas of Limehouse. These four rivers were the last to assume an importance in London's north bank development and the last to disappear. However, by the end of the Victorian era, the beginning of the twentieth century, the disappearance of even these four rivers was virtually complete.

For the purpose of describing the role played by London's rivers in its development, the two millennia covering the span of London's existence have been divided into six periods:

- 43 to 410 CE: Roman
- 410 to 1066: Anglo-Saxon
- 1066 to 1603: Norman to Tudor
- 1603 to 1760: Jacobean to Hanoverian
- 1760 to 1837: Regency
- 1837 to present: Pre- to Post-Victorian

This chapter will focus on the general role played by the rivers in the above periods. The historical context, specific to each of the rivers, is dealt with in the respective chapter devoted to each of them.

Roman London

Prior to the arrival of the Romans, the rural area now known as London appears to have been very sparsely populated. The London Basin, north of the Thames, was for the most part heavily wooded – the area that became known as the Forest of Middlesex from the time of William the Conqueror. There were more open areas, principally over and around Ludgate Hill and Cornhill, where gravel underlay a thin layer of soil and the more distant heathland in the sandy and hilly hinterland area of what became Hampstead Heath. There was also low-lying marshland along the Thames from what is now Westminster through to Chiswick and possibly a marshy area immediately north of the Roman city's northern boundary, at Moorfields. There does not appear to be archaeological evidence of a settlement of any significance in the general area of the cities of London and Westminster prior to the Roman invasion in 43 CE, although pre-Roman settlements have been excavated in the vicinity of Heathrow and at Chelsea. In these areas, some evidence of small-scale occupation by prehistoric hunter-gatherers has been found, as well as basic farming activity during the Mesolithic, Neolithic and Bronze Ages.

London, or Londinium as it was named by the Romans, was not chosen immediately as the principal city of Roman Britain. This honour fell to Colchester in Essex, about fifty miles to the north-east and the site of an important pre-Roman development. However, the advantages of Londinium as an administrative and trading centre rapidly became evident and, less than fifty years after the invasion, it became the principal city of the Roman administration in the Province of Britain. Later in the Roman occupation, throughout the third century CE, administration and defence of the Roman Province of Britannia was divided between Londinium and Eboracum (York), with the former continuing to be by far the greater centre for national and international trading. Throughout the final century of the occupation, the two Provinces were each sub-divided into two units and the south-east corner of Britannia, including the southern parts of the Midlands and East Anglia, Maxima Caesariensis, was governed from London.

The conquering Romans initially selected the site for the development of a trading port and garrison town based on a number of strategic factors:

• The site chosen was at the upper limit of what was then the tidal flow in the Thames – and so merchant and military vessels would be assisted up and down the river by the tides;
• A port constructed at the inland point of a long, winding estuary gave greater protection from the elements than would a coastal town;
• The river narrowed at this point and could be readily bridged; at the time of the invasion, a bridge had been formed using boats bound side by side to support a temporary roadway, but this was soon substituted by a more permanent bridge;
• Marshy land along the southern bank of the Thames – and the Thames itself – provided a degree of protection from attack from the south;
• A development on the north bank could be rendered defendable as there were two areas of raised elevation, close to the Thames, which were quite close together – later known as Ludgate Hill and Cornhill; these were separated one from the other by a narrow, fast-flowing river, which would later become known as the Walbrook;
• The northern river bank of the Thames, being better defined than the southern marshy bank, could be more readily developed for wharves to service vessels used for the import and export of goods and for the landing of construction materials, military personnel and weaponry;
• The Walbrook and natural springs and wells in the area provided sources of clean water for drinking and other uses;
• The Fleet river, a broader, more significant stream than the Walbrook, ran through a steep-sided ravine into a small, more open estuarial lagoon at its mouth into the Thames, at a point centred upon where Blackfriars Bridge is now situated. Probably due to its excellent defensive potential, the Fleet was used as the western boundary of the Roman settlement.

Two of London's now hidden rivers, the Walbrook and the Fleet, therefore played a role in the choice of a site for London. It is important to stress that, as far as we can be aware from archaeological finds to date, there were no previous settlements on the site. In spite of the Walbrook quite obviously offering itself as a source of drinking water for the development, it is probable that the Roman population soon became aware of an even cleaner, more reliable source of water underground, in the gravels that underlay their development. This is

indicated by the numerous wells, some almost industrial in character, sunk by the population into the gravel, and more circumstantial evidence of considerable pollution of the Walbrook's watercourse. It is doubtful whether the defensive potential of the Fleet was ever put to the test in Roman times, but its protected estuary was almost certainly used as a harbour for smaller boats and there is evidence of at least one early mill, which may have made use of tidal movement to power its machinery.

The Anglo-Saxons: from Departure of the Romans to the Norman Conquest

In 410 CE, Rome issued an edict that the Province of Britannia would henceforth have to look to its own defence. Londinium, the core area of the present City of London, suffered a period of slow, progressive deterioration during the period following the departure of the Romans, early in the fifth century CE.

No archaeological evidence has yet been found of the continued occupation of Roman Londinium as a functioning urban unit in the period following the final departure from Britain of Roman military and administrative personnel in about 430 CE. It seems probable that the town gradually deteriorated into a set of rather grand ruins.

Following the departure of the Romans, the indigenous people seem therefore to have abandoned the area of Londinium and settled on the western side of the Fleet. The development grew along the strand that was the riverside strip west of the Fleet. Initially called Lundenburh, or 'London fort', by the sixth century, this new development came to be called Lundenwic. This development still appears to have continued as a trading port – as the name means 'trading town of London' – and it is possible that the Fleet and its estuary gained greater importance in this period. Lundenwic was an early form of 'ribbon' development. Excavations have shown it extending along the Thames between what is now called Trafalgar Square and the Aldwych. Early in the eighth century, the Venerable Bede described Lundenwic as 'a trading centre for many who visit it by land and sea'.

It was not just the early invasion of the Germanic peoples that was to have a major influence on the future Britain. The Anglo-Saxon invaders of the fifth century were pagan. At the end of the sixth century, on the invitation of Aethelbert, an Anglo-Saxon king, Augustine was instructed by the Pope to start a ministry in England, a proselytising mission. There had been a thriving Christian population in London and its environs during the Roman period, but these were people practising the religion, not actively proselytising. The Roman form of Christianity won out in England over the Celtic form, with the issue of an edict to that effect in 664 CE. Initially established at Canterbury, after a few short-lived returns to paganism, Christianity spread rapidly throughout Anglo-Saxon England.

The period of about 600 years between the departure of the Romans and the Norman invasion of 1066 was a turbulent one for England. The departure of the Romans appears to have emboldened the three Germanic tribes, the Angles, the Saxons and the Jutes, to realise their ambition to invade and occupy Britain. They soon successfully occupied much of the north-east, east and south-east of the country. However, from the sixth century onwards, between feuds and battles among the ruling Anglo-Saxon elites and disagreements between various parts of the Church, England was in turmoil for a long period, weakening it and opening it to mainly successful attacks by the Danes and the Vikings.

In the ninth century, Scandinavian peoples, in particular the Danes, mounted waves of attacks along the eastern coasts and beat the Saxon peoples back from large swathes of eastern England, which they then occupied for the rest of the first millennium.

For about a decade, in the second half of the ninth century, the Danes even occupied Lundenwic itself until they were beaten back to the north and east of the town by King Harold. The Saxons were restricted to occupying the south, west and south-west of the country and were constantly subjected to attack by the Danes. The Saxons were constrained to pay a substantial tribute to the Danes in order to avoid further incursions and to hold on to the land remaining to them. However, for the majority of the time, although bordering on that part of the country under the Danelaw, the area which included Lundenwic and the ruins of Londinium remained under Saxon rule.

It would appear that, in response to a series of attacks by the Danes through the first half of the ninth century, the old Roman city area of Londinium was re-occupied by the Anglo-Saxons, who rebuilt and strengthened its walls and their surrounding ditch. They renamed this development Lundenburgh, and the strand area became known as 'ealdwic', the old town, or Aldwych as it is now known.

Although the revival of the core city, the site of Londinium, was begun in the late ninth century, it only fully regained its previous status with the arrival of yet another invading force, the Normans under William the Conqueror.

Two things of note took place within this period with respect to London's rivers and the later evolution of the city. The River Fleet became far narrower, reduced to about a third of its former width, and on an island formed in the delta of the River Tyburn, the first of a number of churches was built. Preceded in its construction by St Paul's, the minster in the east, it was initially called St Peter's, or the West Minster. This area through which the Tyburn flowed into the Thames was to play a major role in the history of London and the entire country; it was to become known as the City of Westminster, home to the royal palaces and the government.

First and foremost, and quite naturally considering its size, the Thames continued to loom large in the formation of the character of the area. The same characteristics that had so influenced the Romans in selecting London as their principal town for commerce, both national and international, influenced the Saxons, who filled the management void left by the departure of the Romans.

Norman to Tudor Periods

The period begins with two main centres of population, the cities of London and of Westminster, linked by a narrow band of development along the Thames, known as the Strand. The City of London continued to grow and enhance itself as a commercial centre, a major port trading with northern and southern Europe. The City of Westminster was chosen by the Normans to be their principal residence in England and the centre for their administration and government. William I strengthened the Tower of London as much to intimidate its citizens as to protect the city. For hundreds of years, royalty viewed the profits and assets of London's rich merchant class as the 'cash cow' that funded their own lifestyles and wars. There was therefore an understandably uneasy relationship between the

two centres which lasted for many centuries, in particular between the Corporation of the City of London, dominated by merchants and guild craftsmen, and the royal household and its associated aristocracy.

It was almost certainly the international trading activities of the City of London that led to a sinister import that would have tragic consequences for the city and the country as a whole – the plague. Arriving via continental Europe, probably from South Asia, and carried by ship's rats, it devastated the population many times from the early 1300s through to the Great Plague of 1665. On occasion, it reduced the population of London by a third. This clearly had an effect on London's demand for water. Without the effects of the plague, London would have had a need to search for water sooner, and would have had to tap rivers remote from the city earlier.

In this period, both the Fleet and the Tyburn were valued for their recreational and aesthetic value. City living was crowded and noisy and highly objectionable odours permeated every street and dwelling. Londoners liked to leave the city to walk, sometimes as far as Islington, and play at sports in the fields just outside the walls to the north and west. The Tyburn was a contributor to the marshy nature of Moorfields, just outside the northern walls, and skating in this area, when it was frozen in winter, was a favourite sport. The springs that contributed to the Fleet and Tyburn rivers, the former between St Pancras and Mount Pleasant and the latter at the intersection of Old Street and City Road – to use later place names – were known to be fresh to drink and their remedial properties were gaining some recognition.

In the early Middle Ages, water for domestic purposes was mainly obtained from within the confines of the City of London. Water was drawn from wells sunk into the gravel that formed the hills of the City, as well as from the Thames. Water bearers conveyed water from its various sources to customers who purchased it from them, a trade that continued through to at least the fifteenth century and, to a much reduced extent, later. A need to supplement local groundwater sources of water caused the Corporation of the City of London to first tap the Tyburn and later, a little further afield, the Westbourne. They also began to eye up the Hampstead and Highgate sources of the Fleet but, within this period, never managed to connect them to the city.

Charterhouse, founded in 1371 as a monastery and later converted to a hospital and school, located immediately north of Smithfield, constructed a conduit to conduct water from above the Angel, Islington, to serve its needs in 1430. This appears effectively to have cut off the head waters of the Walbrook, and as a consequence the marsh at Moorfields began to improve. Windmills were constructed on the marsh to hasten the drying process from the middle of the sixteenth century.

By the end of the fifteenth century, the Walbrook had been totally covered over within the city walls, partly to fight the stench that emanated from its highly polluted waters but mostly in order to provide more space for housing.

Outside of Westminster, first the Tyburn and then the Westbourne began to interest royalty with respect to their hunting activities. Following the Dissolution of the Monasteries by Henry VIII in 1536, he dammed both the Tyburn in St James's Park and the Westbourne in the area of Hyde Park to form small lakes, at which the deer that he hunted would gather and take water. Hunting parties would sport around the parks and the lakes formed from the rivers.

Sixteenth-century water carrier with a standard water tankard.

Jacobean to Hanoverian

By the start of this period, the Walbrook had all but disappeared from view, but the Fleet still remained open along its whole length. The arm of the estuarial Tyburn that had formed Thorney Island, on which Westminster was founded, had been filled in to accommodate construction of the many palaces, residences of the aristocracy and buildings used by the monarchy, clergy and government. In effect, the Tyburn now only passed to the south of this development and Westminster had long ceased to be an island.

As mentioned previously, the Fleet River was also known as the River of Wells between St Pancras and Farringdon. The wells that give rise to this name, and a few found in the area of the Old Street/City Road intersection, were found to be chalybeate in nature. That is, they contained salts of iron which led to their being attributed with medicinal properties. From the restoration of the monarchy with Charles II until the earlier part of the nineteenth century, these waters became the basis for establishing numerous spas where Londoners could take the waters and generally enjoy themselves. It was not only the wells just outside London that attracted custom; wells in Hampstead, at the head of the Fleet River, and near the head of the Tyburn River in Belsize also became famous – and, inevitably, infamous.

The middle of the seventeenth century saw the beginning of the rapid increase in London's population and the beginning of the demand for housing to be constructed on land ever more distant from the city's centre. This, in turn, led ever-increasing lengths of the city's

rivers to be arched over, culverted and covered, removing them from view and turning them into hidden rivers. More frequently, the rivers could be called sewers as they served to carry away not just rainfall run-off but also domestic sewage.

Queen Caroline, George II's wife, concerned herself with the gardens of Kensington House and Hyde Park and it was she who formed the lake in the latter to its present shape, by raising the dam on the River Westbourne. She was also responsible for creating small ponds on the northern boundary of Green Park from the waters of the Tyburn.

The banks of the Fleet around and to the north of Farringdon were used for defensive purposes during the Civil War. Londoners, who in general supported Cromwell, built earthworks along the river as a defence against the advancing forces of Prince Rupert. However, he was stopped at the Battle of Turnham Green on the Stamford Brook in 1642 and the defences were never tested in battle.

It would be remiss of a book dedicated to London's hidden rivers to make no mention of the New River. As its name implies, it is not a natural river but an artificial channel constructed to bring water a distance in excess of 64 km (40 miles) in open channel from Hertfordshire to Islington, and from there to have it transmitted into the cities of London and Westminster.

This book is primarily concerned with ancient watercourses, and so the New River does not at first sight appear to have a natural place here. However, there were two principal uses for the water, as defined by the originators of the plans for the New River, and which served as their justification for Parliament to approve the project, and it is those objectives that justify its inclusion.

London was poorly served by supplies of water for domestic use and industries such as meat preparation. Small-diameter pipes conducted very restricted quantities of water to public conduits and a very few privileged residences. In the 1580s, an entrepreneur, a Dutchman called Peter Morice, obtained permission to commandeer one of the arches of London Bridge to build a waterwheel that pumped water from the Thames into the city. But, in spite of an increase in the numbers of wheels operating, the supply was very limited, not least by tidal variations and the vagaries of flow in the river, particularly in its shallows near the north bank. The New River was conceived to bring a continuous supply of good-quality water in large quantities from two springs at Amwell and Chadwell, providing adequate amounts of water for all the city's residents and activities. Eventually, water was also drawn from the River Lea to supplement the water sourced from the two springs. This was the business side of the project.

However, Parliament was principally populated by land-owner MPs who were not enamoured with a project that would pass through their lands, and that had the potential to disrupt the agricultural activity that brought them their wealth. In order to curry favour with the authorities, particularly the councils of the cities of London and Westminster, the promoters of the project, led by Hugh Myddleton, proposed that two-thirds of the water would be used to scour the rivers and drains and to clean the streets of London. The Walbrook, the Fleet and the Tyburn were three of the rivers that were by now causing considerable nuisance. Having been culverted and covered, it was no longer possible to easily clear them of obstructions. In addition to rainwater run-off from roofs and streets, they also carried sewage. Drains and sewers constructed to discharge to them also became choked. All

Peter Morice's water wheel at London Bridge.

this resulted in a continuous foul stench throughout London and frequent flooding of streets and buildings by sewage. The prospect of ridding themselves of this continual headache appealed to the city authorities, and so they placed considerable pressure on Parliament to overcome the objections from land-owners and to pass the necessary acts, which, not without delays, they eventually did.

The New River and its buildings, storage reservoirs and pumping plant located at New River Head, next to Sadler's Wells, together with their distribution mains, were completed in the five years to 1613, when supply began.

The New River does therefore justify a mention, as it served to alleviate the problems caused by covering the hidden rivers – however, its success in this regard may be considered very limited. Its objective of serving as a supply of water for domestic and industrial use was far more successfully achieved and the New River continues to supply a significant proportion of London's water.

It could perhaps be argued that the New River has a place in the book as it has been substantially arched over and covered for the last 5 km (3.2 miles) or so downstream from the former pumping station at Green Lanes, Manor House, to New River Head below the Angel, Islington.

The New River could also claim its place in this book for the influence it exerted on the author, from an early age, to become a water engineer. Together with his brother, he fished

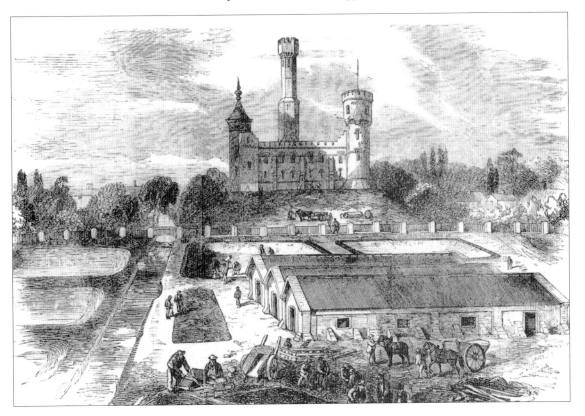

The Victorian pumping station on the New River at Green Lanes.

for 'tiddlers' in the ponds in Clissold Park which were fed by New River water. Mylne's Scottish baronial pumping station in Green Lanes, on the way to the park, made a long-lasting impression on a young mind. From the park, the river then proceeded under the wide central reservation along Petherton Road, where the author's grandfather had his bakery. An uncle who was a civil engineer and living at the family's bakery explained the project's history to him and this sparked an interest in water which later became a life-long passion and his profession.

Rapidly increasing population meant a similar increase in demand for water and by the end of the seventeenth century, further sources needed to be found. The Hampstead Water Company was established in 1692 to tap the source waters of the Fleet River and, in 1723, the Chelsea Waterworks Company was founded, based on waters abstracted from the Thames, the Tyburn and one of the two arms of the Westbourne which outfalled to the Thames at Chelsea.

Regency London

Industrialisation in the latter half of the eighteenth century led to huge numbers of rural workers leaving the land for the cities, particularly London. Vast areas of suburban housing had to be built to accommodate these workers.

The very poorest were housed in appalling conditions of horrendous squalor in East London. The crowded quarters were built along unpaved streets which became a muddy mire when it rained, and the conditions within the leaking dwellings were little different to the streets, particularly when pigs and poultry were accommodated on the ground floor of the same buildings. It was at this time that the Black Ditch was covered over.

Housing in west and north London appears to have been in a better state, even for manual workers and servants. By the end of this period, urbanisation had spread north to Camden Town, Kentish Town, Hampstead, Highgate and Kilburn, east to Hackney and Bethnal Green and westwards through Paddington, Bayswater and Kensington as far as Hammersmith. This meant that most of London's rivers, other than the Thames, had become hidden rivers, disappearing below the urbanised area. Only the headwater lengths of the Tyburn and the Fleet at Hampstead and Highgate and the westernmost sections of the Stamford Brook remained open and in sight.

In the 1820s, the Prince Regent had Regent's Park laid down and its pond was formed from the waters of the Tyburn River.

Damage caused by the Fleet explosion, 28 June 1862.

Construction of the Paddington arm of the Grand Union Canal and the Regent's Canal along the contours cut across the routes taken by the Westbourne, the Tyburn and the Fleet on their way through the contours to the Thames. The Westbourne had to be carried under the Paddington arm at Westbourne Green, the Tyburn was carried over the Regent's Canal into Regent's Park, and the Fleet was culverted below the same canal at Camden Town.

Pre- to Post-Victorian London

During the remainder of the nineteenth century, urban development continued to expand in all directions, radiating away from Central London. By the end of the century, all of the rivers had disappeared below ground, with the visible exceptions of their manifestation as ponds on Hampstead Heath and the lakes in the Royal Parks. However, the rivers became too polluted to be used to feed the lakes of the Royal Parks, and their water was either drawn from artesian sources below London or from the Thames. An attempt was made to clean the Westbourne before it fed the Serpentine, but the project was a failure in this respect, although it left a legacy of ornamental ponds and fountains at the head of the lake.

In one famous case, the Fleet River appeared to fight back against the abuse that it had suffered at the hands of society. In 1846, the culverted Fleet literally 'blew up', with disastrous consequences. A blockage caused a build-up of sewage deposits, which became septic and gave rise to an inflammable and poisonous eruption of methane and hydrogen sulphide. It is not known what ignited this mix, but there was a huge explosion that sent a tidal wave of sewage along the Fleet and the streets above it. The force of the wave, tsunami-like, destroyed buildings, flooded basement storages of goods, swept away cattle and furniture, and from Bagnigge Wells to the Thames rendered roads impassable. Three poorhouses were destroyed and the leading wave of sewage ended up damaging a river steamer boat by throwing it against the abutments of Blackfriars Bridge.

It would appear that the Fleet may have been acting not only on its own behalf but in revenge for all of London's hidden rivers for the use and abuse to which they have been subjected.

CHAPTER 4

A Story of Use and Abuse

The rivers of London – which, unfortunately, have now been ignominiously reduced to hidden rivers – have played a large part in the origin, history and life of the city. This magnificent and most handsome of cities would have been that much more attractive had our predecessors had the foresight to protect them from degradation, and had they not hidden these degraded works underground. However, the rapid growth of the city's population at a time when the country was at the very beginning of its economic development meant that little thought was given to safeguarding them. But before their disappearing trick was complete, they had entered deep into the life of London's citizens and, as is often the case with a good friend, were only properly valued and appreciated with their passing.

This chapter will describe both the uses to which the rivers, sources, springs and wells were put, and the abuses that they suffered, albeit thoughtlessly rather than deliberately. Nicholas Barton has a chapter on this subject in his excellent book *The Lost Rivers of London*. Where he has dealt with a particular use at length, this aspect will also be referred to in this chapter, but only in outline. However, there are some aspects of use and abuse not dealt with in that book. Specific instances of use and abuse are also described in the historical context sections of the chapters which deal respectively with each of the rivers. Uses and abuses of the hidden rivers are dealt with under the following headings:

•The Royal Parks and Their Lakes
•Strategic value
•Bathing and laundry
•Water supply
•Recreation
•Navigation
•Rivers as sewers
•Mills and power

However, before moving to the specific, it is worth examining a fascinating paradox. In general, how can society have such a love of water in nature and yet, so often, end up abusing it?

RIVERS AND SOCIETY – THE PARADOX

The rivers flowing through the centre of the London Basin to the Thames – the Walbrook, the Fleet, the Tyburn and the Westbourne – all exerted a considerable influence on the development of urban London from its Roman beginnings, until their upper reaches were covered over and they were no longer visible. At various times, they played a prominent role in historic events and dictated the nature of development and of their immediate physical environment. In their turn, the citizens of London exerted a considerable influence on the character, flow and quality of the rivers, eventually leading to their complete disappearance from sight. It is interesting to explore the reasons for the interdependence between rivers and the society which builds around them. It is equally of interest to try to understand why the rivers are so abused by society when they are recognised by that same society to have such great beneficial value. Why is society's abuse of them taken to such extremes that they are rendered useless and debased to the point that the only role left to them is as part of a hidden drainage network?

Water is one of the essentials of life. A sufficient source of clean, wholesome drinking water is a fundamental requirement for our daily survival. Rivers and streams in their uncontaminated state are one of the main sources of potable water, the only other current source of significance being water flowing or trapped underground. If contaminated water is drunk, it can lead to disease or deformities and may cause death.

We make use of water for other domestic purposes – for cooking, personal hygiene and the washing of clothes, cooking utensils and floors. We use it for flushing away our wastes and, in recent, more affluent times, we have even used copious quantities of this precious resource to water our gardens. Water is essential to agriculture, horticulture and animal husbandry. Indeed, these productive uses for water that generate our food may consume about three to five times the amount of water we use in our homes. Some industries draw heavily on water in their processes, a few examples being mining, metal production and working, brewing, textiles, food processing and any industry that washes its process vessels and floors.

As the energy needs of society developed, rivers and streams were one of the first sources of energy to be harnessed. The power of moving water was used to turn the mills that ground corn and for driving other simple machines. In many countries having appropriate geographic and topographic conditions, water is retained behind huge dams. On its release from the dams, water is used to drive turbines that generate the enormous amount of power which keeps their economies productive and satisfies the demands for the energy that enables the privileged developed world to maintain an overly luxurious lifestyle.

From the beginning of human history, rivers and streams have proved a focus of fascination for people throughout the world. We appear to be drawn to them. This attraction stems from the general appeal we feel for water in any of its natural or managed states – oceans, coastal waters, whether turbulent or flat calm, lakes, reservoirs and even garden ponds. A view over water is an essential element of feng shui, the Chinese art of creating an environment of well-being. What is it that draws us to water? What is it that draws us to rivers and streams?

When, by chance, we cross over a river bridge on foot, almost inevitably we stop to lean over the parapet. We gaze into the water below, almost trance-like. We seek even the most fleeting glimpse of fish or become mesmerised by the fascinating patterns made by rooted,

submerged algal fronds gently waving to and fro in the flow. We appear to gain little of substance from our encounter with the river, yet we feel better in ourselves for having given the time to stop and reflect.

We are not taught to love water – it just comes naturally. It's a feeling that appears to be built into each one of us. There is almost certainly something primeval in this. Living in temperate climates, modern peoples, particularly those living in cities and towns, are commonly unaware of the true value of water to them, how essential and fundamental it is to life. Only those who live in dry climates, totally dependent for their very survival on the arrival of seasonal rains, are brought face to face from childhood with the absolutely vital nature of water. Whereas we could survive for many weeks without food, we instinctively know that we are able to survive just a few days without access to drinkable water. If evidence of the true value of water to life were needed, witness the unfettered joy of primitive peoples living in dry climates on the coming of the rains and you get a feel for the true value of water to life. In the course of his professional career, the author has been privileged to witness this joy on a number of occasions and to take part in the celebrations that the rains or, better, a piped supply of water, bring.

Nevertheless, even the pampered peoples of western civilisations find themselves drawn to water. We may not be conscious of it, but the people of the developed world have as great a dependence upon water as do the peoples of developing countries – perhaps even more so. We appear to have an inner, unconscious affinity for water. After all, the first nine months of every mortal's existence is spent submerged in water in the womb. It is, therefore, the first environment that we experience. It is not unheard of for babies to be born underwater to relieve the stress of childbirth, and a new-born baby appears to retain a natural ability to swim well into its first year of life outside the womb.

There is little doubt that our aqueous origins and the cleaning properties of water give rise to a feeling in sensitive people that water has a spiritual quality, and it is therefore no surprise that religions of many colours have used it in their ritual initiation and purification ceremonies.

We are attracted to walking beside rivers, whether they are rushing headlong down a mountain or hillside, slowly meandering their way through farmland, meadows or forests or carrying the commercial traffic of a town or city, flanked by interesting riverine infrastructure – wharves, cranes, boat-builders and barges.

If asked to imagine and then describe a stream that would be attractive to them, most people would use words such as 'clear', 'pure', 'sparkling' and similar descriptions of water flowing in its uncontaminated form. This attraction to, and love of, water as a symbol of purity is one half of the paradox; the thoughtless misuse of what we claim to love completes the paradox. From pre-history, we have without thought rid ourselves of all that is dirty by discharging it into a river or stream. We do this in the hope that our waste will be carried away and not be a nuisance to us – if not immediately, then when the river rises in flood.

Wastes discharged to rivers have not been restricted to human and animal wastes; industry has played its part in our abuse of these bodies of water supposedly so dear to our hearts. From earliest times, the fine, talcum-like powder generated by the cutting and working of marble and the debris created by mining has choked ancient watercourses. Leather tanning and dyeing, an industry going back many thousands of years, has always been dependent

upon high concentrations of heavily polluting chemicals. The waste skins and flesh and the effluents from tanning discharged to rivers have particularly noxious and objectionable effects. Even animal slaughterhouses, which have always utilised the hides, the fat and the bones of the animal carcases, need to discharge the wastewater from washing floors and containers. These are contaminated with large quantities of blood, a liquid that is approximately 300 times as polluting as domestic sewage.

River water has an amazing natural capacity to render organic waste material discharged to it harmless and innocuous. This characteristic of natural bodies of water is called their 'self-purification capacity'. The same bacteria and other microscopic organisms at the base of the food chain that feed on leaves and other natural organic matter reaching the rivers also feed on the constituents of human waste. Indeed, most wastewater treatment plants use these natural processes to speed up decomposition by optimising the conditions for these same bacteria and protozoa to feed.

Isolated dwellings and farms can, under the right conditions, discharge a small amount of waste without permanent damage to a watercourse. A small village might also be able do this if the river flow is consistent and great enough. Problems occur when the amount and nature of waste thrown into a river exceeds the river's capacity to self-purify effectively over a short distance. When this capacity is exceeded – and it does not take much waste to exceed this critical capability – oxygen dissolved in the river water falls below a critical level essential to fish and other aquatic flora and fauna, as well as to the bacterial decomposition processes. When this happens, fish die and it becomes increasingly difficult for anything other than some plant life to survive. Polluted river water may be turbid, but it may also still remain clear. Alternatively, pollution levels can be so great that no oxygen remains dissolved in a river's waters, the bacterial flora change completely in nature and the river becomes a source of highly objectionable odours.

So, as was bemoaned in the popular old song, 'we always hurt the one we love' – and therein lies the paradox.

We are attracted to and need the water in rivers and streams for our existence, but our ever-growing societal needs result in our destroying their value to us. In the case of densely populated cities such as London, this eventually leads to our hiding their contaminated state by covering smaller rivers to create yet more land for development and settlement. There is an almost inevitable progression in the symbiotic relationship between an urbanising society and the rivers and streams within its boundaries:

• The progression begins. Rivers, streams and lakes in a pristine state, in open countryside.
• A community develops by the body of water. Communities spring up close to the banks of the river to satisfy the growing need for a convenient and clean source of water. Development is stimulated by commercial pressures, for improved defence or sometimes even a spiritual purpose.
• The community uses the river water. Given favourable political, commercial and, sometimes, religious conditions, the original settlements develop beyond the size of villages into towns, frequently testing the capacity of the rivers associated with them to satisfy their demand for water for drinking and other domestic and trade uses, as well as for horticulture and animal husbandry within the community's limits.

•The community discharges its liquid waste and refuse to the river. It is a natural human observation that rivers can be used to carry wastes away from communities, conveniently and at virtually no cost. This has meant that, until very recently, little thought was given by people to the effects of discharging the contents of their latrines as well as domestic and trade wastes, both liquid and solid, to the rivers until it was too late to effectively recover the situation.

•Alternative sources of unpolluted water are sought and exploited. As a consequence of this contamination, abstractions of water from the rivers has to be moved upstream of their polluted lengths and sometimes other, more distant, sources of uncontaminated water exploited.

•The river is considered only as a sewer. Given the significantly reduced quality and value of the rivers within the urban development, they are increasingly considered only as drains.

•The polluted river is considered worthless and irredeemable. Increasingly used as sewers and drains, the stench arising from the rivers becomes so objectionable that they have to be covered over to reduce smell nuisance to acceptable levels.

•Population growth stimulates a need of land for development. Covering the rivers helps satisfy demand for land for housing, industry and commerce.

•This natural progression continues until the city's rivers have all disappeared from sight and public consciousness. This common cycle seals the fate of the smaller rivers in the vast majority of cities. Hidden from sight forever, they become incorporated into the city's sewer and drainage systems.

The rivers of London were subjected to this succession of events. A full cycle of degradation is rarely completed by returning the rivers to their natural, pristine state. Although credit is due to the London authorities in that, at immense expense, the Thames has been saved from its highly polluted Victorian state, where it was devoid of most life, to the point that, since the 1970s, it has supported a large variety of fish.

Having examined the paradox of our love for and abuse of rivers, an examination is now made of the specific uses and abuses of London's hidden rivers.

THE ROYAL PARKS AND THEIR LAKES

The Royal Parks are a major feature in the lives of Londoners, providing large open areas around the inner city for relaxation and recreation. The sensation of open, semi-rural space that this parkland creates, beautified by gardens and trees, is further enhanced by their lakes. These give opportunities for fostering wildlife, particularly birds, as well as for boating, swimming and, sometimes in winter, even skating.

The Long Water and Serpentine in Hyde Park, the lakes in St James's Park and Regent's Park, and, in an earlier age, the small pond and reservoir in Green Park, all owe their origins to the harnessing of water from two of London's hidden rivers, the Westbourne and the Tyburn. The histories of their development by various English kings and queens, principally Henry VIII, Charles II, Caroline, the wife of George II, and the Prince Regent prior to his becoming George IV, are all described in the chapters covering those two rivers.

This section concentrates on the Royal Parks and their association with the hidden rivers, a relationship that has not been without its difficulties.

St James's Park and Hyde Park

The lakes in St James's Park and Hyde Park were created using the waters of two separate rivers, the Westbourne for Hyde Park and the Tyburn for St James's Park. However, as the rivers became polluted, the fortunes of the two sets of lakes became intertwined.

When Henry VIII took over the land for St James's Park, it was marshy, a consequence of frequently being flooded by the River Tyburn. It was James I who had the park drained and landscaped. Until the era of Charles II, St James's Park was considered solely for the pleasure of the monarchy, principally for hunting but also as a suitable place for romantic dalliances.

Charles II, in the mid-seventeenth century, diverted water from the Tyburn to form a lake. As part of formal gardens in the French style, the lake was in the form of a straight canal along the length of the park, with shaded, tree-lined walks on each bank. Charles II entertained his mistress Nell Gwynne here and by the mid-seventeenth century, the park had become notorious as a place for amorous assignations of a commercial nature. In the 1760s, the canal was shortened at its eastern end to form Horse Guards Parade. It was the Prince Regent who commissioned John Nash, the architect and town planner, to design the less formal lake which is the central feature of today's park. The bridge linking the northern and southern halves of the park was opened in 1957. Previous bridges, constructed in Victorian times, were first a Chinese-style 'willow-pattern' wooden bridge, which was followed by a Victorian iron suspension bridge.

In the early eighteenth century, the waters of the Tyburn were diverted to the treatment plant of the Chelsea Waterworks Company by the Thames and there was little turnover of water in St James's Park lake other than water draining from the surrounding land. By the late eighteenth century, the water had become objectionable and it was decided to drain water from the Serpentine in Hyde Park through the St James's Park lake in order to flush it through with what, at the time, was cleaner water. Sometime in the second or third decade of the nineteenth century, a 15-inch (380 mm) diameter, cast-iron pipe was laid from the north bank of the Serpentine, at a point not far from its eastern end, across Hyde Park Corner and down Constitution Hill to the Buckingham Palace end of the St James's Park lake. The surface of the water in the Serpentine is at an elevation of about 10 metres (33 feet) above that of the water in the lake at St James's Park, and so water flowed along the pipeline from the Serpentine to St James's Park by gravity; no pumping was necessary.

By the middle of the nineteenth century, the Serpentine was itself becoming highly polluted. Easton & Amos, engineers, dug a well on Duck Island, towards the eastern end of the St James's Park lake. The island is actually a peninsula-like protrusion into the lake from its eastern end. The well was filled with gravel, and water drawn from the lake was circulated through it to improve its condition by filtration. This was only partially successful. The well was deepened to a point that water rose into it from the water-bearing chalk strata under artesian pressure and fed to the lake. The feed to St James's lake from the Serpentine was halted. The lake is still fed today by water drawn from the aquifer in this way, although there are now four boreholes feeding the pumps: one sunk on Duck Island and three on the

'mainland' at the end of the lake, by the 'island'. The lake also receives a certain amount of new water from rainfall draining off the surrounding park.

The cast-iron pipeline constructed between the lakes in the two parks was not abandoned – it was put to further good use, as described below.

The land occupied by Hyde Park and the adjacent Kensington Gardens was placed under the stewardship of Westminster Abbey just before or just after the Norman invasion. It is thought that the land would have been marshy. The monks first used the waters of the Westbourne to create a series of terraced fishponds near the eastern end of the land. With the dissolution of the monasteries, Henry VIII took the land back under the ownership of the monarchy. He had a rudimentary dam built in the area of the fishponds to flood the land upstream, in order to create a large pond that would attract game as a source of drinking water, particularly deer. Covered, terraced stands were also built so that guests of the King could be entertained while watching the spectacle of a hunt without themselves experiencing any danger.

Towards the end of the seventeenth century, William III (1650–1702) bought Nottingham House on the western edge of the park and moved his court to what became known as Kensington Palace. The move from the damp and misty riverside land surrounding Whitehall Palace was said to have been prompted by his asthma. He employed Christopher Wren to enlarge the house. Queen Caroline (1683–1737), George II's wife, was a keen gardener. Hyde Park had become frequented by Londoners seeking a place for relaxation. In the 1720s, Caroline carved off 110 ha (275 acres) of Hyde Park to create a garden separate from the public area, called Kensington Gardens. She built a 'ha-ha', or ditch, along its eastern perimeter.

It was Queen Caroline who created a much higher dam that resulted in forming the lake that can be enjoyed today. It was one of the first artificial lakes to follow natural contours, and so be irregular in shape rather than the more formal rectangular lakes which were created until then. The natural look became the fashion. The Serpentine occupies an area of 11.3 ha (28 acres). Its name derives from the shape carved out by the Westbourne River as it wound its way, serpent-like, between the Bayswater Road and Knightsbridge.

An impression of the width of the Westbourne channel can be obtained by viewing the wall, lying behind the Victorian Pumphouse at the Italian Gardens and fountains in Hyde Park, which retains and supports the Bayswater Road. The wall includes four brick arches which can be seen in the wall opposite. These are the downstream side of the bricked-up arches of the bridge through which the Westbourne flowed under the Bayswater Road. They seem to be very wide for a relatively short river with a modestly sized catchment area. However, the Westbourne was known to be 'flashy', that is, it could carry a greatly increased flow suddenly should there be an extreme storm event in the catchment. The width of the four brick barrels was needed for times when the Westbourne carried run-off from these extreme storm events, or at times of heavy, prolonged rainfall.

Although Londoners were moving 'out west' by the beginning of the nineteenth century, intensive development of the land upstream of Hyde Park did not really get properly under way until the 1840s. The Westbourne therefore remained relatively unpolluted until about 1840. It was for this reason that engineers considered the Serpentine as a source of cleaner water for the lake in St James's Park a little earlier in the century. However, water quality in the Westbourne – and hence the Serpentine – underwent a rapid deterioration from

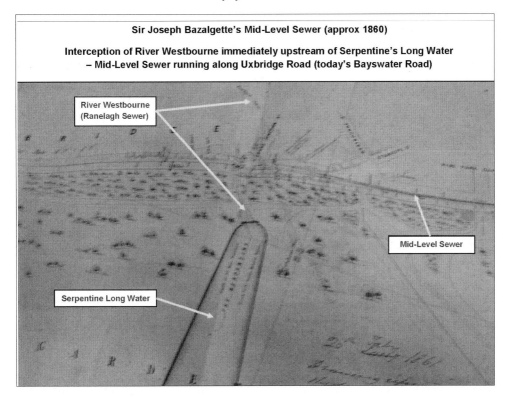

Sir Joseph Bazalgette's Mid-Level Sewer (approx 1860)

Interception of River Westbourne immediately upstream of Serpentine's Long Water – Mid-Level Sewer running along Uxbridge Road (today's Bayswater Road)

River Westbourne (Ranelagh Sewer)

Mid-Level Sewer

Serpentine Long Water

Sir Joseph Bazalgette's Mid-Level Sewer (*c.* 1860).

the 1840s with the rapid development of housing in the river's catchment. By the 1850s, on average, about 265,000 people a year were using the Serpentine for bathing. Dr John Snow had just demonstrated that cholera and other diseases were communicated through polluted water, and there were fears for the health of the bathers.

A water engineer who had gained national fame, Thomas Hawksley (1807–93), was commissioned to devise a plan to clean the waters of the Westbourne before they were fed to the Serpentine. Hawksley was one of the Victorian era's most famous water engineers, whose championing of continuous water supply – as opposed to the then-norm of intermittent supply, with all its inefficiencies and dangers to health – led to a vast improvement in public health. The use of a continuously pressurised water network became standard water supply practice throughout the developed world. He founded the engineering consultancy which became Watson Hawksley, of which the author is proud to have been a principal. However, in spite of his national and international fame, the Serpentine Pumping Station and filters were not Hawksley's best project. He proposed to improve the quality of the water of the Westbourne by first passing it through slow sand filters. The pump station and filters were completed in 1862. However, practical difficulties related to managing the accumulated filth on the filters led to their abandonment as a treatment facility. They had been conceived with a double function and were commissioned for the other purpose as ornamental ponds – the Italian Fountains at the head of the Long Water which leads into the Serpentine. They are still functioning today.

The Italian Gardens and Fountains at Hyde Park, from *The Illustrated London News*, 12 May 1860.

With the failure of Hawksley's attempt to clean the waters of the Westbourne, the river was diverted upstream of the lake into a sewer, later known as the Ranelagh Sewer. Water can still reach the Long Water from the Ranelagh Sewer when the capacity of the sewer is exceeded by surface water run-off at times of extreme storm. With the Westbourne now cut off from the Serpentine, it was necessary to find an alternative source. A well was sunk about 65 metres (213 feet) through the bed of the Westbourne down into the chalk and, partly by artesian pressure and partly by pumping, water was abstracted from the aquifer into the Long Water. Pumps extracted water from the lake and circulated it through the fountains in the centre of each of the ornamental ponds.

However, the water from the aquifer abstracted was neither reliable in quantity (it appeared to be subject to the amount of rainfall in the area) nor particularly clean, almost certainly indicating a short-circuit between the river and the abstraction point. The well was deepened, probably in the mid-1860s, to about 98 metres and the water supply situation to the lake improved. In addition, an arrangement was made with the Chelsea Waterworks Company to supply water for the lake. Triggered by the poor experience of the first well, a decision was made to arrange to make an alternative supply available to the Serpentine.

By this time, the well on Duck Island which pumped water from the aquifer into the lake at St James's Park had functioned well for a decade or so. It was decided to re-commission the closed-off pipeline constructed earlier between the Serpentine and St James's Park. Short pipeline extensions were constructed at both ends of the pipeline, to link it to Duck Island and to the Italian Gardens at the head of the Long Water, and more pumps installed at Duck Island. The Serpentine was emptied, cleaned and re-filled with expensive Chelsea Waterworks water in 1869–70. The new regime was then initiated. Flow through the pipeline was reversed by pumping from the well on Duck Island, and so the Serpentine ignominiously received cleaner water from the lake that, previously, it had been intended to supply.

Water from the pipeline was also passed up to the Round Pond in Kensington Gardens along a side branch of the pumping main. On its way between the parks, water was also drawn off to feed the ponds in the grounds of Buckingham Palace.

The supply to the Serpentine from Duck Island, St James's Park, continued until 1997, when it was discontinued as the 130-year old pipeline between the lakes was by now leaking extremely badly. In addition to its age, it had not been designed to take the pressures of a pumping main and it was operated against the intended run of the joints.

The Serpentine is presently supplied from a number of different sources. Principally, it receives water from a borehole sunk in the late 1990s near the Italian fountains to a depth

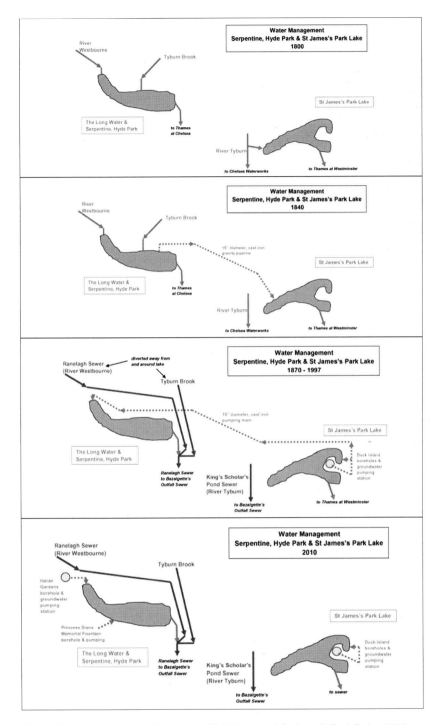

Water Management in the Serpentine, Hyde Park and St James's Park Lake, 1800, 1840, 1870, 1997 and 2010.

of about 130 metres (426 feet); new pumps installed in the Victorian pump-house abstract water from the aquifer and feed it not just to the Long Water, but also to the Round Pond. The abstraction licence is for 90,000 m³ annually. A separate borehole, 133 metres (436 feet) deep, provides the supply to the Princess Diana Memorial Fountain, and 10 per cent of the water abstracted daily is siphoned off from the fountain to keep the water in it refreshed. It is that excess, not a large quantity, that is discharged to the Serpentine. There is also surface water run-off from around the lake, between the road nearest to the lake and the lake itself. This is not a large quantity of water as where the run-off meets a road, in its passage across the land, it is intercepted into the sewer system.

Water surplus to the needs of the Serpentine overflows the dam at the eastern end of the lake. This excess water discharges to the Ranelagh Sewer, which passes by the lake at that point. The water exiting the Serpentine has always either passed back to the Westbourne when it was a river or to the Ranelagh Sewer, the river in another guise.

The separate and interlinked fortunes of the lakes in Hyde Park and St James's Park over the period 1800 to 2010 are shown in the diagram overleaf.

Regent's Park

Regent's Park and the Regent's Canal were designed by Nash more or less contemporaneously, although the canal from Paddington through to Camden Town was completed some years earlier than the park.

The Charlbert Bridge over the Regent's Canal in the northern part of Regent's Park has a dual function: to allow pedestrian access to Regent's Park and to carry the Tyburn River over the Regent's Canal. The bridge had to be designed as an aqueduct, and this function is apparent from the sealed access covers in the centre of the bridge.

The lake in Regent's Park was originally fed from the River Tyburn, supplemented by a small stream which ran south to the lake from under the London Zoo, opened in the 1820s.

The Tyburn River issued from the lake at a point about halfway along the western side of the lake and resumed its natural course around the outside of Sussex Place, before crossing Park Road and passing south-eastwards between Glentworth and Chagford streets, parallel to and to the west of Baker Street on its way to Oxford Street, Mayfair, Green Park and, eventually, the Thames.

As the land to the north of the park – St John's Wood, Primrose Hill and Swiss Cottage – was developed from the 1820s through the first half of the nineteenth century, the quality of the water in the Tyburn rapidly deteriorated. The Tyburn was progressively covered and became known as the King's Scholar's Pond Sewer, named for its point of discharge to the Thames at Westminster. The Tyburn was disconnected from the lake in Regent's Park at some point in the middle of the nineteenth century and diverted around the Outer Circle of the park, past where the London Mosque now stands, to Sussex Gardens, where it joined the previous route of the river southwards to the Thames.

In 2004, a borehole was sunk into the chalk water-bearing strata deep beneath the park, at the point where the river formerly entered the lake at its north-western arm. That borehole supply continues as the main supply to the lake today, although 94 per cent of the water

pumped from the borehole is used for irrigation; only a small proportion is sent to the lake. A small amount of surface water run-off from the park is also drained to the lake.

Green Park

The Queen's Basin, named for Queen Caroline, wife of George II, was a pond constructed near the central northern perimeter of the park. It was fed by water from the Tyburn River where it entered the park. In 1746, the pond was taken over by the Chelsea Waterworks and converted to a reservoir for the supply of water to the newly developed area of Mayfair. Another reservoir was constructed by the company at the north-east corner of the park. The reservoirs can be seen as marked to the ownership of the water company on John Rocque's famous map of London of 1746.

The Chelsea Waterworks, founded in 1723, was situated at the Thames, just to the east of the Chelsea Bridge. The Tyburn was one of its sources of water, the other being the River Westbourne. The water company is described in greater detail in Chapter 9, which is devoted to the Tyburn. The two reservoirs were eventually demolished by order of Queen Victoria.

STRATEGIC VALUE

Rivers have played a major role in stimulating the development of villages, towns and cities ever since people began congregating in settlements for their mutual benefit and good. Water being even more essential to survival than food, the ready availability of a sufficient supply of 'wholesome' water in or nearby an area has always been a major factor contributing to the growth of an urban development.

However, rivers also act as a physical barrier to travellers, whether these are farmers, merchants or itinerant artisans pursuing their peaceful business or armies, brigands or popular uprisings whose objective is to physically protect or safeguard the rights of the population that spawned them or to commit acts of aggression against them.

In a few cases, rivers can act to facilitate trade by acting as navigable routes for vessels. This is particularly the case with major rivers and, in times when sail or oars were the only means of propulsion, if the navigable river is served by tidal movement, this is a great boon.

As described in an earlier chapter, these considerations – water supply, defence and trade – were three of the most important factors in the choice by the Romans of the site for a significant urban development that was to become the City of London. First and foremost in their thoughts had been the Thames, which, prior to its bridging by a pontoon made from boats, had acted as an effective barrier to the progress of their army. The point of their crossing the river was also its then tidal limit, which rendered it attractive for access by military and merchant vessels from the 'French Sea', as the Elizabethan chronicler John Stow called the English Channel.

But two of the hidden rivers figured in their choice of the site. When the Romans first arrived, the Fleet was almost certainly considered as a defensive barrier which would serve to protect the western end of the development. Later, it was put to other strategic purposes. To the east of the Fleet and a little way back from the Thames were two low hills, later called

Ludgate Hill and Cornhill. Another river, the Walbrook, ran between these two hills, in a direction parallel to the Fleet, discharging into the Thames. The two hills had been formed from water-bearing gravel deposits overlying London Clay. Seepage from the two hills fed the Walbrook. Ludgate Hill and Cornhill were not just valued by the Romans for their defensive potential, but also for their capacity to provide water for the future settlement through wells dug into them.

Not long after the Romans had established a small settlement on the north bank of the Thames called Londinium, its defensive characteristics were tested – and, frankly, found wanting. In about 60 CE, Queen Boudica (Boadicea) and her allies, the Trinovantes, the Icenian tribe that occupied most of Suffolk and Essex, attacked the embryonic London and destroyed it. One of a number of critical confrontations, it is claimed, took place at what then became known as Battle Bridge, a point along the Fleet at what is now known as King's Cross.

Incidentally, according to legend, the Trinovantes were said to have been the original occupiers of the site of London, which had been called by them Trinovantum. The same legend has the Trinovantes descending from the people ousted from Troy, with Brutus founding the city that became London even before the founding of Rome. This legend, although fascinating and promulgated by William FitzStephen in his twelfth-century chronicle and promoted by Stow, is almost certainly just that, a legend without any basis in fact. Certainly, no archaeological evidence has been found of a pre-Roman settlement.

Needless to say, the Romans, who rapidly re-occupied and re-built London after the Boudica-led revolt, no longer relied solely on the natural defensive properties of its hills and rivers. They greatly reinforced these natural barriers, eventually building a wall and moat along the three landward sides of the City.

Much later, from the twelfth century through to the seventeenth century, the Fleet was used as a defensive barrier at particular periods of rebellion and civil war. The sections involved lay in its lower and middle reaches, from its deep, ravine-like valley at the Thames up to the fields at Battle Bridge. The Fleet acted as a boundary between the Cities of Westminster and London, and the Fleet and Oldbourne (Holborn) bridges were of strategic importance on a number of occasions. These critical moments are described in the chapter on the Fleet.

Interestingly, the Fleet did not prove an effective barrier to the westward passage of the Great Fire of London in 1666. The flames leapt the Fleet Valley and the fire reached as far west as Fetter Lane and Temple Church, the latter being spared by a whisker.

The importance of the hidden rivers to the military is demonstrated by the map produced to coordinate army resistance to the Gordon Riots. In 1780, Lord George Gordon organised a march of the people on Parliament to protest against an act that proposed to repeal anti-Catholic laws. He did not organise the extensive riots in and about London that grew out of this march, which probably were fuelled at their core by the same principles that were shortly to lead to the French Revolution. In addition to troop placements, the map (based on one produced earlier by Rocque) shows the watercourse of the Westbourne, the Fleet and the New River more clearly than any other map printed earlier. However, the riots were put down in less than a week, albeit bloodily (estimates of the dead range from 200 to 1,000), and without recourse to the rivers as lines of defence or for trapping rioters.

The rivers of London were therefore exploited for their strategic and defensive value before they became hidden. However, they have never succeeded in the repulsion of attacks, although they were useful in delaying the inevitable or have appeared to present a greater barrier to an advance than in reality they were.

BATHING AND LAUNDRY

The remains of a Roman public bath house have been excavated in the valley of the Walbrook, in the vicinity of Cornhill. Although it is probable that, originally, these baths were designed to draw water from the Walbrook, it is not known how long this practice continued. It appears that the Walbrook rapidly became polluted within the walls to the extent that it could not be used for drinking or for domestic use. It is probable that, for much of its useful life, the bathhouse was fed by water drawn from a shallow well sunk into the gravel which overlay the city in that area.

In common with developing countries today, the water in rivers and streams and from springs and wells would have been used for personal hygiene by rural inhabitants, whether individual dwellings or communal settlements. However, it is worth pointing out that bathing to keep bodies clean was not considered as essential as has become the custom today, and the washing of clothes was undertaken infrequently in order to prolong their useful life. Urban dwellers would have washed rarely, as all water had to be hauled to its point of use. The vast majority of the rural population would not have had privies or toilets in their dwellings and would have practised what is graphically called 'open defecation'. However, in itself, this would not have been sufficient to pollute the rivers. In part this was because the population was sparse, and partly because the quantities concerned were small in relation to the pollution generated by livestock.

All of the hidden rivers would have been used as sources of water for bathing and laundering of linen and clothes while they remained rural in character. Wherever and whenever their banks and surrounding areas became densely urbanised, the increasingly filthy state of the rivers would have rendered their use for these purposes futile. The Walbrook within the city walls ceased to be of a quality that could be used for public hygiene soon after the Romans built them as the town's population grew. The Fleet was used for domestic purposes until the early Middle Ages, but its lower reaches downstream of Mount Pleasant were so heavily polluted by sewage and trade effluents by the middle of the twelfth century – by effluents from tanneries, the butchering of meat and food processing – that they became highly objectionable and unusable.. However, the middle and upper reaches of the Fleet and the Walbrook would have continued to be used by households near to them until the period of rapid expansion of urban London which had its beginnings in the sixteenth century, and which gained pace through the eighteenth and nineteenth centuries.

In like manner, the Tyburn, Westbourne, Counter's Creek, Stamford Brook and Black Ditch would also have continued in daily use by rural and semi-rural households until swallowed by London's urban spread.

WATER SUPPLY

It is, of course, stating the obvious to say that without a source of water, all life must die. However, most of us, in our modern, first-world cosseted cocoon, take our ease of access to an adequate supply of safe water for granted. We open a tap and out it flows, in abundance. We are no longer conditioned to think that access to clean water is the most vital factor in choosing a site for a dwelling, a farm or a settlement. Nowadays, we are so confident that a continuous supply of wholesome water will be piped into our houses that we no longer give it a thought. However, this is only a very recent phenomenon, even for London, where a continuous supply of safe water was only available to a few in the mid-1800s. It may seem difficult to accept today, but a continuously-pressurised supply of water, that is water on tap twenty-four hours a day, every day of the year, was only made available to everyone living and working in London at the start of the twentieth century. Until then, intermittent supply, with its inherent danger of contamination in the networks, was the norm.

The primitive communities that inhabited the countryside around the Thames where, millennia later, London would be sited, would have ranked a reliable source of water among the top considerations for choosing a place to set down roots. They would have set up either on the banks of the Thames, on one of its tributary rivers, or where natural springs, wells and ponds were to be found.

On the north bank of the Thames, the rivers that would be named the Walbrook, the Fleet, the Tyburn, the Westbourne, Counter's Creek and Stamford Brook would have figured large in the consciousness of the inhabitants of the area before the arrival of the Romans. The rivers were the reason that they could consider settling there; other factors followed on in their consideration after this.

It would have been the same for the Roman invaders. The ready availability of a reliable source of wholesome water would have been uppermost in their minds when locating the site for their 'green-field' development, Londinium.

Early Roman London appears to have used the Walbrook as its principal source of potable water. However, as the settlement grew and water quality in the Walbrook deteriorated, shallow wells sunk into the gravel deposits in the vicinity of Cornhill and Ludgate were used to supplement and then substitute for the Walbrook. It is also probable that water was drawn from both the Fleet and from the Thames. Although Londinium was sited right at the upstream tidal limit of the Thames, the water was not saline at that point. It was suitable for drinking, given that there were no settlements of any size for many miles upstream to contaminate the water. Thames water would have either been carted to the city or carried there by people hoping to sell it in small quantities. Given their expertise in hydraulic works, although a matter of speculation, it is also possible that the Roman settlers piped water from the Walbrook from outside the settlement into the town to draw it off before it became contaminated by urban activity. However, no evidence of this has been found.

It appears that the population of Roman Londinium never exceeded the combined capability of the Thames, Walbrook and Fleet, supplemented by local springs and wells, to supply it with water.

This was probably also the case through the Saxon period of settlement, from departure of the Romans to the arrival of the Normans, when Lundenwic, which developed along the riverside strip now known as the Strand, was the principal settlement.

London in the early Middle Ages continued to source its water supply from the non-tidal Thames, from the rivers outside of the town and from numerous wells. At this time, with three centres – the City of London in the east, the City of Westminster in the west and the riverside, ribbon development between – the lower reaches of the Fleet and the Tyburn, local to developments, were used as water sources, together with the Thames and groundwater drawn from shallow wells.

Even though all the sources used were local to the dwellings and trades that they served, this water had nevertheless to be conveyed to its points of use. Wealthier citizens would have either been in a position to sink their own wells or have their servants convey water to their houses, by cart or by foot. They would also have been in a position to buy, and to store on their properties, water carted and sold to them in bulk. Less wealthy residents would either have had to fetch and carry the water themselves or purchase water from water carriers, a low class of worker who earned a living collecting, conveying and selling water from 3-gallon (13.5 litre) wooden tankards.

However, the very same rivers which provided water for domestic use were convenient places into which to discharge sewage and contaminated drainage from the streets. The rivers were also used for dumping refuse, and effluents from trades such as butchery, tanning and dyeing were discharged to them. The streets of London were particularly dirty as shops and market traders left wastes from their trades in front of their shops and stalls. Householders would also dump human wastes into the streets for rainwater run-off to eventually wash them away. In truth, the city stank in every nook and cranny. By the 1200s, local sources of water were becoming ever more polluted and their quality and quantity were inadequate for satisfying the needs of an increasing population. From the early 1200s until the late 1500s,

A London
water
conduit.

the waters from the middle reaches of the Tyburn, the Fleet and the Westbourne rivers were increasingly used to supplement the City's local sources of supply – urban springs and wells and the Thames.

Between the Thames and the local reaches of the Tyburn, the Palace of Westminster, the houses of the aristocracy and the dwellings and offices of government appear to have been supplied with sufficient water from local sources well into Tudor times. However, the City of London needed to obtain water from remote sources. In 1236, the city's first water supply project was initiated. The council of the City of London contracted with the owner of the land at Tyburn, Gilbert Sanforde, to abstract water from the River Tyburn at a point where the underground, culverted river now crosses Oxford Street at Bond Street station as a sewer. The water was to be conveyed to the City of London '... for the poor to drink, and the rich to dress their meat ...'

Lead pipes were laid from Tyburn via Westminster and the Fleet Bridge to a cistern, called the Great Conduit, at West Cheap, which was ready for use by 1285. The work of the late fourteenth and early fifteenth centuries appears to have centred about the building of a number of cisterns, or conduits as they were then called, around the city for the local convenience of citizens.

The fourteenth century saw rises and falls in the population of London as waves of plague, including the Black Death of 1348–9, hit the city. It was only towards the end of the fourteenth century and into the fifteenth century that the Tyburn source became insufficient for the needs of the population. In 1440, the city negotiated with the Abbot of Westminster, who owned lands at Paddington, to collect water from springs on land near present-day Paddington Station and to convey them to Tyburn for onward transmission to the city using the original conduit. According to Stow, this led to a series of conduits being constructed throughout the city. He mentions 'bosses' and 'conduits' being installed in eighteen locations, in addition to the first at West Cheap.

These conduits were substantial edifices, generally placed in the middle of a major thoroughfare. Citizens and water carriers could draw water from these structures at set times, under the watchful eye of the guardian of the conduit. There was occasionally trouble between the citizens and traders who drew off too much water, particularly brewers, of which there were, quite literally, hundreds of small producers. However, in general, the system appears to have worked well and the facilities were appreciated by the citizenry. Wealthy, influential citizens made illegal connections, called quills, to the main pipe conveying water.

Some religious establishments made their own arrangements for water supply. One of these was the Charterhouse, a monastery of the Carthusian Order, paradoxically a 'community of hermits', which was established in 1371 north of Smithfields. Further to the north of the monastery, near the summit of the rise above the Angel, Islington, was an area of abundant springs. These lie on a ridge that divides two hidden river watersheds. To the immediate east is the head of the catchment that feeds the Walbrook, and to the immediate south is the catchment of the Fleet.

In the fields on which Cloudesley Terrace has been built, were also deep ponds, and close by, at the back, on the north side of 'White Conduit House', (now Albert Street,) and at the south end of Claremont Place, there existed a deep and dangerous pool called the Wheel-

Pond; this pond was fed by the land springs, and the overflowings of the water received at the White Conduit, and many persons were drowned in this water either by misadventure or suicide.

The purity and abundance of the source springs for the White Conduit were known from at least the early Middle Ages. The springs at White Conduit Fields were used as the source of water for the London Charterhouse, and were conducted there through the White Conduit constructed in 1430. The monastery fell into ruins following the Dissolution and was bought by Thomas Sutton for the construction of a house. After his death in 1611, the house was extended and converted into the Charterhouse School and an almshouse, Sutton's Hospital in Charterhouse, funded from his estate. The White Conduit continued to supply water to the Charterhouse until the late eighteenth century, but it fell into disrepair and the hospital came to rely increasingly on New River water from 1654.

Turning back again to the Middle Ages, over a period of about 350 years from 1236, many wealthy national and foreign businessmen donated funds to the city for the construction or repair of conduits or for water supply schemes which would benefit the general population. Although they did not receive any direct commercial benefit from these donations, some were given elevated public office and some rose even to become the Lord Mayor of London. One of these privately-donated projects for the public good gave rise to the well-known Bloomsbury place name, Lamb's Conduit Fields.

A tributary of the Fleet, which had as its source springs near New North Street, and which ran along Guilford and Roger streets, immediately west of Mount Pleasant, drained the fields to the north, to what is now the Euston Road. This area was called Lamb's Conduit Fields after William Lambe, a citizen of London from Kent and a wealthy cloth-worker who, in 1577, paid for a supply of water from here into the City. He had the Fleet's tributary dammed and drew water to pass through a line of lead pipes south-eastwards to an existing conduit at Snow Hill. It is claimed that the quality of this source of water was preferred over that which arrived from the New River, which entered into operation some forty years later. The tributary was dammed near what was to become known as Coram's Fields, named after Thomas Coram, who founded the London Foundling Hospital in 1739, seven years before the conduit was destroyed.

In 1377, London's population has been estimated at 40,000 and, in spite of occasional outbreaks of plague, by 1580 it had tripled. By then, the inadequacy of existing sources of water to provide for the needs of London was becoming a major topic of public concern.

The first two privately funded water schemes for commercial gain drew on Thames water, one based upon London Bridge and the other just upstream of the bridge.

In 1582, Peter Morice, or Moris, almost certainly a Dutchman, proposed to build a waterwheel between two of the landward piers of London Bridge, and to use it to generate the pressure that would supply Thames water to properties on higher ground in the city. He turned the scepticism of the Mayor and aldermen into firm belief by succeeding in pumping a jet of water over the spire of St Magnus' church near the river, much to the amazement and delight of bystanders. He was granted a 500-year lease on the piers and his company continued to supply relatively small quantities of water of ever-decreasing quality, and with ever-decreasing reliability. By the middle of the eighteenth century, four wheels were

operating, three at the north end of the bridge, daily supplying the city with about 175,000 cubic metres of water (4 million gallons), and one at the south end, supplying Southwark. Water quality was so poor and the danger created to river traffic so great that in 1822, an act of Parliament was passed for the removal of the wheels from London Bridge, and London Bridge was replaced by a stone structure in 1831. Incidentally, Thames Water is still constrained today to honour the original 500-year lease. It continues to pay out £3,750 each year in compensation to the shareholders of the London Bridge Waterworks Company, and will do so until the lease expires in 2082.

The second scheme was on smaller scale. In 1593, a mining engineer, Bevis Bulmer, obtained a lease from the Corporation of London to erect a pump and water tower at Broken Wharf. Water was pumped into the tower from the Thames using a chain pump driven by horses. From the 36-metre-high (120 feet) tower, he supplied water to Cheapside, the area around St Pauls and, later, as far as Fleet Street. The installation was destroyed in the Great Fire of London in 1666.

The first commercially driven enterprise to make a major contribution to London's water supply was the New River. First conceived by a military man, Edmund Colthurst, in 1600, it was carried to fruition by Sir Hugh Myddleton, entering into operation in 1613. It was a bold plan to bring water from springs, later supplemented by water from the River Lea, by gravity in a canal about 64 km (40 miles) to the outskirts of London at Islington, and from there to distribute it into the cities of London and Westminster.

It would be remiss of a book dedicated to London's hidden rivers to make no mention of the New River. As its name implies, it is not a natural river but an artificial channel. This book is primarily concerned with ancient, natural watercourses and so it might, at first, appear that the New River does not warrant a place here. However, there were two principal uses for the water as defined by the originators of the plans for the New River and which served as justification for Parliament to approve the project, and one of these related to keeping two of the hidden rivers, the Fleet and the Walbrook, in a cleaner state than that into which they had declined.

In spite of the contributions made by Morice's and Bulmer's water-supply companies, London was still poorly served by supplies of water for domestic use and industries such as meat preparation. Small-diameter pipes conducted very restricted quantities of water to public conduits and a very few privileged residences. Morice's scheme in particular delivered a very poor service. This was due not only to the vagaries of flow in the river, but also to the poor quality of Thames water at London Bridge, particularly in the shallows near its banks from where the water was drawn. Another problem was that tidal height variations meant that the wheels had continually to be raised and lowered – and this was done manually.

The New River was conceived to bring a continuous, good-quality supply of water in large quantities from two springs at Amwell and Chadwell in Hertfordshire, providing adequate amounts of water for all the city's residents and activities. Eventually, water was also drawn from the River Lea to supplement the water sourced from the two springs. This was the business side of the project.

However, Parliament was principally populated by land-owner MPs, who were not enamoured with a project that would pass through their lands and that had the potential to disrupt the agricultural activity that brought them their wealth. In order to curry favour with the authorities, particularly the councils of the cities of London and Westminster, the

promoters of the project, led by Hugh Myddleton, proposed that two-thirds of the water would be used to scour the rivers and drains and to clean the streets of London. The Walbrook, the Fleet and the Tyburn were three of the rivers that were by now causing considerable nuisance. Having been culverted and covered within the urbanised area, it was no longer possible to easily clear them of obstructions. In addition to rainwater run-off from roofs and streets, they also carried discharges from privies, kitchens and industries. Drains and sewers constructed to discharge to them also became choked. All this resulted in a continuous foul stench throughout London and frequent flooding of streets and buildings by sewage. The prospect of ridding themselves of this continual headache appealed to the city authorities, and so they placed considerable pressure on Parliament to overcome the objections from land-owners and to pass the necessary acts, which they eventually did, but not without delays.

The New River and its buildings, storage reservoirs and pumping plant located at New River Head, Islington, next to Sadler's Wells, together with their distribution mains, were completed in five years and supply began in 1613.

The New River, although a constructed watercourse, does therefore justify a mention as it served to alleviate the problems caused by covering the hidden rivers – however, its success in this regard may be considered very limited. Its objective of serving as a supply of water for domestic and industrial use was far more successfully achieved, and the New River continues to supply London with about 110,000 m³ (24 million gallons) each day of water, a not insignificant proportion of London's water supply.

Returning to the hidden rivers as a source of water for the citizens of London, only three of London's rivers continued to make any significant contribution to London's needs for a safe and adequate water supply – the Thames, the Fleet and the Westbourne.

In the middle of the sixteenth century, the Corporation of London looked further abroad for their supplies. In 1554, the City of London was granted a right over springs rising in Hampstead, as well as in St Pancras and Hornsey, which were the various sources of the Fleet River. The Bishop of Westminster was to be paid a 'pound of pepper' as the annual rent of these springs, which were on Church ground. Rights to the water were only exercised by the Corporation of London in 1590, but the venture was never a commercial success.

In 1692, the Corporation leased the rights to the water from Hampstead Heath to a private consortium which called itself the Society of Hampstead Aqueducts, more popularly known as the Hampstead Water Company. They constructed more ponds below Caen, or Ken, Wood, which were fed by the springs in the vicinity of Ken Wood House which were also a source of water for the River Fleet. However, the company was never commercially viable. This was due in great part to the unreliability of the sources and their inability to provide sufficient storage to ensure a constant supply.

The Hampstead Water Company continued into the nineteenth century to struggle to supply water to Hampstead and an area between there and Camden. However, they were really up against it, as the quality of water deteriorated and they found themselves unable to keep up with demands. They built a pond at the foot of the Vale of Health in South Hampstead, but even this failed to improve the reliability of their supply. They were constantly seeking financial arrangements with their creditors and, from 1800, they frequently called upon the New River Company for water to supply their customers. The Company generally acceded to their requests, if rather reluctantly.

The 1852 Water Act sealed the fate of the Hampstead Water Company. Restricted to drawing its water from the Hampstead and Highgate ponds, it had only ever been able to supply water intermittently and, from the late eighteenth century, the quality had deteriorated significantly. The Water Act required all water to be filtered, and all reservoirs storing filtered water to be covered. In addition, all suppliers were to ensure that they progressively converted to providing a continuous supply through continuously pressurised distribution networks. The Hampstead Water Company could not comply, and their undertaking was taken over by the New River Company. They decided that the Fleet water discharged from the Highgate and Hampstead ponds should not be filtered, but would be supplied to customers that could use it in its unfiltered state. Unfiltered water that would otherwise have formed flow in the Fleet River was supplied to the two railway companies operating out of King's Cross and St Pancras from the mid-1850s. Later, they also supplied St Pancras Borough Council for public lavatories, and for watering gardens in public parks. The New River had to periodically renew the lease on the Hampstead and Highgate ponds and in 1936, after the railways indicated they no longer needed the water, they decided not to renew any more. The Fleet then ceased to supply water to London.

The Westbourne River was only recognised as a potential source of water in the eighteenth century. John Rocque's map of London, Westminster and Southwark of 1746 shows a bifurcation of the Westbourne little more than a few hundred metres from its discharge into the Thames. The western fork is shown continuing to the Thames, while the eastern fork headed towards some channels belonging to the Chelsea Waterworks, which was established under letters patent in 1723. The waterworks occupied a vast area stretching from the present location of Victoria station to the Thames between Ebury Road and Turpentine Lane, an area of 40 hectares (approx. 100 acres). Maps of the time, including Rocque's map, indicate that while the waterworks mainly drew water from the Thames, it also received water from the Westbourne, downstream of its passage through what was to become an up-market development, Belgravia, about a century later.

At the time, apart from agricultural wastes, the Westbourne would have been relatively clean, as it still flowed through open country and the Serpentine in Hyde Park on its way to the Thames. Water from the treatment plant, principally channels and reservoirs where suspended material settled out, was pumped into distribution from a pumping station located on ground now occupied by the Grosvenor Hotel in the Victoria station complex. The pumps were first driven using horses and, from the mid-eighteenth century, by steam-powered engines.

Eventually, the water abstracted from the Thames and the Westbourne became so heavily polluted that it was thought that the Chelsea Waterworks would have to be closed. In the 1820s, the company's engineer devised slow sand filters to improve the quality of the water, the first time that this process had been used for public water supplies anywhere. It was a success, but over the next thirty years the source water deteriorated so much that the process could not cope. The Chelsea Waterworks Company moved its treatment plant upstream when the Thames and the Westbourne (and possibly the Tyburn) became too polluted to use as water sources, in spite of their pioneering work on sand filters. This transfer upstream was partly in response to the outcry about the quality of the water it supplied, and partly because the land had become too valuable due to its development potential. The Westbourne thus ceased to be a source of water to London in the mid-1850s.

By the middle of the nineteenth century, none of the hidden rivers were being used as sources of water supply for domestic purposes. Only the springs that gave rise to the Fleet staggered on, providing water of second-grade quality to industry and the railways, and that was totally discontinued, as previously described, before the start of the Second World War.

RECREATION

The rivers of London were a source of recreation in the period between the Norman invasion and the end of the Tudor Period, say from about 1100 to 1600 CE. At a time when very few leisure activities would have been arranged for the population by others, the people were adept at organising their own. Many of the sports resembled and developed out of war-like activity, and were indeed seen as good preparation for war. But there were other activities that were more peaceable in origin and rivers and water frequently featured in these, for example:

•fishing
•walking
•skating
•jousting on water

Fishing

John Stow writes about the 'The Town Ditch Without the Wall of the City'. He describes them as

> ... begun to be made by the Londoners in the year 1211, and was finished in the year 1231 ... being then made of 200 feet broad ...

However, the ditch was not an innovation of the Middle Ages. It had originally been constructed by the Romans around the outside of the walls that they had constructed for Londinium's defence. Over time, since the departure of the Romans, the ditch had become filled in and had virtually disappeared as a recognisable feature. In Roman times, it had then been filled with water draining off the marshy ground of the moor directly outside the walls, and so it was again when rebuilt early in the thirteenth century.

Stow goes on to describe the waters of the ditch, at various times since the first decade of the thirteenth century, as having

> ... therein great store of very good fish, of divers sorts, as many men yet living, who have taken and tasted them, can well witness ...

The marshy nature of the moor will have been created by the tributaries of the Walbrook, and of overflows from local springs and wells. Additionally, the ditch was dug into ground which was generally at a higher level than the Thames. It is therefore unlikely that fish of

any reasonable size and suitable for eating would have originated naturally from either the Thames or the Walbrook's tributaries. It is more likely that, at some time, the ditch will have been stocked with fish taken from the Thames. This could have included, among others, tench, barbel, roach and dace. But the town ditch is unlikely to have contained shark, even though a 3-metre long specimen had been caught in the Thames off Poplar in 1787. When opened up, it was found to have in its belly some cloth and human possessions, including a numbered edition of a watch. This had helped to identify the unfortunate young boy drowned and eaten by the shark when he fell overboard, off the English coast.

Although some may have tried to farm fish in the town ditch commercially, it is unlikely that this was successful, nor is there any evidence of commercial fishing on any of the hidden rivers. The only commercial fishing carried out successfully would have been from the Thames.

John Stow goes on to bemoan the fact that in his day, writing at the end of the sixteenth century, fishing and eating the catch from the town ditch was no longer possible as the ditch had once more been filled in with rubbish and its banks let out for development.

However, small fish could be found in all of the hidden rivers. These were commonly one of a number of varieties of stickleback, commonly found in English streams, rivers and ponds. There are references to these being found in the Stamford Brook and Charles Dickens, in *The Pickwick Papers*, has Samuel Pickwick deliver a paper in 1827 to the Pickwick Club and reported in their transactions:

> That this Association has heard read, with feelings of unmingled satisfaction, and unqualified approval, the paper communicated by Samuel Pickwick, Esq., G.C.M.P.C. [General Chairman--Member Pickwick Club], entitled 'Speculations on the Source of the Hampstead Ponds, with some Observations on the Theory of Tittlebats; ...'

The 'tittlebat' was an old-fashioned name for a stickleback. These little fish brought untold happiness to small boys, among which count the author as a child. In simpler times, he and his brother caught them in small hand-held, home-made nets made from their mother's discarded, laddered nylon stockings, carrying them home in jam-jars. Inevitably, if rather unfortunately, those sticklebacks would unselfishly sacrifice themselves to the curiosity of the young. Clissold Park's ponds were fed from the New River.

Walking

It is always pleasant to walk beside water, whether it is a flowing stream or river or a body of water such as a pond or lake, and it is clear from many references in literature that this has ever been so.

The earliest record of London's hidden rivers being attractive to walk along comes from the late twelfth century. It was then particularly the custom to walk into the fields and the countryside in general in the month of May. It was called 'to go a-Maying'. When the people returned to the city, there would be dancing around the maypole, Morris dancing, archery and other sports, and, in the evenings, street plays would be enacted and there would be bonfires.

It was William FitzStephen, perhaps with his rose-tinted glasses well in place, who wrote:

> There are also round about London in the Suburbs most excellent wells whose waters are sweet, wholesome and clear, and whose runnels ripple amongst pebbles bright. Amongst these Holy Well, Clerke's Well and St Clement's Well are most famous and are visited by throngs and greater multitudes of students from the schools and of the young men of the City, who go out on summer evenings to take the air.

The 'suburbs' to FitzStephen would not have extended much beyond Moorfields, Clerkenwell and Smithfields to the north, Holborn Hill in the west and Aldgate, outside the walls to the east. Walks along the banks of the Fleet and the Walbrook 'without the walls' were particularly well liked.

Skating

In drier places on the moorfields outside the walls of the city, youths would indulge in horse-racing, archery (which at times was required by law to maintain youths in a state of preparation for war or defence of the City), cock-fighting, wrestling, 'casting the stone and ball' and so on.

However, perhaps the greatest fun was had and ingenuity displayed when the sheets of water that covered much of the moor froze in winter. It is fascinating to read William Fitzstephen's early medieval account, and to note how little winter sports have changed over the last 800 years:

> When the great fen or Moor, which waters the walls of the City on the North side, is frozen, many young men play upon the ice, some striding as wide as they can, do slide swiftly; others make themselves seats of ice, as great as Millstones; one sits down, many hand in hand do draw him, and one slipping all of a sudden, all fall together; some tie bones to their feet, and under their heels, and drawing themselves along by a little spiked staff, slide as swiftly as a bird flies in the air, or an arrow out of a crossbow. Sometimes, two run together with poles, and hitting one another, either one or both fall, not without damage; some break their arms, some their legs – but youths that like glory of this sort practises against time of war.

Jousting on Water

At Easter, it would appear that a particular sport was enjoyed that was not without its dangers. Where a river ran with a reasonable current, a game that can be likened to a waterborne form of jousting was practised. This was definitely played on the Thames, could well have been played on the Fleet and possibly at the estuary of the Tyburn.

A target was set up on a pole fixed into the bed of the river. The jouster would take up station on a small, unstable boat tied upstream of the target. On release of the boat, the jouster would float rapidly downstream towards the target, and with a long lance attempt to

topple the target. More often than not, it would be the jouster that would be toppled and end up in the water. As swimming was not a common pastime, boats would be stationed near the target to pull out of the water those that took a plunge.

NAVIGATION

Only two of London's north bank hidden rivers, the Fleet and the Walbrook, can be considered as having been navigable in the sense of routinely being able to accommodate commercial and military vessels, and then only over very limited lengths.

The Thames at the site chosen by the Romans for London was about three times wider than it is within Bazalgette's embankments, constructed in the middle of the nineteenth century. The river was much wider, shallower and less well-defined, its southern banks being marshland. However, it was eminently navigable for the small vessels of the time, and oscillating tidal currents carried these craft alternately upstream and downstream twice a day.

The Roman bridge spanned the Thames at the approaches to Londinium from an embryo Southwark on its south bank. It fell into decay after the departure of the Romans from the country early in the fifth century, and does not appear to have been replaced until the ninth or tenth century. However, the Roman location for the bridge has remained the site for the various reconstructions of London Bridge. Its precise location at each re-building shifted only slightly upstream or downstream, in order to accommodate the need to maintain a crossing in operation while a new one was being built.

The mouths of the Fleet and the Walbrook are respectively located about one kilometre and a couple of hundred metres upstream of London Bridge. The bridge had an influence on the usefulness of both the Fleet and the Walbrook to accommodate vessels at their wharfing facilities, as the height and width of its spans at any time acted as a barrier or partial barrier to larger vessels.

In its most famous incarnation, the medieval bridge depicted so well on Wenceslas Hollar's bird's-eye-view painting had twenty arches supported on nineteen substantial abutments or 'starlings'. Although a drawbridge was provided between two of the starlings, the sixth and seventh from the Southwark end of the bridge, the narrow passage between the starlings created two problems for navigation. Clearly, the width of a vessel was limited by a need to safely pass between the starlings, a passage which was very narrow at low tide. However, perhaps more serious, the total width of the starlings combined to act as a partial barrage across the Thames, creating a flume effect. This meant that at times of spate flow down the Thames, water level on the upstream side of the bridge could be as much as 2 metres (6.7 feet) above the level downstream, and the flow through these 'rapids' could be fast and extremely dangerous. In modern-day parlance, attempts to pass between the starlings, when the Thames was in flood, would be classified as an extreme sport rather than a conventional form of transport. Indeed, faced with so provocative a challenge, youths would 'shoot' the rapids created by the starlings as sport or for a dare. More seriously, movement downstream through the bridge led to frequent and substantial damage to vessels. The bridge was the cause of many deaths of many foolhardy persons and unfortunates by drowning.

Due to these considerations, the wharves upstream of London Bridge along the Thames and those within the two river inlets to the Fleet and the Walbrook were restricted to servicing smaller sailing vessels and barges.

The form taken by the Walbrook at its confluence with the Thames is a matter of ongoing study. It is thought that it may well have been a small, natural or man-made delta with at least one channel either side of a small, central island linking the original inland section of the river to the Thames. However, the topography close to the Thames at this point would have meant that the navigable section of the Walbrook at Dowgate, the area of its wharves, would not have been more than 150 to 200 metres in length. Reports of the remains of wooden, clinker-built vessels being dug up further inland were almost certainly mistaken in their interpretation. More probably, they were the remains of the wooden revetments used to strengthen the naturally weak embankments of the river.

The estuarial length of the Fleet, however, offered greater opportunity for navigation and wharfing facilities. It was much wider at its mouth during the Roman period, by about 100 metres or so than by the turn of the first millennium, by which time it had been reduced to about one-third its original width. Potentially, the Fleet could be navigated by vessels as far as Oldbourne Bridge, a distance of about 700 metres from the Thames. However, construction of the Fleet Bridge at the bottom of Fleet Street at some time in the Middle Ages probably further limited wharfing facilities to barges and vessels with very low clearance.

Following the devastating Great Fire of London in 1666, Sir Christopher Wren canalised the Fleet from its mouth back to the Oldbourne Bridge, in part to beautify a run-down area and in part to provide modern berthing and wharfing facilities. However, this privately-funded venture was never a commercial success and lasted less than 50 years. The canalised Fleet was partially covered over in the 1730s between Oldbourne and Fleet bridges, and a permanent market was housed above it. The downstream portion of the canalised Fleet was later also arched over and covered, and the market demolished. A new main road was constructed above the Fleet, Farringdon, through to the Thames at Blackfriars, where a new bridge was opened in the second half of the eighteenth century.

It is often claimed that the Fleet was navigable from the Thames up to Kentish Town, north of the small settlement of Camden. This claim is based upon the discovery of a small anchor, about one metre in length (3.28 feet), in the Fleet at Kentish Town. However, observation of the topography between the Fleet's estuary with the Thames and Clerkenwell would indicate that the gradient would be too steep for a boat to negotiate, at least attempting to move upstream. Above Kentish Town, the bed of the stream rises too steeply for any navigation to be possible. However, on the other hand, it is quite possible that small rowing boats could have been used on some lengths of the Fleet, perhaps for small-scale fishing or the carrying of goods and, possibly, even for pleasure. This could be the case between Clerkenwell and Somers Town, just north of St Pancras, possibly even as far as Kentish Town. In Peter Ackroyd's enjoyable and fascinating book, *The Clerkenwell Tales*, set in Chaucer's London of the late 1300s, Gilbert Rosseler, a shipman, poles his lady-love up the Fleet from Clerkenwell on a small barge laden with Newcastle sea-coal. He manages to get as far north as 'Kentystone'. The scene might just be plausible, but, in the author's opinion, Gilbert would have begun to meet fast currents above Somers Town, just north of St Pancras church. It is unlikely that the river would have been deep enough, and the currents slow enough from

this point on, to pole or row a small boat further upriver and virtually an impossible task for a barge loaded down with coal. It is probable that Peter Ackroyd, eminently knowledgeable about the rivers of London, knows this and was just making use of poetic licence, but the doubtfulness of Gilbert's feat should not go unremarked.

Apart from the Fleet and the Walbrook, none of the other five north bank hidden rivers is of sufficient width or depth to be navigable.

RIVERS AS SEWERS

It is common throughout the world for people to use their rivers and streams as the repositories for domestic sewage, industrial effluents and solid waste, and the citizens and rural populations of London and its surrounding rural areas have been no different since its founding. Indeed, this may be described as the great abuse of watercourses rather than 'use', a word which might be construed as conferring a degree of dubious legitimacy on the practice.

The hidden rivers appear to have been able to cope with what were relatively small discharges made to the rivers, as the rural population around London was relatively small up to the end of the Middle Ages. These discharges were composed of domestic sewage and septage – the term coined for the contents of cesspools and septic tanks – and polluted run-off from animal husbandry. In spite of these discharges, there are literary references from the early and late Middle Ages which refer to sparkling clear rivers with respect to the Walbrook and the Fleet outside of London's city walls.

However, within the city walls it was a very different story. As early as Roman times, the Walbrook was receiving effluents and waste materials from the trades of dyeing, tanning and butchery, which were located on its banks and in its catchment. Dyeing would turn the river different colours and the tanning process discharged large amounts of highly polluting, evil-smelling chemicals into the watercourse. So significant were the amounts of these effluents that the river would often be blocked by the build-up of material, and it would flood riverside developments with foul-smelling water.

Later, in the early Middle Ages, as the area of Smithfields outside the city walls became the site of the meat market, industries based on meat grew up around it, such as slaughterhouses and fat and bone rendering. The market and these highly polluting industries discharged their effluents and waste material to them along the east bank of the Fleet River and its tributaries. The Fleet itself would run a red colour from a mix of the blood from these processes and the dyeing of leather. Blood has a huge potential to absorb oxygen dissolved in rivers and without oxygen, fish die and rot. The odours given off by rotting fish and anaerobic mud can become unbearably sulphurous, giving off a smell similar to that of rotten eggs mixed with that given off by rotting cabbage. Not one much sought after by perfumers.

Within the City, houses were constructed close to the banks of the Walbrook, as well as on the bridges that crossed it. This construction of dwellings close to the river was not due to a desire on the part of the owners to appreciate the natural beauty of the neighbouring watercourse. They were sited on the river banks so that privies serving the houses could

be constructed over the watercourse itself and discharge their foul products directly to the Walbrook. A little imaginative thought will serve to convince the reader that the sight was not a pretty one, and that the perpetual stench near the rivers was only bearable to those who had grown up with it, or who had become inured to it over time.

A contract drawn up in 1374 between the City authorities and one of its citizens gives a fascinating insight into the disgusting condition of the Walbrook. The terms of the contract required Thomas atte Ram, a brewer by trade, to keep the channel of the river clean. To pay him for this service, he was allowed to levy a fee on every 'latrine, privy or garderobe' discharging its waste to the river. In addition, he was also permitted to keep anything of value found while cleaning the watercourse.

It was only in the 1850s that it became clear that cholera was propagated through the drinking of, or contact with, water polluted by human waste. Once introduced from Asia, possibly in the eighteenth century, cholera became endemic in London until the middle of the Victorian era. Polluted watercourses and the dumping of refuse into the river and on its banks encouraged a huge population of rats, which were to be found everywhere – in houses and shops, as well as the streets. Hence epidemics of bubonic plague and, later, cholera would regularly break out and kill off a significant proportion of the city's residents and those unlucky enough to be visiting at the time.

By the eighteenth century, discharge of sewage and trade effluents to the Fleet had become so much the norm that even when Wren systemised the lower reaches of the river into a canal, the whole project foundered as it proved impossible to clean up the stretch of water, which remained black, foul-smelling and full of the dead carcases of dogs, cats and larger animals from the slaughterhouses. So bad was the situation – and so well-known a problem to the general populace – that two writers of the time, Jonathan Swift and Alexander Pope, wrote poems decrying the situation.

Pope wrote

Fleet Ditch with disemboguing streams,
Rolls the large tribute of dead dogs to the Thames.
The King of dykes!
Than whom no sluice of mud,
With deeper sable blots the flood....

Swift, more graphically still, wrote:

... filth of all hues and odours seem to tell what streets they sailed from by their sight or smell. They, as each torrent drives with rapid force ... and in huge confluence joined at Snowhill ridge, fall from the conduit prone to Holbourne Bridge; seepings from butcher's stalls, dung, guts and blood, drown'd puppies, stinking sprats, all drenched in mud, dead cats and turnip tops ...

Given these horrendous conditions, it is not surprising that the City authorities legislated for the covering over of the Walbrook through the city just after the middle of the fifteenth century. Gradually, in fact, not to any significant extent until the late eighteenth century, the same fate

An example of the prime-quality brickwork used in Victorian conversion of rivers to sewers.

progressively befell the Fleet. Although conditions on the Tyburn and the Westbourne were not so critical as those for the Walbrook and the Fleet, nevertheless, as the areas through which they flowed were developed, they too became polluted and were covered over.

Covering and culverting of the hidden rivers appeared to legitimise their use as sewers, and their employment for this purpose intensified as London extended into the surrounding rural areas through the eighteenth and nineteenth centuries. The stench from the Thames became completely unbearable, and following a hot summer in the middle of the nineteenth century, as described in the previous chapter, Parliament had to be suspended due to what became known as 'the Great Stink'. Sir Joseph Bazalgette's plans to create a system of large sewers that would run parallel to the Thames on both its banks, three sewers to serve the north bank and two to serve the south bank, was accepted in 1858. Work began in 1859 and, although substantial elements were completed and operating within seven years, work on the project continued until 1879. Bazalgette's project has been described in greater detail in Chapter 3.

MILLS AND POWER

Through to the eighteenth century, in England, if a pumping, milling or grinding process required power, it could rely on three sources of energy – man, horses, or wind and water. In general, other than through the use of a treadmill, which has limited usefulness, man could not muster the power necessary to drive a mill. Horses were a more common means of driving machinery, but were quite an expensive option to control and to feed. The principal sources of power for milling were based on energy derived from the wind and from water, in the form of rivers and streams.

There are historic records of windmills shown on maps and parish registries in the districts surrounding London dating from the eleventh century. These were used mainly for two purposes: grinding corn and flour and drainage of marshy land. There were at least three on the moor outside the wall in Tudor times, to assist in draining the boggy land. The mills used appear to be of three types. With the post and hollow-post types, the whole structure of the mill can be turned around a central post to turn the sails into the wind; in the former the post is solid and in the latter, the post is hollowed out to take a driveshaft which turns machinery in the basement, it being particularly used for drainage. The third type was a tower mill, in which the body of the mill remains stationery and only a cap which carries the sails is turned into the wind using a long tail pole, which is also used to fix the cap into position to prevent further rotation.

However, due to the erratic nature of the wind, both in direction and strength, power derived through using water to turn a wheel immersed in a stream, the revolving of which is used in turn to drive the milling machinery, was favoured where it was possible to use this form of energy generation.

William FitzStephen on the northern suburbs outside the walls of the City:

> On the north side, are its pastures, & plain meadows, with brooks running through them, turning water mils, with a pleasant noise.

It is clear from FitzStephen's account that flows in London's rivers were significant enough to power various types of mill. In order to render the flow more reliable, a river might be dammed and water stored in the watercourse above the dam, or in a separate reservoir. This use for the rivers continued well into the eighteenth century, when steam power became more reliable and better served the more intensive needs of industrialisation.

The moor outside of London Wall, marshy ground formed by the sources of the Walbrook, was dotted with windmills which were used to drain the moor, the water so pumped being used to feed water to the ditch outside the wall which protected the city, the overflows from which entered the Walbrook within the City.

The valley of the Fleet appears to have attracted many mills, both water- and wind-powered. Indeed, relatively recent archaeological excavations have shown that one of the first mills to be located in London could well have been a tide-mill constructed near the mouth of the Fleet River by the Romans, towards the end of the second century. If so, it would have been one of the earliest examples of this type of mill. It used the tidal movement of the Thames into and out of the Fleet to power a waterwheel. Later, to overcome the cyclical nature of the milling process using this type of water movement, the Fleet was dammed further upstream and water led along a channel to the mill race. This enabled the mill to work at any hour of night or day.

It was in a water mill located on a tributary of the Fleet in the mid-eighteenth century, upstream of Holborne Bridge, near Smithfield Market, that an attempt was first made to make commercial use of a machine to spin wool or cotton into thread and yarn. However, it was not a success.

One of the old names for the River Fleet upstream of Holeborne Bridge was Turnmill Brook, so many were the mills on the main stream and its tributaries. Anything that required grinding before it was sold to the public could be ground in the water mills, for example

talcum powder, snuff (pulverised tobacco), the rasping of timber to produce dyes – and even liquorice. In order to remove grease from wool, it would first be ground with Fuller's earth, a non-plastic clay or claylike earthy material used to decolourise, filter and assist in the removal of oils and grease from materials.

All of the mills in the catchments of the hidden rivers on the north bank of the Thames have been destroyed or dismantled. Only occasionally are they remembered through street names.

This extract comes from *Latinae Libellum se situ et Nobilitate Londini* (a preface to a biography of Thomas Becket, *Vitae S. Thomae*, variously translated as *History of the Most Noble City of London* or *Description of the Most Noble City of London*). William FitzStephen, 1174–83, wrote on the Moor and Moorgate – 'Fensbery fields & Morefieldes an vnprofitable ground':

This fielde of old time was called the More. As appeareth by the Charter of William Conqueror to the Colledge of S. Martin declaring a running water to passe into the Citie from the same More. Also FitzStephen writeth of this More, saying thus: When the great Fenne or More, which watereth the walles on the north side is frozen, &c. This Fen or More field stretching from the wall of the City betwixt Bishopsgate and the posterne called Cripples gate to Fensbery, and to Holy, well, continued a wast and vnprofitable ground a long time, so that the same was all letten for foure markes the yeare, in the raigne of Edward the 2: but in the yeare 1415. the 3. of Henry the 5. Thomas Fawconer Mayor, as I haue shewed, caused the wall of the Citty to be broken toward the said More, and builded the Posterne called Moregate, for the ease of the Cittizens to walke that waye vppon Causeyes towardes Iseldon and Hoxton: moreouer he caused the ditches of the Citie, and other the ditches from Soers ditch to Deepe ditch, by Bethelem into the More ditch, to be new cast and cleansed, by meanes whereof the sayde Fenne or More was greatly dreyned and dryed: but shortly after, to wit in 1477, Raph Ioceline Mayor, for repayring the Wall of the Cittie, caused the sayde More to bee searched for Clay and Bricke to bee brente there, &c. by which meanes this fielde was made the worse for a long time.

Gardens without Moregate, destroyed and made plaine ground.; Ditches east to dreine the Morefield.; Slewces to conuey the standing water out of the More.; Morefield raysed, and wind mils set thereon.

In the yeare 1498. all the Gardens which had continued time out of mind, without Moregate, to witte, aboute and beyonde the Lordship of Finsbery, were destroyed. And of them was made a playne field for Archers to shoote in. And in the yeare 1512. Roger Atchley Mayor caused diuers dikes to be cast, and made to drein the waters of the sayde More fields, with bridges arched ouer them, and the groundes about to bee leuelled, whereby the sayd fielde was made somewhat more commodious, but yet it stoode full of noysome waters: Whereupon in the yeare 1527. sir Thomas Semor Mayor caused diuers sluces to be made, to conuey the sayd waters ouer the Towne ditch, into the course of Walbrooke, and so into the Thames: and by these degrees was this Fenne or More at length made main and hard ground, which before being ouergrowne with Flagges, sedges and rushes, serued to no vse, since the which time, also the further groundes beyonde Fensbury Court haue been so ouerheightned with Laystalles of dung, that now three windmilles are thereon set: the ditches be filled vp, and the bridges ouerwhelmed.

CHAPTER 5

Mapping London's Hidden Rivers

The routes taken by London's hidden rivers from their respective sources through to their outfalls in to the Thames have not previously been depicted on large-scale street maps and made readily available to the general public.

Plans do exist which record the routes of those sections of the rivers that are used as drains to carry surface water or, in some cases, where they have been used to carry sewage. These records were prepared by the various organisations that were historically responsible for drainage and sewerage – the Metropolitan Board of Sewers, the London boroughs, the London and Middlesex county councils and their successor, the Greater London Council. From 1974, in its public authority form and on privatisation of water and sewerage in 1989, these records were inherited by Thames Water. Post-privatisation, local borough councils remained responsible for draining surface water within their jurisdictions but, in practice, they engaged the services of others, such as Thames Water, to manage the operation and maintenance of sewerage and drainage infrastructure. However, over the ages, in systemising the channels of the hidden rivers, their routes were sometimes diverted or straightened. This may have been done to accommodate the nature and siting of a particular development and to suit its drainage needs. Alternatively, the route may have been altered in order to improve the hydraulics of the culverted or piped river in order to render it better suited to its revised role. Therefore, although the records of the hidden rivers that are retained by Thames Water are, in general, a good record of the routes taken by the original hidden rivers, in particular areas the original routes may differ from those shown on their plans.

In undertaking the research into the routes of the hidden rivers, it would therefore appear to have been a logical first step to have first approached Thames Water for sight of the plans showing those sections which form part of their drainage and sewerage system. However, in the knowledge that these might not be an accurate representation of the original routes, the author considered it better to carry out his own research into these original routes and then to check the results against the Thames Water records.

In the approach taken by the author to identify the original routes of the rivers, considerable cartographic and literary research was first undertaken. This was backed up by

on-site research into the underlying natural topography of the areas through which the rivers were considered to have passed. The following steps in the methodology were applied:

Step 1: Initial literary research – this provided a basic routing from an existing small-scale map and some description of hidden river routes, which were transcribed onto large-scale street maps and Ordnance Survey maps.

Step 2: Cartographic research – consultation of old maps of London to add to, as well as to refine, the routes derived during Step 1.

Step 3: Walking the routes and marking the direction of slopes of streets over an area to either side of the routes that could indicate with greater precision the likely courses taken by the original rivers.

Step 4: Consultation with local library references.

Step 5: Consultation with Thames Water.

Inevitably, the five steps in the methodology were not always consecutive and, for many situations, the process was an iterative one as new information came to light.

For those who are interested in the details, this chapter now expands upon each of these steps.

STEP 1 – INITIAL LITERARY SEARCH

Anyone wishing to research the hidden rivers of London should be aware that there are two excellent publications that are essential reading: *The Lost Rivers of London* by Nicolas Barton (1962, revised 1992, Historical Publications Ltd, London) and *London Under London: A Subterranean Guide* by Richard Trench and Ellis Hillman (1984, new edition 1993, John Murray (Publishers), London).

The first of these, *The Lost Rivers of London*, provides descriptions of nine 'lost rivers' on the north bank and five on the south bank of the Thames, plus brief descriptions of what are called five 'dubious' rivers. While remaining highly readable, the research has clearly been carried out painstakingly and to the highest academic standards. Numerous literary references to the rivers over time are cited and interesting quotations drawn from them. Considerable background is also provided with respect to the origins of the rivers and their uses. Perhaps, most importantly of all, with regard to the research carried out for this present book, the publication includes a small-scale map of the 'lost river' routes. The author is in agreement with the general routes shown on this map, although his research resulted in differences in the detail. In the course of this present research, and as best could be done, the routes shown on this small-scale map were transposed onto street maps of London which were to scales of 3 and 4 inches to the mile. Clearly, this could only provide a starting point, as the process of up-scaling could only build in large inaccuracies.

The second book, *London Under London*, under a chapter with the highly evocative title 'Smothered Streams and Strangled Rivers', briefly describes the routes taken by six hidden rivers on the north bank of the Thames and five south bank rivers. The route descriptions in this book are more detailed than those in the book by Nicolas Barton, and in some sections these descriptions differ quite significantly from those described in *The Lost Rivers of London*.

It was the differences in the routes described in the two books that convinced the present author that every inch of the proposed routes had to be walked in order to determine a personal view. This was reinforced by what was discovered in Step 2. In the event, each of the routes was walked many times, checking and re-checking.

STEP 2 – CARTOGRAPHIC RESEARCH

What we now consider the hidden rivers of London were just London's rivers before they became covered. This rather obvious statement has importance in the context of the research undertaken for this book. While the rivers and streams that passed through London remained open at the surface, they could be shown on maps, although the cartographers did not always consider them of sufficient significance to show them

Historic maps of London can be divided into three categories for our purposes:

Prior to 1600: These are generally limited to showing the City of London, the City of Westminster, the land between the two and, in some instances, Southwark on the south bank of the Thames. They make no pretence to be to scale and, in most cases, are pictorial depictions of the areas, and, in this sense, can be considered more as artist's impressions than true cartography.

1600 to 1840: In the early seventeenth century, the first attempts were made to produce plans of London to scale. There was an inevitable overlap with the pictorial depictions until the Fire of London in 1666. Maps became progressively more accurate in their scale representation of street layouts and, as London developed, they covered areas previously not shown on earlier maps, most specifically Chelsea and Paddington to the west and out to Hampstead in the north. However, around 1840, they lose their usefulness to the research as most of the rivers have been covered over and either culverted or converted into piped streams.

Post 1840: As noted, these have very limited usefulness for the research. However, there are some plans of proposed developments, like those for Belgravia, which show, in detail, the courses taken by the rivers prior to their disappearance from view.

The early maps were useful, as they showed where rivers such as the Walbrook and the Fleet outfalled to the Thames many centuries ago and an indication of the importance, or otherwise, given to them at the time of any particular map. In addition, it is also interesting to note from them the marshy nature of a number of areas. One of these was the area

surrounding the 'island' on which the Palace of Westminster came to be built and which was rendered marshy by the Tyburn River that fed into it. Another was the marshy area immediately to the north of the London Wall at Moorgate, which appears to have been fed by a number of small streams that formed a part of the origins of the Walbrook.

It is the second category of maps, those produced to improving scale between 1600 and 1840, which proved to be the most useful to the research. They did not always show the rivers. However, where they did, and given that they were to scale, it is possible to take landmarks that existed then and now and depict the course of the river in relation to them on modern maps with some confidence. As an example, one map used by the military to plan its resistance to the Gordon Riots proved very useful in gauging the course of the Westbourne where it crossed the Edgware Road at Kilburn Priory and at a number of points south of this through to the entrance to Hyde Park. Similarly, a plan used to show the extension of the Grand Union Canal through to Paddington, the Paddington Cut, accurately shows where the Westbourne River was culverted beneath it where the canal crosses its course.

It was particularly difficult to find references to the Black Ditch, which rises in Stepney and, after a circuitous route, outfalls to the Thames at Limehouse. However, The Royal Institute of British Architects commissioned the production of a map for the London Festival of Architecture 2008 in conjunction with the Ordnance Survey, titled 'Dark Waters'. This shows the Inner London sections of some of London's hidden rivers, including the Black Ditch.

It is not always easy to read the contours from Ordnance Survey maps of London. The author was pleased to find a map produced by the Institution of Civil Engineers, based on the OS maps, which clearly showed the contours for much of London through which the hidden rivers flowed.

The maps consulted in the course of the research were numerous and have been listed in the reference section of the book. Interestingly, a number of the most useful maps have been produced on CDs and the street names and districts indexed, which makes them relatively easy to search.

No single map provided information on all of the hidden rivers. Indeed, in most cases, each map only provided clues to the course taken by a river at just one or a few points along its route. Rivers may have been shown on some maps but, as it was impossible to relate them to landmarks of then and now, these could only serve to confirm that the river did actually pass through the area concerned.

STEP 3 – WALKING THE ROUTES

This step in the research proved the most time-consuming, and also the most interesting.

The first two steps allowed the routes – and on some sections, alternative routes – of the hidden rivers to be plotted onto the large-scale street maps. Given the depth of the research conducted by the two authors who had previously tackled the subject and my own refinements from consultation of old maps, it was felt that the routes now shown would be reasonable representations of their actual former courses. However, by carefully studying the natural topography of the land through which the routes passed, it could well be that further refinement of the lines taken would be possible.

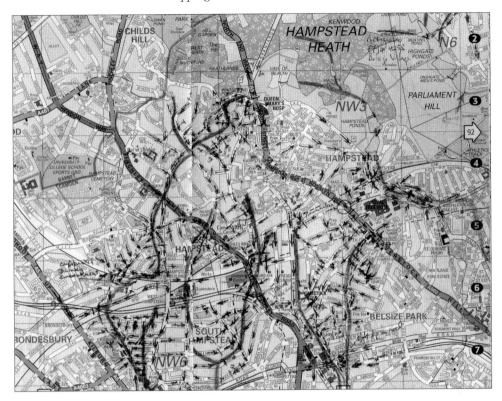

On-site topographic research into street slopes to determine underlying natural ground slopes. Arrows indicate the fall of streets.

This definitely proved to be the case, and many adjustments to the routes probably taken by the rivers had to be made.

In order to get an effective picture of the topography either side of the possible river course, it was necessary to zig-zag backwards and forwards over the presumed watercourses and examine the direction of fall of the streets sometimes a hundred metres or so to either side. The direction of fall of each of the streets walked was marked onto a map and an example of the result is shown above.

These falls were examined in relation to the line plotted and adjustments made to the route there and then on the street maps.

The direction of fall of the streets in the more hilly areas of Hampstead and Highgate could often be clearly apparent to the naked eye. However, for the most part, the fall of the streets was not so obvious and, in the absence of surveying instruments, the author developed a simple device to determine in which direction a street inclined. Engineers, of whom the author is one, are generally tedious and boringly methodical in their work. Thus, walls are almost always constructed with copings and courses of bricks that are horizontal, whether they form part of a house or a boundary wall. As the road falls away, another course of bricks has to be added at the base. By observing the direction in which the additional courses had been added, the slope of the street becomes obvious. It is true that this sloping of the streets was not always natural and had been built in to assist surface water drainage. However, it

was not generally very difficult to differentiate between natural and artificial sloping. There is little doubt that the author's professional experience with water and sewer networks in many urban situations provided an excellent background to this work.

In trying to determine the natural fall of the underlying ground, there was another problem with which to contend. As land is developed for residential and commercial buildings, the developer will tend to 'iron out' excessive topographical features, lopping off areas of high ground and using the excavated material to fill in deep hollows. This poses less of a problem in suburban London where, in general, the developer, not wishing to be involved in the considerable cost of land re-profiling, has retained the general natural fall of the land, save for relatively minor landscaping. However, in Central London, particularly the City and Westminster, alterations to the natural topography have been very significant. The valleys through which the rivers passed as they neared the Thames were sometimes steep-sided and the river beds themselves steep, in particular that of the Walbrook as it neared the Thames. These valleys have gradually been filled with the detritus of urban life through the ages since Roman times. Not only refuse was dumped into these hollows, but also successive generations of housing and other buildings that were built, demolished and rebuilt many times. The original ground profile in Roman times may, in places, be up to 10 to 12 metres below the present ground surface.

However, and rather fortunately, the courses of the hidden rivers which pass through these areas – the Walbrook, Fleet and Tyburn – are relatively well-documented on maps, and so the determination of street slopes in these central areas is of less importance than in the suburban and inner areas developed from Regency times onwards.

It would be remiss of the author not to make mention of the considerable assistance and advice that he received from members of the public along the way. In some areas, the point of source or course of a river was hidden by housing or offices. Once the purpose of the work was explained, the author was never refused access to properties by any householder or office manager in order to get the requisite information. Likewise, when standing in a street and working on the maps to refine the course of a river, concerned local people would approach to enquire what the author was doing. Again, having explained the purpose of the work and shown the maps and prospective line of the hidden rivers, a number offered information on which parts of a street were subject to occasional flooding, which would add a further bit of data as to the precise course of the river.

Some of these encounters are worthy of special mention, either for the invaluable information imparted or the time spent in assisting the author. They are only a small selection of many such encounters. Perhaps the most memorable was the assistance provided by the owner of one of the mews cottages in Chester Mews, close to Sloane Square. The cottages lie behind the northern wall of Sloane Square station. The Westbourne, at this point unflatteringly called the Ranelagh Sewer, is one of only a handful of places where the hidden rivers can be seen. In this case, the river passes across and above the platforms in a large-diameter cast iron pipe. The author wanted to obtain a precise line and position for this visible portion of the river with respect to the ground above. Having explained the situation to the lady resident of one of the cottages, she took the author through her house and into the garden. On her own initiative, she brought a ladder into the garden and, leaving by the back gate into the lane behind, the ladder was placed against the station wall. In turn, both climbed the ladder and, from this privileged position, a bird's-eye view of the pipe permitted

a precise location of the river's course beyond the confines of the station, both upstream and downstream. The owner had previously thought that the river passed beneath her cottage but was relieved to see that it passed some 30 metres or so to the north.

In another notable instance, the author was pondering the precise point at which a branch of the Westbourne passed beneath and across Compayne Gardens in West Hampstead. Finally, after some minutes of indecision, he drew a line on the map at what he considered to be the most likely place. An elderly man, who had been watching curiously, crossed the road and asked what the author was doing. The motivation for this approach was, like many others, a concern that 'the man with the map' was from the public authorities and some change was being contemplated that could affect the road. On explaining the reason for the map, the man examined the positioning of the line and exclaimed, 'Aha! The line you have drawn shows the river passing directly beneath my house. Now I understand why the basement floods so frequently!' Also on the Westbourne, but its main course this time, the occupiers of offices in Sumatra Road, West Hampstead, confirmed that, as a result of a major storm, their premises had been flooded to knee level – and they then learned of the Westbourne that previously had passed unseen beneath the foundations. It is possible that this led to the relocation of the company, as the offices were demolished shortly after and housing was constructed in their place.

Special thanks are due to the proprietor of the Fox and Hounds in Pimlico's Passmore Street. Apart from providing some welcome refreshment at no charge to the author, she was able to confirm that the Westbourne passed immediately behind the pub. Her neighbour came across the culverted river when digging one day in their garden.

On yet another occasion, near Baker Street, a lady of a certain age, having seen him intent on his street map, accosted the author, asking if he were lost. After having remarked on the flooding of the basement in which the lift equipment had been ruined by the Tyburn, she adjusted the collar of his crumpled jacket, noting, 'You now look less like a tramp up to no good and more like an engineer intent on good works.'

It was very easy to get so wrapped up in the *in loco* research as to become oblivious of anybody else. However, taking the time to stop and talk inevitably paid dividends and there was rarely a moment when the author stopped to talk to local residents that his knowledge of the area was not usefully expanded with respect to the hidden rivers.

STEP 4 – CONSULTATION WITH LOCAL LIBRARY REFERENCES

Many of London's public libraries undertake an invaluable role of also being the repository for maps and works documenting local history. Librarians are only too pleased to make this source of data available to those interested. Some London boroughs maintain excellent websites where detailed information on historical background to the social conditions and development of the area under their jurisdiction can be found.

Having completed Step 3 and walked the routes of the rivers and plotted what might now be considered the best available line taken by their watercourses, the libraries of the boroughs through which they pass were consulted for further historical background.

STEP 5 – CONSULTATION WITH THAMES WATER

A discussion was held with a former sewerage operations manager for Thames Water who has a profound knowledge not only of the present sewerage system but also of the historic development of the networks of London and their intimate relationship with the hidden rivers. Unfortunately, for various logistical reasons, this discussion and visit to the sewerage archives at Abbey Mills Pumping Station on the Northern Outfall Sewer could only take place a matter of days before the book was due for delivery to the publishers. However, whatever was gleaned from that meeting has been incorporated into the book.

The routes plotted for the seven hidden rivers covered by this book are the result of the research that followed these five steps. Although a best attempt at their definition, the routes of London's hidden rivers as depicted from this research cannot be considered to be precise representations of the original routes. Dependent upon the nature of the records that have been consulted and interpreted, each of the sections has varying degrees of accuracy – or, rather, depending upon your viewpoint, inaccuracy – built into them.

Defining the routes taken by the rivers was relatively straightforward in the outer and inner suburbs, as the natural slope of the ground in these places was generally quite well-defined and had not been altered much in the course of development. This was not the case in the areas closer to the Thames which are, with the exception of a few low rises, extremely flat. Falls across this vast area, stretching from Westminster in the east, through Belgravia, Chelsea, Kensington and Hammersmith to Chiswick, are less than 5 metres. The original land surface would have been some metres lower, as much of this area had been marshy in nature and the present higher ground level owes much to reclamation carried out in the course of its development for residential, commercial and industrial buildings and roads. Where the natural slope of the land was visible, reliance was placed on *in loco* observation; where reclamation had altered the natural slope, greater reliance was placed upon old maps.

The probable accuracy of the routes shown on the maps therefore varies according to local conditions. Under the best of conditions, that is well-defined, natural slopes, it is probable that the line shown follows the actual route within a few metres either side. On the other hand, where reliance has had to be placed on old maps, the line shown is probably accurate only to within 15 to 20 metres either side. However, a greater accuracy may well have been achieved for even these inner city conditions on some lengths of the river's routes where roads, buildings and local landmarks shown on the maps are still standing.

The objectives of attempting to define the routes of London's hidden rivers and to depict them on large-scale street maps were the following:

•To 'unearth' the hidden rivers so that the general public may better identify with them and, in particular, the relationship of these rivers to the development and conditions found in the areas through which they pass;
•To provide the basis for a series of guided walks based on the hidden river routes – to be published in a companion volume in the autumn of 2011 – that would bring to life the roles played by the hidden rivers as well as provide a picture of society past and present along their routes.

Given the large scale of the maps used in this book to depict the original river routes, there may be a temptation to use them to try to explain local conditions. These might include a propensity for an area or building to suffer flooding or damp. However, given the specific objectives behind the mapping of the routes of London's hidden rivers and the element of inaccuracy inherent in interpreting the historical records available to the author, particularly for the inner city areas, it is important to repeat the disclaimer included at the beginning of this book.

The routes of London's hidden rivers, as depicted on plans in this publication, are a best representation based upon considerable research – cartographic, literary and on-site examination of the underlying, natural topography of the urban areas through which they pass. However, by the very nature of their character, that of being hidden from sight, combined with a lack of accurate historical records, this research into the routes taken by the hidden rivers has in some sections necessitated a degree of speculation.

Therefore, in spite of the best efforts of the author, the actual routes taken by the hidden rivers – and their successor culverts and pipelines – may not, in some sections, be accurately depicted on the plans in this book. Such inaccuracy could occur at any point along the lengths of the routes shown for the hidden rivers. In particular, there is no intention to imply that the route of any of the hidden rivers depicted in this book pass beneath any particular building, house, structure or infrastructure. As such, these plans of the routes of the hidden rivers must not be used for insurance, conveyancing or for any legal purposes or processes.

CHAPTER 6
The River Walbrook

THE WALBROOK – THE CITY OF LONDON'S RIVER

Given the two syllables of which it is composed, it would appear at first sight evident that the name Walbrook could well have been derived from the fact that the stream entered the City of London by flowing beneath its northern wall. This was the explanation for the name supported by the historian John Stow, who wrote at the end of the sixteenth century.

However, earlier historians had given a different explanation. The principal of these was Robert Fabyan who, in his chronicle written at the end of the fifteenth century, attributed the naming of the river to a battle that took place in 232 CE between the Franks and the Romans. The victorious Roman general was Luicius Gallus and the brook was named for him, Gallus being the name given to that part of Britain which included Wales and Cornwall. In Fabyan's view, Walusbroke gradually evolved into Walbrook, which appears to have been the name in popular use at least since the twelfth century. William Loftie, a clergyman and historian who wrote on the history of London in a number of publications in the 1880s and 90s, supported Fabyan's view of the derivation of the Walbrook's name.

In truth, there is no definitive proof that either explanation can claim to describe the true origin and there may well be others. Given that these two are the views most commonly held, it will depend whether a reader leans more towards the pragmatic or the historic-romantic as to which they might favour. The author favours Stow's pragmatic derivation for Walbrook – but then he is but a simple engineer!

THE WALBROOK – PRINCIPAL SOURCES, WATERCOURSE AND TRIBUTARIES

There were two principal tributaries of the Walbrook which converged to form the river given that name about a kilometre (0.6 miles) to the north of the line of the Roman city walls. The first of these tributaries, the furthest from the city, had as its origins the springs and ponds on the rise above, and just to the north of, the Angel, Islington. The second tributary

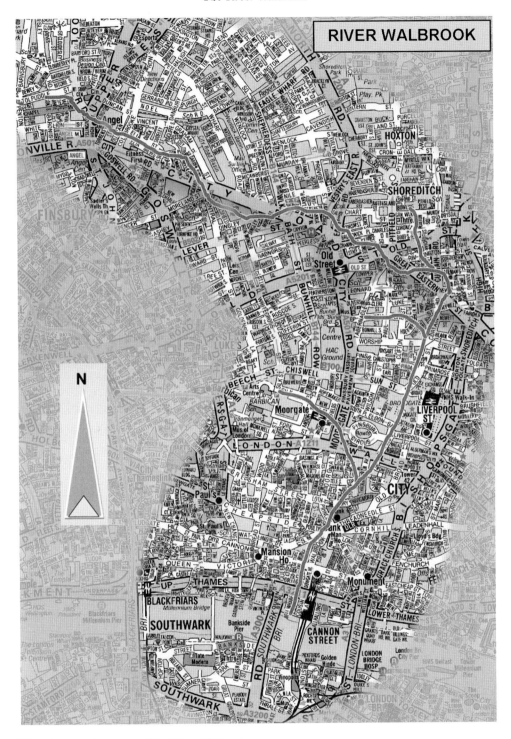

Map showing the course of the River Walbrook.

The outfall of the River Walbrook to the Thames by Cannon Street station (cityscape context viewed from dome of St Paul's).

was much shorter and originated from the springs and wells in the Hoxton and Shoreditch areas.

The springs and ponds above the Angel were the source of the water for the White Conduit which supplied the London Charterhouse located in Clerkenwell, as described in the section on water supply in Chapter 4. The White Conduit, and the springs and ponds that fed it, were located just below the summit of the hill above the Angel, Islington, and on its southern slopes. These slopes are at the watersheds of both the Walbrook and the Fleet (as well as that of the Hackney Brook to the east). Given the difficulty of knowing the precise location of the springs and ponds above the Angel, it is difficult to be sure as to whether the source waters of the White Conduit originally fed into either the Walbrook or the Fleet catchments or to both. The slopes, falling away from a high point at Cloudesley Terrace, fall both towards the Walbrook and Fleet catchments. Given this local topography and the probable location of the springs and their creations, the ponds, below the southern half of the highest point, there is a high probability that some of the springs in this area fed into both catchments. However, present-day White Conduit Street is just to the north side of Chapel Market and on that part of its slope leading towards the Walbrook tributary which flowed down and a little to the east of the ancient path that would become today's City Road.

White Conduit House, which has an interesting history, is written up in Chapter 4, where the wells, springs and spas located in the Walbrook catchment are discussed.

Based on the topography of the area, the tributary of the Walbrook would have passed down the slope from the Angel just to the east of what would become the City Road, meandered eastwards past St Clare's Well (present-day Old Street station) to Curtain Road and the Holy Well Priory, where it turns south to cross the new Broadgate development and then to the east side of Finsbury Circle. Here it crosses under the line of the Roman wall about 200 metres to the east of the Moorgate and passes through the city via the Carpenters' and Drapers' halls, under St Margaret's church, Lothbury, under the north-west corner of the Bank of England, past Grocer's Hall, under St Mildred's church and down just to the west of the sloping street named Walbrook. The river discharged to the Thames immediately to the west of Cannon Street station, having first made a final curve after passing under Horseshoe Bridge. The nature of the mouth of the Walbrook has been variously described as a single channel at Dowgate and as a delta having two branches, perhaps 100 metres apart, one being the former navigable inlet at Dowgate. The other tributary, which rises in the Hoxton and Shoreditch areas, probably drew its flow from overflowing wells as its main source waters. This short stream joins the one from the Angel in Curtain Road, at the Holy Well Priory.

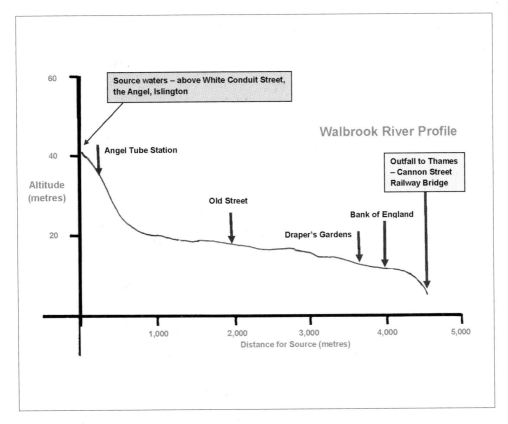

Profile of the River Walbrook.

A Profile of the Watercourse of the River Walbrook

In drawing up the profile, it has been assumed that the culverted Walbrook is between 1.5 and 2 metres below ground from its source at the Angel through to just north of the London Wall. Between the section from north of London Wall, along under the Wall, beneath Throgmorton Avenue to Drapers Gardens, it varies from between 3 and 5 metres below present ground level. Archaeological excavations in the City of London have demonstrated that the Walbrook used to run far below the ground, particularly from the Bank of England to the Thames. For this stretch, the river may be anything up to 12 metres below ground level due to the considerable amount of infilling of natural valleys with rubble which was not carted off-site when buildings have been demolished or burnt to the ground over a period of almost 2,000 years.

The principal boundaries forming the watershed limits for the catchment area of the Walbrook are a line forming the northern boundary running roughly south-eastwards from the Angel, Islington, through Shoreditch and Hoxton to Spitalfields (to the north of this line, land drains towards the Hackney Brook and the River Lee); a line running roughly north–south from the Angel just to the east of Goswell Road/Aldersgate Street, the western end of the Barbican to the Thames (to the west of this line, land drains towards the west into the Fleet); and in the east, a line running south from Spitalfields along Middlesex Street and to the Thames west of the Tower of London.

The Walbrook catchment includes much of the City of London and an important feature of the catchment is the Roman wall, which ran from west to east across it. The wall was first constructed towards the end of the second century. Its construction was a massive undertaking. It required an estimated 86,000 tonnes of Kentish ragstone to be transported down the Medway to the City in barges, each having a capacity of about 25 tonnes. The stone then had to be hauled uphill for much of the building of the 6 metre (20 feet) high wall. A ditch varying in width from 3 to 5 metres (10 to 16 feet) was dug around the outside of the wall. The massive nature of the wall had a significant effect on the land through which it passed.

Prior to the building of the wall, a large area both inside and out of the northern part of the city had been described as marshy. The water that gave rise to this sizeable marsh came from the wells to the north of the area and the tributaries of the Walbrook. The wall had the effect of cutting off the land within the wall from the water draining out of the marsh. This improved the land within the City but the wall acted as a dam and, having partially trapped the water outside, it considerably worsened the marshy nature of the moorland to north of the wall and its ditch. Descriptions of the moor give the impression that in places, particularly in winter, it was totally underwater.

Water draining out of the moor was used to fill the ditch around the wall as an additional defence for the city. The main tributaries of the Walbrook were culverted through the wall, probably in at least two places.

The moor became a major feature in the life of the City, it variously being used for a range of recreational activities (see Chapter 4), as a refuse dump, as tenter grounds (where washed cloth woven from wool was placed under tension on hooks to prevent shrinkage while drying), and for horticulture. In the Middle Ages, the city constructed windmills to drain the moor, and the area was further improved in the second half of the seventeenth century

when spoil from the reconstruction of St Paul's Cathedral and other buildings following the Great Fire of London.

It was only in 1415 that the wall was breached near the course of the Walbrook and the Moorgate was built. However, although a causeway was then built across the moor, it was used only to access the immediate area outside of the wall. It only developed into the point of departure for a major road following the improvements to the moor after the Great Fire of London in 1666.

THE WALBROOK THROUGH HISTORY

Roman London – 43 to 410 CE

The origins of the City of London, or Londinium as the Romans called it, with reference to the rivers and their influence on its development, are detailed in Chapter 3.

At first the Romans built their houses and public buildings from wood, and mostly to the east of the Walbrook, in the general vicinity of the modern Bank of England. The area to the north of this was marshy in nature. Boudica and her allies destroyed the early settlement in 60 CE, but it was soon rebuilt. London became the administrative capital of the Province of Britain towards the end of the first century. An elaborate building, almost certainly the

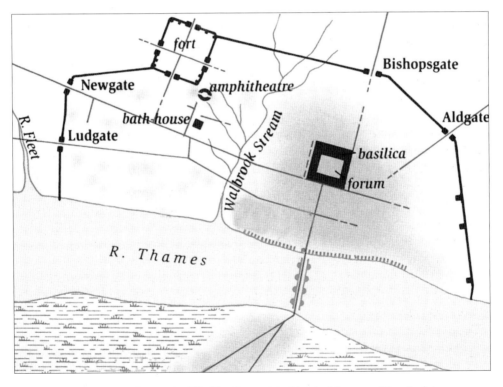

Depiction of Roman London, *c.* 200 CE. (Based on original by the Museum of London)

governor's palace, was constructed on the terraced land immediately to the east of the mouth of the Walbrook. The northern boundary of the settlement was given some protection by a fort constructed on higher ground at Cripplegate, to the north-west of the Walbrook. By the start of the second century, the city had developed to the same extent on both sides of the Walbrook. To provide the city with greater protection, when the military presence was reduced in size to fight elsewhere, the wall was constructed to enclose the city on its three landward flanks, leaving the riverside un-walled for most of its length. River frontage was about 2 km long and the average width of the walled area was approximately 0.75 km, a total area of just under 1.5 km² or approximately 0.6 square miles. Interestingly, the City within the walls is often referred to as the Square Mile. However, when measured out, it can be seen that the area known as the City actually occupies considerably less than a square mile.

William Loftie, previously referred to, writing in the later nineteenth century claimed that

> The banks of the Walbrook were especially popular as sites for villas. All along its winding course at a varying depth we come upon evidences of the wealth and luxury of the old Roman dwellers in the pleasant ravine beside Threadneedle Street on the rounded summit of Cornhill by the great northern highway. It is here that the finest remains have been found, many of them covered with layers of black ashes, which betray at once the fragile character of the wooden houses and the constant occurrence of destructive fires.

It is possible that the destruction of the villas may have been due battle damage, as would have been the case in 232 CE when a great battle took place in the city on the banks of the Walbrook.

After a time, an edict forbade the building of residences in the valley of the Walbrook and existing houses were demolished, possibly due to the watery nature of the ground. The valley area was then used for industries such as ceramics, for baths and, in 240 to 250 CE, a temple, a Mithraeum, was built on its east bank.

The banks of the Walbrook were weak and the Romans strengthened them by constructing revetments using overlapping timber planks. In the course of modern re-development of parts of the City, short lengths of this strengthening of the river's banks have been uncovered. Originally, these timber remains were mistakenly identified as the remains of boats and ships formed in the same 'clinker' fashion as the revetments. However, the remains were discovered too far upstream for any vessels to have ventured.

Indeed, it is doubtful that the Walbrook was navigable for more than a hundred metres or so inland from the Thames due to the steep slope down which it flowed at its lower end. However, evidence has been uncovered of quays for the loading and unloading of vessels on this tidal inlet. The wharves, from which ever-increasing cargoes of supplies, soldiers and materials were loaded and unloaded, spread either side of its short, navigable inlet out along the banks of the Thames.

It is unlikely, with the exception of the very earliest stages in the development of the area, that the Walbrook provided a clean enough source of drinking water for the Romans. A reliable and adequate source of water would have been derived from wells dug into the permeable chalk, sand and gravel layers beneath the city's surface layers of clay. But it is

thought possible that there were watermills located in its lower reaches for the milling of corn, evidenced by a number of millstones found along its banks.

However, the Walbrook did play a role of some significance during the Roman period of occupation. Archaeological digs have unearthed public baths near to its banks and perhaps, most notably, a temple to the Roman god Mithras was also found. The sect devoted to this god was a rather mysterious one and it could well have been that the shallow ravine through which the Walbrook flowed may have provided the temple with a degree of privacy. The activities of the temple were later 'brightened up' when it was re-dedicated to Bacchus.

Departure of the Romans to the Arrival of the Normans – 410 to 1066 CE

No archaeological evidence has yet been found of the continued occupation of Roman Londinium as a functioning urban unit in the period following the departure from Britain of Roman military and administrative personnel in about 430 CE. As mentioned previously, it seems probable that the town gradually deteriorated into a set of rather grand ruins. Saxon settlement appears to have favoured the area now known as the Strand, the stretch of river bank between modern Trafalgar Square and the Aldwych ('the old port'), which they called Lundenwic ('the London port').

The period of about 600 years between the departure of the Romans and the Norman invasion of 1066 was a turbulent one for England. The departure of the Romans can only have emboldened the three Germanic tribes of the Angles, the Saxons and the Jutes to realise their ambition to invade and occupy Britain. They soon successfully occupied much of the north-east, east and south-east of the country. In the ninth century, Scandinavian peoples, particularly the Danes, in their turn, mounted waves of attacks along the eastern coasts and beat the Saxon peoples back from large swathes of eastern England, which they then occupied for the rest of the millenium.

For about a decade, in the second half of the ninth century, the Danes even occupied Lundenwic itself until being beaten back to the north and east of the town by King Harold. The Saxons were restricted to occupying the south, west and south-west of the country and were constantly subjected to attack by the Danes. The Saxons were constrained to pay a substantial tribute to the Danes in order to avoid further incursions and to hold on to the land remaining to them. However, for the majority of the time, although bordering on that part of the country under the Danelaw, the area that included the ruins of Londinium and Lundenwic remained under Saxon rule.

Two things of note took place within this period with respect to its rivers and the later evolution of London.

First and foremost, and quite naturally considering its size, the Thames continued to loom large in forming the character of the area. The same characteristics that had so influenced the Romans in selecting London as their principal town for commerce, both national and international, influenced the Saxons, who filled the management void left by the departure of the Romans.

The Walbrook only came back into the picture when Alfred re-occupied the former Roman settlement of Londinium in the late ninth century. However, the Walbrook had to be cleaned out before it could begin to serve any useful purpose.

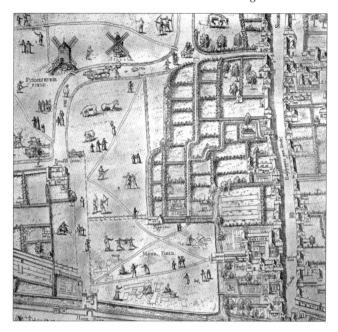

A remnant of the 'Copperplate Map' of *c.* 1555, showing the Walbrook entering the moat from the north and to the right-hand side of the map.

Norman to Tudor Periods – 1066 to 1603 CE

During the later Saxon period, on its reoccupation and development by Harold, Londinium, or Lundenburh as the Saxons had renamed it, expanded its administrative boundaries beyond the Roman walls in order to protect the approaches to its principal gates. This almost doubled the land area of the town to 2.9 km² or 1.16 square miles, from which one of the nicknames for the City is derived, 'the Square Mile'.

Government of the city evolved from late Saxon times through the Norman period, and by the early twelfth century was well-defined. Administratively, the city was divided in half using the River Walbrook as the boundary between the two halves, each half being itself divided into twelve wards. Each ward elected an alderman, a locally-respected older man, to chair their local council, their wardmote, and to represent them on the ruling council of the city, the Folkmoot. Interestingly, for our subject at least, a ward was described as 'east of the Walbrook' or 'west of the Walbrook'. By acting as an administrative boundary, the Walbrook demonstrated its continuing significance to the inhabitants of London of the period.

From records of the proceedings of the Common Council of the City of London, it is clear that through to the late fifteenth century, the River Walbrook figured large in the life of the city. There were a number of bridges over the river and it appears that these were built upon with houses for the wealthy. No doubt garderobes discharged to the stream below the bridge and all manner of rubbish was disposed of into the watercourse from these buildings.

The equal division of the twenty-four wards of London and their designation as either 'east of the Walbrook' or 'west of the Walbrook' continued through the Middle Ages and was used as a means of raising given numbers of men for representation of their ward on the Common Council of the City, as well as for armies raised by the monarch and for juries for important criminal cases such as murder.

With more intensive development of the City of London in the two centuries following the Norman Conquest, the Walbrook became increasingly used as a receptacle for rubbish and sewage. In spite of orders to clean its course, the Walbrook was progressively covered over, a process that probably began in the thirteenth century.

Responsibility for the maintenance and cleaning of the Walbrook was the subject of dispute between the two wards of St Stephens Walbrook and Dowgate. In 1301, an inquisition charged the people of St Stephens Walbrook with this onerous duty, but they do not seem to have taken much action. Twenty years later, all of the drainage channels, including the Walbrook, were generating a lot of nuisance, objectionable smell and flooding. The Common Council designated Thursday for the cleaning of the Walbrook. However, once again, little actual cleansing took place.

Another insight into how the Walbrook had become degraded is a seven-year right granted by the city council to a brewer, Thomas atte Ram, over the waters of the Walbrook at Moorfields in 1374. He was given the right to levy a rent for each latrine, privy or garderobe discharging its waste to the river and, in lieu of a rent for this right, he was required to keep the watercourse clear of dung and other rubbish. Interestingly, for his pains in this regard, he was permitted to keep anything of value found whilst carrying out the clearing work. This is reminiscent of the scavenging of London's sewers by what were called 'toshers' in the Victorian period, by individuals as well as whole families, and the children who were engaged in sifting the mud of the Thames at low water for anything of value, the so-called 'mud-larks'.

By 1415, the river was referred to as the Fosse of Walbrook and was by that time considered as little more than a sewer.

In 1477, an act of the Common Council of the City of London prohibited the discharge of latrines into the Walbrook. The tanners were particularly singled out as polluters who should remove all their waste from the watercourse. The owners of houses along the banks of the Walbrook and on its bridges were charged with arching over of the river and its covering. Over the next 100 years, the river was totally culverted over and paved level with alleys and street that crossed it and ran along its banks. By the middle of the sixteenth century, it is probable that, within the city walls, little of the river would have been visible and by the end of that century no visible trace would have remained. By this time, it is doubtful that any London ward would have continued to consider itself as lying 'west of the Walbrook' or 'east of the Walbrook'. In 1574, however, we have been given an insight into the nature of the stream at Dowgate Hill as being even then unculverted and swift-flowing, so much so that a youth who fell into it was swept away and drowned at the Watergate before the Thames.

There are various references to many ditches within the city walls draining streets and alleys into the Walbrook. John Stow makes mention of a 'great stream breaking out of the ground' at some point along Fenchurch Street, making its way westward along Lombard Street before turning south along Sharebourne Street. He names this watercourse as the Langbourne, but given the proximity of Sharebourne Street to the street named Walbrook, it is possible that this became a tributary of the Walbrook. In any event, by the time that Stow was writing, towards the end of the 1500s, the source had long been stopped up and the Langbourne filled in and paved over.

It therefore seems clear that by the end of the Tudor period, the Walbrook had become the first of London's rivers to totally disappear from view. The City of London's very own river had become London's first hidden river.

CHAPTER 7

Hampstead Heath –
Source of Three of the Hidden Rivers

It is often difficult for the general public to understand how the hidden rivers of London originate. Part of the object of this chapter is to attempt to dispel the mystery surrounding the origins of the rivers. In the forthcoming companion book *Walking on Water: The Hidden River Walks*, three of the walks are based in and around Hampstead, Highgate and Hampstead Heath. The routes of these walks go by the springs and wells that constitute the headwaters of three of the rivers – the Fleet, the Tyburn and the Westbourne – all of which rise on the slopes of the Hampstead and Highgate Massif, and are a very practical way of understanding the source waters for the rivers.

SOURCES OF THE THREE HIDDEN RIVERS: THE FLEET, THE TYBURN AND THE WESTBOURNE

Although the Hampstead and Highgate Massif is the source of water for only three of London's hidden rivers – the Fleet, the Tyburn and the Westbourne – the source waters for the other four rivers covered in the book are derived from one or more of the same types of sources, i.e. springs, wells and surface-water run-off.

The springs and wells of Hampstead and Highgate are a consequence of the geology of the area. The hills which form the main topographic interest of both Hampstead and Highgate are capped by a sandy stratum, the Bagshot Sands. The Bagshot Sands are one of the youngest geological strata and were formed about 50 million years ago. They had been laid down when the North Sea covered southern and south-east England. Later in a geological timeframe, at the start of the last ice-age, as sea-levels began to fall and the sandy layer was exposed, it is thought that a great river, the Great Bagshot River, flowed westwards from what is now the West Country along a route which covered the area that would in later times become the Thames.

Apropos of the hidden rivers – and of great hydrological interest – the second ice age started about 20 million years ago and ended for northern Europe only about 10,000 years ago. As icing up on a geological scale proceeded, sea levels were drastically reduced, probably by more than 100 metres (330 feet), and a land bridge was exposed, linking Britain to mainland Europe. This land bridge was formed as an extension of what is now East Anglia. At this time the Thames flowed eastwards to become a tributary of the Rhine, which then flowed southwards into the depression which later became the English Channel. As the ice melted, sea levels rose, covering the land bridge and creating a continuity between the North

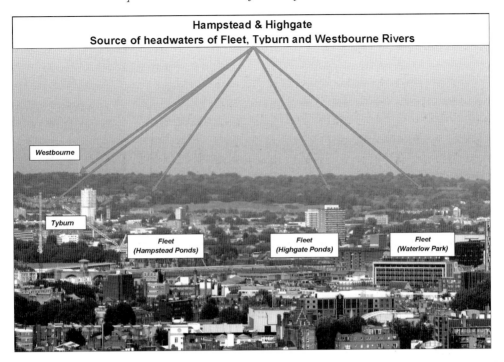

Sources of the headwaters of the Fleet, Tyburn and Westbourne Rivers in Hampstead and Highgate.

Sea and the English Channel sometime between 15,000 and 10,000 years ago – just a blink of an eye in geological time.

The Bagshot Sands consist of a buff-yellow, fine-grained sand which contains significant local beds of flint and gravel laid down by the great river, the latter having originated from as far away as Dartmoor. Underlying the Bagshot Sands is a deep stratum of London Clay, or brickclay as it is sometimes known. The Bagshot Sand is porous and permeable, that is it absorbs rain falling upon it, which passes down through the sandy layer and then along its impermeable, sloping interface with the clay. Where this underground flow of water and impermeable interface meets the ground surface, a spring erupts out of the ground. Where conditions do not create springs, a well may be dug into the sand down to the level of the aquifer from which water can be drawn.

When rain falls on a ground surface consisting of impermeable clay and when prolonged rain falls on water-logged, sandy soil, rainwater flows over the surface to the nearest ditch or stream. Clay surfaces are found in the area of Hampstead, Highgate and the Heath below an elevation of about 90 metres (295 feet). Rainwater run-off flows over the land surface to the nearest ditch or watercourse. Where the land surface has not been developed and remains of a rural nature, the time taken for surface water to reach a watercourse may be considerable and it may be absorbed into the ground before it reaches natural or artificial drainage. Where land has been urbanised and paved, rain falling on roofs and roads is channelled rapidly to watercourses or an underground drainage system.

This means that rainwater falling on the Heath will be absorbed into the ground above 90 metres elevation, where it falls on sand and issues as springs where the sand-clay interface

meets the ground surface. These springs are the main source of water for the twenty-four ponds on Hampstead Heath. Some of these ponds have formed naturally in depressions in the clay while others are man-made, being either the depressions left by sand and gravel 'mining' or reservoirs constructed to store water before treatment and distribution by the Hampstead Water Company.

The spring mechanism in relation to the sources of the Fleet, Tyburn and Westbourne rivers is shown in the diagram overleaf.

Below the 90-metre elevation on Hampstead Heath, rainwater flows only slowly over open ground to drainage ditches and the ponds. In the villages of Highgate and Hampstead, until the early nineteenth century, surface-water run-off would only slowly have drained away and into ditches and streams feeding the hidden rivers, whereas now, as a result of total urbanisation, the water is rapidly conducted away into drainage systems and only reaches the hidden rivers where these have been covered over and incorporated into the man-made drainage system of London.

Walkers by Hampstead Ponds.

Right: The outlet of Hampstead Ponds.

Below: Spring 'mechanism' and river sources, Hampstead and Highgate.

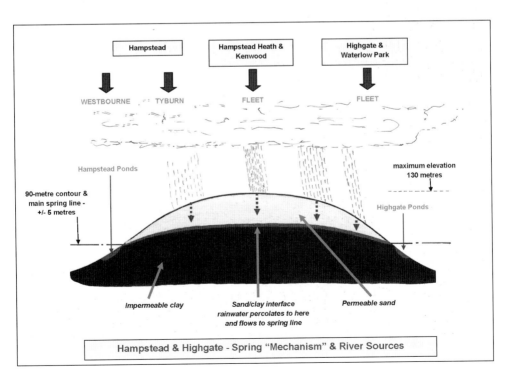

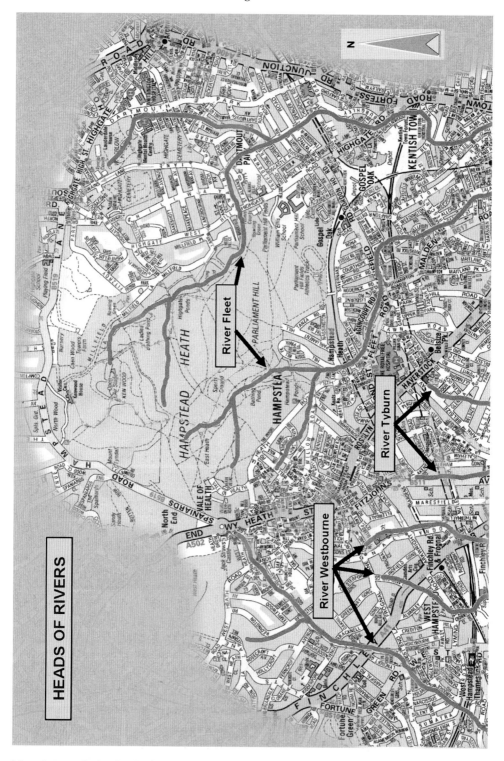

Map showing the heads of the rivers.

HIGHGATE AND HAMPSTEAD VILLAGES

Archaeological investigation has demonstrated that the general area of Highgate was sparsely settled even in Roman times and that pottery was produced there, possibly due to the ready availability of clay to work with and wood for making charcoal to fuel the kilns. Hampstead has been the name for the area, with many forms of spelling, since Anglo-Saxon times. The manorial areas of Hampstead and Highgate were historically situated in the County of Middlesex. They were considered to be in the gift of royalty since the late Anglo-Saxon period and their benefits were granted to individuals for services to the crown.

The county of Middlesex, meaning Middle Saxon, was referred to in the Domesday Book which divided Middlesex into six hundreds, a term that had earlier been used to denote an area considered to be capable of supporting 100 households or provide 100 fighting men, but by this time was used for a larger unit with its own local government. Hampstead and Highgate lay in the hundred called Ossulstone, which extended to the county's south-eastern border and included the City of London. Under the 1965 reorganisation of local government, Middlesex as an administrative unit disappeared, much of it being absorbed into Greater London, parts also going to Hertfordshire and Surrey.

Through the Medieval period, the land was covered by the Forest of Middlesex. It was used by royalty as a place for hunting. William FitzStephen, the late twelfth-century chronicler, refers to:

> ... vast forest, its copses dense with foliage concealing wild animals – stags, does, boars and wild bulls.

Through the twelfth century, as London's citizens were encouraged to become proficient in the use of weaponry, they were granted the right of free chase in the Royal Forest. Hampstead and Highgate were less than 10 km (6 miles) north of the City and their situation on top of high hills would have brought the advantages of their environment to the notice of Londoners from the earliest of times. The sandy nature of the land would have been quite different to the clay of the plains on which, in the main, the City was founded.

Both Hampstead and Highgate villages were set in deeply rural situations and their hilltop locations gave ample visual evidence of this. Development ultimately engulfed them from the first half of the nineteenth century. Until that time, their environment might well have been described as idyllic.

Over the centuries, as the City evolved into a highly polluted, overcrowded and unpleasant environment in which to live, both Highgate and Hampstead attracted more and more members of the aristocracy and wealthy merchants. From the early sixteenth century, they and other citizens began to build their residences around these hilltop villages. Depending partly on their wealth, these houses would either be their permanent residence or used only occasionally for recreation from time to time. Located on hills at an elevation between 90 and 130 metres (295 and 425 feet), the views southwards, with the city in the middle ground and the Surrey hills as a background, were magnificent. The air would have been clean and clear, unpolluted by the smoky outpourings from myriads of coal- and wood-burning hearths of the City which, themselves, would have provided a picturesque foggy mantle to

the city's houses, pierced only by the pre-Great Fire spire of St Paul's Cathedral, and later Wren's dome, as well as the towers and spires of numerous other churches. The nature of Hampstead and Highgate's geology assured local residents of copious amounts of unpolluted water for drinking and other domestic uses.

Indeed, it was the many wells of Hampstead which led to Hampstead becoming the more popular of the two villages as a recreational location and which, together with other environmental benefits, also led to many writers and artists taking up residence. The first major migration from London to Hampstead almost certainly took place in 1665 when aristocrats, merchants and members of the judiciary fled here from the Great Plague. From this time and throughout the eighteenth century, Londoners also flocked to Hampstead to take its waters at the privately financed spas that were established, based on its many wells and springs. Other entertainments were attracted to the area, building upon the custom of the spas – inns, pubs and dance halls. Gradually, as with other spas operating in London, the entertainments became more coarse and carnal, resulting in breakdowns in law and order. It is not a coincidence that the Hampstead Lock-up, still visible in Cannon Lane, was constructed at about the time that the spa opened in 1720. Pressure was applied by local residents to close the spas and they fell into disrepair and disuse by the early nineteenth century. Hampstead reverted to a place for the gentry to live and for artistic, literary and musical culture to thrive. Hampstead has remained an upmarket residential area through to the present day.

Highgate was the site for constructing many grand houses from the sixteenth through the eighteenth centuries. Much of its population during that period would have been a relatively few wealthy families and a much greater number of servants and suppliers of food and services to them. The village and surrounding lands were granted to the Bishop of London from the eleventh century and the main road northwards out of the City and up Highgate Hill came under his ownership. By the early fourteenth century, a toll gate had been constructed at the very top of the hill, at what is now the principal road junction in the village. The existing Highgate bypass, which passes to the east in a deep cutting through the hill, was only constructed on a second attempt in 1813. Until that time, travellers had to pass directly up the hill and through Highgate. Quite understandably, there were a number of old-established inns and public houses in the town at which travellers could refresh themselves, either following a tiring ascent or before heading down into the City. Only a few remain in operation today. For hundreds of years, the road through Highgate was used by those going to the markets that serviced the City and, although this provided a certain amount of local trade, it damaged the lanes and roads of the village, particularly the considerable traffic of cattle being driven to Smithfield. Increasingly, through the nineteenth century, Highgate became linked to London by privately funded means of transport. The opening of a cable tramway up the hill from Archway in 1884 meant that the village could be readily accessed without effort. This operated for twenty-five years and opened it up to development and as a transit for the general public wishing to visit Hampstead Heath. The crowds on Sundays and bank holidays were further increased when the railway reached Highgate station. This was located on the new bypass road, with its famous landmark arch bridging the deep cutting, and which gave its modern name to the development at the foot of the hill, Archway.

Hampstead and Highgate lie respectively at the south-western and north-eastern extremities of a vast area of open land called Hampstead Heath. It is the nature of the

geology of the Heath which, in parts, extends below the two developments and gives rise to the outflows of water that provide the main sources of water for the Fleet, the Tyburn and the Westgrove rivers.

HAMPSTEAD HEATH

Hampstead Heath lies only a little more than 6 km (4 miles) north of the centre of London. It is a vast, open area, parts of which resemble another of London's many parks and parts like the countryside typical of southern England. It occupies a very large area, approximately 320 ha (790 acres), and is comprised of a number of distinct parts, generally relating to their former ownership or physical character.

The Heath did not always look as it does today. Prior to Saxon times, the lower slopes would have been heavily wooded while above the 90-metre elevation mark, on the Bagshot Sands, trees would have given way to open heathland covered with gorse and bracken. If a modern-day equivalent were needed, it would be the New Forest region. From late Saxon times at least, the area was Church land under the Bishop of Westminster. However, from shortly after the Norman Conquest, the land was offered to men who had demonstrated that they were loyal servants of the King. Divided between a few lords of the manor, each demesne was progressively cleared of trees and used to grow crops and rear sheep and cattle. Some woodland was left intact to provide wood for charcoal-burning. A portion of the land termed 'the lord's waste' or 'common waste' and 'common field' was used for public roads and paths, and as common pasture by the lord's tenants or other commoners to practise animal husbandry and agriculture. In time, a large portion of the Heath became common land, although still privately owned. From the late seventeenth and into the eighteenth centuries, the Heath had become owned by just a few families, who built grand houses and converted parts of their property into landscaped gardens. They planted trees, some of them species alien to the area, mainly to shield their properties from the gaze of the common crowd, but part was also left as heathland. As grazing and cultivation finished, shrubs and trees began to re-colonise the whole area. The Heath today is a mix of ancient and modern woodland, coppiced trees, marsh, ponds, hedgerows and grassland, disturbance of the ground sometimes exposing sand, sometimes clay.

Presently, the whole of the Heath is in public ownership and London's population has been provided with a magnificent 'lung' where they can take their recreation in many different ways – walking, swimming, model-boating, concert-going, ice-skating and tobogganing in the winter, nature-watching, athletics, cross-country running and, most recently, if a pressure group has its way, naturism. The transition from private to publicly owned land took place over almost a century and involved many hard-fought battles, fuelled by greed on the part of some of the landowners. However, fortunately, the battles were fought democratically and mostly in public debate. It was only through the actions and energy of a number of public-spirited persons and some notable philanthropic acts by wealthy individuals that all parts of Hampstead Heath passed into public hands and, as a consequence, has been safeguarded from the urban development that currently surrounds it.

For those only interested in the Heath because of the commercial gain they could make from it, this beautiful rural space meant only two things: a source of building materials (sand,

gravel and clay), and an area for housing development and associated speculation. Following the Great Fire of London, brick replaced timber as the main material for building houses and many other constructions. The demand for bricks led to pits being dug on Hampstead Heath in order to extract brickclay, and also led to the construction of brickworks. Sand and gravel were not only useful building materials; they were also spread on weak and frequently damaged roads which were not yet covered by tarmac or by cobblestones in order to reduce their muddiness. However, at the end of the eighteenth century and through the nineteenth century, industrialisation encouraged a huge movement of rural populations to London, its rapidly increasing population creating a burgeoning demand for housing. The demand for development land in Hampstead and Highgate intensified with the extension of the railway to these areas. Some of the owners of land on Hampstead Heath quickly caught on to the potential to turn their unproductive land into cash by obtaining planning permission for housing developments and selling off their land to builders.

At the same time, the vastly increased population of London needed areas for recreation. Fortunately, the period of temptation to sell off the heathland for development coincided with a rise in social conscience in some wealthy and influential individuals. In the first half of the nineteenth century, the three principal owners of the land forming Hampstead Heath were Sir Thomas Maryon Wilson, David Murray, the 3rd Earl of Mansfield, and owner of the Kenwood Estate, and Eton College. In terms of the story of the Heath, they could simplistically and respectively be labelled, the Bad, the Good and the Indifferent.

Maryon Wilson, who owned the western half of the Heath that straddled the Spaniards Road, attempted to obtain planning permission for housing but was opposed by the Earl of Mansfield over a period of many years. However, Wilson went ahead with an accelerated exploitation of the sands of Sandy Heath and constructed a paved road on the east side of the Spaniards Road to the Hampstead Ponds in anticipation of an eventual permit to develop. On Wilson's death, his land on the Heath, including Sandy Heath, was sold to the Metropolitan Board of Works. An act of Parliament of 1871 charged the board with the responsibility of conserving the land in its natural state. In 1889, the 4th Earl of Mansfield, William Murray, sold Parliament Hill Fields to local government, the purchase price being raised through public subscription. At the end of the nineteenth century, Thomas Barratt, the chairman of Pears Soap, saved Golders Hill Park from developers by purchasing the land and its house and donating them to the public. In the early 1900s, Henrietta Barnett led a successful campaign to raise money for the purchase from Eton College of what was farmland, Wylde's Farm, but which, following its purchase, became known as the Hampstead Heath Extension. In 1922, the three wealthy and influential leading lights of the Kenwood Preservation Council, Arthur Crosfield, Henry Goodison and Robert Waley-Cohen, arranged to purchase South Meadow and Cohen's Fields on the southern and eastern boundaries of Kenwood House and donated them to the public. Finally, the Earl of Iveagh bought Kenwood House and its remaining grounds, which, on his death a few years later, he bequeathed to the nation.

Through this succession of events, the whole of Hampstead Heath, including the lands of the Kenwood Estate, are now in public hands and safe from incursions by developers. After the dissolution of the Greater London Council, the Corporation of the City of London was given the task of managing and policing Hampstead Heath. English Heritage has responsibility for managing the Kenwood Estate.

The River Fleet

THE FLEET – RIVER OF MANY NAMES

The river now most commonly referred to as the Fleet has, in the past, been given many names as it flows from Hampstead Heath through to the Thames at Blackfriars. Sometimes these refer to the whole length of the river and sometimes locally to particular stretches. It would be as well to dispel the myth that the Fleet River runs down Fleet Street – the street is named for the river that ran past its lower end.

As is the case with the Walbrook, the origin of the name 'Fleet' is disputed. The river has figured in history since the arrival of the Romans and ought to have had a name at that time, but no record remains of this. There was a Saxon word, *flod*, which means 'flood' but a more likely candidate is perhaps the Anglo-Saxon term *flēot*, meaning a tidal inlet or estuary. In the twelfth century a reference was made to the river as 'the Flete', and this spelling appears to have continued for at least another century. The physical configuration of the Fleet at the time lends weight to the Anglo-Saxon origin of the name. From at least the Roman period, the Fleet did have a well-defined estuary large enough to hold about a dozen ships in the Middle Ages, being about 100 metres wide at its mouth and 700 or 800 metres in length. None of the other six hidden rivers had an estuary as significant or as useful as that of the Fleet. The estuary of the Walbrook could only act as a berthing area for ships because the Romans artificially widened it.

The Fleet originates as two completely separate branches which flow south to combine at Camden Town. The more westerly branch of the two is referred to as the Fleet Dyke or Fleet Ditch. The easterly branch originates in Ken Wood and is sometimes referred to as the Caen Ditch, being an old spelling for the area, or Ken Ditch. The name Fleet Ditch was synonymous with Fleet River along its whole length from the Middle Ages through to the Georgian period. It has been speculated that the district of Kentish Town derives its name from the easterly branch of the Fleet that passed through it. However, there are those who know the easterly branch as Highgate Brook.

Downstream of Camden Town, south of its crossing beneath the Regent's Canal, as far as King's Cross, the river has been known as the Pancras Wash, although this does not appear to have been in common use. More common are the names given to the river below King's

Cross, through to its estuary: River of Wells and the Turnmill Brook. The former is a reference to the many named wells along that stretch of the river, among them Skinner's Well, Tod's Well, Fogg's Well, Black Mary's Hole and Bagnigge Wells, some of them forming the basis for spa establishments from the late 1600s through to the first few decades of the nineteenth century. Turnmill Brook refers to the many mills that were located along its banks.

The Fleet is sometimes incorrectly referred to as the Holeburne, or Holebourne, in its lowest stretch, adjacent to its estuary. This was, in fact, a river that rose from a spring on higher ground above the valley of the Fleet at Holborn Bar, one of the turnpikes leading into the City of London. It was a tributary of the Fleet, entering the river from the west at a point near to where the Holborn Viaduct now stands. The name has Anglo-Saxon origins, *Holburna* or 'stream in a hollow' – a possible reference to the ravine through which it flowed into the Fleet.

The River Fleet became so degraded with sewage, rubbish and the detritus of many small industries that it was at one time called the '*cloaca maxima* of our metropolis', a reference to the main sewer in Ancient Rome.

THE FLEET RIVER – PRINCIPAL SOURCES, WATERCOURSES AND TRIBUTARIES

The Fleet is one of the three hidden rivers that owe their origins to the water-bearing Bagshot Sands that overlay the clay on the hills that form Hampstead Heath and its environs. This has already been described at length in chapters 2 and 7.

Hampstead – the outlet from the lowest pond discharging to the head of the Fleet.

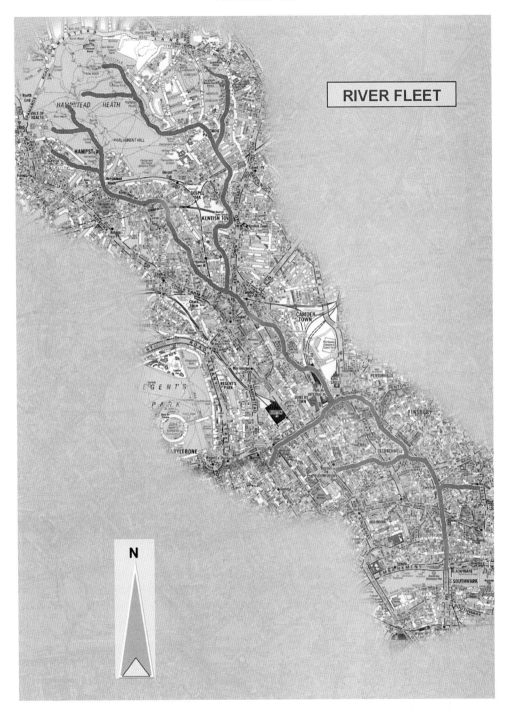

Map showing the course of the River Fleet.

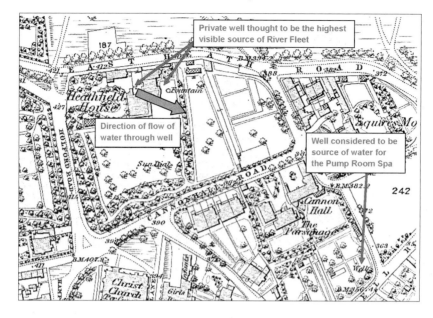

The highest visible source of the River Fleet.

There are two main branches that form the Fleet, one that collects the outpourings from springs and that flows through the ponds on the west side of the Heath, beginning with the pond in the Vale of Health, and the other which flows down through the ponds on the east side, or Highgate side, of the Heath with its origin being the springs below Ken Wood House.

The westerly branch of the Fleet, sometimes known as the Fleet Dyke or Ditch, is also fed by a secondary branch which formerly fed into the lowest of the Hampstead Ponds before it was filled in. Water flowing from this branch had been the source of water for the famous Hampstead Pump Room Spa so popular in the eighteenth century and described in Chapter 2. The source of the waters for the spa has previously been considered to be a spring at the top end of Well Passage, above Well Walk. However, in the course of researching this book, the author was introduced to a resident of apartments near the top of East Heath Road which have a well in the grounds of their private property. This well and an associated fountain are shown on a large-scale 1866 OS map of the area. On inspection, it was found that there was a significant stream of water passing through the well, issuing from it in the direction of Well Passage. Whether the water from this well formed the source water for the spa would require further investigations, but what is certain is that this private well is the highest source of the River Fleet visible today.

Having passed the site of the spa in Well Walk, and flowing now beneath ground through Gainsborough Gardens, water from this branch flows under the Freemason's Arms in Downshire Hill and into the main course of the river below the ponds. The river then follows Fleet Road in Hampstead, east along Mansfield Road for a short way before turning south again under Lismore Circus, Wellesley Road and Basset Street and through Kentish Town by way of Talacre Road. It then crosses Harmood Street and Clarence Way into Hawley Road at Camden Town, where it junctions with the eastern branch of the Fleet.

The easterly branch originates with the series of ponds which string out south-eastwards down the slopes of the Heath, starting with the Thousand Pound Pond below Ken Wood House. One of the ponds is fed by a stream which enters from Highgate Hill. The river leaves the Heath flowing eastward for a short distance along Swain's Lane, before turning south across St Alban's and Croftdown

The Fleet at St Pancras church in the late 1700s (the church has since been re-designed and re-built).

Roads to York Rise. Halfway along York Rise, the river receives the water from a tributary that originates in Waterlow Park, which is adjacent to, and south of, Highgate High Street. The river continues along York Rise, crossing Chetwynd Road and running beneath a main-line railway and parallel to the west side of Burghley Road, to cross Highgate Road and run under another railway line. The river crosses Regis and Holmes roads, beneath an industrial estate, along Cathcart Street into Willes Road. The river crosses beneath the Prince of Wales Road, and into and along Castlehaven Road to junction with the westerly branch at Hawley Road.

The two branches, having combined into a single watercourse, pass immediately to the east of Camden Street and beneath Bonny Street and the Regent's Canal. The river passes along Lyme Street, across College Street and winds its way through the low ground to the west of St Pancras Way, the grounds of the Royal Veterinary College. The river then follows the curve of Pancras Road with St Pancras church and the adjacent site of the former St Pancras Spa, from where it crosses beneath the elevated and renovated St Pancras International station and again into and along Pancras Road to the Euston Road at King's Cross.

Where it enters the Euston Road the Fleet receives another tributary, this time from the west. The small stream has its origins near Tottenham Court Road, close to University College Hospital. That stream runs about 50 metres to the south-east of, and parallel with, the Euston Road.

The Fleet runs very briefly north-eastwards from Pancras Road, past the frontage of King's Cross Station, where it begins to curve around to the south-east, initially following the route of the Metropolitan line. It follows the route taken by the railway, which is hidden by its cut-and-cover construction, along King's Cross Road as far as Wharton Street, which is almost opposite the site of the famous former spa of Bagnigge Wells. The valley through which the river then passes is quite apparent at this point, and it diverges from Farringdon Road to turn south along Pakenham Street, under the Mount Pleasant Post Office Centre and along Warner Street, which itself is bridged by Roseberry Avenue. A tributary arrives from the west to join the Fleet at the Mount Pleasant site. This is the stream that flows from Lamb's Conduit Fields which was tapped by Lamb as a water supply to the City.

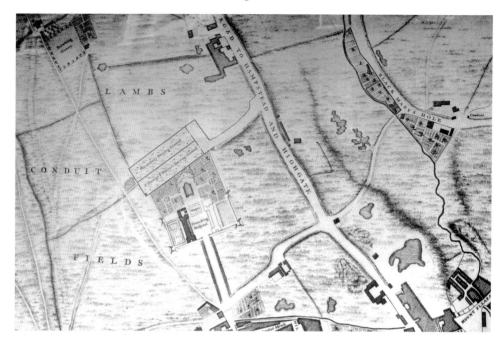

The Fleet at Mount Pleasant (flowing north to south on the right-hand side of the map).

Farringdon from the Holborn Viaduct.

The Fleet then crosses under Farringdon Road and passes along the railway side of Turnmill Street. From Farringdon Station, the watercourse returns to proceed first southwards along the east side of Farringdon Street and then downstream of Holborn Viaduct, under the wide street itself, past Ludgate Circus to discharge into the Thames under Blackfriars Bridge, offset towards the upstream side of the bridge abutment.

The final stretch of the river receives tributaries from both its east and west banks south of Holborn Viaduct. There would have been the Holebourne itself, and then streams arriving from Smithfield, Saffron Hill and Shoe Lane.

The diagram overleaf shows the topographic profile followed by the westerly branch of the Fleet. The Vale of Health spring source of the Fleet lies at an elevation of about 100 metres, some 30 metres (100 feet) below the highest point of Hampstead Heath. The river losses height quite rapidly through Camden Town, after which its bed slopes more gently past St Pancras as far as Mount Pleasant, when the gradient again steepens down to the Thames.

The profile of the Fleet watercourse shows the river departing from its various sources – Highgate and Hampstead ponds on Hampstead Heath, the wells and springs of Hampstead itself and those in Waterlow Park, Highgate – around and about the 90 to 100 metre contour line. The steepest section of the river is through the ponds on the heath and Waterlow Park, with the gradient of the river easing slightly as it flows through Kentish Town and Camden Town to St Pancras. It would be fair to speculate that the river ran quite briskly through to this point and in dry weather would have been quite shallow, probably less than 15 cm (6 inches) deep. From St Pancras through to Mount Pleasant, the river would have flowed more sluggishly as the gradient eases off very considerably over this section.

By 1862, the Fleet had been culverted for most of its length and covered over. As noted later, an accumulation of deposits in the bed of the Fleet in the King's Cross area led to the generation of sludge gas, containing highly inflammable methane. This concentration of gas exploded, with devastating consequences from the tsunami of water and sewage that flooded area along the downstream watercourse through the city as far as the Thames itself. Although the source of the flame that ignited the gases is unknown, it could have been related to the construction works associated with the building of the Metropolitan Railway alongside the river at that point. However, it is almost certainly the case that the solids deposited in the Fleet at that juncture because the gradient in its bed eased there. Swift river flows from the source through to Hampstead would have swept any waste solids from sewage and refuse through, past St Pancras and into the slower river stretch that starts at King's Cross.

The slope in the river bed increases again downstream of Mount Pleasant to a point just below where the Holborn Viaduct stands. Once again, the gradient eases here through to the river and this, combined with the effects of the tidal fluctuation, led to a build-up of the solid detritus of the city in this reach of the river – sewage, bones and carcases from the butchery associated with Smithfields meat market, chemicals from tanning and the dyeing of cloth and so on.

THE FLEET THROUGH HISTORY

Roman London – 43 to 410 CE

Archaeological work carried out from 1988 to 1992 at the mouth of the Fleet has shown that, immediately upstream of its confluence with the Thames, its course had a distorted hourglass shape, with a distinct bias of the northern and southern rounded shapes towards its eastern bank. Each of these rounded bays housed an island, both being not more than 60 metres in length and varying in width from 20 to 30 metres.

The foundations of a Roman bridge, dated to the early second century, have been discovered at the narrowest part of the hour-glass shaped section, its 'waist'. This bridge appears to be located in the immediate vicinity of today's Ludgate Circus, which links Ludgate Hill and Fleet Street.

Perhaps most fascinatingly, archaeological finds have been interpreted as suggesting that the Romans constructed a mill at the southern end of the northernmost island. This whole section of the Fleet would have been tidal and it has been surmised – and demonstrated to be feasible – that this mill had initially been conceived as a tidal mill. This theory is, as yet, unproven, but in support of this supposition, the mill was found to be located over a channel cut through the island between the main stream of the Fleet on its western side and the channel on its east which formed the island. This encouraged an oscillating movement of the water within the cross-island channel over which the mill had been built. Today's interest in alternative sources of energy provides an added boost to the attractiveness of this possible early application of tidal movement to power industrial processes. The Fleet mill would not be the only example of a tidal mill built by the Romans, but it is likely to have been among the first, if not the prototype.

The island mill would probably have served to grind the grains delivered to it from the vessels that tied up along the banks of the river.

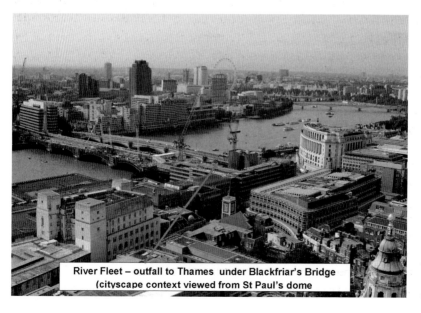

River Fleet – outfall to Thames under Blackfriar's Bridge (cityscape context viewed from St Paul's dome

The outfall of the River Fleet to the Thames under Blackfriars Bridge (cityscape context viewed from St Paul's dome).

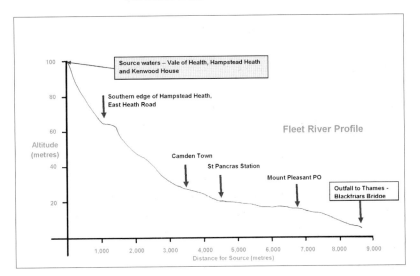

Profile of the
River Fleet.

If the theory is correct, it is probable that the mill, constructed in the first half of the second century, may have initially been powered by the tidal movement of the estuarial waters, but not for long, due to adverse alterations to tidal patterns in the middle of the second century. The same set of archaeological excavations also uncovered evidence of an aqueduct which would have delivered water to the mill from a point well upstream of the tidal reach of the Fleet, which would have allowed the mill to convert to more conventional water power and to increase its milling reliability and capacity. It is probable that this aqueduct was used to power other mills in the lower reaches of the Fleet.

Departure of the Romans to the Arrival of the Normans – 410 to 1066 CE

The Fleet River, or Flēot as it was called in the language of the Anglo-Saxons, was once again used as an urban development boundary. However, this time, Saxon development occupied the land westward of the Fleet's western bank. The Saxon settlement west of the Fleet, along what is now known as the Strand, was an area of raised land, the foot of its slopes being lapped by the Thames. This ribbon development appears to have been bounded by the Thames over an area which, using modern-day place names, extended from near Trafalgar Square, along the Strand and some way down Fleet Street towards the Fleet River at its eastern extremity. As had been the case in Roman times, the principal importance of this town was as a trading port, indicated by the Saxon name of Lundenwic, the suffix 'wic' indicating a port from which trade was conducted. Writing in the first decades of the eighth century, the Venerable Bede described London as 'a mart of many peoples coming by land and sea'.

The visual aspect looking eastwards over and across the valley of the Fleet would have been far more open than today. No tall buildings would have blocked the view to the east, and the principal aspect would have been a view of the ruins of Roman Londinium. From a modern tourist's point of view, the sight of the ruins of magnificent buildings in a semi-rural setting would be spectacular. However, the Saxon inhabitants of Lundenwic would probably have taken a far more pragmatic view of the ruins, seeing them as a source of building materials

for their own use. Many a foray must have been mounted across the Fleet River to plunder the remains of buildings left by the Romans to decay.

Although the Roman city was left to fall into ruins, the old city was not totally void of activity. The clergy, at least, appear to have adopted it – an important church, St Paul's, was established on Ludgate Hill in the early seventh century.

Pictorial maps of London, produced after the eleventh-century Norman invasion, depict the Fleet as being narrower than in Roman times, when it had been about 90 metres wide (about 300 feet). Not only was there a narrowing of the river in its estuarial section, but these pictures do not show any islands off its east bank near the mouth. It is a matter of surmise as to the process by which these topographic changes to the Fleet came about in the 600-year period following departure of the Romans. However, it is quite possible that the mill and the aqueduct feeding it, built by the Romans on the northernmost of the two islands, decayed and the ruins fell into the channel between the island and the river's east bank. This would have impeded flow in the channel, which would have slowly silted up above and below the obstruction, eventually completely filling in the channel and rendering both islands part of the east bank of the Fleet. The disappearance of the islands was probably an inevitable natural development, but it is also possible that the Roman ruins accelerated the process.

The basic industrial and trading activities of Lundenwic appear to have ceased for a short period as a result of further invasions in the middle of the ninth century. However, following the eventual repulsion of the invaders, King Alfred led a move to re-occupy and re-vitalise the area within the Roman walls. So, by the early eleventh century, Lundenwic could be said to stretch along the Thames from the eastern end of the London wall westwards to an area now occupied by Trafalgar Square.

Norman to Tudor Periods – 1066 to 1603 CE

It has been said that prior to the thirteenth century, the Fleet between the Thames and Oldbourne Bridge could accommodate sea-going ships which would load and unload their cargoes at the wharves, which were better protected than those along the main river. It may be hearsay, but the number of ships that could be accommodated was said to number between ten and a dozen. These included ships transporting sea-coal from the Newcastle coastline. However, by the 1300s, the river had become choked with the filth discharged from tanneries and other industries, as well as by refuse thrown there by the citizens, so much so that navigation had become severely hindered. By order of Parliament, the short navigable stretch of the Fleet was cleaned at the beginning of the fourteenth century so that once again ships carrying goods and fuel for the city could find a berth there. However, it appears that the Fleet must have regularly fouled up, as there are records of a number of subsequent cleansings which were carried out to render it capable of harbouring merchant shipping.

The Fleet was the natural receptacle for the wastes from many highly polluting industries, such as tanning, dyeing and butchery, as well as receiving wastes from numerous privies or 'houses of office' as John Stow refers to them.

Towards the end of the sixteenth century, a plan was drafted to bring various springs in the general area of Hampstead together to increase the base flow in the Fleet along its whole

length, and to effect a natural scouring of waste and refuse. However, apart from some initial works, the plan was never put into effect.

As the sixteenth century progressed and the population increased very significantly, probably tripling to about 150,000 by 1600, water supply posed an increasingly critical problem. The Corporation of London looked further abroad for sources and, in 1554, was granted a right over springs arising in Hampstead, as well as St Pancras and Hornsey, which were the source of the Fleet River. The Bishop of Westminster was to be paid a 'pound of pepper' as the annual rent of these springs, which were on Church lands. Rights to the water were only exercised by the Corporation of London in 1590 but the venture was never a commercial success.

According to John Stow, the Oldborne was a stream that was a tributary of the Fleet River. It was thought to have run parallel with and close to the street called Holborn, discharging into the Fleet at Oldborne Bridge. Its source was reputedly a spring near the Holborn Bar, the old city toll gate on the summit of Holborn Hill. However, it had already become one of London's hidden rivers by the time of Stow's researches at the end of the sixteenth century and is not referred to by William FitzStephen 400 years earlier. There does not appear to be any concrete evidence of the Oldbourne having existed, although the number of references to it do provide weight to it having flowed at some time.

The Houses of Stuart and Hanover – 1603 to 1760 CE

In spite of frequent outbreaks of Bubonic Plague, particularly the major events of 1603 and 1665, London's population grew rapidly through the seventeenth century from about 200,000 to more than half a million. Among increasing demands for many things, there was a significant rise in the need for coal. This was brought from the north-east of the country in barges which unloaded at wharves in the tidal Fleet, hence the street names on the east bank of the Fleet, Old Seacoal Lane and Newcastle Close.

The strategic value of the Fleet with respect to defence of the city has already been mentioned with respect to the Roman choice of its site for Londinium. Once again, this characteristic is apparent in the seventeenth century. During the Civil War, in 1642, the banks of the river north of the ravine at Holborn Viaduct were put to use by the people as a defence against Royalist forces which threatened the city.

Prince Rupert of the Rhine, appointed head of cavalry by his uncle Charles I, had proposed a rapid attack on London after Rupert's failure to provide cavalry support at the Royalist defeat at Edgehill. Others urged caution and the attack force moved only slowly towards London, giving Londoners time to build their defences along the Fleet. The people gave freely of their services over many days to build embankments alongside the Fleet through Clerkenwell to act as an impediment to invading troops. These hastily constructed defences were key to the failure of Rupert's plan, and it is probable that this outcome proved a pivotal point in the eventual failure of the Royalists to regain power.

The Fleet also figured in the movement to assassinate Charles II and the future James II, both Catholics in a predominantly Protestant England. After the failure of the assassination attempt in 1683, Sir James Scott, Duke of Monmouth, and other conspirators surveyed the area around the Fleet Bridge for a possible position to attack supporters of the King. They

considered it suitable for setting up their artillery on the higher ground south of Snow Hill and above the bridge. They also thought that they would be able to build defence works, behind which their snipers could hold off troops advancing from the west side of the Fleet. There was never an opportunity for this plan to be put into action as Monmouth, a pretender to the throne, began his rebellion in the West Country. His only entry to London was in 1685 for his trial and execution.

Tragic though the Great Fire of London of 1666 was, it presented an opportunity to reconstruct according to a more logical plan, and in materials that were not as inflammable as timber. Christopher Wren's part in this reconstruction with respect to his design of St Paul's Cathedral and another fifty-four of London's churches is well known. Perhaps less well-known is his preparation of a plan for reconstructing London. This included a proposal to clean up the lower Fleet and to turn it into a canal. He obtained private backers to finance the project, which was granted permission to proceed. In the period 1671–4, the river was reconstructed as a canal over the length from the Thames up to Holborn Bridge, having a standard width of 40 feet and depth of 5 feet. The walls of the Fleet Canal were constructed out of stone and four bridges were built over it. The bridges were constructed as high arches, similar to those on the Grand Canal in Venice, and, impractically, were suited only to pedestrian traffic.

Wren conceived the plan as a commercial venture; the canal was to pay for its construction and operation through port charges. However, in this respect it was a dismal failure and the canal's wharves soon fell into disuse and disrepair. In part, this was due to the huge amount of detritus – discharges from the meat market at Smithfield and the associated tanneries. These accumulated in the canal and gave rise to horrendous odours from rotting flesh, hides and blood, as well as from sludge formed from vast amounts of stale sewage that gave off strong sulphurous odours.

The Fleet figures throughout this period as the principal London river, second only to the Thames. Although totally open at the beginning of the eighteenth century, by the end of it it had been arched over and covered for most of its course downstream of King's Cross.

The Fleet valley from Clerkenwell down to the Thames was a degraded area with poor housing and slum areas. It housed many of London's prisons, the Fleet, Ludgate and Bridewell prisons and nearby Newgate Gaol, above the river's western bank at Holborn. It was during the seventeenth and eighteenth centuries that Turnmill Street and its immediate surroundings, on the east bank of the Fleet, consolidated its reputation as one of the most dangerous places in London. All manner of vice was practised in the area with felons, victims and clients of professional women fuelled by drink at the many hostelries of the district. Known for its unsavoury character at least since Shakespeare's time, it was not a good place for law-abiding citizens with any moral fibre to frequent.

There are two news stories from the time which give an insight into conditions by the Fleet River, one amusing and one which could be material for a black comedy.

A boar, escaping from a butchers in Smithfield, lived for five months in the Fleet Sewer and was recaptured on 24 August 1736: 'a fatter boar was hardly ever seen ... and was improved in price from ten shillings to two guineas' – a four-fold increase in value.

There had been a number of accidental deaths, mostly drunks stumbling into the river after a night at the bars and stews along Turnmill Street. One unfortunate, a barber in town from the country, fell into the Fleet, got stuck in the mud and was found, still standing upright,

frozen to death the following day, although it is probable that he was asphyxiated first by the gases given off by the putrid mud.

John Rocque's map of 1746 shows the Fleet partially arched over and covered in the area between Saffron Hill and Turnmill Street and north of Saffron Hill until Mount Pleasant. However, it remains open in this period northwards from Mount Pleasant right through to its two main sources in Hampstead and Highgate.

The canalisation of the tidal Fleet by Wren proved extremely unpopular, and in 1737 the canal was arched over and covered from Holborn Bridge down to Ludgate Circus, leaving the final section to the Thames open for the time being. Wren's canal had lasted only about fifty years, with its commercially useful life being less than half that. The Fleet Market, selling meat, fish and vegetables, was constructed over and along this first section of the Fleet to be covered. It is a sad fact that Wren's expensive canal served only as foundations for the structure covering it.

At the upstream end of the Fleet in Hampstead, the Corporation had failed to make good use of its right to draw off water from the source springs of the Fleet in Hampstead. In 1692, it leased the rights to the water to a private consortium which called itself the Society of Hampstead Aqueducts, more popularly known as the Hampstead Water Company. The company constructed more ponds below Caen (or Ken) Wood, which were fed by the springs in the vicinity of Ken Wood House which were one of the sources of the Fleet. However, the company was never able to become commercially viable.

Regency London – 1760 to 1837 CE

Culverting and covering of the Fleet continued in this period. In 1769, covering of the lower end of the Fleet was completed with the section from Ludgate Circus through to the Thames. The work was undertaken to create a wide road leading to Blackfriars Bridge (originally called William Pitt Bridge), the construction of which was completed in the same year.

The Hampstead Water Company continued to struggle to supply water to Hampstead and an area between there and Camden, but it was really up against it as the quality of water deteriorated and it found itself unable to keep up with demands. It built the pond at the foot of the Vale of Health in South Hampstead but even this failed to improve the reliability of its supply. It was constantly having to seek financial arrangements with its creditors. From 1800, in order to supply its customers with water, it frequently called upon the New River Company, which generally acceded, if rather reluctantly, to its requests.

In 1812, the course of the Fleet was culverted and covered from Battle Bridge (known as King's Cross from 1832, after an outbreak of patriotism) upstream to Camden. This work was undertaken to assist the construction of the Regent's Canal, which crosses over the Fleet River at Camden Town.

The Fleet Market, constructed over the Fleet between Ludgate Circus and Holborn Bridge, was demolished in 1829 and moved to nearby Farringdon Market. The removal of the market and the Mansion House cleared the way for the extension of Farringdon Road from Ludgate Circus northwards towards Battle Bridge.

Pre- to Post-Victorian London – 1837 CE to Present

The two branches of the Fleet upstream of their junction at Camden were the last to be covered over as the suburbs progressed northwards. Inevitably, the culverted rivers were used for the disposal of greatly increased flows of sewage generated by these developments. Bazalgette's scheme for the main drainage of London included High, Mid and Low Level Interceptor Sewers, which, as their name suggests, intercepted the flows from all sewers and drains that carried sewage.

As mentioned previously, in *The Pickwick Papers* Samuel Pickwick addresses his creation, the Pickwick Club, on the subject of 'Speculations on the Source of Hampstead Ponds with some Observations on the Theory of Tittlebats'. In the story, we never actually get to learn the content of his paper, but had he made this public we would have heard how the springs of the Heath were the source of the ponds and they, in turn, were the source of the Fleet River. However, we might also have learned that the Tittlebat was none other than one of the most common fish in Britain's streams and lakes, the Stickleback – or 'Tiddler' as countless youngsters know it.

In 1846, the Fleet, which had long been covered over at least as far upstream as St Pancras, 'blew up', causing havoc and considerable damage. No longer graced by its description as a river, the Fleet was by now acknowledged to be a sewer. The culverted river appears to have become blocked, probably over some considerable period, in the vicinity of King's Cross. Sewer gases, including a lethal, inflammable and explosive mix of hydrogen sulphide and methane, built up behind the blockage. What triggered the explosion is not known but the subterranean upheaval released a tidal wave of sewage along the Fleet and the streets above it. The force of the wave flooded and destroyed buildings, including three poorhouses, and ended up throwing a river boat against the abutments of Blackfriars Bridge, as previously mentioned.

The 1852 Water Act sealed the fate of the Hampstead Water Company. Restricted to drawing its water from the Hampstead and Highgate ponds, it had only ever been able to supply water intermittently, and from the late eighteenth century the quality had deteriorated significantly. The Water Act required all water to be filtered, and all reservoirs storing filtered water to be covered. In addition, all suppliers were to ensure that they progressively converted to providing a continuous supply through continuously pressurised distribution networks. The Hampstead Water Company could not comply and its undertaking was taken over by the New River Company, which decided that the Fleet water discharged from the Highgate and Hampstead ponds should not be filtered, but would be supplied to customers that could use it in its unfiltered state. Unfiltered water, which would otherwise have formed flow in the Fleet River, was supplied to the two railway companies operating out of King's Cross and St Pancras from the mid-1850s, and later to St Pancras Borough Council, for public lavatories and watering of gardens in the public parks. The New River had to periodically renew the lease on the Hampstead and Highgate ponds and in 1936, after the railways indicated they no longer needed the water, they decided not to renew.

With the Fleet no longer contributing to London's water supply, it was soon subjected to its final degradation when, in the 1870s, it was intercepted into the High Level Sewer as it passed through lower Hampstead and Highgate.

CHAPTER 9

The River Tyburn

THE TYBURN – ORIGIN OF THE NAME

The River Tyburn passes from north to south through the area formerly occupied by the manor of Tyburn. The manor was one of two in the parish of St Mary-le-Bourne, or Marylebone. The Tyburn manor house was situated at the intersection of Oxford Street and the Edgware Road, formerly the Tyburn Road and Tyburn Lane respectively. The River Tyburn formed the eastern boundary of the manor, which is named in the Domesday Book. The name therefore probably pre-dates the Norman Conquest, which gives weight to a common assertion that the name Tyburn was Anglo-Saxon in origin. It is thought to have originated as either Teo Burn or Ty Burn, both interpreted as 'two streams'. In fact, the Tyburn was composed of two branches through Marylebone. One wound its way north to south, along the line of today's Marylebone High Street, and the other originated in Hampstead and arrived from the west side of Regent's Park, formerly Marylebone Farm. The two streams met at Marylebone Lane.

An explanation of the name that carries less credence in the author's view is that the stream was named for the Saxon god Tyr or Tiw, who was the god of single combat and, according to one source, law. It appears that prior to the construction of a church to St Peter on Thorney Island, there had been a tree which was a Druid meeting place, and that this is the ancient origin of law-making on Thorney Island, later to become Westminster, home of the British Parliament. The Tyburn branched at its estuary with the Thames, forming Thorney Island. Although the link appears tenuous, it could be the reason why British lawmakers are so confrontational in their deliberations.

It is difficult to know whether the name 'Aybrook' is used interchangeably with the Tyburn on its passage through Marylebone, or whether it is the name of a short tributary of the Tyburn which made its way north to south along the line of Aybrook Street to enter the Tyburn as it made its way along Blandford Street. However, it is curious that Tyburn does not appear in any modern street or place names. Tyburn has virtually no resonance with Londoners with respect to a river; it is in common use only with respect to the place of execution at Marble Arch, the site of the notorious three-sided 'Hanging Tree', from 1571 to 1783. The river passes across Oxford Street about 700 metres to the east of Marble March.

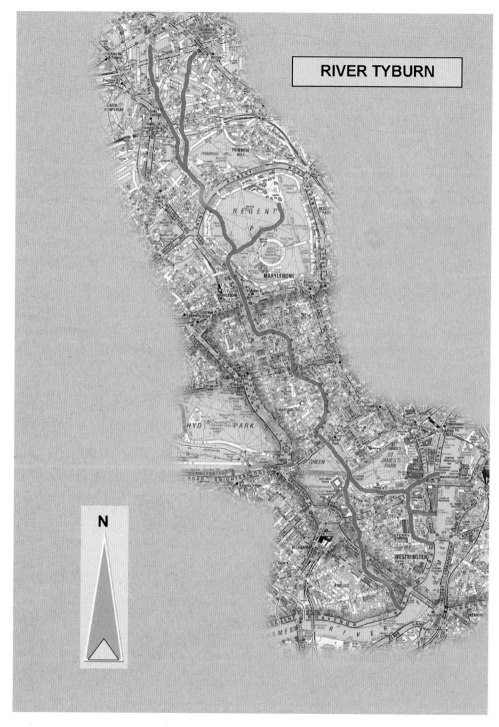

Map showing the course of the River Tyburn.

In the first millennia of the Common Era, the Tyburn appears to have been a readily identifiable river through to the area of Green Park and Buckingham Palace, although it long pre-dated these relatively recent landmarks. The land from that point through to the Thames was low-lying and flat, and therefore marshy. There are a number of theories as to the course – or courses – taken by the Tyburn through the marsh to the Thames, but almost certainly only a very few were well-defined.

Enough map and documentary evidence exists to support the contention that a number of delta-like fingers connected the Tyburn at the southern end of Green Park to the Thames. One of these continued on a southward path just to the north-east of Victoria and discharged into the Thames just upstream of Vauxhall Bridge. This stretch of the Tyburn, from Victoria to the Thames, was known as the Tachbrook. It is also the route taken by the King's Scholar's Pond Sewer, acknowledged to be the name for the tainted form of the Tyburn over the length between St John's Wood and the Thames at Vauxhall.

On occasion, the River Tyburn has been confused with another watercourse, the Tyburn Brook. This latter has its source just to the north and west of Marble Arch, the site of the Tyburn Hanging Tree, about 900 metres to the west of where the River Tyburn crossed under Oxford Street. The Tyburn Brook passes southwards from its source a relatively short distance before entering the Serpentine. It was once a tributary of the Westbourne, the original source river for the Serpentine.

THE TYBURN – SOURCES AND WATERCOURSE

There are two sources of water for the River Tyburn, both being springs on the southern slopes of Hampstead and issuing at about the 90-metre contour, the approximate elevation of the interface between the Bagshot Sands and the underlying clay.

The principal source of the River Tyburn is the spring known as Shepherd's Well in Fitzjohn's Avenue, Hampstead. Until the 1870s, this well was set into a rural hillside. Shepherd's Well was a brick-arched conduit fed by a spring that produced Hampstead's purest water, very low in mineral content. The source never froze in winter and water-carriers made scant living carrying buckets of its water to remote dwellings. The well played its role in Dr Snow's famous discovery in 1854 that cholera was a waterborne disease. A wealthy local woman refused to drink Shepherd's Well water, as it was 'tasteless'. Coming originally from Soho, she insisted on water being brought from the Broad Street Pump to drink. Snow demonstrated that those who drank the water from that pump were most likely to die from cholera during the 1854 outbreak. The Hampstead woman was among the first to die, but no other person living near Shepherd's Well and who used its waters died from the disease.

The second source of water for the Tyburn was a spring, only 750 metres to the west of Shepherd's Well, that rose just off Haverstock Hill, behind the present location of Hampstead Town Hall.

It is possibly a coincidence, but like the waters of Shepherd's Well, the lake in Regent's Park rarely froze in its early years, when it was still fed by the River Tyburn. The waters of the Tyburn remained clean enough to drink through the Middle Ages, as they formed one of

the principal sources of drinking water for the cities of Westminster and London. However, by the early seventeenth century, the lower reaches were already polluted.

The main course taken by the River Tyburn from the Shepherd's Well, situated where Lyndhurst Road meets Fitzjohn's Avenue, to the Thames at Crown Reach, immediately upstream of Vauxhall Bridge, is 9.1 km (5.7 miles) long.

The profile of the river bed is shown on the diagram following the map of the river's course. The Shepherd's Well source issues at precisely the 90-metre (295 feet) contour. The river then slopes steeply down to Swiss Cottage at a level of 57 metres, and then much less steeply to Woronzow Road in St John's Wood at 40 metres. From Regent's Park to the river, the gradient of the river bed is a gentle one, the Embankment being at a level of about 5 metres.

From Shepherd's Well the river runs in a general south-south-east direction the whole way to the Thames, with the exception of a few local turns and curves. However, it first flows south down Fitzjohn's Avenue for a few hundred metres before taking up its general course just east of south under Belsize Lane, Belsize Park and Buckland Crescent. It passes under the basement of the Central School of Speech and Drama (which used to be the avant-garde Embassy Theatre) and the Swiss Cottage leisure and community centres on Winchester Road, crosses Adelaide Road, and passes along the eastern boundary of a school. After the school, the river crosses diagonally under Avenue Road at Queen's Grove and crosses Norfolk Road to flow between Townshend and Woronzow Roads. At its junction with Allitsen Road, the route turns south for about 300 metres while crossing under Shannon Place and Eamont Street and resuming its previous direction at Charlbert Street. Here, the river passes beneath Prince Albert Road to cross over the Regent's Canal. John Hollingshead, a Victorian adventurer and eccentric, made an escorted trip along the King's Scholar's Pond Sewer, starting in St John's Wood and finishing at the Thames. He wrote of the crossing of the Regent's Canal:

> … We passed through an iron tube, about three foot high and two feet broad, which conveys the sewage over the Regent's Canal, through the crown of the bridge.

The bridge referred to is the pedestrian bridge which still exists today, by means of which visitors can gain access to Regent's Park. Note that in 1860, the river was already a sewer draining the immense amount of development that had taken place in St John's Wood and Swiss Cottage over the previous forty years. Incidentally, Hollingshead's journey was made mostly on foot through treacherously dangerous sewers, but the last part, downstream of Buckingham Palace, was undertaken in a small boat.

The river passes under the Outer Circle, Regent's Park's perimeter road, and through the grounds of Winfield House, the residence of the US Ambassador. After leaving these private grounds the river enters the Royal Park and was used to form the large ornamental lake which occupies much of the south-west portion of the park. However, the river was used for less than thirty years for feeding the lake; it became so polluted that it was diverted and alternative sources of water used.

Leaving the lake about halfway along its western bank, the river passed under the Outer Circle and through Sussex Place to cross Park Road and pass between Chagford and Gelentworth Streets to the Marylebone Road. The route crosses under the Marylebone Road

The River Thames from Lambeth Bridge.

about 100 metres west of Baker Street station, and passes under a series of late Victorian mansion apartments in Bickenhall and York streets and along Montagu Mansions. Having crossed under Dorset Street, the river turns eastwards for about 400 metres along Blandford Street, in the course of which it crosses Baker Street.

At Marylebone High Street, a tributary arriving from the north along that road past the original Marylebone village joins with the main river at Marylebone Lane. It is this junction which, in all probability, gave the river its name, as previously explained. The river passes around the inner curve of Marylebone Lane as far as Wigmore Street, but here edges to the west to pass down a narrow lane, Stratford Place. Crossing Oxford Street just west of Bond Street station, the river curves back to resume a south-easterly direction by way of Gilbert and Weighhouse streets, passing down South Molton Lane. At the bottom of the lane, the route crosses over Brook Street and along Avery Lane, over Grosvenor Street and down the slope of Bourdon Street. At the low end of the street, the river passes beneath buildings before crossing under Bruton Street and entering into and following the curves of Bruton Lane. Issuing from the lane, the river crosses Berkeley Street, after which it flows under Lansdowne Row to Curzon Street.

From its crossing of Oxford Street, the river executes a long curve, over a distance of about 2 km, from a south-easterly direction to a south-westerly one along Curzon Street. Just before Queen Street, the river executes a turn back to its original direction of just east of south to pass by the eastern edge of Shepherd Market, and along White Horse Street to cross Piccadilly into Green Park. The river flows straight across the park and curves around the Queen Victoria Memorial, which fronts the precincts of Buckingham Palace, on its St James's Park side.

It is difficult to avoid reporting the intrepid Hollingshead's delicious account of this point in his journey along the Tyburn, by that point long a sewer. They had previous surfaced for

air at Piccadilly and Green Park before returning to the sewer, which was, by now, more than tall enough to stand up in:

> ... We had not proceeded much further in or downward course when ... the guides stopped short, and asked me where I supposed I was now? I thought the question unnecessary, as my position in the sewer was pretty evident ... "I give up," I replied. "Well, Buckingham Palace," was the answer. Of course my loyalty was at once excited, and, taking off my fan-tailed cap, I led the way with the National Anthem, insisting that my guides should join in the chorus.

The tongue-in-cheek humour of the British appears to have changed little over the centuries.

It is at this point, the lower end of Green Park, that the river would have entered what would, at the time of the Norman invasion, have been a broad swath of marshland stretching from the Mall southwards through Whitehall, Victoria and Westminster to Vauxhall and, possibly, beyond. This marshland was to be the site for the City of Westminster, the development which would centre its activities around the monarchy and government. Over the 500 years following the arrival of the Normans, this area was gradually reclaimed as it was needed for palaces, Church buildings, schools, administrative offices and housing to accommodate the aristocracy, Church personnel, civil servants and the population needed to serve the needs of 'their betters'. It was an area that was also home to the criminal classes, due in part to the rich pickings of the locality and in part to the easy sanctuary available to them in Westminster Abbey when the 'hue and cry' was raised. It might well be that these low-lifes were the original inhabitants of the area, its marshy nature affording them an excellent place to retreat to and hide out in.

The Tyburn is thought to have spread its fingers delta-like from this point through to several points on the Thames.

One finger that almost certainly flowed eastwards itself split and formed an island, Thorney Island, the site of the West Minster and nucleus for the palaces, abbey and court. Another branch from this finger of the Delta followed Tufton Street and Horseferry Road to discharge to the Thames upstream of the modern Lambeth Bridge.

However, the main route for the Tyburn from the area of St James's Park was southwards through Victoria, across Vauxhall Bridge Road and along Tachbrook Street, which echoes the former local name for the Tyburn. The river crosses the eastern end of Lupus Street into Bessborough Place and from there into the Thames, having crossed under Grosvenor Road.

The diagram shows the profile of the River Tyburn along its course from Shepherd's Well through to the Thames at Westminster and Lambeth bridges. Shepherd's Well is situated approximately on the 90-metre contour at which level most of the springs on Hampstead, Highgate and the Heath are situated. The fall along the river can be seen to be pronounced as it flows down Fitzjohn's Avenue away from the well, through Swiss Cottage to Regent's Park, where it plateaus before descending again at a much lesser rate than previously. The area around St James's Park has been raised about 5 metres (16.4 feet) over the last thousand years but would have previously been only very slightly above the level of the banks of the Thames, causing the marshy conditions that were characteristic of the whole of Westminster and its hinterland.

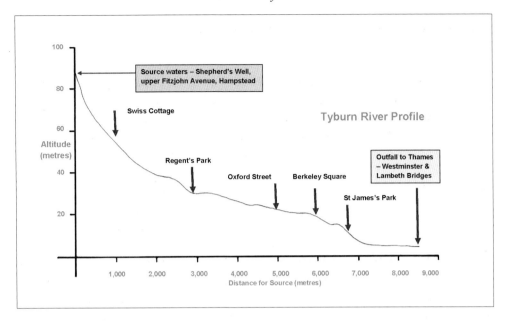

Profile of the River Tyburn.

THE TYBURN THROUGH HISTORY

Roman London – 43 to 410 CE

The Tyburn does not appear to figure as a feature of Roman London. It flows into the Thames several kilometres to the west of the area chosen for the development of Londinium. However, there remains some doubt as to where the Romans made their first crossing of the Thames – from the shallow reaches surrounding the islands that would become Southwark, or in the vicinity of what would, some six centuries later, become the site of an abbey, the West Minster on Thorney Island at the mouth of the Tyburn. It would be another 1,800 years or so before the Thames would be narrowed and 'tidied up' by the embankment walls built by Joseph Bazalgette, and the Thames at Thorney Island was just above the tidal limit and far wider and much shallower than today. Whether or not that first crossing by the Roman military was made opposite the marshy estuary of the Tyburn, the area does not subsequently appear to have played any significant role during the period of their occupation.

Departure of the Romans to the Arrival of the Normans – 410 to 1066 CE

As important as these physical developments to the future establishment of London as England's premier city was the arrival of institutionalised Christianity into Britain at the end of the sixth century. There had been a thriving Christian following in Roman Britain, but it is probable that this was due to laypersons who happened to practise the faith immigrating. Now, in company with Canterbury and Rochester, London was chosen as one of the sites for some of the first churches. About 400 years later, in the decades preceding the Norman

invasion, King Edward, known as the Confessor, was concerned to find a site for a great church, the architecture of which was to emulate the Norman style.

At this point, another of the hidden rivers, the Tyburn, begins to play its part in the story of London, although, at the time, it was not hidden at all. The stream now known as the Tyburn emanated from the southern slopes of Hampstead and created a marshy area which extended from the present site of Buckingham Palace to the banks of the Thames between Vauxhall and Westminster. Just before entering the Thames, the Tyburn divided into three distinct streams, two of which created an island covered in thorn bushes, hence its name Thorney Island, on the slightly higher land between them with the Thames forming its eastern boundary.

In the century following the arrival of evangelical Christianity, a monastery was built on Thorney Island. According to legend, St Peter appeared to a fisherman and his son and asked them to ferry him across the river from the island to its southern bank, and so the monastery was dedicated to St Peter and it became the custom for Thames fisherfolk to present gifts of fresh fish to the monastery.

Edward I chose this island on the north bank of the Thames, known as Thorney Island, as a site for his church. By the time that Edward began the construction of his magnificent church, Westminster Abbey, St Peter's Monastery had already become known locally as the West Minster. St Paul's, on Ludgate Hill, was known as the East Minster.

As grand and imposing as Edward's Westminster Abbey is today, the isolation of this great church on an island formed by the Tyburn at its confluence with the Thames, and devoid of any other developments, must have emphasised the grandeur of the construction to an even greater extent.

Edward began a development trend, continued and strengthened by the Normans, which led to a bi-polar development of London, with Westminster at one extremity and the City in the east.

Norman to Tudor Periods – 1066 to 1603 CE

By the time that William arrived in England to be crowned as its Conqueror, the three areas from which London then developed were already defined: the redeveloped Lundenburgh (with Roman Londinium as its core) in the east, Westminster in the west and, between them, the area that the Saxons had previously known as Lundenwic. However, by then, Lundenwic had been abandoned as a town and the area had all but reverted to rural land.

William constructed a castle to protect the eastern end of the development, the Tower of London. However, he chose for the site of his palace an area of land very close to that chosen by Edward for his Westminster Abbey. The Palace of Westminster is still there today.

Until the twelfth century, the citizens of London appear to have been able to make use of local sources of water for their domestic and trade use – wells sunk into the gravel which underlay the City or water drawn from the rivers and their main tributaries, the Thames, the Walbrook and the Fleet. However, John Stow, writing in the late seventeenth century, states that these sources had become so polluted as to be unsuitable. In 1237 Gilbert Sanforde, who was the owner of the Manor of Tyburn, granted a right over water from the River Tyburn to the City. A lead pipe was laid from what is now Stratford Place, immediately north of Oxford Street at Bond Street underground station, into the City. The water was

supplied free to citizens through public water fountains, misnamed conduits at the time. These were set up in the main streets and were quite ornamental in design. So the Tyburn was the first of the hidden rivers to have its waters conducted some distance to supply London's citizens with water. The Tyburn, referred to by Stow as the Tybourne, was also tapped at another location in the middle of the fourteenth century. In 1433, John Wells, who built the chapel of the Guildhall, financed the transmission of water from the Tyburn as far as West Cheap for the use of the general citizenry of the City. William Eastfield, another mayor, similarly arranged for water from the same source to be brought to new outlets at Aldermanbury church and in Fleet Street.

Although it is speculation on the author's part, the later eleventh century and the twelfth century probably saw the beginning of the process by which London's rivers came to be 'hidden', starting with the northern branch of the estuarial Tyburn. The culverting and covering over of this stretch of the river would have been necessitated by the construction of administrative and residential buildings associated with the needs of the palace and the monarchy. Indeed, maps of the time, although generally not much more than sketches and artists' impressions, show only the southern branch of the Tyburn draining the nearby marshy areas into the Thames near modern-day Horseferry Road. The inaccuracy of depiction of actual situations on these plans and maps means that dating the start of the process of hiding London's rivers to this time can only be conjecture.

In 1174, William FitzStephen, a servant of Thomas Becket, described the streams before they entered London as 'sweet, wholesome and clear whose runnels ripple amid pebbles bright'. Another translation from medieval English has the same phrase more poetically represented as 'mid glistening pebbles gliding playfully'. FitzStephen described many aspects of London of the time, always in glowing terms, as to him it was 'the city of London – seat of the English monarchy – one whose renown is more widespread, whose money and merchandize go further afield, and which stands head and shoulders above the others'. Even given his tendency to put an exaggerated gloss on London and its inhabitants, it is possible to understand that the banks of London's rivers, outside the urban area, were very pleasant places to take recreation and were indeed used for that purpose.

The first example of this relates to St James's Park, the first of the London Royal Parks. Until the 1530s, the land occupied by the park was owned by the Church and a leper hospital for women had been built there, St James's. In the course of the Dissolution of the Monasteries, or Suppression of the Monasteries, over a period of five years from 1536, Henry VIII acquired the hospital's land as a deer park for hunting, the land being close by his palace in Whitehall. The Tyburn passed through the western end of this land and rendered the area marshy meadowland, subject to frequent flooding by the river. St James's Palace was originally built by the King as a hunting lodge. It is probable that, due to the intervention of the Tyburn, the marshy nature of the ground attracted ducks and geese which would have broadened the range of quarry for the huntsmen.

We are fortunate that Henry VIII had a great liking for hunting deer and the creation of parks near to his residences in which to keep them while they waited upon his attention. Henry confiscated another piece of land through which the Tyburn passed, this time from the Abbess of Barking. The land was in the Manor of Tyburn and Henry expropriated a large area, roughly circular in shape, which he enclosed using earth embankments and stocked with deer.

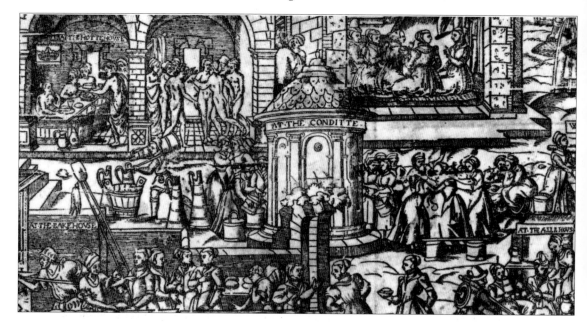

A City of London water conduit, probably in the fifteenth century.

He called this Marylebone Park, which was to be later re-modelled at the beginning of the nineteenth century as the Regent's Park. However, it was his son, Edward VI, in the middle of the sixteenth century, who fenced the area and used the waters of the Tyburn to form ponds. Queen Mary tried to sell off both Hyde Park and Marylebone Park but, fortunately, she failed, and Elizabeth then renovated Marylebone Park, including its Tyburn-fed water features.

The Houses of Stuart and Hanover – 1603 to 1760 CE

During government of Britain by the Commonwealth, Marylebone Park, later to be known as the Regent's Park, was pillaged for wood and the Tyburn-fed ponds were allowed to deteriorate. The park ended up in a very poor state. After the Restoration in the mid-seventeenth century, the park was leased to tenant farmers and it remained principally as pasture land for herds of cows until the beginning of the nineteenth century.

Water from the Tyburn continued to contribute to the range of interests offered to the monarchy by St James's Park in the reign of James I, who added to the recreational value of the area by draining and landscaping the area. He arranged for a pond to be formed at the west end of the park, Rosamond's Pond, and for further water features at the Whitehall end – ponds and duck islands.

On his return to England as king, Charles II arranged for a Frenchman, André Mollet, to landscape the gardens in the formal French style. This included an impressive rectangular lake 780 metres (2,560 feet) long, running east-west, and 38 metres (125 feet) wide. The lake was lined either side by two lines of trees. The water for the lake was drawn off the River Tyburn. Charles opened the park to the general public, and would frequently take a stroll along the lake with his mistress, Nell Gwynne.

Rosamond's Pond, a much smaller rectangular basin, also fed by the Tyburn, created by Henry VIII, was left in place at the western end of Mollet's 'canal' until, in 1770, it was finally filled in.

Another of the Royal Parks was also fed by the waters of the Tyburn. This was Green Park, or Upper St James's Park as it was known until 1746. It lies between Hyde Park and St James's Park, just south of the area known as the Mayfair, and is the link in forming a virtually continuous green belt from Kensington through to Whitehall. Land was acquired for the park by Charles II, who wanted to be able to walk unhindered through parkland from Hyde Park through to St James's Park.

The Tyburn turns south out of Mayfair and crosses into Green Park. At the beginning of the eighteenth century, a small pond was formed in the park and named Tyburn Pool. Although long filled in, a small depression in the ground still marks its general location. Queen Caroline, the wife of George II, had a fondness for gardening and landscaping. Green Park was a favourite of hers and, in the 1720s, she had a larger pond built there to serve St James's Palace and Buckingham House. This was also originally filled from the Tyburn and called the Queen's Basin. She had a long, tree-lined promenade constructed leading to the reservoir which, in its turn, was called the Queen's Walk. However, on construction of the Chelsea Waterworks, the two ponds were converted into reservoirs.

John Rocque's excellent 1764 map of London, Westminster and Southward shows both of these reservoirs, now rectangular in plan. The smaller one is not named on the map but the other is noted as 'Reservoir to Chelsea Waterworks'. This is shorthand for 'belonging to Chelsea Waterworks'. The water was pumped to the reservoirs in the park from the Chelsea Waterworks before distribution to houses in St James's – and possibly the neighbouring parts of Mayfair. It is unclear – but possible – that the Tyburn continued through Green Park to the area in front of the north-east aspect of Buckingham House (later Palace), and then south to the Chelsea Waterworks. Chapter 9, on the Westbourne, contains more background on Chelsea Waterworks, as that river was one of the sources of water for the treatment works.

George IV opened Green Park to the public in 1826, but by the middle of the nineteenth century, at Victoria's request, both Tyburn's Pool and the Queen's Basin had been demolished and the visible links to the Tyburn in the park had disappeared.

Regency London – 1760 to 1837 CE

It was George IV, formerly known as the Prince Regent, who arranged for the reconstruction of St James's Park into the gardens of today. He engaged the architect John Nash, whom he had used on many other great projects while the Prince Regent. Nash, who had also been involved in a re-design of the neighbouring Buckingham Palace, produced a less formal, more natural layout for the gardens and, in particular, the ornamental lake, which was enlarged, widened and curved from west to east.

Nash was not necessarily the most precise of designers. The triumphal arch that he had designed and had built at the entrance to Buckingham Palace had to be rapidly taken down and re-constructed at the intersections of Park Lane and Oxford Street, at Marble Arch, as it was too narrow for the passage of the King's broadest carriages!

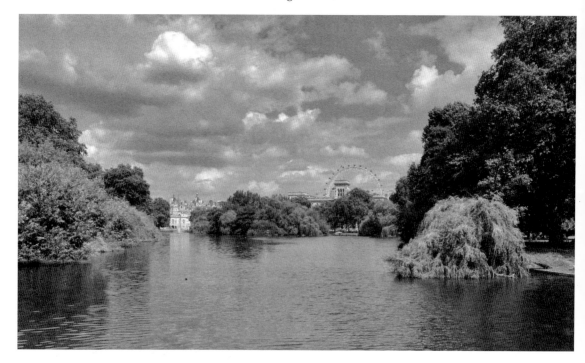

St James's Park lake, looking towards Whitehall.

The employment of John Nash by the Department of Woods and Forests in 1806 led to his meeting the Prince Regent. Their combined talents, the vision of the Prince Regent and the capabilities of Nash as both architect and landscaper, resulted in many projects that beautified London and which remain with us today. By the end of the eighteenth century, the leases of the tenant farmers who worked the land in Marylebone Park for dairy farming and hay-making were coming to an end. It had become clear that something needed to be done to rehabilitate the area.

The greatest project created by Nash at the Prince Regent's request – and with his involvement – was to create a wide thoroughfare and crescents, appropriately lined with residences for the wealthy, to link his then-residence, Carlton House, The Mall, to the Regent's Park, where the Prince Regent envisaged a summer pavilion would be built for him. The Prince Regent was already heavily involved in promoting the construction of a canal which would link the Paddington Basin to Limehouse on the Thames: the Regent's Canal. Unsurprisingly, the proposed road from Pall Mall to the Regent's Park was to be called Regent's Street!

Nash was asked to produce plans for Regent's Park. Fortunately, the elitist plans for fifty mansions in their own park with the Regent's Canal bisecting the land from west to east never proved a commercial success. Only eight residences were ever built and the rest of the land was laid out as a park, with the Tyburn-fed ponds once again providing the water feature. The Regent's Canal was re-directed around the northern boundary of the park and the Tyburn still crosses over it in a culvert beneath a footbridge, shortly after the canal enters the park from the west.

In 1836 Parliament determined that the Regent's Park should be opened to the public.

The establishment of Regent's Park and the building of magnificent houses around the southern half of its perimeter, as well as a few within the park, gave the area an ambience of opulence. This became a major factor in the development of the area north of the park, from St John's Wood – until then woodland – through to Hampstead. Developers saw the potential for constructing housing for the wealthy on land that had views over the park towards London. From the 1820s onwards, the area became the site for houses which now rank among the most expensive real estate in London. This trend was further assisted by the contemporaneous building of the Finchley Road between Regent's Park and Frognal, on the western slopes of Hampstead. The improved road conditions enabled larger horse-drawn coaches and omnibuses to terminate at Swiss Cottage and convey residents into the City. Later in the century, popular housing for artisans, workers and clerical staff took up the remaining undeveloped areas. Indeed, it was in St John's Wood that the concept of the semi-detached house, peculiar to the British, with two dwellings with each forming half of a single house was first tried out.

Pre- to Post-Victorian London – 1837 CE to Present

The Tyburn, which through to the beginning of the nineteenth century had remained a sparkling, clear stream through to the New Road, now Marylebone Road, was first used to form the pond in Regent's Park and was then progressively covered over as development spread northwards. By the 1830s, it had disappeared underground as far as Swiss Cottage. Then, as housing spread along the progressively extended Fitzjohn's Avenue, between Swiss Cottage and Hampstead, the Tyburn disappeared from view completely. In its underground form, it was incorporated into the surface water drainage network, but, from the time of the first development north of the park, it was also used to carry domestic sewage and by the 1860s was a sewer.

The sewers of London appear to have had a strange fascination for Victorian gentlemen, and this has carried through to a few London eccentrics today. From where the Tyburn entered Mayfair, crossing Oxford Street at Bond Street station, the Tyburn was – and remains – known as the King's Scholar's Pond Sewer, named for where it passes through Westminster School into the Thames. In 1860, as previously mentioned, John Hollingshead became the first of the Tyburn's 'explorers' to walk the sewer from St John's Wood into town. He did this in company with a number of sewer-workers. Having come up for a breath of fresh air in Piccadilly, before the park, there was a comic moment when he insisted on the men standing to attention as they reach Buckingham Palace. They were then required to doff their caps as they sang the National Anthem.

CHAPTER 10

The River Westbourne

THE WESTBOURNE – ORIGIN OF THE NAME

The Westbourne is possibly the least enigmatic of the hidden river names with respect to the origin of its name, although there certainly is some element of doubt.

It is a name that can be traced back only a few hundred years or so and is thought to have been a description of its situation in relation to the rapidly developing parish of Paddington – 'the bourne west of Paddington'. Although the name is recognised by Londoners as being an area of the capital, very few would make the connection with the river north of Maida Vale, even if they live on its route. The name is not found applied to any street or district north of Westbourne Park and Westbourne Green, immediately west of Paddington.

However, there is a small possibility that the river is named after West End in West Hampstead, as the river passes through West End village and green a little way downstream of where it rises on Hampstead Heath.

Travellers to and from London using Watling Street, the pilgrims' route to St Albans, now the Edgware Road, would have been aware of the river as they crossed the bridge over it at the southern end of the settlement called Kilburn. However, as the name suggests, a different name was used for the Westbourne at this point – the Kil-burn. There is much speculation as to how this name came to be applied. Nicholas Barton proposes two possible derivations – 'cyne-burna' and 'cyna-burna', which he translates as 'royal stream' or 'cow's stream' respectively. However, one cannot but speculate as to the position of his tongue with respect to his cheek on this particular one. An unnamed researcher has proposed Cuneburna, 'cattle stream', as the name has been found in a late-twelfth-century document with reference to the priory which was located by the stream at this point. This research also throws up 'Cyebourne' and 'Kelebourne'. Another researcher, Steven Denford, proposes 'Cuneburna', also translated as 'cow's stream', so some overlap there. But he goes on to suggest 'Kyle-bourne', with obvious similarity to 'Kelebourne', meaning 'cold water'. This author favours the last offering, but for no other reason than that it is the most similar in spelling and sound. There are a number of references to the water emanating from the springs on Hampstead's western slopes as being cold, and this might be considered as adding weight to the argument in favour of this derivation.

Lower down the Westbourne, Bayswater has been used for a short length of the stream to the west and south of Paddington, immediately north of Hyde Park. The use of 'Bayswater' seems to go back many centuries. There are two main theories as to the derivation of the district name, Bayswater. A reference from 1380 mentions a site, Baynard's Water Place, after the owner of the land situated where the Westbourne crossed over the main road, the Oxford Road, now the Bayswater Road. The other is that Bayswater was a term applied, at least from the middle of the eighteenth century, to a place where horses were refreshed from a stream or conduit – a practice referred to as 'bayswatering'. The name Bayswater is now applied to a large area extending north from the Bayswater Road between east of Notting Hill Gate, south of Bishop's Bridge Road and east of Westbourne Terrace.

Within the area now known as Hyde Park, the Westbourne was marked onto a seventeenth-century map as the Serpentine River, so called because it executed a series of serpent-like curves through this area. This is clearly the origin of the name 'the Sepentine' for the lake in Hyde Park. It is officially labelled by the Royal Parks in two parts, 'the Long Water' being the western part and 'the Serpentine' the eastern.

However, the alternative name most commonly applied to the Westbourne was the Ranelagh (the most commonly heard pronunciation of this unusual name was 'ran-lar'). The Earl of Ranelagh, an Irish title and the name of a village south of Dublin, built a house and gardens close to the Thames at Chelsea towards the end of the seventeenth century. The Westbourne ran through the grounds of the house, and after a few hundred metres discharged into the Thames upstream of where the Chelsea Bridge was to be built 150 years

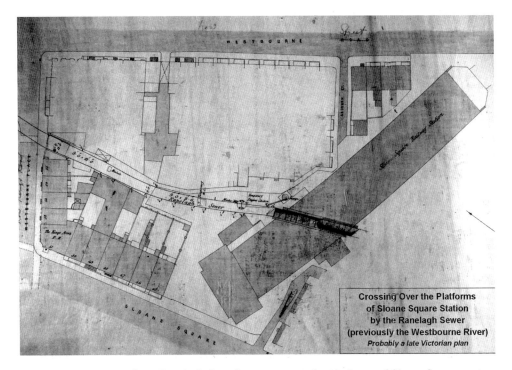

Crossing Over the Platforms of Sloane Square Station by the Ranelagh Sewer (previously the Westbourne River) *Probably a late Victorian plan*

The River Westbourne (now Ranelagh Sewer) crossing over the platforms of Sloane Square station, probably a late Victorian plan.

later. The name of the family came to be applied to the river progressively northwards. With the development of housing in Belgravia from the middle of the eighteenth century, the river was increasingly degraded by the much-increased quantities of domestic sewage discharged to it. The river, from its crossing of Knightsbridge through to the Thames, became known as the Ranelagh Sewer from this time. Similarly, development of Bayswater in the first half of the nineteenth century led to vastly increased pollution of the Westbourne. However, a sewer was constructed to parallel the course of the river, about a hundred metres to the north-east of it, which on the advent of Bazalgette's main drainage project was linked across Hyde Park to the Ranelagh Sewer – a name that was then applied to the complete run of the sewer from Bayswater through to the Thames at Chelsea Bridge.

It is this sewer that can famously be observed passing at an angle to, and over, the platforms at Sloane Square tube station as depicted on a plan, thought to date from the late Victorian period, reproduced with the kind permission of Thames Water.

Westbourne Road is now known simply as Bourne Street, somewhat masking its origins. Westbourne Place, which the river crosses north to south, is now named as forming part of Sloane Square leading into Cliveden Place, so eliminating any mention of the river.

THE WESTBOURNE – SOURCE AND WATERCOURSE

The principal watercourse of the Westbourne starts in the steep-sided valley which runs away to the south-west of Whitestone Pond, the highest point on Hampstead Heath. The source of the river is not the pond itself but the springs that arise within the valley, which lies between West Heath Road and Judge's Walk.

The length of the river through to the Thames at Chelsea, having passed through Ranelagh Gardens, is 11.5 km (7.2 miles). The valley below Whitestone Pond varies in elevation between a high of about 130 metres (426 feet) and 115 metres. By the point that it has reached the junction of West End Lane and Fortune Green Road, below the crossing of Finchley Road, a distance of about 1.3 km (0.8 miles), it has already fallen to an elevation of 60 metres and by Kilburn's Grange Park to 40 metres. The slope of the river bed is more gentle after this, and the river reaches an elevation of about 20 metres at its crossing beneath the Grand Union Canal, Paddington Branch, and less than 5 metres at its discharge to the Thames. A longitudinal profile of the river, from its source to its outfall to the Thames, is included after the map showing the route taken by the river.

From the valley below the Whitestone Pond, the river flowed under a road, Branch Hill, and down through the former grounds of Branch Hill House, along Reddington Gardens and Heath Drive to the Finchley Road.

Midway between the south-western perimeter of Branch Hill House grounds and the Finchley Road, a short tributary joined the Westbourne from the north, fed by the springs on Telegraph Hill.

The river flowed down through the centre of the village of West End, past the village green, and through the land to be developed in the second half of the nineteenth and early twentieth centuries as West Hampstead. The railways that were built in the middle of the nineteenth century and which stimulated development in the area had to bridge the river as

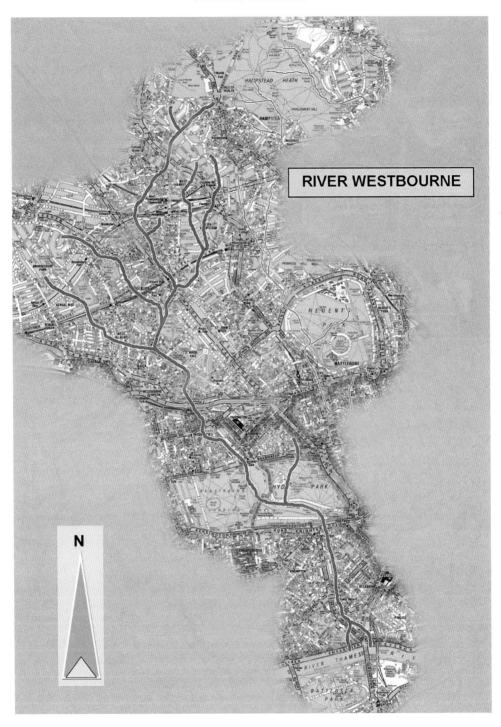

Map showing the course of the River Westbourne.

The point at which the River Westbourne crosses under the Regent's Canal.

it executed a long curve around to the south-east through to Kilburn. The river headed past Kilburn Priory, having flowed about a hundred metres to the north-east of, and parallel with, Watling Street. Just downstream of Kilburn Priory – and what was for about a hundred years the premises of the Kilburn Spa – the river crossed beneath Watling Street, the Edgware Road, at a point at which the Kilburn Turnpike was situated.

Immediately before the crossing of the Edgware Road, the river swings to just west of south. It is at this point that the main course of the river is joined by a substantial tributary, which is itself a combination of two streams, both rising from different points on Frognal Lane on the south-western slopes of Hampstead. The more easterly branch of this tributary originates from a spring just north of the grounds of University College School, the stream flowing through the basement of the school.

Having crossed the Edgware Road, the Westbourne then follows the line of Kilburn Park Road, initially in low ground to the west of the road, but after the large roundabout at Carlton Vale, to its eastern side, where it acts as the western boundary of Paddington Recreation Ground. South of this, the river is prevented from continuing in the same direction by the gentle slope of Maida Hill and the course of the river executes a sharp turn to flow south-eastwards, just to the north of Shirland Road. After crossing under Elgin Avenue, it passes beneath the BBC studios on Delaware Road, parallel with the main road in the low ground below Delaware Road. Having crossed under Sutherland Avenue, the river passes through what is now Elnathan Mews, midway along which it turns sharply just west of south to pass beneath the Grand Union Canal, Paddington Branch, across Westbourne Green and beneath the tracks of the main-line railway out of Paddington station and the Metropolitan and Circle lines at Royal Oak.

Downstream of this major crossing of the railways, the course of the river passes under Gloucester and Orsett terraces, where it begins a long curve that takes it beneath Bishop's Bridge Road and through the Hallfield Estate. After crossing at an angle under Cleveland Street, the river passes along Gloucester Mews, over Chilworth Street into Upbrook Mews and then over Craven Road into Brook Mews, both with obvious links to the river. At the lower end of Brook Mews the river curves to the south along Elm Mews, crosses the Bayswater Road and enters Hyde Park. From here the river originally took the curving path that gave the Serpentine its name, turning east to the point now marked by the eastern end of the lake.

About three-quarters along the length of the lake, a tributary joined the main course of the Westbourne from the north. This was the Tyburn Brook – not to be confused, as it often is, with the Tyburn River. This tributary rose from a spring to the north of the Bayswater Road and east of the Edgware Road, not far from the Tyburn Hanging Tree and the Tyburn Estate from which the stream and the gallows draw their names.

From the cascade at the eastern end of the Serpentine, the river turns south to pass under Rotten Row and south Carriage Drive. The bridge of Knightsbridge carried the old road leading to Piccadilly over the Westbourne, which made its way through Belgravia by way of Lowndes Square and Cadogan Lane and to the east of Sloane Square. It is at this point that

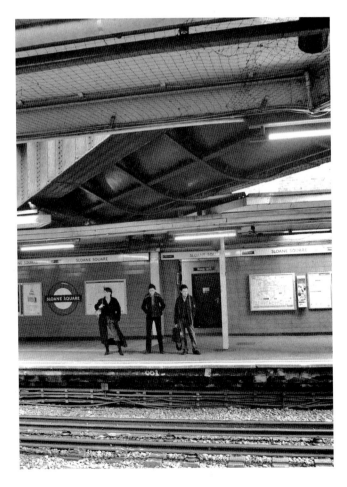

The Westbourne piped over the platforms at Sloane Square Station.

The Westbourne discharging to the Thames (the outlet is on the left of the picture).

the river makes itself visible, although cloaked by the pipe in which it flows, by passing above the Sloane Square platforms of the District and Circle lines.

The river continues on under Pimlico Road, after which it flows through the grounds of the Chelsea Barracks, now the site of a controversial re-development, and splits to form a delta.

The eastern branch continues through the grounds of the barracks, after which it would originally have flowed into the Thames. However, with the formation of the Chelsea Waterworks Company in 1723, the river was intercepted to supplement water drawn from the Thames to serve the western districts of central London in Piccadilly, St James's and Belgravia. With the closure of the treatment works in the 1850s, the water from this branch of the Westbourne flowed briefly into the Thames before being intercepted by Bazalgette's main drainage about a decade later.

The western branch of the Westbourne turned south through the Ranelagh Gardens and the grounds of Chelsea Hospital into the Thames, about 300 metres upstream of Chelsea Bridge. The outlet to the Thames can still be viewed, set into the Thames' Chelsea Embankment. It still discharges surface water to the Thames at times of storm, when flows exceed the carrying capacities of the sewers into which it otherwise flows.

The diagram presents the profile of the watercourse of the Westbourne along its longest branch – from its source on the western side of the Whitestone Pond on Hampstead Heath through to the Thames at Chelsea Bridge. It is possible that the Westbourne has the highest source waters of the seven hidden rivers, in that the Whitestone Pond is at an elevation of 130 metres and surface run-off from this level flows down the slopes of the valley below Judges Walk to the spring level at 90 metres, from where the river derives most of its source waters.

In common with the other two rivers that rise on the slopes of Hampstead and Highgate, the Fleet and the Tyburn, the river gradient is initially very steep in the case of the

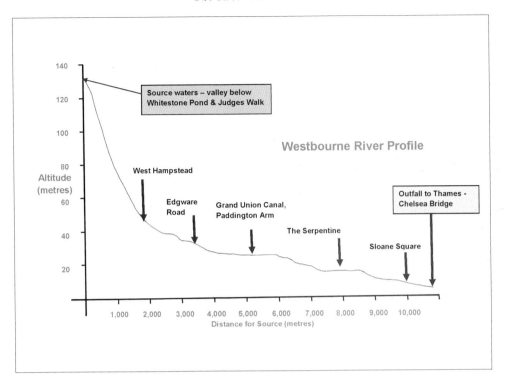

Profile of the River Westbourne.

Westbourne through to just downstream of West End in West Hampstead. There is a slight easing of the slope through Kilburn as far as Paddington Recreation Ground. There then follows a stretch of very gently sloping ground which takes the Westbourne under the Grand Union Canal and the railway lines out of Paddington. The river's gradient increases again through Bayswater to enter Hyde Park, through which the slope eased again while it still flowed as a river, until the early sixteenth century. The slope of the river bed then increased again through Sloane Square to the Thames at Chelsea Bridge.

THE WESTBOURNE THROUGH HISTORY

Roman London to the Arrival of the Normans – 43 to 1066 CE

The point at which the River Westbourne outfalls to the Thames, the site of the present Chelsea Bridge, is a kilometre or so further along the banks of the Thames from Westminster. Although it is possible that the Romans were aware of the Westbourne, it would not have figured in their consciousness. Chelsea was a small settlement based on fishing the river from at least the late Anglo-Saxon period, but as the Westbourne was never a navigable stream, except for the very smallest of boats, it does not play a part in London's development until the fifteenth century.

Water abstraction point on the River Westbourne at Paddington.

Norman to Tudor Periods – 1066 to 1603 CE

As already related, the Tyburn River had been the first of the hidden rivers to be used as a remote source of water for the City. However, by the middle of the fifteenth century, this source was insufficient to satisfy the increasing needs of the citizens. In 1440, the city authorities came to an arrangement with the Abbot of Westminster to tap springs that were on Church land in the Manor of Paddington. These springs fed water into the Westbourne and, once they were diverted and piped to the city to supplement the Tyburn supply, the flow in the river would have been reduced.

The land now used for Hyde Park formed part of the lands owned by the monks of Westminster Abbey. The watercourse of the Westbourne River arrived from the western slopes of Hampstead and flowed south-eastwards across their land, before turning south towards the Thames. Deer, boar and wild bulls roamed over the area. On dissolution of the monasteries in 1536, Henry VIII expropriated the land and, having fenced it, converted it for use as a hunting ground. He dammed the Westbourne to create a small pond at which the hunting prey could drink. Interestingly, the Royal Parks have noted that he also constructed grandstands so that those who did not participate in the actual hunting could view the day's sport, and later enjoy a banquet of the catch.

The Houses of Stuart and Hanover – 1603 to 1760 CE

In 1637, Charles I enhanced the hunting area created by Henry VIII and which we know as Hyde Park and Kensington Gardens. After its military use during the Civil War, and the restoration of the monarchy, it was returned to use as a park by Charles II for the enjoyment of the public.

Having resided in the damp, riverside Palace of Whitehall, William III and his queen, Mary, made Kensington Palace, originally Nottingham House, on the western boundary of the park their principal residence. It remained the principal royal residence until the death of George II in 1760. George's wife, Queen Caroline, had a great influence over the park, and in 1728 took a large area from the western half to create Kensington Gardens. More relevant

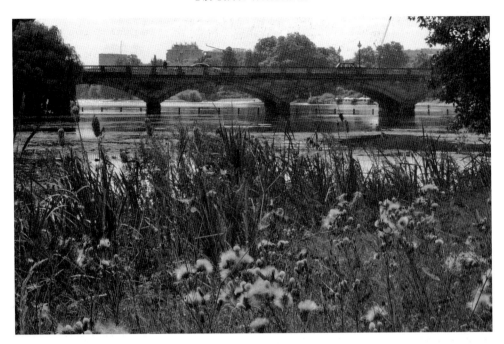

Rennie's Bridge over the Serpentine's Long Water.

to this book, perhaps, she had the Westbourne dammed at the eastern end of the park and created a winding lake called the Serpentine. Previous fashion would have dictated that the lake should have been dug as a geometric shape, usually a long, narrow rectangle – much as the lake of that time in St James's Park – but Caroline determined that the edges of the lake should be far less formal, creating a more natural look and, in the process, a new and lasting fashion.

The flow over the weir of the dam can still be seen before the Westbourne disappears into culverts which conduct it through Belgravia to the Thames.

John Rocque's map of London, Westminster and Southwark of 1746 shows a bifurcation of the Westbourne little more than a few hundred metres from its discharge into the Thames. The western fork continues to the Thames, while the eastern fork heads towards some channels belonging to the Chelsea Waterworks, which was established under letters patent in 1723. The waterworks occupied a vast area stretching from the present location of Victoria station to the Thames between Ebury Road and Turpentine Lane, an area of 40 hectares (approx. 100 acres). Maps of the time, including Rocque's map, indicate that while the waterworks mainly drew water from the Thames, they also received water from the Westbourne, downstream of its passage through what was to become Belgravia about a century later.

At the time, apart from agricultural wastes, the Westbourne would have been relatively clean, as it still flowed through open country and Hyde Park on its way to the Thames. Water from the treatment plant, principally channels and reservoirs where suspended material settled out, was pumped into distribution from a pumping station located on ground now occupied by the Grosvenor Hotel in the Victoria station complex. The pumps were first driven using horses and, from the mid-eighteenth century, by steam. The Chelsea Waterworks Company

A 1790 map showing the course of the River Westbourne through Bayswater and Hyde Park.

moved its treatment plant upstream when the Thames and the Westbourne (and possibly the Tyburn) became too polluted to use as water sources, in spite of their pioneering work on sand filters. This transfer upstream was partly in response to the outcry about the quality of the water it supplied, and partly because the land had become too valuable due to its development potential.

Regency London – 1760 to 1837 CE

On leaving the Serpentine at its eastern, dammed end, the Tyburn turned sharply southward to cross Knightsbridge at the Albert Gate. In the 1820s, Lord Grosvenor, who owned land stretching from Buckingham Palace in the east to Sloane Street in the west and bounded by Knightsbridge in the north, went into partnership with Thomas Cubitt, a wealthy master builder, to develop the land which came to be known as Belgravia. Previous to the development, the Westbourne passed through the land roughly north to south in open channel and the land was open pasture 'where Londoners could graze animals, shoot duck and fight duels'.

Over a period of fifteen years, the land was laid out in a series of elegant squares and crescents and houses for the wealthy constructed. In the course of this development, and during construction of dwellings south of Sloane Square, the first lengths of the Westbourne, from Knightsbridge nearly to the Thames, were culverted and covered.

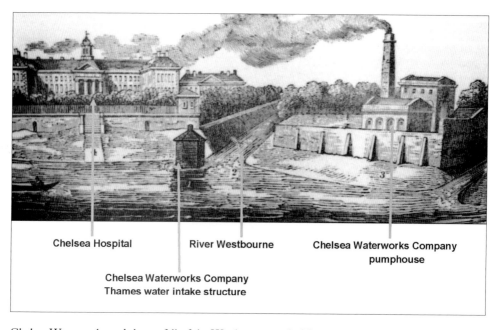

Chelsea Hospital River Westbourne Chelsea Waterworks Company pumphouse

Chelsea Waterworks Company Thames water intake structure

Chelsea Waterworks and the outfall of the Westbourne to the Thames.

The water abstracted from the Thames and the Westbourne became so heavily polluted that it was thought that the Chelsea Waterworks would have to be closed. In the 1820s, the company's engineer devised slow sand filters to improve the quality of the water, the first time that this process had been used for public water supplies anywhere. It was a success, but over the next thirty years the source water deteriorated so much that the process could not cope and the treatment plant was closed and another opened upstream in Surbiton. The Westbourne thus ceased to be a source of water to London in the mid-1850s.

The Westbourne downstream of Belgravia was, by now, so heavily polluted that it was renamed the Raneleagh Sewer.

However, through to the 1830s, the Westbourne north of Hyde Park remained open through to its source on the western slopes of Hampstead.

Pre- to Post-Victorian London – 1837 CE to Present

By the mid-nineteenth century, the waters of the Westbourne were too polluted to be directly used to maintain the water of the ornamental lake in Hyde Park known as the Serpentine. Measures for improving the water quality were formulated. This situation is detailed in Chapter 3, in the section dealing with the Royal Parks. Although never constructed to function as a plant to treat the waters of the Westbourne, a set of ornamental fountains and an ornate pumping station at the Bayswater end of the Serpentine were built and can still be seen today.

CHAPTER 11

Counter's Creek

COUNTER'S CREEK – ORIGIN OF THE NAME

Counter's Creek is thought to be a corruption of the original name for the river that flows through west Kensington and which crosses the Fulham Road at Stamford Bridge. On the Rocque map of 1746, this bridge is shown as Little Chelsea Bridge. However, its first appearance in written records in the middle of the 1300s refers to the bridge as Contessesbrugge, meaning Bridge of the Countess, later variously spelt Contessesbregge and Contassebregge. It is thought that the Countess to which the name refers is Matilda, Countess of Oxford, who owned the Manor of Kensington at the time and probably paid for the bridge to be built and maintained.

The river has been referred to as the Stanford Brook south of the Fulham Road. The name means 'a sandy ford through the brook' and it could have given its name to Stamford Bridge, otherwise known as Counter's Bridge. It has also been called the Billingswell Ditch in this area, named so for the medicinal wells situated nearby and owned by the family Billings.

South of the Fulham Road, between this point and the Thames at Chelsea, this stretch of the Counter's Creek has been known as the New Cut River, Chelsea Creek and Bull Creek.

'New Cut River' probably stems from the work carried out on in the late 1820s on Countess Creek. The river was widened and turned into a canal, the Kensington Canal, for about 3.2 km (2 miles) from where it flowed into the Thames at Sandford Creek, back along the watercourse to where Olympia now stands. However, it was not a commercial success and the canal was bought by the West London Railway Company, drained and converted for use as a railway. In addition to the overground line that still uses the route, part of it is also used by the District Line.

Chelsea became fashionable as an area for Londoners to move to from the eighteenth century, and the area around the Thames end of Counter's Creek became known as Little Chelsea Village for a while. It may well be that the name, 'Chelsea Creek', for the lower end of Counter's Creek was considered more attractive and specific than the basic name of the river.

Kensal Green Cemetery, the site of the source of Counter's Creek.

The origin of 'Bull Creek' is a matter of even greater speculation. In other places, this type of name for a stretch of river spun off the name of a well-known local inn or public house in the area.

COUNTER'S CREEK – SOURCE AND WATERCOURSE

Counter's Creek was one of the principal watercourses draining West London as the city extended its suburbs westwards, particularly through the eighteenth and nineteenth centuries. The river rises in a cemetery north of the Grand Union Canal, Paddington Arm, at Kensal Green. The ground beneath the cemetery almost certainly received rainwater that percolated into the ground to the north of the cemetery, in Kensal Rise. The location of the source is at the western end of that half of the burial ground known as Kensal Green Cemetery, at an elevation of about 42 metres; the other half, further to the west, being occupied by a crematorium and St Mary's Cemetery.

The river runs in a southerly direction for the whole of its course, a distance of 10.9 km (6.8 miles).

Starting in the cemetery, it passes beneath the Grand Union Canal and then passes across Little Wormword Scrubs Recreational Ground. The area was originally known as Wormholt, the word 'holt' meaning an area of woodland. In the Middle Ages, the whole of the area around the modern site of Wormwood Scrubs was woodland, certainly as far to the south as Wormholt Park, near QPR's football ground, where a farm of the same name had been situated.

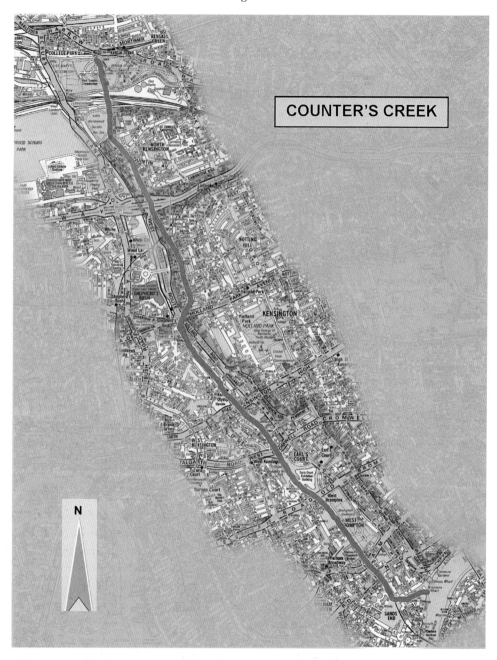

Map showing the course of Counter's Creek.

Counter's Creek, where it crosses under the Grand Union Canal.

The route taken by Counter's Creek has been used for centuries as a boundary between parishes and boroughs, and so must have been a notable feature in the landscape at one time. The route marks the Hammersmith–Kensington boundary and then the Fulham–Hammersmith interface.

Leaving the recreational ground, the river crosses under Dalgarno Gardens, Nursery Lane and Quintin Gardens to pass along Highlever Road and under the elevated Westway (A40). Leaving the Westway at Darfield Way, it passes down Freston Road, under the elevated Metropolitan and Circle lines, and then along the whole length of St Ann's Road to Royal Crescent, which it passes around to the south-west, continuing on that course across the large Holland Park roundabout to Woodstock Grove.

It is from this point that Counter's Creek follows the route taken by the overground railway and, for shorter lengths, the District line to the Thames. In fact, of course, the river pre-dated the railways and it is these that chose to follow the river's course, being both a direct and an undeveloped route the whole way through to the Thames. Reference has already been made to the canalisation of the river over this length and the purchase of the canal land for redevelopment as the railway.

The river's route passes immediately to the east of Olympia, across Hammersmith Road and the Cromwell Road (A4) to pass beneath the south-western side of the Earl's Court Exhibition Building.

A remnant of the river can be seen as a drainage ditch from the platform for northbound trains to Olympia at West Brompton Station.

Counter's Creek then passes along the south-western edge of the Brompton Cemetery, across the Fulham and King's roads and along Lot's Road before turning east into Chelsea

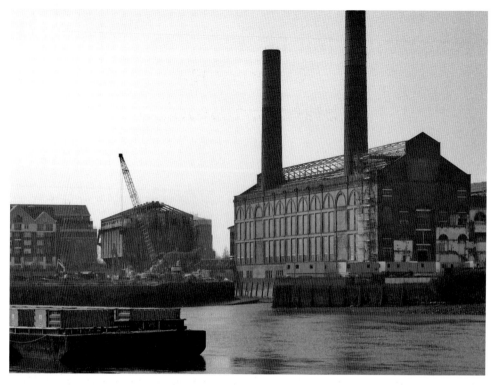

The outlet of Counter's Creek to the Thames at Chelsea Wharf.

Creek, or Sands End Creek as it was formerly known, immediately before the Chelsea Harbour development. It is at the turn of Lot's Road to the east that Counter's Creek is visible from a bridge through to the Thames and Cremorne Wharf. The nineteenth-century canalisation of Counter's Creek is quite apparent over this 'estuarial' stretch of the river.

CHAPTER 12

Stamford Brook

STAMFORD BROOK – ORIGIN OF THE NAME

Research has found only two, very similar, possible origins of the name 'Stamford Brook'. One suggests that it was derived from the Anglo-Saxon Steanforde, meaning a stone ford. It is thought that this could relate to the Romans, who first built the Bath Road, having created a fording place for the road through the river by setting stones into its bed. There was, through to the early twentieth century, a bridge that carried the road over the river, near Brook House on the Stamford Brook Road that was referred to as the Stamford Bridge. This should not be confused with the bridge of the same name to be found in Fulham which carries the Fulham Road over Countess Creek, another hidden river. It is the latter that gives its name to Chelsea Football Club's home ground.

The second, related explanation of the river's name is that the origin is 'Samforde', interpreted to mean 'sandy ford'. However, this is less likely, as the soil in the area is not sufficiently sandy to be notable.

Of course, it is just possible that the river was named for a landowner in the area called either Stanford or Stamford, but no suggestion of this has been found.

STAMFORD BROOK – SOURCE AND WATERCOURSE

The Stamford Brook is not so much a single watercourse, with minor tributaries contributing to its flow, so much as a system comprised of three rivers – all attributed with the same name – that only finally combine just before the river discharges into the Thames, just upstream of Hammersmith Bridge.

It is the central arm of the river that is shown on John Rocque's map of 1746 and marked as the 'Stanford Brook'. It appears that Stamford Brook, rather than Stanford Brook, came into common use in the nineteenth century. The central arm of the three rivers rose on Horn Lane, at an elevation of about 30 metres, just south of where today is the Acton Main Line station and north of the centre of today's Acton. Interestingly, there was an eighteenth-

Sites of outlets of Stamford Brook to the Thames upstream of Hammersmith Bridge (to the left side of the picture).

century spa area, based on a local spring, a short distance to the north of the river's source, an establishment which also organised horse races.

From its source, this central arm of the Stamford Brook flowed just a shade west of south and crossed what was the North High Way, now High Street Acton, coming from Shepherds Bush. The character of the river at this point was unusual for any of the hidden rivers. Here, immediately south of the crossing of the main road, this central branch of the Stamford Brook cascaded through a fall of between 5 and 7 metres in less than 100 metres before turning from a southerly to a south-easterly direction towards the area called the Stamford. Downstream of what must have been an attractive, fast-flowing section through the rapid fall, the river skirted around the southern boundary of the Duke of Kingston's property before continuing south-eastwards across fields to an area shown as Stanford Brook on Rocque's map, at the head of Stanford Brook Lane, now Stamford Brook Avenue. The location of the stone-built Stamford Bridge was at this point. The river flowed past the eastern sides of two properties, 'The Brook' and 'Stamford Brook House', and then east and south through the grounds of Paddenswick Manor, now Ravenscourt Park, where it was used to form a moat to the house. South of the park boundary, the river again turns south-eastwards, to cross what is now King Street, Hammersmith, immediately east of a point marked as '4 miles west of Hyde Park Corner' on Rocque's map. The river passes under the land now occupied by Hammersmith Town Hall, under the Great West Road, and discharges to the Thames at what was, until the late nineteenth century, a busy creek with wharfing in the centre of Furnivall Gardens.

There is some evidence for a fork in the Stamford Brook at the point where it turns towards Ravenscourt Park. One arm of the fork continued southwards, instead of turning to the east, flowed down the west side of Goldhawk Road and along British Grove to enter the Thames at the north-east corner of Chiswick Eyot, the island in the Thames.

The two other arms of the Stamford Brook meet the main central arm at two separate points. The westerly arm junctions with the main course at the location of the erstwhile Stamford Bridge. The easterly arm meets the central arm downstream of Ravenscourt Park just before its crossing of King Street.

The westerly arm rises on the eastern slopes of Hanger Hill, just south-east of Hanger Lane, at a level of about 45 metres, on Ashbourne Road – a possible indication of the local name for the watercourse. The route passes beneath the Piccadilly line at Hanger Vale Lane and Hanger View Way before passing across a sports ground, Queen's Drive at Rutland Court, and a school's playing fields. The river passes beneath a series of railway lines and then flows southwards about 100 metres or so to the west of Twyford Avenue, Acton, crossing Creffield Road, Layer Dardens and Stanway Gardens. It crosses under the Uxbridge Road and follows Hart Grove to curve around to the east and then back south-eastwards to pass through the grounds of the Reynold Sports Centre, across Gunnersbury Lane and then left at Acton Town station to pass down and around the long Bollo Lane. At this point, the river was known locally as the Bollo or Bollar Brook. After crossing under the overground railway line in Bollo Lane, the river curves slightly more eastwards and passes under a series of back streets to arrive at Acton Green Common, the site of the 1642 Civil War battle of Turnham Green.

At the point where the Stamford Brook, or Bollo Brook, curves away from Bollo Lane, an off-take of the river was constructed in the eighteenth century to feed a long ornamental lake in the grounds of Chiswick House. The overflow from the lake was conducted in a conduit to the Thames which followed the line of Promenade Approach Road.

The western arm of the Stamford Brook followed the northern boundaries of Acton Green Common and the adjacent Chiswick Common to turn slightly north of east along South Parade and the Bath Road, eastward to its junction with the central branch of the Stamford Brook at the north-east corner of Stamford Brook Common.

Before the construction of the railway at Old Oak Common and the Grand Union Canal, Paddington Arm, the easterly branch of the Stamford Brook is thought to have had its origins in the area of the railway sidings. This is possibly still the case but it is more likely that after the construction of the nineteenth-century infrastructure, this part of the Stamford Brook was cut off and the river then rose solely in the area of the Wormwood Scrubs Park at an elevation of about 18 metres. The river then passes in a southerly direction for its whole length along Old Oak Common Lane, passing under the Westway just to the east of Savoy Circus and again just to the east of Old Oak Road, crossing over the Uxbridge Road to follow the curve of Askew Road to the easterly of the two mini-roundabouts at Seven Stars Corner. The river then follows the line of Paddenswick Road and Dalling Road to junction with the central arm of the Stamford Brook at King Street, immediately north of the town hall.

The table shows the lengths and upstream starting point elevations of the three Stamford Brook arms.

Arm of Stamford Brook	Limits of Arm	Length (km)	Elevation (metres above sea level)
Central	Horn Lane (Acton Main Line Station) to the Thames upstream of Hammersmith Bridge	4.92	30
Westerly	Ashbourne Avenue (Hangar Hill) to Stamford Brook Common	5.43	45
Easterly	Wormwood Scrubs Park to King Street, Hammersmith	3.82	18

A separate element of the Stamford Brook catchment is Parr's Ditch, sometimes called the Black Bull Ditch. There are medieval records that mention Parr's Ditch. The probable line of the ditch can be traced from a point about midway between Hammersmith Broadway and Shepherd's Bush, at the western end of Brook Green. From here the brook runs south-eastwards along Brook Green. It then curves to the south and then west to make its way to the Thames. It is the Brook Green end of Parr's Ditch that was known locally as the Black Bull Ditch after the Black Bull Inn, which now serves as the house of the High Master of St Paul's School. The brook was already shown as a sewer on Salter's plan of 1830.

The Stamford Brook catchment area, from the Parr's Ditch outlet to the Thames downstream of Hammersmith Bridge (right of centre of picture).

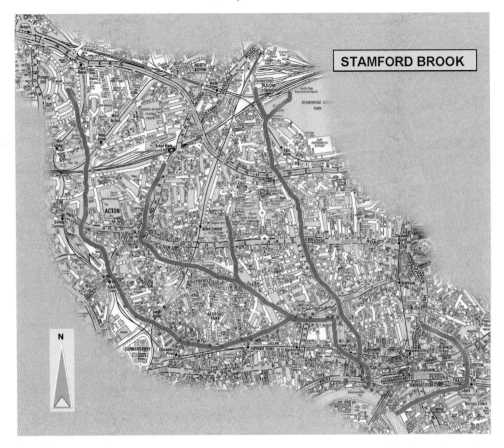

Map showing the course of Stamford Brook.

Parr's Ditch has been described as discharging to the Thames at Chancellor's Wharf at the end of Chancellor's Road, downstream of Hammersmith Bridge. However, archaeological work carried out by the Museum of London Archaeological Service in 2000 in Winslow Road, Hammersmith, a short distance downstream of Chancellor's Road, has uncovered traces of a broad channel which is thought to have been Parr's Ditch. The report refers to this as a natural 'paleochannel', an old channel. The width of it might suggest that, a long time ago, at least a thousand years ago and probably a lot more, one or more of the arms of the Stamford Brook might not have outfalled to the Thames upstream of the present site of Hammersmith Bridge, but have continued on an eastward route to link into Parr's Ditch at some point along the route already described.

CHAPTER 13

The Black Ditch

The Black Ditch is just one of many watercourses that ran through the low-lying land to the east of the Tower of London and west of the River Lea. It was perhaps unusual in two of its features, warranting its inclusion in this book as an example of the many streams and ditches that drained the area. Most of those small watercourses ran south on a direct route to the Thames, while the Black Ditch flows eastwards and then completes a 180-degree curve to flow westward for its final stretch to the river at Limehouse. It was also, possibly, the longest of the local watercourses, rising in East Spitalfields, east of the north–south ridge along which runs Brick Lane, through Stepney and Poplar, where it executes its broad curve back to Limehouse and its discharge to the Thames.

Until the late Middle Ages, the whole area forming the catchment of the Black Ditch was just a small part of the area known as Stepney, or an earlier version of the name. South of a line eastwards from the Tower of London, at the level of Cable Street and the East India Docks Road, the area was subject to flooding by the Thames at times of high tides during the Roman occupation. This boundary, running east–west, was formed by the embanked end of a gravel stratum which overlay clay north of the line. The difference in level between the land north of the line and that south of it was several metres and readily visible as a boundary. Further tidal depositions of alluvial mud over the centuries following the departure of the Romans raised the level of the land, but only sufficient for it to become marshland, riddled with myriads of channels between small patches of drier high ground. During this same period of Anglo-Saxon settlement, various land-owners built river walls to gradually reclaim the low-lying land. By judiciously using ditches and streams linked to the Thames, a number of tidal-powered mills were able to function. On the higher ground, in addition to windmills, conventional water mills were constructed, possibly using rivers such as the Black Ditch.

The Thames river walls were more or less complete by the twelfth century. However, it has been remarked that the small riverside settlements were better served from the river, as access to and from the land to the north was so difficult due to the poor ground conditions. The name Stepney derives from 'Stybba's Hythe', a landing place on the Thames in an otherwise marshy and inaccessible area.

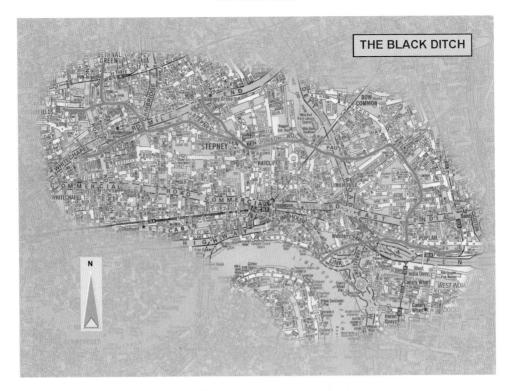

Map showing the course of the Black Ditch.

A number of streams – all now hidden – have been identified running through the area of Shadwell, to the west of Limehouse, and a hidden river rose and flooded streets in Bromley in the twentieth century, just to the east of the course taken by the Black Ditch.

The history of the area covered by the Black Ditch catchment has been one of gradual degradation, and only recently can it be said that it has begun to reverse its fortunes. For much of its history the area was sparsely populated, peppered with a few large houses or halls and a great number of small freeholders eking out a hand-to-mouth existence based on their small agricultural holdings. So poor were the majority of the area's residents that they could not raise the funds demanded of them by the authorities to maintain the protective river walls, and so flooding would have been a frequent occurrence.

However, the area was viewed as a rural retreat for Londoners through the sixteenth and seventeenth centuries. A number of large houses were built in Bethnal Green, and one housed an academy for gentlemen where the painter Rubens was once a guest.

From the eighteenth century onwards, the nature of the settlements changed. In 1685, Louis XIV of France began a persecution of Protestants which led to 15,000 French Huguenots fleeing to London, where they set up in Spitalfields. They were mainly weavers of silk, who some years later also founded a settlement at Mile End. In the first half of the eighteenth century, they had so grown in numbers that they needed an overspill area for their accommodation. This they found between the two main settlements at Bethnal Green. By this time, the work available to weavers could not support the numbers of workers in that field

and, inevitably, it was the poorer families that settled in Bethnal Green. Accommodation was of poor quality and services virtually non-existent. By the nineteenth century, other factors had led to a considerable intensification of development in the whole of the Black Ditch catchment and much of the river had been culverted and covered over. Whereas prior to the eighteenth century, the Black Ditch was probably a clean, rural river, almost certainly known by a more attractive name, by the end of the eighteenth century, it was carrying so much sewage that it warranted the name by which it is now known.

Industrialisation brought with it further degradation of the area. Powered looms ended any hope of work for the weavers. Industries producing the foulest effluents were sited in an area known to be the poorest and most underprivileged close to London. The considerable extension of the docks in Shadwell, Limehouse and the Isle of Dogs led to a vast influx of low-income labourers and their families, many of whom would have struggled to find regular work. The area became synonymous with the worst form of slum living and its reputation for generating and housing the criminal low-life of London was second to none.

The whole of the Black Ditch catchment was the worst area of London into which one could be born. John Timbs, in *Curiosities of London*, writing in 1867, reported the *Athenaeum* of 1862 as describing the situation as

... numerous blind courts and alleys, form a densely-crowded district in Bethnal Green. Among its inhabitants may be found street vendors of every kind of produce, travellers to fairs, tramps, dog-fanciers, dog-stealers, men and women sharpers, shoplifters and pickpockets. It abounds with the young Arabs of the streets, and its outward moral degradation is at once apparent to anyone who passes that way. Here the police are certain to be found, day and night, their presence being required to quell riots and to preserve decency. Sunday is a day much devoted to pet pigeons and to bird-singing clubs prizes are given to such as excel in note, and a ready sale follows each award. Time thus employed was formerly devoted to cock-fighting ...

Dr Hector Gavin made a study of the area in 1848 and published the findings of his painstaking, street-by-street research in *Sanitary Ramblings, Being Sketches and Illustrations of Bethnal Green*. The picture he paints of the horrendous living conditions can only be described as a hell on earth, rivalling the worst slums found today in the cities of India in which this author has carried out much of his recent professional work.

The area has gone on to house various waves of immigrants: the Irish, the Jewish people arriving from the pogroms of eastern Europe, Caribbean peoples and, most recently, immigrants from Bangladesh and other parts of South Asia. Generally, this was due to the proximity of the docks, but also because most arrived penniless and could find accommodation in no better districts than these.

At the peak of its crowded period, in the 1850s, the population of Bethnal Green may well have reached 200,000 people; by 1901, it had fallen to 130,000, and today it is about 30,000. Improvements to property and its proximity to the City and Docklands have led to a considerable rise in property values.

Today, much of the Black Ditch catchment area is gradually pulling itself out of its degraded condition. Gentrification of the riverside areas along the Thames, the Docklands

developments such as Canary Wharf, with its high-income workers in finance, and now the Olympic site to the east have all had a beneficial effect, assisted by improved transport such as the Docklands Light Rail.

THE BLACK DITCH – ORIGIN OF THE NAME

The earliest reference to the use of the name Black Ditch appears to be from the late eighteenth century. It is thought that the watercourse may have had earlier names, but by the late 1700s it was already a highly polluted watercourse, subject to rapid covering, and it is probable that the name reflects the colour and sluggish nature of any liquid that it carried.

THE BLACK DITCH – PRINCIPAL SOURCES AND WATERCOURSE AND ITS TRIBUTARIES

There are not many maps showing the Black Ditch. The author has based his own on-site research, walking the river's course, on two sources. The first of these was a plan of the sewerage of the metropolis produced by Captain Veitch of the Metropolitan Commission of Sewers in 1851. The other was a recent map, commissioned by the Royal Institute of British Architects for the London Festival of Architecture 2008 in conjunction with the Ordnance Survey, titled 'Dark Waters'. Although its principal purpose was to highlight London's riverside built environment, it clearly shows the course of the Black Ditch.

The original sources of the Black Ditch in its river form were almost certainly springs issuing where water-bearing gravels overlay the clay on which most of London is founded. These sources are to the east of the Brick Lane ridge in Spitalfields. One is near the primary

Docklands from Limehouse Cut.

school in Deal Street, one rises on the west side of the original green, at Bethnal Green, and another is on the southern side of the East London Mosque on the Whitechapel Road, in Fieldgate.

Their combined flows pass along south of the Mile End Road, along Adelina Grove and Redman's Road and past the southern end of Stepney Green, where they are joined by a fourth branch, which originates by Stepney Green station. The route then follows Ben Jonson Road, at the end of which it crosses beneath the Regent's Canal, where it turns south-eastwards along Rhodesia Road and St Paul's Way, executing a long curve around to the north-east. It then crosses Burdett Road and through a public housing estate, to and along Thomas Road. At the junction with Bow Common Lane, it again turns south-eastwards and generally southwards to Poplar High Street, having crossed under Cordelia, Ricardo and Grundy Streets, as well as the East India Dock Road. At Dingle Gardens, immediately south of and below Poplar High Street, it accepts flow from another tributary, which flows from the east in Poplar along the low ground below Poplar High Street.

The final stretch of the river passes westwards, below a major road interchange, into Milligan Street and Colt Street, newly-developed riverside housing and offices, where it passes under the Thames Path into the main river at Limehouse, immediately west of the Canary Wharf development.

The Hampstead Water Conduit: A Scheme to Restore London's Hidden Rivers *or* London's Hidden River Assets – Resurrection and Revelations?

THE HAMPSTEAD WATER CONDUIT – SUMMARY

On 15 June, 2008, *The Sunday Times* carried an article in which the advisers to Boris Johnson, the recently-elected Mayor of London, described how he was considering ways of 'unearthing stretches of buried rivers and creating new parkland'.

Unfortunately, due to the discharge to the hidden rivers of thousands of uncharted sewage pipes, it is not possible to simply unearth stretches of buried rivers and restore them as a public amenity. Even were it to be practical as an approach, the cost would be prohibitive. However, this final chapter describes how some of London's hidden rivers could be restored in a simple, practical and affordable way.

The Hampstead and Highgate ponds, respectively flanking the western and eastern sides of Hampstead Heath, are fed by numerous springs which issue from the interface of the Bagshot Sands and London Clay, which occurs at approximately the 90-metre contour level. The water feeding the ponds is clean and they are used for a number of recreational purposes, including swimming and model boating. The ponds were originally formed and systemised to provide water for London through the now-defunct Hampstead Water Company.

Water issuing from both sides of the Heath originally formed the headwaters of the River Fleet, the two main branches of which met at Camden Town. Instead of using it for water supply, water still issues today of relatively good quality from each of the lowest of the two sets of ponds and is discharged – wastefully – to the local sewers. It is this water – and other water discharging from the Heath but not captured in the ponds – which it is proposed would be used in the scheme to restore stretches of London's hidden rivers, the Fleet, the Tyburn, the Westbourne and, possibly, the Walbrook.

Without affecting the present amenity value of the ponds, water would be conducted, without pumping, via a new pipeline, the Hampstead Water Conduit, into Central London where it could be used to:

•Refresh the lakes in the Royal Parks, the Serpentine in Hyde Park (originally formed from the River Westbourne) and the lakes in Regent's Park and St James's Park (originally

sourced from the River Tyburn). This would substitute for the practice of pumping from the aquifer beneath London, saving on cost and preserving the aquifer;

•Feed new stretches of water in selected areas of the London boroughs of Camden and Westminster, alongside or near to the routes of the hidden rivers, along which new lengths of parkland, walks and cycle paths could be created – as has already been achieved using New River Water by the London Borough of Islington; a similar approach to creating one or more green 'oases' in the City of London, near the course of the River Walbrook, might also prove feasible;

•Assist the City of London in its present task of reducing the risk of flooding from the pond on Hampstead Heath.

THE HAMPSTEAD WATER CONDUIT – THE CONCEPT

In the opening chapter of this book, seven of London's hidden rivers are referred to as a 'squandered asset'. A flight of fancy is described in which London's rivers, tributaries of the Thames, had remained not only visible for Londoners to enjoy their clear, sparkling waters but which also offered opportunities for recreation and relaxation along their banks. Visitors to the 2012 Olympics were excited to experience London, fancifully renowned on account of its many rivers as the 'Riverine Capital'.

This book has described the sources of the rivers and how Londoners had first used and then abused the rivers to such a point that, given their highly polluted state, they were hidden from sight and almost totally erased from the civic memory of the city's population. But each of our hidden rivers has played its part in the history of London, some a significant part, others a more modest one, from its founding by the Romans through to the late nineteenth century, by which time they had been completely banished to a subterranean future.

The book begs an obvious question – would it be possible to bring the rivers back to open view, to resurrect them, clean them and to benefit from the improved urban environment?

The answer is a resounding 'yes' – with a big 'but' attached.

First, to deal with the big 'but'. It would be neither practical nor affordable to just open up long lengths of the hidden rivers, particularly commencing with their inner-city, downstream stretches. This is because they have been completely integrated into the combined sewer system, carrying both sewage and rainfall run-off, that is, the predominant form of the wastewater network serving London. Over many centuries, tens of thousands of wastewater connections have been made directly into the hidden rivers. These involve not only domestic sewer connections but also discharges of industrial effluents, most of them undefined and unmapped. To separate out these tens of thousands of connections of wastewater away from each of the rivers and into a new separate sewerage system is rendered impractical by the immense cost involved. The construction of rider sewers either side of the rivers to intercept these discharges would not only entail immense cost but be beset with countless practical difficulties and high maintenance and operational costs for future generations to bear.

But all is definitely not lost. It is most certainly both practical and affordable to recreate short, clean stretches of the Central London rivers – more particularly, the Fleet, the Tyburn, the Westbourne and, possibly, the Walbrook, the City of London's own river.

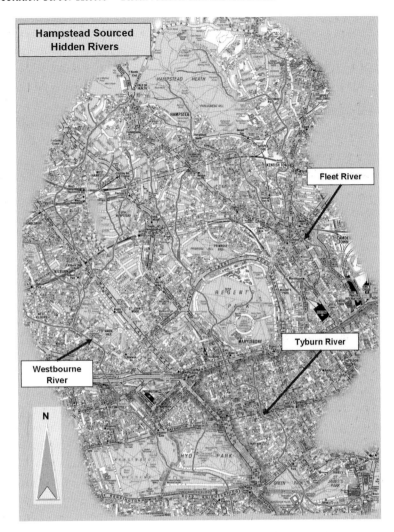

Hampstead Sourced Hidden Rivers

Fleet River

Tyburn River

Westbourne River

N

Hidden Rivers with
their sources in
Hampstead.

The kernel of a practical scheme for the resurrection of these three hidden rivers is a simple one.

The source waters for the Fleet, the Tyburn and the Westbourne rivers are the springs and surface water which drain naturally from Hampstead Heath. These are the only source waters of the hidden rivers that have been protected from pollution and which remain eminently accessible today.

For the most part, although not entirely, these natural waters form the Hampstead Ponds and the Highgate Ponds, respectively draining water from the western and eastern sides of Hampstead Heath. Presently, excess water from these ponds – clean enough for the ponds to be used for bathing and capable of supporting fish – is decanted directly into the heads of local sewer systems.

It is this source of water that could be used to recreate short stretches of the hidden rivers, particularly in the London boroughs of Camden and Westminster as well as the City of London. At present, once used by the recreational facilities of the Heath, this asset is sent to waste.

To be clear, the present, immense amenity provided by the Heath and its many ponds would be preserved and protected. These waters would only be used once they have passed through the existing ponds of Hampstead Heath. In determining how a project to resurrect the hidden rivers could be structured, two main options have been considered.

OPTION 1 – THE HAMPSTEAD WATER CONDUIT

Water draining naturally from Hampstead Heath, through the Highgate and Hampstead Ponds, would be conducted by gravity through a new pipeline into central London. Flow could be further enhanced by a drain along the southern edge of the Heath to catch surface run-off that does not drain to the ponds. The waters could then be used in a number of ways, with two being very attractive with respect to the possibilities for urban enhancement that they offer.

The first of these would be to use the water from the Hampstead Water Conduit to recreate short stretches of watercourse along, or close to, the former inner London routes of the Fleet, the Tyburn, the Westbourne and the Walbrook rivers.

The use for the water of the Hampstead Water Conduit would be to refresh the lakes in the Royal Parks – Regent's Park, Hyde Park and St James's Park. The lakes are presently refreshed with water pumped from the aquifer beneath London. This use would therefore have the additional advantage of allowing the management of the Royal Parks to reduce its reliance on energy-consuming pumping of groundwater to refresh the ponds.

OPTION 2 – OPENING UP THE FLEET RIVER

With this option, rider sewers would be constructed along both sides of the River Fleet, commencing from its upstream end, near the lowest of the Hampstead Ponds, in order to separate away from the river all discharges of sewage. Buildings would be cleared from over the Fleet watercourse, which would then be opened up to view. Beautification of the river banks and the creation of riverside walks and recreational areas would follow as this renovation work progressed. The pace of progress would depend on the availability of funds.

Option 2, the progressive separation of sewer connections from the River Fleet, is unlikely to offer much attraction. For many years, it would offer only limited benefits to people in and around Hampstead and Highgate, a population already well-served by the Heath for their recreation and relaxation. In addition, due to the immense cost involved, it would probably take many generations before the improvements would get anywhere near benefiting inner London. It would, almost certainly, prove highly disruptive, generating antipathy to the project in the areas affected by its implementation.

Option 1, however, the Hampstead Water Conduit, has considerable attractions:

•Affordable. For a relatively small capital outlay, the water could be brought into central London by a new pipeline, the Hampstead Water Conduit.
•Environmentally beneficial. Significant environmental benefits would accrue from the project. In order to feed and refresh the water in the lakes of the Royal Parks and

to provide water for irrigation of the parkland, water is presently pumped from the aquifer beneath London. Water from the Hampstead Conduit could substitute for this groundwater, saving on pumping energy, hence reducing annual operational costs, and preserving the aquifer.

•Reduced risk of flooding by the Hampstead and Highgate Ponds. A recent report has indicated that the lives of up to 1,500 people are at risk from the potential of the Hampstead and Highgate ponds to overtop and flood. The Corporation of the City of London is currently considering a scheme to remove that risk, estimated at a cost of £10–15 million. The Hampstead Water Conduit could be integrated into this flood-alleviation project, to conduct water away from the ponds, with possible savings in cost to both projects through shared infrastructure.

•Socially beneficial. Short stretches of river, perhaps a couple of hundred metres in length, could be constructed in the lower catchments of the Fleet and Walbrook, for example in Farringdon and the street named Walbrook. As well as beautifying parts of the City of London, these would enhance its environment, provide a further attraction for tourists and would offer city workers new opportunities for relaxation in their lunch breaks and after working hours (witness the newly made New River Walk in the London Borough of Islington).

•London Borough opportunities. The pipeline would pass into Central London along a route similar to that taken by one or more of the hidden rivers, certainly at least that of the Fleet. London Boroughs along the route of the Hampstead Water Conduit, such as Camden, would be able to tap into the main for water to feed their own short stretches of resurrected hidden river. Water so used would be returned to the main at the downstream end of the new stretch of river. Boroughs would be able to create these greened waterside walks and cycleways as and when they had the funding.

•Hampstead Heath assets protected. Water for the conduit would be abstracted from the lowest ends of the Heath, in order that all current environmental and recreational uses of that water would be able to continue.

•Conventional infrastructure. It is difficult to be specific about the physical specification of the new pipeline. However, in order to give an indication of its practicability, the following is offered. The line could consist of one or two gravity mains of a synthetic material, PVC or polyethylene, perhaps each of 500 mm diameter, laid over a length varying from 5 to 10 kilometres, depending on the nature of the uses to which the water would be put. A primary objective would be to avoid pumping.

•Minimal adverse impacts of construction. There would be no more disruption of suburban areas than is experienced every day by Londoners used to their roads being continuously dug up for pipelines and cables of one sort or another. Disruption would be far less than that created by construction of the sewers in Option 2.

It is important to stress that the benefits of the scheme would begin to accrue immediately on completion of the pipeline through to the Royal Parks and their lakes. Other benefits, such as the construction of sections of river in the City and the London boroughs, through which the Hampstead Water Conduit would pass, can be realised as and when finance becomes available.

London Borough
of
Islington

The
New River
Walk

The New River Walk, London Borough of Islington.

The London boroughs of Camden and Westminster would be best placed to benefit early from the scheme. They could 'tap' water from the pipeline to create Fleet River and Tyburn River Walks en route to the Royal Parks. This approach has already been taken by the London Borough of Islington along the route of the New River. Where the river remains exposed for a short distance, the Borough has created an excellent river landscape walk, the New River Walk, between St Paul's Road and Canonbury Road, a distance of 0.75 km approximately. The facility is much appreciated by local residents and is very well-used every day. The photos demonstrate how Camden and Westminster could benefit from the Hampstead Water Conduit scheme.

PROJECT FEASIBILITY

That there is sufficient water draining from the springs on Hampstead Heath to recreate the hidden rivers and to make a real difference to the quality of water in the lakes of the Royal Parks is not in doubt. The management of the Royal Parks has a licence to abstract groundwater at a rate of 90,000 m^3 annually to feed the Serpentine in Hyde Park. This is an average of just 246,000 litres a day, less than 250 m^3 a day. In the past, the Hampstead Waterworks Company derived its water from the same source and was delivering more than just 250 m^3 a day.

However, as a first step towards implementation, it would be prudent to carry out an outline feasibility study, mainly with respect to the identification of a practical route for the Hampstead Water Conduit and its cost. Once feasibility has been verified, there would almost certainly need to be a public consultation process to determine the level of interest in the concept on the part of Londoners and the various public, private and local government organisations that could be involved. The feasibility study would include checks on:

- Reliability and magnitude of the flows of water from the Heath that could intercepted from the two sets of ponds, the Highgate Ponds and the Hampstead Ponds;
- Practicability of the general route proposed for the pipeline;
- Annual quantities of water needed for irrigation and refreshing the ponds in Regent's Park, Hyde Park and St James's Park;
- Project cost;
- Value of the project benefits;
- Respective interest of the two London boroughs through which the Hampstead Water Conduit passes – Camden and Westminster – in using the water to create small 'oases' with water interest for their residents along the route;
- General interest of the public in such a project.

The concept is represented on the diagram overleaf and a suggested route for the three pipeline components comprising the Hampstead Water Conduit are shown on the map, also overleaf.

Ground-surface levels at the various key points along the proposed Hampstead Water Conduit would permit the water to be conveyed by gravity from start to finish, with no pumping needed:

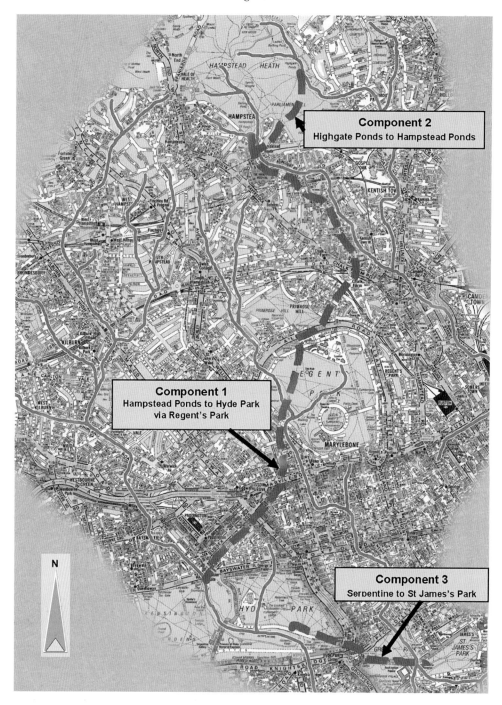

Proposed route for the Hampstead Water Conduit.

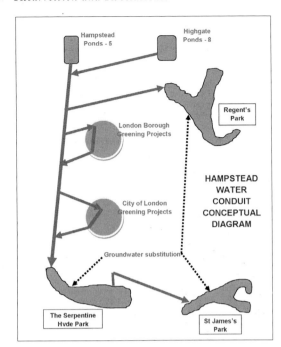

Conceptual Diagram of the Hampstead
Water Conduit.

Point on the Hampstead Conduit	Metres Above Datum
Highgate Ponds	70
Hampstead Ponds	67
Regent's Park lake	30
Hyde Park (Long Water & Serpentine)	15
St James's Park lake	5

Preliminary estimates of the cost for constructing the Hampstead Water Conduit – which take account of the densely trafficked nature of the roads along much of the route – have been very conservatively estimated as:

Project Component	Pipeline	Length (km)	Cost (£M)
1	Hampstead Ponds to Hyde Park	6.6	25.1
2	Highgate Ponds to Hampstead Ponds	1.2	2.5
3	Serpentine (east end) to St James's Park	1.8	4.5
Total cost			32.1

It is worth noting that an old Victorian cast-iron pipeline does still exist, linking the east end of the Serpentine to the lake in St James's Park. The use of this was abandoned in recent times as it was leaking badly. However, this was probably because it was being used for a purpose

for which it was not designed – as a pumping main, working at relatively high pressures lifting water from St James's Park to the Serpentine. It would be worth determining whether by reverting to its intended use as a gravity pipeline from the Serpentine to St James's Park, the construction of Component 3 of the Hampstead Water Conduit could be avoided – with consequent saving of £4.5 million of the capital cost.

THE HAMPSTEAD WATER CONDUIT – HIDDEN RIVER LEGACY

The Hampstead Water Conduit is an attractive concept from a number of points of view. It might well have to await improvements in the general economy of the country before it could be implemented. On the other hand, it is a 'feel-good' project, the implementation of which could not only lift spirits in depressing times, but also contribute a small stimulus towards better economic times.

Apart from the benefits that could accrue to the management of the Royal Parks and the environment generally, the nature of the 'oases' that could be created for residents in the boroughs of Camden and Westminster – and, eventually, even the City of London – render the concept worthy of serious consideration. An idea of the nature of those 'oases' can be obtained by a visit to the district in Islington, where the New River has remained open to the public gaze.

The opening up of a part of the New River to create a much-used and popular inner-city oasis by the Borough of Islington has already been mentioned. The boroughs of Brent and Hillingdon have done much to create and protect recreational walks along the banks of the Dollis Brook/Brent and the Pinn respectively. These benefit the residents of their boroughs and others who seek relaxation in an urban environment without the need to travel to find it.

It would be a wonderful thing to be able to say, 'London's rivers, hidden? No, following their partial resurrection and revelation due to the Hampstead Water Conduit, we can again take pleasure from them in Camden and Westminster!'

Were this to happen, the author would be happy to re-title any subsequent edition of this book, altering it from *Walking on Water* to *Walking by Water*!

References

The following is a list of the books read in the course of researching this book. Where, on a very few occasions, a particular text has been quoted in the text, particular reference has been made to it there. In general, only historic writings have been quoted.

CHAPTER 1: LONDON AND ITS HIDDEN RIVERS

Barton, Nicholas. 1962, rev. 1992: *The Lost Rivers of London*. (Historical Publications Ltd. London.)

Clunn, Harold P. 1932, rev. 1937 & 1950: *The Face of London*. (Spring Books. London.)

Gourlay, Chris. 15 June 2008: 'Boris Johnson to Revive London's Rivers'. (*The Sunday Times*. London.)

Inwood, Stephen. 2008: *Historic London. A Traveller's Companion*. (Macmillan. London.)

Ivimey, Alan. 1932: 'Some Lost Rivers of London'. Vol II pp 465-476. *Wonderful London*. Ed. St John Adcock. (The Educational Book Co. Ltd. London.)

Smith, Stephen. 2004: *Underground London. Travels Beneath the City Streets*. (Little, Brown Book Group. London.)

Stow, John. 1603: *A Survey of London Written in the year 1598*. Introduction by Antonia Fraser. (The History Press. Stroud. 2009.)

Trench, Richard and Hillman, Ellis. 1984, rev. 1993: *London Under London. A Subterranean Guide*. (John Murray, a Division of Hodder Headline. London.)

Wittich, John. 2009: *Discovering London Curiosities*. (Ashford Colour Press. Gosport, Hants.)

CHAPTER 2: NOBLE BEGINNINGS, BRIEF RENOWN, RACK AND RUIN

Curl, James Stevens. 2010: *Spas, Wells & Pleasure Gardens of London*. (Historical Publications. London.)

Dobraszczyk, Paul. 2009: *Into the Belly of the Beast – Exploring London's Victorian Sewers*. (Spire Books Ltd. Reading.)

Gavin, Hector 1848: *Sanitary Ramblings – Being Sketches and Illustrations of Bethnal Green, A Type of Condition of the Metropolis and Other Large Towns*. (Reprinted and published by Frank Cass & Co., London. 1971.)

Halliday, Stephen. 2009: *The Great Stink of London – Sir Joseph Bazalgette and the Cleansing of the Victorian Metropolis*. (Sutton Publishing. Stroud.)

Hansen, Roger D. Undated. 'Water-Related Infrastructure in Medieval London'. (WaterHistory.Org. www.waterhistory.org/histories/london)

McCann, Bill. August 2010: 'Poised for planning: the Thames Tideway Tunnel'. (*Water 21*, IWA. London.)

CHAPTER 3: A CITY GROWS, ITS RIVERS BEGGARED

Binnie, G. M. 1981: *Early Victorian Water Engineers*. (Thomas Telford. London.)

Calendar of Letter-books of City of London. Folio cccxviii Dimissio More et cursus aque de Walbroke. St James (25 July) 48 Edward III (AD 1374)

Clout, Hugh. 1991. *History of London*. (Times Books. Harper Collins. London.)

Fabyan, Robert. 1516: *Fabyan's Chronicle. (Also known as The Concordance of Hysteryes)*. Published 3 years after his death as *The New Chronicles of England and France*. (Richard Pynson.)

Faulkner, Alan. 2005: *The Regent's Canal: London's Hidden Waterway*. (Waterways World. Burton-on-Trent, Staffs.)

FitzStephen, William. 1183: *Latinae Libellum se situ et Nobilitate Londini (a Preface to a Biography of Thomas Beckett, Vitae S. Thomae, variously translated as History of the Most Noble City of London or Description of the Most Noble City of London)*. (English translations used Henry Thomas Riley & 1812 edition of John Stow's *A Survey of London*)

Flaxman, Ted and Jackson, Ted. 2004. *Sweet & Wholesome Water*. (E. W. Flaxman. Cottisford, Oxon.)

Graham-Leigh, John. 2000. *London's Water Wars*. (Francis Bootle Publishers.)

Halliday, Stephen. 1999. *The Great Stink of London. Sir Joseph Bazalgette and the Cleansing of the Victorian Metropolis*. (Sutton Publishing. Stroud, Glos.)

Hughson, David. Hughson (pseudonym of Dr Edward Pugh). 1806. *Being an Accurate History and Description of the British Metropolis and its Neighbourhood to Thirty Miles Extent*. (David J Stratford, Holborn Hill.)

Jackson, Peter. 1971 & 2002: *London Bridge – A Visual History*. Peter Jackson. (Historical Publications. London.)

Metropolitan Water Board. June 1961. *The Water Supply of London (Extract)*. (MWB. London.)

Mortimer, Ian. 2009. *The Time Traveller's Guide to Medieval England*. (Vintage. London.)

Roberts, Gwilym. 2006. *Chelsea to Cairo – "Taylor-made", Water Through Eleven Reigns and in Six Continents*. (Thomas Telford. London.)

Sabine, Ernest L. July 1934: 'Latrines and Cesspools of Medieval London'. Ernest L Sabine. *Speculum* Vol 19, No. 3. pp 303–321. (Medieval Academy of America.)

Spain, Dr Robert. 2002. *A Possible Roman Tide Mill*. Boxley. England.

Swain, Hedley & Williams, Tim. 2008. 'The Population of Roman London'. (Paper in *Londinium and Beyond – Essays on Roman London and its Hinterland for Harvey Sheldon*.) (Council for British Archaeology. York.)

Veitch, Capt. 1850. *Statement in Explanation of the Plans of the Drainage of Southwark*. (Metropolitan Commission of Sewers. London.)

Ward, Robert. 2003: *London's New River*. (Historical Publications. London.)

White, J. 1904: *History of the ward of Walbrook in the city of London together with an account of the aldermen of the ward of two remaining churches St Stephen Walbrook and St Swithin, London Stone with their rectors.*

CHAPTER 4: A STORY OF USE AND ABUSE

Ackroyd, Peter. 2004. *The Clerkenwell Tales*. Peter Ackroyd. (Vintage. London.)

Bird, Sir James. 1922: Historical introduction: The Well of Dame Agnes Clare. Survey of London: Volume 8 Shoreditch. (British History Online.)

Seymour. 1734: *History of the Parishes of London and Westminster.*

Summers, Judith. 1989: *Soho -- A History of London's Most Colourful*. pp. 113-117. (Bloomsbury, London, 1989.)

The Every-day Book and Table Book. William Hone. 1837

Tindall, Gillian. 2003: *The Man Who Drew London – Wenceslaus Hollar in Reality and Imagination*. (Pimlico. London.)

Tomlins, Thomas Edlyn. 1858: *Yseldon. A Permabulation of Islington.*

Thornbury, Walter. 1878: *Old and New London: Volume 1*, pp 32-53. 'Fleet Street: General Introduction'.

Thornbury, Walter. 1878. *Old and New London*. Volume 3, pp 15-25. 'St Clement's Danes – The Law Courts'.

Walford, Edward. 1878. *Old and New London*. Volume 5, Chapter XXXIX, pp 494-504. 'Hampstead: Belsize and Frognal'.

CHAPTER 5: MAPPING LONDON'S HIDDEN RIVERS

Individual maps consulted in researching the book are listed separately.
Whitfield, Peter. 2006. *London. A Life in Maps*. (British Library. London.)

CHAPTER 6: THE RIVER WALBROOK

Bird, Sir James. 1922. *Survey of London: Volume 8: Shoreditch*. 'The Well of Dame Agnes Clere'. (British History Online.)
Corporation of London. 2007. *Bunhill Fields Burial Ground*. (The City Gardens Office. London.)
Corporation of London. *The Livery Companies of the City of London*.
Cromwell, Thomas & Storer, Henry. 1835. *Walks Through Islington*.
Delaney, Ven. Peter. *St Stephen Walbrook. Thoughts on the Architecture*.
dePijper, Margreet & ten Napel, Henk. 2009. *The Dutch Church Austin Friars London*. (The Dutch Church. London)
Downes, Prof. Kerry. *A Thousand Years of the Church of St Stephen Walbrook*.
Finsbury Official Guide. Historical Notes.
Hone, William. 1837. *The Everyday Book and Table Book*.
Hyde, Ralph. 1999. *Ward Maps of the City of London*. (W. S. Maney & Son. London)
Lewis, Samuel. 1831. *A Topographical Dictionary of England*, Vol. IV, p 551. (S. Lewis. London)
Martin, C. Martin. 2002. *City of London Churches*. (City Churches Development Group. London.)
Milne, Gustav. 1985. *The Port of Roman London*. (B. T. Batsford. London.)
New York Times. 25 March 1904. 'Queen's Nine-Cent Dinner'.
Percy, Sholto, Percy, Reuben & Byerly, Thomas. 1824. *London*.
The Temple of Mithras and its Surroundings. (Extract from an unknown source.)
Vickers, Dr John A. 1994. *Wesley's Chapel*. (Pitkin Guides. Andover, Hants.)
2008-9. *Wesley's Chapel and Leysian Mission Annual Magazine*. Wesley's Chapel and Leysian Mission. London)

CHAPTER 7: HAMPSTEAD HEATH – SOURCE OF THREE HIDDEN RIVERS

2003. *Map of Hampstead Heath, Hampstead & Highgate Villages*. (MAP.U Publishing)
Bryant, Julius. 2001. *Kenwood. The Iveagh Bequest*. (English Heritage. London.)
Cooper, Pam. 2006. *Waterlow Park. A Graden for the Gardenless*. (Chico Publications.)
Friends of Highgate Cemetery. 2007. *Highgate Cemetery*. (Basildon Printing . London.)
L of M. 1895. *Illustrated Guide to Waterlow Park, Highgate*. (Langley & Son. Highgate, London.)
Oppenheimer, Stephen. 2006. *The Origins of the British*. (Constable & Robinson. London.)
Richardson, John. 1989, rev. 2004: *Highgate Past*. (Historical Publications. London.)
Wade, Christopher. 2008. *Hampstead Town Trail*. (Camden History Society)
Yuille, Judith. 1991. *Karl Marx. From Trier to Highgate*. (Highgate Cemetery. London.)

CHAPTER 8: THE RIVER FLEET

Ackroyd, Peter. 2004. *The Clerkenwell Tales*. (Vintage. London.)
Aston, Mark & Marshall, Lesley. 2006: *King's Cross. A Tour in Time*. (Camden Local Studies and Archives Centre. London.)
Baker, T. F. T. et al. 1985. *A History of the County of Middlesex: Volume 8*, pp 20-24, 'Islington: Growth: South-East Islington'. (British History Online.)
British Postal Museum. *Early History: Cold Bath Fields Prison*. www.postalheritage.org.uk
Gardiner, Rena. 2005. *The Story of St Bartholomew the Great*. (The Parish Church of St Bartholomew the Great. London.)

Hayes, David A. 1998: *East of Bloomsbury*. (Ed. F. Peter Woodford. Camden History Society.)

Milne, Gustav. 2003. *The Port of Medieval London*. (Tempus Publishing. Stroud, Glos.)

Richardson, John. 1991. *Camden Town and Primrose Hill Past*. (Historical Publications.)

St James Clerkenwell. A Short History.

St Pancras Old Church. Undated. Unknown author.

Thornbury, Walter. 1878. *Old and New London: Volume 2*, pp 298-306, 'Coldbath Fields and Spa Fields'. (British History Online.)

Thornbury, Walter. 1878. *The Fleet River and Fleet Ditch*. (British History Online.)

Thornbury, Walter. 1878. *Old and New London: Volume 2*, pp 404-16, 'The Fleet Prison'. (British History Online.)

Tindall, Gillian. 1980: *The Fields Beneath*. (Paladin Books. London.)

Wade, Christopher. 2000: *The Streets of Hampstead*. (CHS Publications. London.)

Wade, Christopher. 1989. *Hampstead Past. A Visual History of Hampstead*. (Historical Publications. London.)

CHAPTER 9: THE RIVER TYBURN

2009. *Central School of Speech and Drama Prospectus*.

London Borough of Camden. 2005. *Belsize Walk. Primrose Hill to Parliament Hill*.

Denford, Steven. 2009. *The Hampstead Book. The A-Z of its History and People*. (Historical Publications. London.)

Elrington, C. R. et al. 1989. *A History of the County of Middlesex: Volume 9: Hampstead, Paddington*. pp 81-91. 'Hampstead: Social and Cultural Activities'. (British History Online.)

Nicola. 2010. *Tyburn Angling Society*. (www.ediblegeography.com)

St Marylebone Parish Church. Church History. (www.stmarylebone.org.uk)

Unknown author. *St John's Wood History*. (The St John's Wood Society.)

Walford, Edward. 1878. *Old and New London: Volume 5*. Chapter XXXIX pp 494-504. 'Hampstead: Belsize and Frognal'. (British History Online.

Wittich, John & Dowsing, James. *The Hidden World of Regent's Park*. (Sunrise Press.)

CHAPTER 10: THE RIVER WESTBOURNE

Brindley, Brian. 1999. *St Mary's, Bourne Street. Infinite Riches in a Little Room*.

Bryson, Bill. 2010. *At Home. A Short History of Private Life*. (Transworld Publications. London.)

Croot, Patricia E. C. 2004. *A History of the County of Middlesex: Volume 12: Chelsea*. pp. 217-233. 'Public Services. Public Order'. (British History Online.)

Ellis, Peter, J. 2008. 'Thomas Hawksley and the Project to Cleanse the Serpentine'. (www.pureandconstant.talktalk.net)

St Augustine, Kilburn. Guide Book.

CHAPTER 11: COUNTER'S CREEK

Bird, James & Norman, Philip. 1915. *Survey of London: Volume 6: Hammersmith*. p 122. 'Counter's Bridge and Creek'. (British History Online.)

Sheppard, F. H. W. 1983. *Survey of London: Volume 41: Brompton*. pp 2,241-245. 'Stamford Bridge and the Billings Area'. (British History Online)

CHAPTER 12: STAMFORD BROOK

Coleman, Reginald & Seaton, Shirley. 1992. *Stamford Brook. An Affectionate Portrait*. (Stamford Brook Publications. London.)

Chapter 13: Black Ditch

Baker, T. F. T. 1998. *A History of the County of Middlesex: Volume 11: Stepney, Bethnal Green*. (British History Online.)

Dark Waters Project Group. 2008. *Map of the River Thames.*

Greville, Charles. February, 1832. *Abstract from Diary on Bethnal Green.* (VictorianLondon.org)

Hobhouse, Hermione. 1994. *Survey of London: Volumes 43 and 44: Poplar, Blackwell and Isle of Dogs.* British History Online.)

CHAPTER 13: THE BLACK DITCH

Barker, T. F. T. 1998. *A History of the County of Middlesex: Volume 11: Stepney, Bethnal Green.* (British History Online.)

Dark Waters Project Group. 2008. *Map of the River Thames.*

Greville, Charles. February, 1832. *Abstract from Diary on Bethnal Green.* (VictorianLondon.org)

Hobhouse, Hermione. 1994. *Survey of London: Volumes 43 and 44: Poplar, Blackwell and Isle of Dogs.* (British History Online.)

LIST OF MAPS CONSULTED

Title of Map Consulted	Mapmaker	Publisher	Date	British Library Ref., ISBN or other Ref.	Principal Contributions to Research
Pre-Reformation London	Briset, Jordan & Fitz Alwyn, Henry		1530	Crace 1/7	Map; NTS; Fleet and mouth of Walbrook
Copperplate Map			1555	Museum of London	Pictorial plan/map; NTS; Walbrook arm from Shoreditch, confluence with moat on outer side of the London Wall between Bishopsgate and Moorgate
Meropolis of London	Braun & Hogenberg		1572	Maps 215.f.1	Pictorial plan; NTS; River confluences of Fleet (at Blackfriars), Tyburn (at Westminster) with the Thames and the Walbrook at moat on outer side of the London Wall between Bishopsgate and Moorgate
Map of Westminster	Norden, John		1593	Crace 1/22	Map; NTS; not yet viewed
Map of the City	Norden, John		1593	Crace 1/21	Map; NTS; not yet viewed
London – Agas Map	Ralph Agas		1633	BL Maps 1/8	Pictorial plan probably updating the 'Copperplate Map', has same info

Titles of Maps Consulted	Mapmaker	Publisher	Date	British Library Ref., ISBN or other Ref.	Principal Contributions to Research
Plan of London and its Environs	Newcourt & Faithorne		1658	Crace I/35	Central London rivers
London - Bird's Eye View	Hollar		1658	British Museum Dept Prints & Drawings	Pictorial map; general interest
Mayfair - ancient manor of Ebury			1664	BL Add MS 38104	Plan; NTS; shows Tyburn River as eastern edge of Ebury Estate
London - fire damaged area	John Leake engraved by Hollar		1669	Crace I/50	Scale map commissioned to show London post-fire; Fleet river shown up to Clerkenwell Road, further than earlier maps; Walbrook shown at base of Dowgate Hill and within and south of the London Wall at Bishopsgate
London	Ogilby & Morgan		1676	Crace II/61	Precise scale plan; possible confluence of Walbrook with Thames at foot of Dowgate Hill, an extension of Walbrook (Street)
London, Westminster and Southwark	John Strype		1720	BL Maps Crace II/85 (have copy on CD)	Scale map; Tyburn from north of Oxford Street to St James's (Green) Park; Fleet from St Pancras to Blackfriars

Titles of Maps Consulted	Mapmaker	Publisher	Date	British Library Ref., ISBN or other Ref.	Principal Contributions to Research
Hyde Park (public area)			1720s	BL Maps Crace X/4	Scale map; shows Tyburn Brook (often incorrectly confused with the Tyburn River) entering the eastern end of Serpentine from north
Westminster and the West End	John Rocque		1745	Crace III/104	
Plan of London, Westminster and Southwark	John Rocque		1745	Crace III/107	Central London rivers
Plan of London and Environs	John Rocque	John Pine, John Tinney & Thomas Bowles	1746	Crace XIX/18	Original survey; scale map; short stretch Tyburn crossing Oxford Street from north to South Moulton Row
Plan produced by order of Parliament to compare respective areas of London and Paris	John Rocque		1762		Scale map; clear depictions of Fleet, Tyburn, Westbourne, Counter's Creek and Stamford Brook outside then urbanised areas
Gordon Riots – troop concentrations			1780	BL Add MS 15533 f39	Military version of Rocque's 1762 map; clear depiction of rivers shown on Rocque's map - but highlighted
15 Miles Around London in 1786	John Cary	Motco Enterprises Ltd	*c.* 1786	ISBN 978-0-9545080-9-8	Information from John Andrew & Andre Drury's survey

Titles of Maps Consulted	Mapmaker	Publisher	Date	British Library Ref., ISBN or other Ref.	Principal Contributions to Research
Mayfair - Grosvenor Estate			1790	Crace X/19	
London, Westminster and Southwark	Richard Horwood		1792–1799	BL Maps Crace X/23 (have copy on CD)	Original survey; scale map; clear depiction of Westbourne (Ranelegh Sewer) from exit from Serpentine to Thames, the King's Scholars' Pond Sewer through Pimlico and the pond receiving Tyburn in Green Park
London – 1805 to 1822	OS	Cassini maps	1805–1822 (rep 2007)	ISBN 978-1-84736-268-1	Scale map, re-projected and re-scaled to match National Grid; shows north bank rivers except Walbrook outside urbanised areas
Original Plan for Construction of Regent Street	I. Nash		1814	BL Maps Crace XII/17	Scale plan; over-drawing of route of King's Scholars' Main Drain or River Tyburn from New Cavendish Street part through Mayfair
Belgrave Square Development Plan			1826	Crace X/25	Scale map; Westbourne River passing Belgrave Square showing bifurcation of stream and its re-unification

Titles of Maps Consulted	Mapmaker	Publisher	Date	British Library Ref., ISBN or other Ref.	Principal Contributions to Research
London 1829 map	G. F. Cruchley		1829 (rev 1847)	Crace VII/253	Original survey; scale map; not yet viewed
London	Christopher and John		*c.* 1830		Original survey; scale map; shows urban and rural lengths of Fleet,
	Greenword				Tyburn, Westbourne and Counter's Creek
London and Its Environs	B. R. Davies		1832	Crace VII/248	Scale map based on OS and railway's maps; shows Fleet, Tyburn, Westbourne, Counter's Creek and Stamford Brook outside urban areas
Parish of Paddington	George Oakley Lucas		1842	Crace XIV/2	Original survey; scale map; Westbourne – Kilburn Priory to Hyde Park north end
London	Joseph Cross		1844	Crace VII/254	Scale map; shows Westbourne (limited benefit)
Hyde, St James's and Green Parks – Plan of Pipes			1852		Shows inter-linkage of park lakes and reservoirs
London	Edward Stanford and Trelawney Saunders		1861	3480 (260)	Original survey; scale map based upon OS grid
Westbourne, Ty Bourne, Hole Bourne and Fleet		Edward Stanford	1888		Mapmaker as yet unknown; potentially excellent on river routes

Titles of Maps Consulted	Mapmaker	Publisher	Date	British Library Ref., ISBN or other Ref.	Principal Contributions to Research
London 1897–98	Ordnance Survey	Cassini	Compilation 1893–1904	ISBN 978-1-84736-269-8	Scale maps based on original OS
London 1920	Ordnance Survey	Cassini	1920	ISBN 978-1-84736-270-4	Scale maps based on original OS – 1912–1926
Developments on Roman London's Western Hill	S. Watson and K. Heard	Museum of London's Archaelogical Service	2008	ISBN 978-1-90199-266-3	Fig. 1 Walbrook and Fleet in City
A–Z Greater London – Digital Mapping	Geographer's A–Z Map Co. Ltd with OS	Geographer's A–Z Map Co. Ltd	2008		Digital map of London
Anquet Ordnance Survey – Digital Mapping	Ordnance Survey	Anquet Maps	2009		Based on Ordnance Survey and Philip's mapping
Developments on Roman London's Western Hill	S. Watson and K. Heard	MoLAS monograph	Recent		Fig. 1 Walbrook and Fleet in City

Index

Abbey Mills 57–8, 61, 66, 124
Ackroyd, Peter 112, 210
Amwell 81, 104
Angel, Islington 13, 79, 82, 102, 126, 128–30
artesian wells 50, 73
 Fountain Court 32
 geology of, 31–33
Augustine 77, 212

Bagshot Sands 32, 46, 136–7, 143, 146, 161, 199
Barnet Gate Wood 46
Barnett, Henrietta 144
Bartholomew, Robert and Elizabeth 42
Barton, Nicholas 69, 86, 172
Battle Bridge 25, 36, 98, 157
Bazalgette, Sir Joseph 55, 57–9, 61–3, 66, 165,
 209–10
Becket, Thomas 69, 116, 167
Beckton 57–8, 65–6
Belgravia 17, 51, 61, 63, 106, 119, 124, 174, 177–8,
 181–3
Belsize 80, 162, 211–2
Bethnal Green 84, 195–6, 198, 209, 212–3
Big Stink 74
Billingsgate 55
Billingswell Ditch 184
Bishop of Westminster 105, 143, 155
Black Bull Ditch (Parr's Ditch) 14, 26, 192–3
Black Ditch 194
 name, origin of 197
 sources and watercourses 197
Blackfriars 13, 25, 44, 51, 60, 76, 85, 111, 145, 151–2,
 157–8, 213–4
Bollo Brook 191
Bond Street Station 102, 163, 171
Boudica, Queen (Boadicea) 98, 131

bourne, born or burn, definition of 20
Bramah, Joseph 54
Bridge Waterworks Company 104
British History Online website 12, 210–12
Broad Street pump 43, 52, 161
brook, definition of 20
Brook Green 26, 192
bubonic plague 70, 113, 155
Buckingham Palace 91, 94, 161–4, 166, 169, 171, 182
Bulmer, Bevis 104
Burbage, Richard 40

Camden Town 44, 84–5, 96, 145, 148, 151, 157, 199,
 212
Canary Wharf 197–8
Carthusian Order 102
Celandine Route 46
cesspools 52–4, 74, 112, 210
Chadwell 81, 104
Chadwick, Edwin 55, 74
chalybeate 34, 36–8, 80
Charlbert Bridge 96
Charles I 155, 180
Charles II 37, 80, 90–1, 155, 168–9, 180
Charterhouse (London) 36, 42, 79, 103, 128
Chelsea
 Barracks 51, 178
 Bridge 51, 57, 61, 97, 173–4, 178–9, 184
 Bridge Pumping Station 57
 Harbour 188
 Hospital 51, 178
 Waterworks Company 74, 83, 91, 94, 106, 178, 182
child morbidity 52
Chiswick Eyot 191
chlorosis 38
cholera 36, 43, 52–3, 70, 73–4, 93. 113, 161

cisterns 50, 53, 102
City of London
 wall of, 28, 60, 98, 107, 115–6, 120, 129–32, 154
City of Westminster 24, 74, 78, 101, 119, 164
Coldbaths Fields Prison (Clerkenwell Gaol) 36
Colthurst, Edmund 104
Commissioners for Sewers 21, 51, 65
conduits
 definition of 20
Coram, Thomas 103
Cornhill 23–4, 75–6, 98–9, 100, 132
Corporation of London 47, 79, 104–5, 144, 155,
 157, 203, 211
Counter's Creek 184
 Countess of Oxford 184
 History 185
 Kensal Green Cemetery 26, 185
 name, derivation of 184
 New Cut River 184
 sources, watercourses and tributaries 185
 Wormwood Scrubs 26, 185, 191–2
creek, definition of 20
Crossness 57
Cubitt, Thomas 182
culvert, definition of 20
Cummings, Alexander 54
Cuneburna 172

Deephams Wastewater Treatment Plant 58
dike, dike or dyche, definition of 20
Dissolution of the Monasteries 40, 79, 92, 103,
 144, 167, 180
distemper 38
ditch, definition of 20
drainage, definition of 20
dropsy 38

Edward I, King (The Confessor) 166
Effluviam (Miasmatic) Theory 52
elm trunks 53
Embankment, Thames 26, 51, 57–9, 162, 165, 178
Environment Agency 65

Fabyan, Robert 69, 126, 210
Farringdon 13, 25, 80–1, 111, 149–51, 157, 203
FitzStephen, William 12, 34, 40, 69, 98, 109,
 115–6, 141, 155, 167
Flask Walk, Hampstead 38
Fleet 145
 Blackfriars Bridge 13, 25, 60, 76, 85,151–2,
 157–8
 Bridge 102, 111, 155
 Caen Ditch 145,
 Canal 156

derivation of name 145
Ken Ditch 145
defensive barrier 97–8
Ditch 113, 145
Dyke 145, 148
Explosion 84–5, 158
history 152–8
Market 157
name, derivation of 145
profile, watercourse 152
River of Wels or Wells 18, 35, 80, 146
Roman 152–3
Sewer 60, 64, 156
sources, watercourses and tributaries 146
Turnmill Brook (Lower Fleet) 115, 146
Vale of Health 105, 148, 151, 157
Forest of Middlesex 75, 141
fosse or foss, definition of 20

Gavin, Dr Hector 196
George II 90, 97, 169, 180
glaciers 44–5
Gordon, Lord George 98, 120
Gordon Riots 98, 120
Grand Union Canal 46–7, 85, 120, 174, 176, 179,
 185, 187, 191
 Paddington Arm/branch 46, 85, 174, 176, 185, 191
Great Bagshot River 32, 136
Great Fire of London 98, 104, 111, 131, 144, 156
Great Plague (1665) 70, 79, 142
Green Park 24, 81, 90, 96–7, 161, 163–4, 169
 Reservoirs 169
Grimes, Professor W. F. 68
Grosvenor, Lord 182

Hampstead 140
 Bagshot Sands (see Bagshot Sands)
 Lock-up 142
 Massif 30, 136
 Village 38
 Water Conduit, The 199
 wells and spas 38
Hampstead Heath
 Bishop of Westminster 105, 143, 155
 Barratt, Thomas 144
 brick-clay 137, 144
 Earl of Iveagh 144
 Eton College 144
 Henrietta Barnett 144
 Kenwood Preservation Council 144
 Parliament Hill Fields 144
 Murray, David (3rd Earl of Mansfield) 144
 Murray, William (4th Earl of Mansfield) 144
 ponds 33, 38, 74, 85, 105–6, 108, 138–9, 144, 148,

151, 157–8, 199–203, 205, 207
Waley-Cohen, Robert 144
Wilson, Sir Thomas Maryon 144
Wylde's Farm 144
Hampstead Water Company 74, 83, 105–6, 138, 157–8, 199
Hampstead Wells 35, 38
Hangar Lane 26, 46
Harrow Weald 46
Hawksley, Thomas 55, 61, 93
Henry VIII 79, 90–2, 167, 169, 180
hidden rivers
 abuse 19, 49, 85–90, 112
 cycle of degradation 90
 industry, by 87–90, 107
 sewers, as 112–4
 base flows 58, 61–2
 feng shui 87
 master map 27
 resurrection 199–208
 revelation 199, 208
 use
 bathing and laundry 99
 fishing 107
 jousting on water 109
 mills 114
 navigation 110
 power 114
 recreation 107
 Royal Parks and lakes 90–7
 sewers 112–114
 skating 109
 strategic value 97
 walking 108
 water supply 100–7
Highgate 30, 32–3, 44–5, 60, 74, 79, 84, 106, 121, 136–9, 141–9, 164, 178, 199, 201–5
 Bishop of London 142
 tramway 142
Highwood Hill 46
Hillingdon 46, 208
Hillman, Ellis 69, 118
Holborn Viaduct 18, 50–1, 146, 150–1, 155
Hollar, Wenceslas (Vaclav) 210, 214
Hollingshead, John 162, 171
Hoxton 40–1, 116, 128–30
Hughes, Thomas 37
Hyde Park 17, 24–5, 51, 61, 64, 75, 79–81, 90–2, 94–6, 106, 120, 168–9, 173–4, 177, 179–83, 190, 199, 202, 205–7
 Italian Gardens 62, 92, 94,
 Kensington Gardens 92, 94, 180–1
 Round Pond 94, 96
 Kensington House 81, 93–4, 96

Long Water 90, 94–5, 173, 181
Princess Diana Memorial Fountain 96
Serpentine 17, 24–5, 51, 61–3, 75, 85, 90–6, 106, 160–1, 173, 177, 181–3, 199, 205, 207–8
water management 90–8

ice-melt 44–5
interceptor or intercepting sewers 57, 59–61, 65, 158
Isle of Dogs 196

Johnson, Boris (Mayor of London) 13, 19, 199, 209

Kelebourne 172
Kemp, William 41
Kensington Gardens 92, 94, 180
 Round Pond 94, 96
Ken (Caen) Wood 105, 145, 148–9, 157
Kensal Green 26, 60, 185
 Cemetery 26, 185
Kentish ragstone 130
Kentish Town 84, 111, 145, 148, 151
Kilburn 35, 60, 84, 120, 172, 176, 179
 Priory 35, 120, 176
 Spa 176
King's Cross 18, 25, 35–6, 60, 98, 106, 145, 149, 151, 156–8
King's Scholar's Pond Sewer 64–5, 96, 161–2, 171
Knightsbridge 17, 61, 92, 174, 177, 182–3

Lambe, William 103
Lamb's Conduit Fields 103, 149
leper hospital (St James) 167
Limehouse 25, 65, 75, 120, 170, 194–8
Loftie, William 126, 131
Londinium 24, 31, 51, 76–8, 98, 100, 110, 131, 133–4, 153, 155, 165–6
London
 Basin 23, 29–31, 44–5, 75, 87
 Bridge 23, 59, 81–2, 103–4, 110–1
 Waterwheels 73, 81, 103, 115
 Charterhouse 36, 42, 79, 102–3, 128
 Floods 65, 123
 floods, properties at risk 65
 founding by the Romans 22–4
 Foundling Hospital 103
 geology underlying 29–31
 Great Fire of 98, 104, 111, 131, 144, 156
 Museum of 12, 68, 193
 population estimates 70–2
 siting of 23
 Tideway Improvement Project 65–6
London Boroughs of
 Brent 208
 Camden 105, 111, 157–8, 200–1, 203, 205, 208

Hillingdon 46, 208
Islington 13, 37, 42–3, 79, 81–2, 102, 104–5, 126, 128, 130, 200, 203–7
 Westminster 200–1, 203, 205, 207–8
Ludgate Hill 23–4, 75–6, 98, 152–4, 166
Lundenburgh 78, 166
Lundenwic 68, 77–8, 101, 133, 153–4, 166

mapping 117–24
Martin, John 57
Marylebone Park 168, 170
Mayfair 25, 96–7, 169, 171
Metropolitan Board of Works 55, 57, 60, 144
Metropolitan Water Board 73
Metropolitan Sewers Act, 1848 55
midden, definition of 21
Middle Level Sewer 60–63
Mill 114
 water-powered 18, 77, 115
 tidal 77, 115, 152–3
Mithraeum 132
Monmouth, Duke of 155–6
Moorfields 41, 75, 79, 109, 135
Mollet, André 168
Morice, Peter (Moris) 81, 103
Mount Pleasant 36, 79, 99, 103, 149–51, 157
Murray, David (3rd Earl of Mansfield) 144
Museum of London 12, 68, 193
Myddleton, Sir Hugh 81, 104–5

Nash, Sir John 91, 96, 169–70
Nell Gwynne 37, 91, 168
New River 81–3
 drain scouring- cleaning 81
 Myddleton, Sir Hugh 81, 104–5
 New River Head 82
 water supply 81–2
New River Water Company 73
Nightingale, Florence 52
Northern High Level Sewers 57, 60, 158
Northern Low Level Sewers 57, 59–60, 158
Northern Outfall Sewer 57–8, 124

Oedema 38
Oldbourn or Oldbourne 24, 34, 98, 111, 154–5
 Bridge 34, 111, 154

Paddington
 Arm, Grand Union Canal (see Grand Union Canal, Paddington Arm)
 Manor of 180
 Recreation Ground 176, 179
Paddenswick Manor 190
Parr's Ditch (Black Bull Ditch) 14, 26, 192–3

Pickwick, Samuel 108, 158
Pope, Alexander 113
Population 70–2
 census, censuses 52, 53, 70
 London 70–2
Prince Regent 84, 90–1, 169–70
Prince Rupert 81, 155
Princess Diana Memorial Fountain 96
public houses
 Adam and Eve, St Pancras 38
 Eagle and Child, Shoe Lane 38
 Fountain, Baldwin Street 41–2
 Fox and Hounds 123

Quills 102

Ram, Thomas atte 113, 135
Ranelagh
 Sewer 25, 61–5, 94–6, 122, 173–4, 178
Ravenscourt Park 60, 190–1
Regent's Canal 85, 96, 145, 149, 157, 162, 170, 176, 198
 Paddington Arm (see Grand Union Canal, Paddington Arm)
 Prince Regent 84, 90–1, 169–70
Regent's Park 24, 84, 90, 96, 159, 161–2, 164, 168, 170–1, 199, 202, 205, 207
 Charlbert Bridge 96
 Lake 96, 161, 199
 London Zoo 96
rivers
 definition of 20
 pollution 13, 47, 50, 55, 65, 77, 89, 99, 174, 201
 processes of formation 29, 44–5
 self-purification capacity 89
 spiritual powers 49, 88–9
 water supply capability 100–7
Rivers
 Brent 22, 46–9, 208
 Dollis Brook 22, 46–9, 208
 Lea 81, 104, 194
 Pinn 46–9, 208
 Roxbourne 46
 Silk Stream 46
 Wealdstone Brook 46
 Yeading Brook 46
Rocque, John 12, 98, 184, 215
Roman invasion of Britain (Claudian) 23, 28, 75–6
Round Pond, Kensington 94, 96
Royal Institute of British Architects 120, 197
Royal Parks 90–8
 Green Park (see Green Park)
 Hyde Park (see Hyde Park)

Queen Caroline 61, 81, 92, 97, 169, 180
Regent's Park (see Regents Park)
St James's Park (see St James's Park)
Serpentine (see Hyde Park, Serpentine)
water management 90–7
Rupert of the Rhine, Prince 81, 155

St James's Park 24, 62, 79, 90–2, 94–6, 163–4,
 167–70, 181, 199, 202, 205, 207–8
 Duck Island 91, 94
 Easton & Amos 91
 hunting 79, 91, 141, 167
 water management 90–5
St John's Wood 96, 161–2, 171
St Magnus Church 103
St Mary-le-Bourne (Marylebone) 159
St Mary's Nunnery 36
St Pancras 35, 38–9, 79–80, 105–6, 111, 149, 151,
 155, 158
 Church 38–9, 111, 149
 Road 38
St Peter 159, 166
St Peter's Abbey 74
St Stephens Walbrook 210
Sadler, Dick 37–8
Sadler's Wells 32, 35, 37–8, 82, 105
Sanforde, Gilbert 102, 166
scurvy 38
Serpentine (see Hyde Park, Serpentine)
 River 173
sewage 21
 overflow, combined (CSO) 21
Sewers
 Fleet Sewer 60, 64, 156
 King's Scholar's Pond 64–5, 96, 161–2, 171
 Ranelagh (see Ranelagh Sewer)
sewer, definition of 21
 combined 21–2, 55, 65–6, 200
 entry procedures 66
 risk, entry 9, 66,
 separate 21, 64, 200
sewerage, definition of 21, 200
Shadwell 195–6
Shepherd's Well 42–3, 161–2, 164
Shepherd Market 163
Shoreditch 37, 40, 128–30
Snow Hill 103, 156
spas and wells 33–44
 Acton 35
 artesian (see wells, artesian)
 Bagnigge House 35–7
 Clerkenwell 32, 35–6
 Coldbath Spring 35–6
 Fagges Well 35

Hampstead Wells 35, 38
Holy Well 34, 40, 109, 116, 129
Kilburn 35, 176
Mary St Clare 34
Peerless Pool (originally, Perilous Ponds)
40–1
Sadler's Wells (see Sadler's Wells)
St Agnes le Clere's Well (Dame Agnes de
Clare) 40–1
St Chad's 34–6
St Clement's 34–5, 109
St Mary's Hole (Black Mary's Hole) 35–6
St Pancras Wells 35, 38–9
Shepherd's Well (see Shepherd's Well)
Skinners Well 36
sunk (see wells, sunk)
Spring Gardens 41
springs 33
 formation 32–3
Snow, Dr John 52, 73, 93
Spitalfields 130, 194–5, 197
Stamford Brook 189
 Hammersmith Bridge 26, 189–90, 192–3
 name, derivation of 189
 Samforde 189
 sources and watercourses 189–90
 Stanford Brook 184, 189–90
Stepney (Stybba's Hythe) 120, 194, 198
stickleback 108, 158
Stow, John 12, 40, 69, 97–8, 102, 107–8, 126, 135,
 154–5, 166–7
Strand 18, 34–5, 73, 77–8, 101, 133, 153
stream, definition of 20
Stybba's Hythe (Stepney) 194
Sutton's Hospital 103
Sutton, Thomas 103
Swift, Jonathan 113
Swiss Cottage 96, 162, 164, 171

Tachbrook 51, 161, 164
tanneries & tanning 50, 88, 89 99, 101, 112, 151,
 154, 156
Temple of Mithras (see Mithraeum)
Thames
 flood plain 30
 Tideway Improvement Project 65–6
 Water 5, 9, 11, 61, 66, 73, 79, 100, 103–4, 106,
 110, 117–8, 124, 174, 181
Thorney Island 17, 25, 80, 159, 165–6
Timbs, John 196
tittlebat 108, 158
toshers (mud-larks) 135
Totteridge Common 46
Town Ditch 107–8

Trench, Richard 11, 69, 118
Trinovantes 23, 98
Turnham Green, battle of 81, 191
Turnmill Brook (Lower Fleet) 115, 146
Tyburn 159
 Brook 161, 177
 derivation of name 159
 Estate 177
 hanging tree 159, 161, 177
 history 165–71
 hydraulic profile 165
 Manor of 25, 159, 166–7
 Shepherd's Well (see Shepherd's Well)
 St Mary-le-Bourne (Marylebone) 159
 sources, watercourse and tributaries 161
 water supply 161, 166–7
typhoid 52–3, 74

Vale of Health 105, 148, 151, 157
Veitch, Captain 197

Walbrook 126
 Bank of England 28, 129–131
 derivation of name 126
 history 131–5
 profile, watercourse 129–31
 Roman 131–2
 sources, watercourses and tributaries 126–29
Ward, Robert 69
Water Act, 1854 53, 73, 105–6, 158
water carriers 50, 79, 101–2, 161
water closet 52–4
water
 bearers (see water carriers)
 leakage 47, 53
 symbol of purity, as 88
water supply 100–107
 continuous 8, 45, 53, 73–4, 81–2, 93, 100, 104–6,
 158
 intermittent 53, 73–4, 93, 100

wells (see also spas and wells)
 artesian 29–33, 45, 50, 73, 85, 91, 94
 sunk 73, 77, 79, 91, 94, 96, 99–100, 166
Well Walk, Hampstead 38, 148
Westbourne 172
 Chelsea Embankment 26, 51, 57, 59, 161, 178
 Green 85, 172, 176
 History 179–183
 Hyde Park (see Hyde Park)
 name, derivation of 172–4
 Park 172
 Sloane Square Station 122, 173, 177
 sources, watercourses and tributaries 174–9
 University College School, Hampstead 176
 watercourse profile 179
 Grove 25
 West End Village 172
West Brompton Station 187
West Cheap 102, 167
Westminster 14, 17–8, 23–5, 37, 60, 64, 70, 74–5,
 78–81, 92, 96, 98, 101–2, 104–6, 119–20, 122,
 124, 143, 154, 159, 162, 164, 166, 169, 171, 179–81,
 200–1, 205, 208
 Abbey 18, 70, 92, 164, 166, 180
 City of 24, 74, 78, 101, 119, 164
 Palace of 17, 25, 102, 120, 166
White Conduit 42, 102–3, 128
 House 40, 42, 102, 128
 loaves 42
Whitehall Palace 92
Whitestone Pond 174, 178
William I (The Conqueror) 78
William III 92, 180
Wilson, Sir Thomas Maryon 144
Winfield House 162
Woodside Park 46
Works as Executed drawings (Bazalgette's
 sewers) 61
Wormwood Scrubs 26, 185, 191–2
Wren, Sir Christopher 92, 111, 113, 156–7